Flintstone Modernism

Flintstone Modernism

or The Crisis in Postwar American Culture

Jeffrey Lieber

The MIT Press
Cambridge, Massachusetts
London, England

This book was set in Helvetica Neue Haas Pro by The MIT Press.
Printed and bound in Canada.
Every reasonable attempt has been made to identify owners of image copyrights.
Errors and omissions notified to the publisher will be corrected in subsequent
editions.

Library of Congress Cataloging-in-Publication Data
Names: Lieber, Jeffrey (Jeffrey D.), author.
Title: Flintstone modernism, or, The crisis in postwar American culture /
 Jeffrey Lieber.
Other titles: Crisis in postwar American culture
Description: Cambridge, MA : The MIT Press, 2018. | Includes bibliographical
 references and index.
Identifiers: LCCN 2017027993 | ISBN 9780262037495 (hardcover : alk. paper)
Subjects: LCSH: Architecture and society--United States--History--20th
 century. | Democracy and architecture--United States--History--20th
 century. | Symbolism in architecture--United States. | Architecture,
 Modern--20th century.
Classification: LCC NA2543.S6 L54 2018 | DDC 720.1/03--dc23 LC record
 available at https://lccn.loc.gov/2017027993

10 9 8 7 6 5 4 3 2 1

To My Parents

Contents

Acknowledgments

It is a pleasure for me to start by thanking Alex Potts, who supervised this project in its earliest incarnation as a doctoral thesis in the Department of History of Art at the University of Michigan, Ann Arbor. Our wide-ranging talks over the years about art, architecture, and historiography have been a continuous source of inspiration. Lydia Soo provided welcome advice, assistance, and good humor throughout graduate school and beyond. Rebecca Zurier, candid critical reader of the thesis, offered valued commentary. During my time as an undergraduate at Vassar College, Molly Nesbit and Gloria Kury introduced me to the field, and their examples continue to inspire me.

I am deeply indebted to my friend and colleague Janet Kraynak, who in recent years has provided vital intellectual engagement and keen advice in many galvanizing conversations. Cathy Soussloff's scholarly camaraderie, and shared interest in interdisciplinary approaches and comparative methods, have been fortifying.

A fellowship from the Gladys Krieble Delmas Foundation allowed me to begin work on this project at the Università IUAV di Venezia. Writing about American architecture and culture from the Tolentini, with a view over the rooftops of Venice, opened up new perspectives. I am grateful to the editors and conference organizers who invited me to present work in progress. In April 2009, I presented parts of chapter 1 at the Society of Architectural Historians annual conference on a panel entitled "Photography of Architecture and Its Political Uses" organized by Vladimir Kulić. In November 2011, I presented on Hannah Arendt at "Exile on Main Street: Fascism, Emigration, and the European Imagination in America," a symposium organized by the art history and literature departments at the University of Chicago. Excerpts from the epilogue were published in different form in *Harvard Design Magazine* in fall 2012, and part of chapter 3 appeared in *Design and Culture* in November 2014.

I am especially grateful to Maria Gough, who arranged for my visiting appointment (2015–2016) in the Department of History of Art and Architecture at Harvard University, where this book finally came together. I thank Ewa Lajer-Burcharth and Robin Kelsey, who invited me to lecture on this

material in their "Visual Culture, Materiality, and Medium" seminar at the Mahandria Humanities Institute and, along with other departmental faculty, offered astute feedback on my presentation. My courses at Harvard provided opportunities to workshop ideas with some of the best students I have ever encountered: Sean Wehle, Harmon Siegel, and Angie Jo were dazzling interlocutors. Haden Guest invited me to curate a three-month-long series at the Harvard Film Archive, where I explored many of the ideas about film in this book. Anne Summerscale and Charles Fried hosted evenings with wonderful discussions and delicious meals at their home, and with their friendship made my year in Cambridge feel complete.

Victoria Hindley, Associate Acquisitions Editor at the MIT Press, recognized the project's appeal and expertly saw it through to completion. I thank her, and the entire team at the Press for making this book a reality.

My closest friends have provided more than mere encouragement: an ongoing and immensely satisfying dialogue about our shared passions. Maureen Foster makes writing about art and film a great joy on a daily basis. Stephanie Harzewski provides the wisdom and solidarity that only twenty-five years of friendship affords.

This book is dedicated with love and tremendous gratitude to my parents, Susan and Steven Lieber, who have always supported my desire to pursue my interests as far as I could, as well as to the memory of my grandmothers, Goldie Ritter and Frances Lieber, whose unqualified confidence in me is really what got me through.

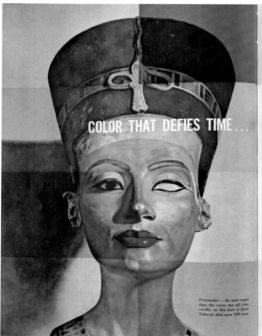

0.1

"Color That Defies Time," Virginia Metal
Products, *Architectural Forum*, July 1958.

Introduction

In February 1958, Hannah Arendt published *The Human Condition*, her disquieting phenomenological study of the central dilemmas facing modern man. Framed as a response to the national hysteria unleashed by the launch of the Soviet Sputnik satellite in October 1957, her book is a critique of economic, political, and social trends that had been on the rise in the United States for over a decade. In the Prologue, pointing to the popularity of slogans, catchphrases of the *Zeitgeist* scripted by corporate PR flacks and pseudo-scientific theorists praising the glories of technology, she wrote: "This, obviously, is a matter of thought, and thoughtlessness – the heedless recklessness or hopeless confusion or complacent repetition of 'truths' which have become trivial and empty – seems to me among the outstanding characteristics of our time."[1]

For Arendt, "science's great triumphs," such as space exploration, had created a crisis in the natural sciences and in the way people viewed the world. The meaning of life was no longer to be found in shared philosophical or religious traditions, but rather in the "truths" of modern science, encompassing "a theoretical glorification of labor," which, she argued, while demonstrable through "mathematical formulas," defied "normal expression in speech and thought."[2] It was with this in mind that she posed the simple question "what are we doing?" She proposed reviewing "the various constellations within the hierarchy of activities as we know them from Western history," namely labor, work, and action, to make sense of transformations in the meaning of these age-old concepts in the modern technological world.[3]

In June 1959, in a speech at the Tamiment Institute in New York, the leading think tank at the time for progressive politics, Arendt expanded her analysis to consider the transformation of culture under these conditions. She spoke frighteningly about the "gargantuan appetites" of the newly liberated laboring class, which, she argued, with more leisure time, hungered not for "culture," but rather for "entertainment."[4] In order to appease the insatiable appetites of the mass audience, she argued, "it is as though life itself reached out and helped itself to things which were never meant for it."[5]

What did she have in mind? What were the "things" life reached out for? The unique durable object, the singular work of art, the great cultural treasures of civilization. "The result is, of course, not mass culture, which, strictly speaking, does not exist," she further argued, "but mass entertainment, feeding on the cultural objects of the world."[6] "Culture is being destroyed to yield entertainment."[7] When Arendt revised her Tamiment talk for publication in her book of essays *Between Past and Future* (1961), which serves as a kind of coda to *The Human Condition*, she retitled it "The Crisis in Culture: Its Social and Its Political Significance."

This book is about that crisis. Arendt's was just one of a number of authoritative, pessimistic voices that came forward in the late 1950s and early 1960s to diagnose seemingly alarming shifts in culture and society. Surveying the scene in 1958 in his controversial tract *The Causes of World War Three*, C. Wright Mills described what he saw as a "cultural default."[8] In 1961, reviewing American foreign policy in the years since the end of the war, the political scientists Edmund Stillman and William Pfaff diagnosed a "crisis of policy": "our national style serves us badly," they asserted, while questioning "the meaning of a whole period of our national life – our period, we like to say, of coming to maturity, of greatness in the world."[9]

—

What are some expressions of the crisis in culture?

First of all, the painful recognition of the failure of the avant-gardes on the part of theorists of the modern movement, who nevertheless attempted to salvage what they could of the modernist project. In an influential essay, "The Need for a New Monumentality," first published in 1944, the art historian Sigfried Giedion argued that what people now desired was architecture expressive of "their aspiration for joy, luxury, and for excitement"; Giedion had been the foremost champion of the gleaming functionalism and white-walled cubic geometry of the Bauhaus, and had helped explain its world-changing significance to American audiences in his book *Space, Time, And Architecture: The Growth of a New Tradition* (first delivered as the Charles Eliot Norton lectures at Harvard in 1938, and published in 1941), but he now wrote of an "eternal need" that could be satisfied only by the return of "symbolic architecture."[10]

Moving away from the artistic and theoretical abstractions of the avant-gardes, architects in the postwar era rediscovered that symbolism in romanticizing historical motifs drawn from ancient civilizations, the Renaissance, and the age of Enlightenment. As a result, they provoked a crisis in architecture

and the understanding of modernism itself. Often overlooked is the fact that in his essay Giedion expressed profound skepticism about the quality of monumentality, which he associated with the fevered dreams of authoritarian, fascist regimes. He wondered if architecture was in fact still capable of fulfilling the masses' desires for what he called "great representation."

Writing in *Art in America* in 1954, a decade after Giedion's essay was published, the Yale art historian Vincent Scully marveled at the return of ancient "archetypes," such as vaults, domes, and pavilions defined by high colonnades, in the work of so-called "second-generation" American modernists such as Philip Johnson, Eero Saarinen, and Louis Kahn. Looking for patterns in the life cycles of civilizations, Scully compared post-World War II America with imperial Rome of the Hadrianic period, which he described in a thinly veiled analogy as "a period of grappling with complex problems of belief and power."[11] In "Modern Architecture: Redefinition of a Style," a lecture he gave at the 1957 meeting of the College Art Association, Scully began to rewrite the entire history of architecture from antiquity to the present in order to make sense of strange neoimperial stylistic tendencies that were appearing in the United States in the 1950s, an endeavor that culminated in a quixotic polemic, *Modern Architecture: The Architecture of Democracy*, published in 1961.

The architectural analogies were less allusive. In *This Is America*, the official United States guidebook to the 1958 Brussels world's fair, Edward Durell Stone's widely celebrated design for the U.S. Pavilion was compared to "the Rome Colosseum." As the guidebook boasted, it surpassed the Colosseum in being the first building of its size free of interior columns to be fully roofed.[12] While Stone looked to Rome, Bauhaus *émigré* Marcel Breuer, living and working in New York, looked to ancient Egypt. In the late 1950s, Breuer articulated a newfound fanaticism for what he called "Pharaonic architecture," and discovered "inner similarities" and "comparable instincts" between "our society, our beliefs, our methods, our culture" and "the Pharaonic one," although they were expressed in different forms and materials, and were connected to different political, religious, and social structures.[13] Breuer put this thesis to the test in his postwar American projects such as St. Francis de Sales Catholic Church, Muskegon, Michigan (1966), a modern take on the ancient Egyptian pyramids at Giza.

Companies that served the building and design trades such as the Mosaic Tile Company, Carduco Structural Wall Units, and Virginia Metal Products mass-produced decorative floor and wall coverings that replicated the look of ancient Egyptian, Greek, and Roman monuments. Their peculiar

print advertisements, which appeared in prestige trade publications such as *Arts & Architecture*, advocated the Vitruvian ideal of "timeliness and time-lessness" and were illustrated with masterpieces of ancient art: cartoons of Assyrian and Old Kingdom Egyptian relief sculptures, the Parthenon, the portrait bust of Queen Nefertiti. Like the rulers of the ancient world, postwar American architects and business executives dreamed of structures that would last a proverbial thousand years, but could also impress on the present the glory of their talents, victories, and wealth.

But: in the postwar American and modernist contexts, what did it mean to be simultaneously timely and timeless? Was this an imperative that would result in epochal monuments that endured through the ages, like the Parthenon? Or would it result in a disposable architecture concomitant with the accelerated economic drives of a mass society? Or perhaps a purely representational, two-dimensional, comic-book architecture of totalitarian proportions, like Sethi's magnificent treasure city in Cecil B. DeMille's film *The Ten Commandments* (1956)? Would it be culture, strictly speaking, or something else – Arendt's "mass entertainment"?

–

DeMille had helped create the biblical epic film in the silent era. By 1935, audience interest in these ancient spectacles waned, largely as a result of the Great Depression, and DeMille produced a series of historical films about the American West and construction of the railroads, which were more in keeping with the civic-minded spirit of the Depression era. But he effectively revived the sword-and-sandal genre with *Samson and Delilah* (1949), the highest-grossing film of 1950. In quick succession similar films followed: *Quo Vadis* (1951), *David and Bathsheba* (1951), *The Robe* (1953), *Demetrius and the Gladiators* (1954), *The Egyptian* (1954), *Land of the Pharaohs* (1955), *Helen of Troy* (1956), *Alexander the Great* (1956), *The Ten Commandments* (1956), *Ben-Hur* (1959), *The Big Fisherman* (1959), *The Story of Ruth* (1960), *Spartacus* (1960), *King of Kings* (1961), *Barabbas* (1962), *Cleopatra* (1963), *The Fall of the Roman Empire* (1964), and *The Greatest Story Ever Told* (1965) – to name only a few. The mania for sword-and-sandal films was also an expression of the crisis in culture.

Most of these films were blockbuster hits. Howard Hawks's *Land of the Pharaohs* was the exception. Hawks's film flopped when it opened in the summer of 1955. Unlike *Quo Vadis* and *The Robe*, *Land of the Pharaohs* is not a biblical-Roman epic dramatizing the righteous fight for freedom against the decadent tyranny of a fascist power, essentially replaying World War II

(and the beginning of the Cold War) in ancient guise. It is a film about architecture – a fantastical dramatization of the construction of the Great Pyramid at Giza – and it is ultimately a morality tale about the megalomaniacal quest to erect a colossal monument in which imperial treasure can be safeguarded for eternity. Hawks's film sent mixed messages about the moral price of victory and accumulation of war spoils to a newly victorious, newly enriched United States, which was in the midst of its own expansive building campaigns.

These films are always very frank about the equivalences they are making between ancient civilizations and the modern world.[14] At the outset of *Land of the Pharaohs*, the Lord High Priest of Egypt, an analogue to a modern American Secretary of State, tells us in voiceover narration that the Pharaoh Khufu has just vanquished Egypt's enemies in war. As a result Egypt has taken its place as "the greatest of all nations in the world." In the opening sequences, Hawks presents two successive, breathtaking pageants in the tradition of D. W. Griffith and DeMille. They replay in ancient costume the Victory Day celebrations at the end of World War II. In the first, the Pharaoh returns to the hypostyle halls of his palace, his armies loaded with spoils and slaves, while in the second, the war dead are carried up the Nile in a procession of solar barges and ritually buried in the desert. Then the work of building the pyramid begins. The theme of the film's first hour is the rebuilding of civilization in the aftermath of an epic war: the war spoils become the foundation for a new empire, conquered peoples are transformed into a massive labor force, and the monument they erect becomes a marker of this foundational, civilizing moment.

But the Great Pyramid is not just a testament to Khufu's reign, it is also very clearly a product of the kind of economic and social welfare principles that were a hallmark of modern American democracy. In some of the now more stilted, unintentionally comedic scenes, the Pharaoh haggles with Vashtar, architect of the pyramid and leader of the slave labor force, like an imperious yet powerless American CEO negotiating with a hard-nosed yet jovial union labor leader – in fact, Hawks later blamed the failure of the film on the dialogue, saying: "We didn't know how a Pharaoh talked."[15] When the Pharaoh demands greater productivity, Vashtar succeeds in getting better food supplies, rest times, and working conditions for his labor force. Similar contemporizing scenes appear in the first half of DeMille's *The Ten Commandments*, in which Moses, overseeing construction of Sethi's magnificent treasure city, initiates humanizing labor reforms, sparking the wrath of Rameses and setting in motion the events that lead to the Exodus. In both films, freedom is found in the liberating capacities of American enterprise.

Meanwhile, in the palace, Princess Nellifer, the Pharaoh's second wife, scornful of his plans for the afterlife, schemes to steal the treasure and rule Egypt herself. Like Princess Nefretiri in *The Ten Commandments*, Nellifer finds her postwar American counterpart in the upwardly mobile executive wife, the so-called "wife of management." Her insatiable lust for luxurious material goods, depicted in lascivious terms, threatens the fate of civilization and leads to her downfall. In the final scene, tricked into entering the pyramid's burial chamber, she is entombed alive with the treasure she covets. While glorifying the male world of design, organization, and management, *Land of the Pharaohs*, like other sword-and-sandal films of the era, sensationalized fears about the role of women in postwar society, especially women in power.

These sword-and-sandal films are fundamentally about the problem of scale. The unbelievable scale of their productions is the stuff of movie legend: the eye-popping budgets and endless armies of extras directors had to corral. But the films themselves dramatize the problem of scale as one of the major preoccupations of government in the post–World War II era — that is what *Land of the Pharaohs* is about, and it is also what Arendt is referring to in *The Human Condition* when she writes about the "glorification of labor." Postwar American architects, executives, and government bureaucrats zealously confronted the problem of scale: in organizational terms, the transformation of a vast wartime apparatus into a postwar administrative infrastructure; in terms of population, the mass mobilization of people, including the return of American GIs and the creation of a new labor force; and in terms of unprecedented forms of mass production and consumption. But most importantly, they confronted scale in terms of civilization, contemplating the meaning of the United States in world history, the American assumption of greatness, and the establishment of edifying links, mostly fictive, between ancient civilizations and modern ideals.

—

At the dawn of the modern age in seventeenth- and eighteenth-century Europe, the clash between ancient civilizations and modern ideals was called "the quarrel of the Ancients and the Moderns." Beginning as a literary topos in aristocratic French salons, it slowly blossomed into a Europe-wide discussion that would, ultimately, give rise to developments such as Neoclassicism and Romanticism. The Italian Enlightenment architect Piranesi transformed antiquity into a theoretical prison in his prints, while the French Revolutionary architect Étienne-Louis Boullée saw it as a fantasy replete with endlessly repetitious colonnades. Napoleon embarked on his cultural-anthropological

Egyptian campaign, which reintroduced ancient Egyptian art into modern European civilization by way of books, paintings, prints, fashion, furniture, and much else. In post-World War II America, ancient civilizations were refracted through the lens of modern technology, literally in the case of Cinemascope, and processed through new modes of mass production. Antiquity became a disposable building product: "Byzantile" bathroom flooring and Carduco's "Great Walls."

I call this mid-century American manifestation of "the quarrel of the Ancients and the Moderns" Flintstone modernism, after *The Flintstones*, a Hanna-Barbera cartoon that ran on ABC TV from 1960 to 1966. Significantly, Fred Flintstone, the beleaguered protagonist of the show, works in the building trade. He operates a dinosaur-powered crane at the Rock Head & Quarry Cave Construction Company, whose slogan is "Own Your Own Cave and Be Secure," a clever pun on real estate development advertising campaigns which promised epochal durability and existential security, a long life without regrets. *The Flintstones* lovingly but pointedly satirized post-World War II American preoccupations, the more quotidian aspects of "the shaping of a civilization." Fred and his long-suffering wife Wilma, their pet dinosaur Dino, and their baby daughter Pebbles live in a suburban split-level cave outfitted with the Stone Age equivalent of modern appliances. They frantically contend with each other, his harried boss, her meddlesome mother, and their best friends Barney and Betty Rubble, who live next door. Unlike modern architecture and the sword-and-sandal films, the cartoon had no aspirations to artistic greatness or moral seriousness. By setting these everyday tribulations in the Stone Age, the show knowingly made a parody of the postwar imperative to be timely and timeless.

Historians of modern art and architecture have long privileged the avant-gardes, focusing on art's oppositional capacity in relation to bourgeois society, an assumed moral responsibility on the part of artists and architects to facilitate reform movements through artistic means. But the kinds of questions posed in the post-World War II era, especially in the United States, suggest that the central issue they faced was the representation of mainstream political ideals. "Is real political freedom incompatible with pervasive beauty?" the publishing impresario and business booster Henry Luce asked in his keynote speech at the centennial celebration of the American Institute of Architects (AIA) in May 1957.[16] "Can a democratic, middle-class, capitalist country like the United States create a great civilization?" *Architectural Forum* asked in a similar vein in a January 1959 issue devoted to new civic and governmental building.[17]

What was "pervasive beauty?" What was "great representation?"

The questions posed by *Architectural Forum* and by Giedion arguably point to a crisis in the concept of greatness. Luce's question points to a crisis in representation by raising the specter of the real versus the ideal, and introducing a troubling notion of pervasiveness. By real political freedom he meant principles of free enterprise and individual liberty, but "pervasive beauty" has a paradisiacal air and is a utopian construct, perhaps even a totalitarian one. How were American architects expected to answer these questions?

These kinds of questions further express a strange duality at play in postwar American culture. On the one hand, the United States saw itself as a bastion of economic, political, and spiritual freedom, symbolized by democratic institutions; but on the other hand it now also saw itself as a victorious and resplendent materially rich imperial power. Film scholars have engaged with this duality in a way that architectural historians have not. Recent film scholarship has emphasized the sense of ideological confusion on view in sword-and-sandal films, in which the United States paradoxically identifies itself with both the imperial powers (the Pharaohs, imperial Rome) and the persecuted proponents of freedom (the Hebrews in Egypt, the Christians in Rome). The films thus grappled with the dangers of "great representation" in a dialectical manner. Architecture generally did not—and when it did, as in Breuer's UNESCO complex in Paris (1958), the meaning and the message were rarely communicated as subtly, complexly, or successfully.

—

Flintstone modernism was modernism in Cinemascope. In the postwar period architecture and cinema performed similar ideological work. Cinemascope was the new widescreen technology developed by Twentieth Century Fox and first used to film the biblical-Roman epic *The Robe*. Paramount Pictures quickly followed suit with their own widescreen process, VistaVision, which DeMille used to shoot *The Ten Commandments*. The producer Mike Todd (Elizabeth Taylor's third husband) developed his own widescreen process, Todd-AO, which Joseph Mankiewicz used to film *Cleopatra*. Anamorphic processes were as old as the history of cinema, and were indebted to the camera obscura and panoramic devices going back at least as far as the Renaissance, but the push for ever more expansive widescreen technologies, especially in relation to the spectacularization of history and myth, reveals a peculiar cultural and political psychosis.

It also finds a direct parallel in the post-World War II obsession with universal, free-span structures and the window wall, the dominant architectural forms of the age. The glass window wall, like the Cinemascope lens, I contend, was an extension of the all-encompassing eye of American enterprise (the term Luce and the editors of *Fortune* used to describe business), democratizing everything that fell within the vista view: art, architecture, monuments, entire nations – in other words, civilization itself.

Cinemascope found its greatest subjects in ancient Egypt and Rome, in stories that filled the screen with vast panoramas of glittering visual detail, but it was employed to equally impressive ends in Jean Negulesco's quintet *How to Marry a Millionaire* (1953), *A Woman's World* (1954), *Three Coins in the Fountain* (1954), *Daddy Long Legs* (1955), and *The Best of Everything* (1959). These films dramatize modern life in the universal, free-span, glass-curtain-walled corporate world of the 1950s. In the Twentieth Century Fox archives, *Three Coins in the Fountain*, a film about three young American secretaries working for the U.S. Distribution Agency in Rome, is linked in publicity materials to the studio's other big releases from that same year, *The Robe* and *The Egyptian*. Despite their differing ancient and modern settings, the films are of a piece in the way they visualize modern American civilization *vis-à-vis* a vanquished (European) past.

"Heritage can be a shackle to art," an enterprising American secretary instructs a louche Italian prince in *Three Coins in the Fountain*. In these films, the Cinemascope lens, like the glass curtain wall, liberates art from tradition. In *Daddy Long Legs*, French art is literally set in motion, transformed into a performing art in a series of magical ballets (director Negulesco described the film as "happy magic"). European civilization as symbolized by its art, which was defiled by the Nazis, will be purified under the chaste stewardship of the United States. That is the point of the orphan/benefactor narrative in *Daddy Long Legs*, as well as the so-called "Villa Eden" in *Three Coins in the Fountain* where the American secretaries live, which symbolizes Italy's return to Edenic purity under beneficent American administration. I term this dynamic, which I explore in chapter 1, "The Cult of Immaculate Form."

Since the late 1960s, post-World War II American architecture has been derided by architectural historians, but celebrated by design connoisseurs. Similarly, over the decades, the postwar sword-and-sandal films have been alternatively celebrated as cult classics or derided as camp. In *America in the Movies* (1975), the film historian Michael Wood describes *Cleopatra* as "oddly formal, lifeless," a description that until very recently would just as readily have been applied to the work of architects such as Gordon Bunshaft,

Eero Saarinen, or Edward Durell Stone.[18] Despite the fact that the films are marvels of modern design, products of the same mid-century imagination as the architecture, they have yet to be rediscovered by a new generation of design enthusiasts. Except for a few scholarly studies that deal almost exclusively with Roman epics like *Quo Vadis* and *The Robe*, the films are almost always discussed in terms of behind-the-scenes studio politics (outsize star personae, battles over infinitely expanding budgets, endless rewrites, odd casting choices, love affairs). And they are almost always critiqued along purely formal lines.

I interpret both the architecture and the films as political and social allegories, moral parables, and fantastic explorations of the efficacy of epic form in the wake of the war. This book grew out of my interest in modernist preservation debates around the turn of the new millennium and came to encompass themes in architectural history, film studies, and visual culture studies. Drawing inspiration from all three fields, I consider architecture and film – especially in the post-World War II American context – as expressions of collective values, and of artistic will. Both mediums communicated period-specific ideas about antiquity, modernity, and the meaning of beauty. Both offer evidence of transformations in the understanding of history, religious faith, and representations of authority.

THE RISE AND FALL OF MODERN ARCHITECTURE IN AMERICA

Modernism had a troubled history in the United States from the start. First of all, it arrived late. By the time of the "Modern Architecture: International Exhibition" at the Museum of Modern Art (MoMA) in New York in 1932, the first wave of great modernist activity in Europe had come to an end. In 1928, Walter Gropius was forced out of the Bauhaus along with the group of artists and designers who had helped him launch the school in 1918. In 1929, Le Corbusier completed his Villa Savoye, the apotheosis of his Purist program, and, discontented with the direction of the modernist movement, left France on a voyage that took him to Latin America, the Soviet Union, and North Africa in search of new inspiration. Erich Mendelsohn, who pioneered the use of the glass curtain wall and transformed Berlin into a modern commercial metropolis, fled Germany in 1932 under the cover of night. Modernism, at least as the avant-gardes of the 1920s had defined it, was scattered and in retreat.

Traveling in Europe in 1930, Philip Johnson, who had just graduated from Harvard with a degree in philosophy but was already associated with the Museum of Modern Art in New York, which had been founded only the year before, hatched the idea for a book and exhibition that would introduce the

work of Europe's modernist architects to American audiences. The exhibition, which he co-curated with the older, more established architectural historian Henry-Russell Hitchcock, and mounted in 1932, displayed models and photographs of already iconic buildings by Le Corbusier, Ludwig Mies van der Rohe, Gropius, J. J. P. Oud, and Bruno Taut. The book published to accompany the exhibition, *The International Style: Architecture since 1922*, became one of the most referenced books on architecture in the twentieth century. Although the European architects had been working within the radical and revolutionary reform movements of their respective countries in the decade after World War I, Johnson and Hitchcock presented their work in terms of shared broad-based stylistic similarities, emphasizing the use of cubic geometry, white walls, and ribbon windows. Divested of its connections to volatile European political and social contexts, the International Style became attractive to American elites. It was quickly embraced by Luce, who promoted it in his magazines, *Time* and *Fortune*. The International Style also found an outlet in Hollywood in Cedric Gibbons's glitzy set designs for MGM, where it was treated as a variant of Art Deco. But it arguably reached its peak in Philip Goodwin and Edward Durell Stone's new building for MoMA just off Fifth Avenue on 53rd Street, which was completed in 1938.

The arrival of the Bauhaus refugees gave modern architecture a further push in America. Gropius arrived in 1937 and was installed at Harvard as director of the Graduate School of Design. Breuer, a star student at the Bauhaus who went on to become an architect in his own right, followed him to Harvard that same year. Mies van der Rohe arrived in the United States in 1938 and settled in Chicago, where he became head of the Illinois Institute of Technology. After stops in Palestine and England, Mendelsohn made his way to San Francisco, where he taught at the University of California, Berkeley, in the years before his death in 1953. They were part of the much larger wave of cultural luminaries, including Thomas Mann, Bertolt Brecht, and Billy Wilder, who found refuge in the United States and brought their cosmopolitan perspectives to bear on American culture.

From the mid-1930s through the mid-1940s, the International Style crossed paths with the powerful indigenous example of Frank Lloyd Wright as well as the monumental neoclassicism of New Deal-sponsored government projects. The *émigré* architects arrived into this muddled context. They quickly revised their ideologically tainted principles to assimilate into American institutions and attract rich American patrons. Their first projects in America, mainly residential designs, were profiled in magazines such as

Architectural Forum (which Henry Luce acquired in 1936 and added to his roster of publications) somewhat incongruously as illustrations of the International Style. For example, Gropius and Breuer's Frank House in Pittsburgh, Pennsylvania, was named "Building of the Month" and "Largest International Style residence in the U.S." in the March 1941 issue of *Architectural Forum*. The magazine was at pains to explain the European origins of the style ("It is significant in the case of the International Style, however, that the social conditions and attitudes in Europe of the 1920s, when the style flourished, were not duplicated here in the 1930s, and the attempts to transplant it met with only fleeting approval from an extremely limited group").[19] It attempted to popularize what it called "a less intellectual, less rigid and a more indigenous" version of the Style, "richer, more assured."[20] The result, however, on view in the Frank House, was a bizarre hodgepodge of modernist motifs mixed with natural materials such as stone veneer and Cabot's Quit, a locally produced form of home insulation. Except among "an extremely limited group" of East Coast elites, the International Style did not make a major impact in the decade before World War II. But with Gropius leading Harvard's design school and Mies at IIT, by far the *émigrés'* greatest achievement was training a second generation of modern American architects.

The end of the Second World War presented untold opportunities. Suddenly, a whole new world opened up. There was a civilization to shape, cities to remake, entire continents to rebuild. In retrospect, however, it turned out to be a very short window of opportunity indeed. Already by the late 1950s, as showpiece projects commissioned in the early and mid-1950s finally came to completion (including Mies's Seagram Building on Park Avenue in New York) and as countless undistinguished imitations popped up all around, critics and preservationists began to ask whether modern architecture was really worthwhile. They also began to notice puzzling differences between pre- and postwar manifestations of the International Style. Although there had never been a coherent set of rules and there were a multitude of stylistic differences, critics began to wonder if American architects in particular were diverging too far from modernist doctrine. They wondered whether these terms even still applied at all.

Scully attempted "to isolate if possible the primary characteristics of the architecture of our era and also to name it" – something he was ultimately unable to do.[21] In October 1959, Thomas Creighton, the editor of *Progressive Architecture*, took this new penchant for naming to its limits. Under the rubric of "The New Sensualism," he sketched out a variety of seemingly antimodernist trends and gave them alluring subheadings such as "Stereo-Structural

Sensualism," "Romantic Expressionism," and "Neo-Liberty."[22] It was unclear to him whether these constituted a "negative manifestation" indicative of a retreat "from any imposed disciplines" or if they represented "a strong positive urge" representative of a new search for the sublime in architecture.[23] While none of these terms stuck, they suggest that modernism, as it had been understood since the 1920s, was a phenomenon of the past.

When Philip Johnson returned to the subject of the International Style in the post-World War II period it was always to clarify what it was and what it wasn't, or more frequently to comment on its demise. He recognized that this monster of his own making had become a straitjacket for architectural thought. In "Style and the International Style," a lecture he gave at Barnard College in 1955, Johnson decreed: "A style is not a set of rules or shackles, as some of my colleagues seem to think. A style is a climate in which to operate, a springboard to leap further into the air."[24] In "Retreat from the International Style to the Present Scene," a lecture he gave at Yale in 1958, he cataloged the varieties of stylistic permutations popping up all around and linked mannered motifs with specific architects, offering witty caricatures of each in turn: he branded Bunshaft an "academic Miesian," Breuer a "peasant mannerist," and Stone "the screen decorator," while he saw himself as a "structural classicist."[25] In "Whither Away – Non-Miesian Directions," another lecture he gave at Yale in February 1959, a few months before Creighton published his socio-architectural diagnosis, Johnson simply proposed substituting "history" for "the debacle of the International Style, which is now in ruins around us."[26]

By the late 1960s, critical opinion turned against modern architecture almost entirely. The increasingly colossal scale of modernist projects, especially in cities like New York, demanded the demolition of historically significant buildings along with large swaths of the urban grid. The destruction of McKim, Mead and White's Pennsylvania Station in New York in 1963 was a cataclysmic, epoch-defining event that led directly to the creation in 1965 of the New York City Landmarks Preservation Committee, which helped save Grand Central Station from a similar fate a few years later. The obliteration of the majestic Beaux-Arts Penn Station building (1910), which was modeled on the ancient Roman Baths of Caracalla, and the construction in its place of an insipid mixed-used corporate complex named Madison Square Garden, was symbolic of what was happening in cities across the country. Neither the luxurious modern skyscrapers in city centers nor the modernist housing estates clustered on urban peripheries seemed to be ushering in the shared economic prosperity that had been promised. On the contrary, as

the burgeoning executive class fled to the suburbs, they compounded rather than alleviated the problems of urban decay – a phenomenon now labeled "white flight." Eventually the suburbs, site of some of the best modern design of the 1950s and early 1960s, became overdeveloped. Critics began to lament modernist "sprawl."

When Breuer's proposal for a giant slab skyscraper rising right out of the roof of Grand Central Station was unveiled in 1968, the critic and historian Sibyl Moholy-Nagy, writing in *Architectural Forum*, wryly called it "Hitler's Revenge." But this was just one project among many about which critics were all saying the same thing. In 1970, Ada Louise Huxtable, the formidable architecture critic for the *New York Times*, won the first Pulitzer Prize for Arts Criticism for her book *Will They Ever Finish Bruckner Boulevard?* (1970), which cataloged the devastation the modernist project had wrought on the American landscape; it contained an entire section headed "New York, Death-Wish City." By 1970, modernism in America was synonymous with death.

POSTWAR VERSUS MID-CENTURY

The architectural landscape was in a state of constant flux. There was no catchphrase for the cultural *Zeitgeist*. But understandably, in historical surveys that were written later, mainly after 1970, there was a need to give the artifacts and buildings produced in America in the period from 1945 to 1965 a name. "Postwar modernism" and the "postwar International Style" came into common use. These are terms, as we have just seen, that were recognized as problematic by critics writing at the high point of postwar activity.

In historical surveys written after 1970, post-World War II architecture in the United States was routinely disparaged in comparison to postwar architecture in Europe. For historians writing from a Marxist perspective, the International Style was already a compromised form of modernism, vacated of the revolutionary drives that originally powered the modernist movement. It follows that the postwar International Style would be viewed as being much worse. In their two-volume history *Modern Architecture* (1979), the Italians Manfredo Tafuri and Francesco Dal Co interpret postwar modernism in America as deeply flawed if not corrupt; by contrast, in his monograph *American Architecture* (1985), the American historian David Handlin interprets it as merely banal. In *Modern Architecture* (2002), the British critic Alan Colquhoun interprets it as something in between: the architecture of an aspiring, but overstretched, Pax Americana. In *Modern Architecture: A Concise History* (1985), Kenneth Frampton excises American architecture

entirely, except for work produced by *émigré* architects such as Mies. These are just a few of the polarized views about the work of this period.

In Europe, the collapse of political structures as well as moral codes, part of the total devastation wrought by the war, resulted in a new awareness of the human capacity for cruelty and destruction, and informed the reconstruction efforts. Along with the scarcity of materials and the truly visionary examples of Le Corbusier and Hans Scharoun, this contributed to a renewal of avant-garde practices, a way of working that sought to overcome the barbarity inherent in civilization. Postwar modernism in Europe, whether working in the interests of business or the state, sought to register the aspirations of the human spirit bounded by the limitations of the human condition. This was the underlying basis of Le Corbusier's *béton brut*, neo-realism in Italy, new brutalism in England, neo-functionalism and neo-expressionism in West Germany, and to a certain extent socialist realism in Central and Eastern Europe. This is the generally accepted view of movements in Europe.

In the United States, by contrast, victory in war resulted in the rise of a new nationalism, an extraterritorial view, and a vast expansion of industry — in other words, everything that had just been vanquished in Europe. The need for new housing blocks in Europe encouraged experimental solutions, while in the United States the burgeoning executive class aspired to achieve a prewar ideal of European bourgeois living, and an architect like Breuer, who was trying to transform himself from an ideologically suspect European furniture designer into a wholesome American architect, was primed to give it to them. In Europe, the architect's vision remained paramount, whereas in the United States the client's desires always seemed to be given pride of place. In Europe, the attempt to salvage the vestiges of the modernist project from the rubble seemed closer to the legacy of the avant-gardes. In America, by contrast, external forces like money, politics, and power had seemingly displaced architecture's internal drives.

This highly contested view of postwar modernism among architectural historians has long existed in stark contrast with the view of design connoisseurs who, beginning in the 1950s, prized what they termed "mid-century modern" furniture and design objects. While "mid-century" has now overtaken "postwar" as the preferred designation in both mainstream and scholarly studies of the period, it is important to recognize that they may signify different states of mind. Originating in the world of connoisseurship, "mid-century" connotes a collector's sense of avidity, enthusiastic enjoyment rather than complex grappling. "Mid-century" liberates cultural artifacts of

the period from the more difficult political, psychological, and social effects of the postwar condition. "Postwar modernism" and "the postwar International Style" at least acknowledge the catastrophic effects of the war, even if they suggest a sense of continuity with prewar modernism that belies the critical discourse of the period. "Mid-century" banishes the war to the distant past; it gives us an exalted, homogeneous view of the period. The mid-century mindset sees the war as a starting point rather than an end point for modernism.

SAVING CORPORATE MODERNISM

Until recently, corporate office buildings from the 1950s and early 1960s were considered the absolute nadir of the postwar International Style. In *Modern Architecture*, for example, Tafuri calls Mies's Seagram Building a void. At the turn of the new millennium, however, corporate architecture of the 1950s began to be rediscovered, reassessed, and reclassified as a subset of mid-century modernism. This gave rise to another new designation: corporate modernism.

This critical reversal of fortune was crystalized in an important conference at the Yale School of Architecture in the spring of 2001 entitled "Saving Corporate Modernism."[27] The event at Yale was billed as a celebration of the restoration of Lever House on Park Avenue in New York (1952), the first commercial glass curtain wall building to rise in the city, but it was also part of a campaign to save Connecticut General Life Insurance Company in Bloomfield, Connecticut (1957), which CIGNA, an insurance company that had acquired Connecticut General, planned to demolish.[28] At the same time, Manhattan House (1950), Lever House's sister building and the first white-brick luxury apartment building to rise on New York's Upper East Side, was converted into multimillion-dollar condominiums. Gordon Bunshaft, the lead design partner of Skidmore, Owings and Merrill (SOM), designed this trio of buildings at the apex of that firm's postwar period of productivity. It is fair to say they put SOM on the map.

In his opening remarks at the conference, Robert Stern, dean of the School of Architecture at Yale, and a famous architect, historian, and preservation advocate in his own right, announced a rebirth of interest in the history of American corporate sponsorship of the arts and architecture. He called Lever House "a great masterwork of architecture," opining it "a signature work" by the "exceptionally talented" Bunshaft. Ironically, back in 1980, as a participant on a panel sponsored by SOM, Stern said the firm's corporate approach to design resulted in "boring" buildings: "tall or short, fat or thin, if

you've seen one, you've seen them all."[29] Now he called for renewed attention to be paid to the "compelling legacy of corporate culture."[30] Peter Blake, former editor of *Architectural Forum* and a former curator in the Department of Architecture at MoMA, was the valedictory speaker at the conference, where he reminisced about his friendships with Bunshaft, Breuer, and Johnson. In a 1965 exposé in *Architectural Forum* entitled "Slaughter on Sixth Avenue," and in books such as *Form Follows Fiasco* (1977), a polemic against modern architecture, Blake had distanced himself from modernism.[31] At the conference, he was less sanguine about the possibilities for restoration. Certain questions lingered in the air: how could Lever House be a signature work by Bunshaft when in the organization of its offices in Washington, Chicago, and New York, SOM had purposefully eschewed the theory of the master builder? How could the same corporate buildings that killed off modern architecture suddenly be transformed into historic landmarks symbolic of a golden age?

There was a concomitant drive on the part of modern architectural historians to reassess postwar corporate culture. In studies such as Reinhold Martin's *The Organizational Complex* (2003), Beatriz Colomina's *Domesticity at War* (2007), and Greg Castillo's *Cold War on the Home Front* (2009), architects and designers such as Saarinen, Eliot Noyes, and Charles and Ray Eames were presented as corporate avant-gardists in new analyses of programmatic approaches to design. These studies examine the transformation of wartime technologies for postwar administrative and domestic use, and the deployment of architecture as Cold War propaganda. In *The Interface: IBM and the Transformation of Corporate Design, 1945–1973* (2011), a critical history of the industrial design of the computer, John Harwood, building on Martin's work, situates IBM as the precursor to companies such as Apple.

These developments found an even more powerful commercial counterpart in the reintroduction into the marketplace of mid-century modern furniture and design objects by new stores such as Design Within Reach, which was launched in 1999. George Nelson, Alexander Girard, Florence Knoll, and the Eameses were suddenly on the tip of everyone's tongue, and they quickly became the subjects of hagiographic museum retrospectives.

Along with historians, there was a new generation of design enthusiasts navigating an intricate nexus of memory and nostalgia: so-called hipsters and social media influencers. Restored buildings such as Lever House and reissued furniture and objects were redeployed as part of a new design discourse oriented around the concept of lifestyle.

SAVING
CORPORATE
MODERNISM

Assessing
Three Landmark Buildings
by Gordon Bunshaft
of Skidmore, Owings & Merrill

0.2

"Saving Corporate Modernism,"
conference and exhibition, Yale School
of Architecture, April 2001.

0.3

Gordon Bunshaft/Skidmore, Owings &
Merrill, Lever House, New York, 1952,
© Ezra Stoller/Esto.

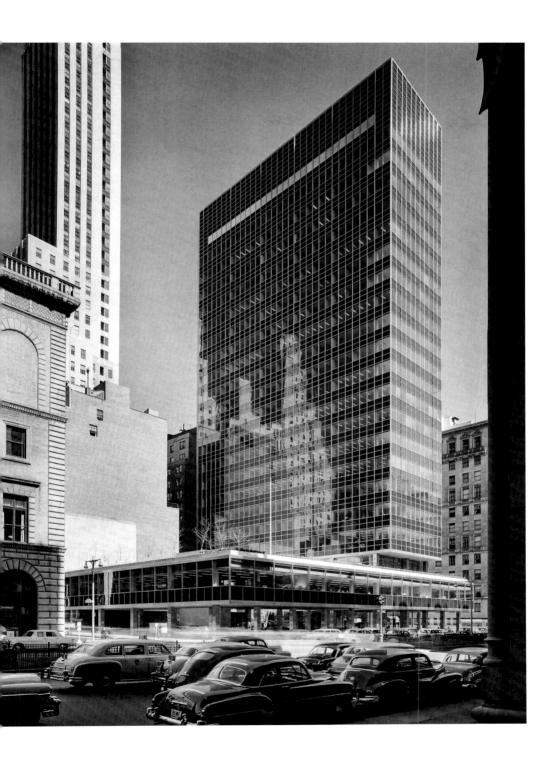

Introduction

In his tome *Life Style* (2000), the graphic design guru Bruce Mau reimagined this concept. He mapped out a new philosophy of the visual environment that was in synch with advanced technological developments and social media trends. Mau envisaged a world in which everything is given meaning chiefly through visualization. The entire range of issues that shape our daily lives — questions of identity, social progress, politics, ecology, architecture and urban planning (he co-authored *S, M, L, XL* with Rem Koolhaas in 1995, the precursor to *Life Style*), critical theory (he designed Zone Books, distributed by the MIT Press), and data management — all fall within the purview of design. Mau outlined a new kind of practice, wherein designers become curators of "leisure domains." (No longer custodians and interpreters of specialized collections of artistically and historically significant artworks, curators at institutions such as the Museum of Modern Art in New York and the Getty Center in Los Angeles began to see themselves as an elite cadre of "visual merchandizers" with their own "personal brands.") The look of Mau's book, and the aesthetic he espoused, was "clean-lined" and "minimalist," buzzwords that became attached to "modern." New shelter magazines, such as *Metropolis* and *Dwell*, which was launched in the year 2000 and reintroduced mid-century modernism to new millennium audiences, further advanced this philosophy.

Dwell sent mixed messages about the new millennium's relationship with the past. Under headlines such as "Mid-Century Remixed" and "A New Shade of Green," it transformed architecture and design objects, which at their inception symbolized the beauty of technological materialism, uniquely American processes of mass production and consumption, and middle-class dreams of upward mobility, into elitist status symbols attached to contemporary platitudes about sustainability. In the December/January 2009 cover story, Kiera Alexandra, a young graphic designer from Williamsburg in Brooklyn, moves to Detroit, takes up residence in a restored Mies van der Rohe-designed Lafayette Park apartment, fills it with artfully assembled furniture pieces, plants a garden, and becomes a pioneer, a new-millennium Candide. Her green-and-white color palette and prominently displayed Daisy Face Environmental Enrichment panel (from 1971), by Alexander Girard, foreground her green creed. She is pictured sitting at her well-appointed kitchen table and watering her lawn in a pastel-blue housedress and fire-red clogs, a reinvention of 1950s housewife iconography (feminist scholars of visual culture such as Diane Negra and Stephanie Harzewski call this kind of remixed housewife imagery "postfeminist").[32] In its aesthetic and editorial stance *Dwell* reimagined good-life modernism magazines of the 1950s, such

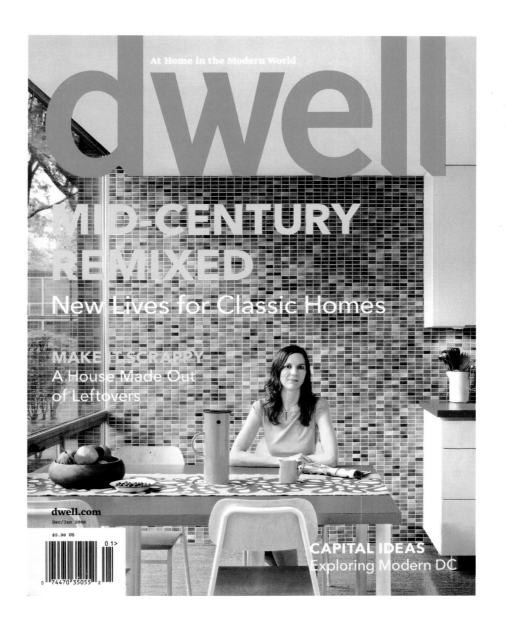

0.4

"Mid-Century Re-Mixed," *Dwell*, December/
January 2009, Courtesy of *Dwell*.

as *Arts & Architecture* and *House & Home*, which educated the public in precepts of modern living by presenting new technologies in the guise of feel-good, socially responsible consumerism.

The restoration of Lever House and the remixing of mid-century modernism in magazines such as *Dwell* found a parallel in the sensational success of *Mad Men*, the television show that premiered on the cable channel American Movie Classics in the summer of 2007. Over the course of seven seasons, *Mad Men* effectively reshaped the popular image of mid-twentieth-century American corporate culture for new-millennium audiences. Set in a fictional Madison Avenue advertising firm named Sterling Cooper, the show followed the lives of a group of advertising executives, secretaries, wives, and mistresses, while also vividly dramatizing the corporate milieu of the early and mid-1960s. As revisionist cultural history, the series strenuously recreated the domestic and office interiors of the era down to minute details. As revisionist social history, it pushed to the foreground the bigotries and prejudices that were openly displayed, even flaunted, before the successes of the civil rights and feminist movements, as well as social behaviors (adultery, alcoholism) that were swept under the rug before the era of contemporary, confessional regimes of self-empowerment. The show won every major establishment award, inspired fashion revivals such as limited-edition *Mad Men* suits from Brooks Brothers, and spawned a handful of less successful imitations such as the short-lived television dramas *Pan Am*, *The Playboy Club*, and *Vegas*.[33]

In 2009, *Mad Men* entered the preservation debates in a clever roundabout way. At the beginning of the third season, in an episode entitled "Love among the Ruins" set in the spring of 1963, Sterling Cooper is hired by the real-estate speculators who want to demolish the old Penn Station to build the new Madison Square Garden. Facing vociferous opposition from beatnik protesters as well as Ada Louise Huxtable, the newly appointed architecture critic for the *New York Times*, they need Sterling Cooper to come up with a campaign to turn the tide and rally public support for the new complex. In a preliminary meeting with the developers, an arrogant young copywriter makes the case for preserving the McKim, Mead and White building. The developers deem him a Communist radical and the firm almost loses the account. The job ultimately falls to Don Draper, the series' protagonist, who wins them over with a seductive pitch over a martini lunch: "change is neither good nor bad, it simply is," Don says. "It can be greeted with terror or joy, a tantrum that says I want it the way it was, or a dance that says look, something new. ... New York City is in decay. Madison Square Garden is the

beginning of a new city on a hill." In an abrupt turn of events, however, he is forced to drop the account by Lane Pryce, a managing partner sent from London by the British owners of the firm, who disapprove of the project.

In the internal dynamics of the episode, the faceoff between the preservationists and the developers parallels the faceoff between Don and Lane over who will control the future of the firm. In the larger dynamics of the series, however, Don's pitch goes to the core of his character and his philosophy of life: running from a dark, troubled past, he has assumed a fake identity, one that has made him the premier adman in New York. His own duplicitousness mirrors the soullessness of the advertising world. Jaded but anxious, he knows how to play to all sides of an issue and has no problem coining the shallow, pragmatic lies that soft drink and tobacco companies need to sell people products he knows will kill them. In this case, he casually coins slogans that pave the way for the demolition of a magnificent relic of the industrial age to make way for a corporate building sporting a shallow, characterless façade, much like his own.

Viewed against the backdrop of the preservation campaigns, this particular *Mad Men* episode trades on a number of ironies. In real life, the mid-century modern landscape the show splendidly re-created was in decay and in need of saving. Although in this episode the young copywriter initially makes the preservationist case, Don Draper ultimately wins the day by making the antipreservationist case even more persuasively. "Love Among the Ruins" serves as an allegory for the series in the way it luxuriantly wades through the moral and physical ruins of the early and mid-1960s — but it also captured the ethos of the new millennial movement to "preserve the modern," which cast a highly romantic gaze over the period and (as in the case of Lever House, Manhattan House, and Connecticut General) transformed decaying buildings into whitewashed icons.

Mad Men sparked debates about authenticity that find parallels in architectural discourses. Writing in the *New York Review of Books*, the critic Daniel Mendelsohn attributed the show's appeal entirely to its visual style, especially its re-creation of early and mid-1960s corporate interiors, arguing: "its attitude toward the past is glib and its self-positioning in the present is unattractively smug."[34] He concludes: "The *Mad Men* craze tells us far more about today than it does about yesterday."[35] Indeed, in its eroticization of the adman and glorification of the explosive growth of the advertising industry, the series celebrated the rise of mass media. Just as the discourses surrounding the restoration of Lever House provided an iconic ancestry for a whole new generation of glass-walled corporate skyscrapers in New York,

Mad Men provided an origins myth for the new generation of social media influencers and Instagrammers. The series affirmed the ethics and aesthetics of contemporary advertising regimes of lifestyle branding.

In a letter to the editor of the *New York Review of Books*, the film critic Molly Haskell responded to Mendelsohn's claim that the show was not only inauthentic, but also "contemptuous and pandering," by reminiscing about her stint as a young secretary at Sperry Rand in the early 1960s. "With its deft blend of satire and sympathy, *Mad Men* has had the cathartic effect of well-imagined art in allowing me to both recognize and gain a forgiving distance from a sometimes embarrassing younger self," she wrote.[36] Haskell's response to *Mad Men* was nostalgic, reflective of a yearning to revisit her own sentimental education in the New York of an earlier age. In her desire for a forgiving distance, she indulged in a form of love among the ruins.

THE SAD FATE OF 2 COLUMBUS CIRCLE

Soon after the restoration of Lever House, a nasty debate arose around the future of Edward Durell Stone's building at 2 Columbus Circle in New York, the former Gallery of Modern Art, originally commissioned by Huntington Hartford, the Harvard-educated heir to the A & P supermarket fortune, a mid-century cultural impresario and notorious playboy.[37] This was the building that Ada Louise Huxtable infamously ridiculed as "a die-cut Venetian palazzo on lollipops" in the *New York Times* when it was completed in 1964.

The battle over the fate of Stone's building raised the stakes in the budding preservation debates because it posed the obvious question: why save Lever House, but not 2 Columbus Circle? Stone's building was denied landmark status by the New York City Landmarks Preservation Committee, which, ironically, advocated its destruction.[38] A & P had been in business for over 150 years and was the largest retailer in the United States at the time, the forerunner of behemoths such as Walmart: wasn't Hartford's museum therefore also part of "the compelling legacy of corporate culture"? Wasn't Stone's "lollipop building" also a "signature work"? For many people – critics, scholars, and pedestrians alike – its impending destruction inspired much stronger emotions than the benign respect afforded Lever House.

At a public hearing sponsored by the organization Landmark West, a watchdog group for the West Side of Manhattan, Stern made a case for the preservation of 2 Columbus Circle, noting that it was "part of an important group of buildings [Stone] designed in the 1950s, many of them triumphantly counterintuitive," including the U.S. Embassy in New Delhi, India (1954), and the U.S. Pavilion at the 1958 Brussels world's fair. He called it "a landmark in

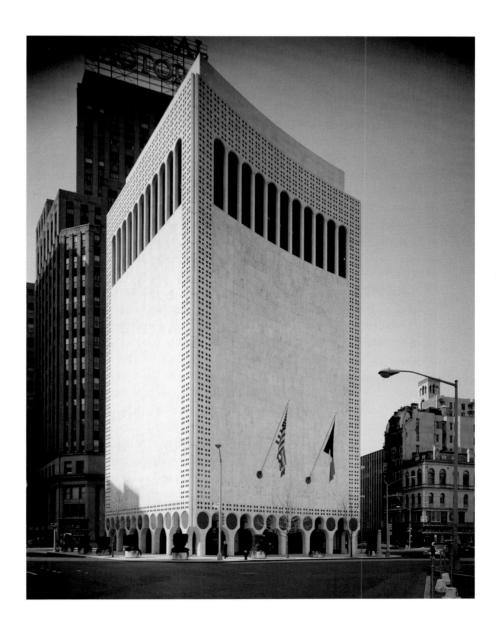

0.5
Edward Durell Stone, Gallery of Modern
Art, 2 Columbus Circle, New York, 1964,
© Ezra Stoller/Esto.

the history of architectural taste," which is different from a landmark in architectural design.[39] When the building nevertheless began to be defaced in the fall of 2005, there was a lingering sense that something ineffable, but essential, was being lost. Lever House and 2 Columbus Circle were built only a few years and a few blocks apart by men at the height of their creative powers. Why was one deemed less representative of the ideals of post-World War II American culture than the other?

To begin with, Stone's building was clearly an obstacle to New York City's redevelopment scheme for Columbus Circle. The New York Coliseum (1956), a white-brick whale of an edifice emblazoned with four monumental civic seals on its façade announcing the power of federal, state, city, and municipal authorities, had already been demolished in the year 2000 to make way for the Time Warner Center, an imperious, neo-Gothic cathedral to corporate conglomeration designed by David Childs, the current lead design partner at SOM. Trump International Tower, whose faceted, mirrored façade was designed by modern architecture's most famous chameleon, Philip Johnson, faced it on the other side. The Time Warner Center was positioned as the direct descendant of the aesthetic and ideological values embodied in Lever House. Stone's building was seen as an embodiment of other ideals: either the personal whims of Huntington Hartford, or the civic appeal of the New York Coliseum (in 1994, Hartford's museum was deeded to the City of New York and served for a time as a dilapidated, makeshift tourist bureau).[40]

The elusive ideal behind Stone's building was largely what was at stake in this debate. In January 2006, Herbert Muschamp, architecture critic for the *New York Times*, published a front-page story in the Sunday Arts and Leisure section entitled "The Secret History." In his article, Muschamp did a number of remarkable things. First, he attempted to save the building's legacy by pointing to the factors that made it an icon of the city's vibrant, progressive social history, but a liability for big business. He argued that a gay New York audience whose sensibility married high style with a taste for pop had adopted the building as its own.[41] For Muschamp, the building was a landmark because it was part of a web of subversive sociocultural associations. He compared the stylistic eclecticism of Stone's building and the criticism leveled at it in the mid- and late 1960s to the stigma attached to "sexual ambiguity" and the socially ambiguous "taste culture of swank," hallmarks of pre-Stonewall gay subculture. "No other building more fully embodied the emerging value of queerness in the New York of its day," Muschamp wrote, adding: "If the Landmarks Commission could miss this significance, then it is reasonable to conclude that many dots in that chapter of the city's social

history have yet to be connected."[42] It was this queer history, he maintained, that was being lost with the destruction of the building, compounding the losses the city had already suffered from the generation lost to AIDS.

There is an aggregate quality to the queer value of the building in Muschamp's account. For Muschamp, it became a memory palace of queer urban experiences, taking up into itself the new sensibility of the 1960s as well as the legacy of 1980s and 1990s AIDS activism. It symbolized the renunciation of white flight, the return to the city center of generations of gay kids fleeing the repressive suburbs. Aside from sexual ambiguity, he connected the building's stylistic eclecticism to the heterogeneous mix of people one encountered in the city. In 1961, Hartford launched *Show: The Magazine of the Arts*, a glossy folio-sized publication that chronicled the culture boom of the 1960s (it folded in 1965). From Muschamp's perspective, with the death from AIDS of so many gay men in the fine and performing arts, Stone's building became a totem to a now-vanished golden age of the arts in New York, a lonely beacon of halcyon days. "Landmarks are not created by architects," he concludes. "They are fashioned by those who encounter them after they are built. The essential feature of a landmark is not its design, but the place it holds in a city's memory."[43] Compare this rich, subjective account to the empty but triumphalist rhetoric about Lever House.

From an architectural standpoint, 2 Columbus Circle symbolized the fracturing of the master narrative of modernism and the hegemony of the white wall. It marked the end of the era of abstraction and the return of fancy figuration in both art and architecture. Stone had designed MoMA's International Style building in 1938. When he completed the museum for Hartford in 1964, many critics felt he was repudiating the MoMA line. Hartford's collection of paintings, moreover, directly challenged the program MoMA had established for the display of modern (mainly abstract) art. Paintings by Burne-Jones and Pissarro were hung in galleries with luxurious dark-wood paneling, colored carpets, and potted plantings, the opposite of the white-walled MoMA box.

In its emphasis on a queer sensibility, Muschamp's article recalled an earlier argument made by the British architecture critic Charles Jencks. In his survey *Modern Movements in Architecture* (1973), Jencks dismissed Stone's architecture, along with that of Saarinen, Johnson, and Paul Rudolph, as an expression of "the attitude of Camp."[44] Jencks completely misconstrued the camp sensibility. Drawing on Susan Sontag's 1964 essay "Notes on Camp," he put forth the idea that American architecture of the postwar decades was so bad, or so confused, or so misguided in its aspirations, that

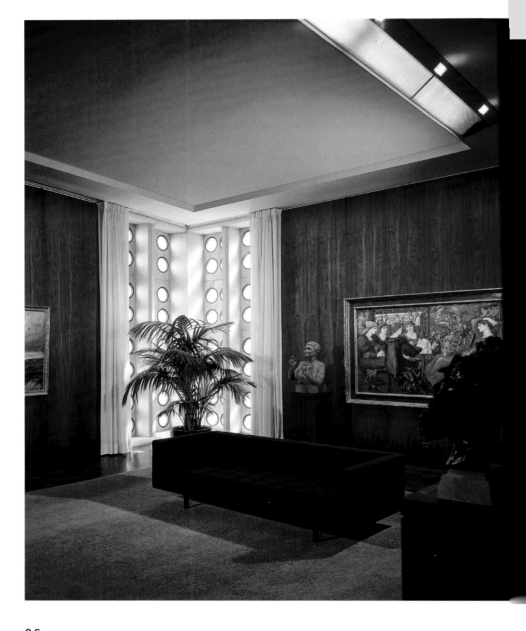

0.6

Edward Durell Stone, Gallery of
Modern Art, interior, New York, 1964,
© Ezra Stoller/Esto.

architects such as Stone, Saarinen, and Johnson could not have been taking themselves seriously. He speculated that they internalized their belatedness in the historical trajectory of modernism as a kind of failure, and therefore substituted "a sort of cheerful open-mindedness" for moral seriousness. He bizarrely denounced their architecture as "amoral" and "destructive of the public domain which depends on both personal sacrifice and morality."[45] Jencks's idealized view of modern architects as selfless social reformers had no real basis in history.

He gleaned the bare outlines of camp from Sontag's essay, but missed the finer points she made about camp sensibility's sense of depth and erudition, and its complex engagement with culture, history, sexuality, style, and taste, and especially its subversive politics. Muschamp would later celebrate all these things as "secret" without applying them to Stone's building *per se*, seeing them more properly lodged as a response to the building by a gay audience at a specific moment in the late 1950s and early 1960s.

Tom Wolfe later designated Stone one of "the apostates" in his irreverent romp *From Bauhaus to Our House* (1981). Tongue in cheek, and rather admiringly, Wolfe characterized Stone as "an anathema" and argued that in designing 2 Columbus Circle he repudiated his early association with the International Style as the junior architect of the Museum of Modern Art.[46] Wolfe postulated that in the late 1950s Johnson ascended to the position Stone had voluntarily abdicated in the architectural establishment. Commercial success for Stone in the postwar era, Wolfe says, came with a loss of prestige: "Stone was poison ... beyond serious consideration ... he removed himself from the court ... he was out of the game."[47] Saarinen, he says, was another of the apostates, a maverick who had no place within "the compounds," an architect whose ambition made him ridiculous, also beyond seriousness.[48] None of this was true, although it may have seemed true in the postmodern critical climate of the early 1980s, when Wolfe was writing.

Wolfe revisited his earlier assessment in the midst of the debate surrounding 2 Columbus Circle. Writing in the *New York Times*, he took issue with Brad Cloepfil's statement that he would render Stone's building more ephemeral (Cloepfil was the Portland-based architect chosen by the site's new owner, the Museum of Art and Design, to redesign the building). The new millennial aesthetic of total transparency was Wolfe's new bugbear, and in the face of what he called "the Platonic ideal of plain transparency, confusing transparency, peekaboo voyeurism, I-see-you voyeurism and hide-and-seek deception of the dominant regime," Stone's white marble museum came out winning. Pitted against the squabbling and corrupt bureaucrats

on the New York City Landmarks Preservation Committee, Stone emerged as a jovial visionary.[49]

Muschamp, like Haskell, indulged in a form of love among the ruins. What was most remarkable about the controversy surrounding Stone's building was the purposeful avoidance of any reference to the actual historical record. An even cursory glance back at Stone's memoir *The Evolution of an Architect* (1962) revealed that the building was in fact part of a larger fantasy, an unrealized redevelopment scheme he had designed for Columbus Circle, which incorporated a larger apartment tower on the north side of the circle where the Trump International Tower stands today. In this fantasy, the apartment tower, the museum, and the New York Coliseum majestically preside over the traffic flow of the circle, just as the palazzi of Venice preside over the traffic flow of the Grand Canal. It was one of an astonishing forty-seven projects Stone designed between 1957 and 1959, during the publicity blitz surrounding the tremendous success of his U.S. Pavilion at the Brussels world's fair. In his memoir, Stone writes:

> The Brussels pavilion yielded many personal dividends for me. We had a fabulous time with our builder, Emil Blaton, a gourmet and bon vivant, and with William Bierach who brought rough-and-ready U.S. know-how to the building of the pavilion: when he roared everybody on the job trembled. When the pavilion was completed my conscience permitted me to spend the remainder of the summer at Palladio's Villa Malcontenta, on the Brenta Canal near Venice. I spend as much time as I can in Venice ... the marvelous qualities of Venice could be paralleled in American cities.[50]

By this he meant not only the glittering, serpentine beauty of Venetian architecture, but also architecture oriented toward a pedestrian experience of the city. Like Frank Lloyd Wright, whom he revered, Stone was famously anti-automobile. His unrealized designs for a Civic Center and Pedestrian Mall in Akron, Ohio (1957) and the Tulsa Civic Center in Tulsa, Oklahoma (1960) created pedestrian urban dreamscapes in Middle American cities based on the models of Renaissance squares in Italian hill towns. 2 Columbus Circle was a revised version of his unrealized design for an International Trade Mart in New Orleans (1957) along these lines.

When, soon after the debacle over 2 Columbus Circle, the architects Diller, Scofidio + Renfro were commissioned to renovate Lincoln Center (1962, 1964, 1966), the greatest urban Acropolis of the post-World War II period, it became clear that there was something about these civic rather than corporate buildings, these non-glass-curtain-walled buildings, that no longer

registered. Like Stone's U.S. Pavilion at the 1958 Brussels world's fair and 2 Columbus Circle, Lincoln Center was modeled on an Italian example: the Capitoline Museums in Piazza del Campidoglio in Rome. In the postwar era, these projects posited the United States as the heir to and guardian of Western civilization and values, and in the case of Lincoln Center, specifically positioned New York as the world capital of culture. In the first anniversary issue of *Show*, Huntington Hartford described what was happening at Lincoln Center (home to the Metropolitan Opera, the New York City Ballet, and the New York Philharmonic) as nothing less than a "cultural revolution." In the new millennial context, these themes no longer seemed to have any historical or institutional authority, or were impolitic in a globalized world.

The movement to save corporate modernism in and around New York and the controversy surrounding Stone's 2 Columbus Circle were two of many such campaigns and controversies that raged nationally as the second decade of the new millennium wore on. It increasingly seemed as if it was only sleek, glass-walled structures like Lever House that were being saved, because they spoke to contemporary obsessions with advertising, branding, and the spectacular display of thin screen surfaces. The classicizing concrete colonnades of modern cultural Acropolises like Lincoln Center, and the romanticizing hybrid façades of buildings such as the New York Coliseum and 2 Columbus Circle, either went forlornly unnoticed or were slated for destruction to make way for new corporate shrines.

SECRET HISTORIES

In 2006, the Yale School of Architecture sponsored another important symposium, this time about Philip Johnson, who died in 2005 at the age of 98. The Yale symposium was one of the first to reassess Johnson's life and work. Speakers parsed the myths he artfully wove for himself over the course of his long life. In paper after paper, exciting analyses devolved into stereotypes and predictable clichés when addressing Johnson's homosexuality and his foray into fascist politics in the 1930s. He was accused of architectural, stylistic, and theoretical promiscuity ("architectural group sex," according to Jencks).[51] Theatrical metaphors also abounded. Joan Ockman likened Johnson's adoption of different architectural styles over the course of his career to a "succession of ill-fitting costumes."[52] He was labeled effete, flippant, and narcissistic, and depicted as a high-strung nihilist and destructive cynic who exhibited "cavalier disdain" toward normal social and political values.[53] When Ockman posited that Johnson's political sympathies went "covert" in the 1950s, she expressed the view of many scholars who have not found much

in the way of political content in his architecture of the 1950s and 1960s, although he seemingly embraced the dictates of corporate capitalism in his postmodern projects of the 1970s and 1980s.[54] But the notion that Johnson harbored covert sympathies raises the specters of his sexuality and politics in an "amoral" light (Jencks's term), painting him as a cunning, Cold War-era homosexual with a secret agenda.

In the cases of both Stone's building at 2 Columbus Circle and the re-assessment of Johnson's work, a "secret" queer subtext ran below the sur-face and acted as a destabilizing force on establishment interpretations of modern architectural history. In fact, there was nothing secret about Johnson's disdain for what he derisively called "Democratic Capitalism" in a speech at the annual AIA conference in 1962. In his architecture and essays of the 1950s and early 1960s, Johnson deployed his queer eye as a form of critique to expose the hypocrisies of democratic mythmaking and the social taboos and political fears of the age. He fought against the spread of cul-tural democracy by designing willfully antidemocratic and anti-utilitarian buildings, first on his estate in New Canaan, Connecticut and then on the national stage. He excoriated the architecture of his contemporaries while construing narratives for his own buildings that purposefully jumbled their meaning or divorced them from their post-World War II American context. Johnson's aristocratic posturing *vis-à-vis* democracy (which continues to alarm and repulse some historians) cues us into a different view of culture and power, one intent on undermining rather than buttressing mainstream views.

Muschamp's article confirmed something I had already suspected. A narrow focus on corporate modernism had obscured the more subversive fantasies that also informed post-World War II American cultural production, especially fantasies about civilization.[55] While Bunshaft almost always dis-cussed his architecture in terms of the organizational needs of his corpo-rate clients, he spoke even more passionately and persuasively about the Renaissance. He made explicit comparisons between Renaissance patrons and corporate executives. Describing the corporate milieu *circa* 1947, he explained: "It was easily more of a Golden Age than the Italian Renaissance with the Medicis. In the corporations in those days, the head man was per-sonally involved and personally building himself a palace for his people that would not only represent his company, but his personal pleasure. They were the new Medicis, and there were many of them."[56] In exactly the same vein, Stone likens Hartford to "a modern day Medici" in his memoir.[57] The frontis-piece is a sketch of the Arch of Titus he made when he was a student in Rome. I think Bunshaft and Stone saw themselves more as modern-day counterparts to figures such as Bernini than as heirs of Le Corbusier.

Like Muschamp, Manfredo Tafuri was interested in secret histories. He called them "subterreanean ideologies." For many years Tafuri chaired the department of historical research at the architecture university in Venice, where he worked up an idiosyncratic research method which he described as "the historical project" in the introduction to *The Sphere and the Labyrinth: Avant-Gardes and Architecture from Piranesi to the 1970s* (published in Italian in 1980 and in English translation in 1987). Tafuri employed the metaphor of "the jig-saw puzzle" to describe the process of historical work.[58] He further wrote of "the labyrinthine path of historical analysis" and the importance of following "an indirect path."[59] Following the indirect path meant "probing what is on the fringes," where "we discover the most useful keys."[60] He was interested in the points where ideologies collided, became "contaminated" (a word that recurs in his writings).[61] Eschewing any one specific methodology, he wrote: "Iconology, the history of political economies, the history of thought, of religions, of the sciences, of popular traditions, will each be able to appropriate fragments of the broken-up work; the work will have something to say for each of these histories."[62] Tafuri's interdisciplinary approach was rooted in the European humanistic tradition. Most importantly, he believed that "failed works" often revealed more than realized projects by highlighting the anxieties of an age.[63]

On the one hand, I was fascinated by the shifting critical fortunes of modern architecture in America. On the other, I wondered, were there things on the fringes that were being obscured, or maybe hadn't been noticed before? Was it possible to create for architects such as the seemingly boring Bunshaft and much-maligned Stone the kind of richly textured case studies Tafuri had forged for Italian Renaissance giants like Jacopo Sansovino and Giulio Romano? Was it possible to see these architects within the broad tapestry of cultural, political, philosophical, and social contexts in which they worked? Was it possible to put them back into dialogue with each other? And finally, could a queer perspective reveal secret histories embedded in their buildings?

A VISTA VIEW

The challenge I set for myself in choosing to work in a highly traversed field was to draw new conclusions from well-known evidence on figures about whom much has already been written. With few remaining gaps in the literature in the field, this book therefore deals mainly in issues of interpretation. What I set out to do is present a "vista view." The book does not offer a new theory, but it does attempt to lay out, as Tafuri says, "many independent histories alongside each other, so that we may recognize where they exist."[64]

Original research was conducted in the realm of visual culture, including films, magazines, and television specials, as well as in the realm of intellectual history, revisiting important philosophical and political texts of the period as they pertain to representations of architecture. While I make use of the architects' writings, the book does not offer in-depth analysis of architectural plans, contracts, the many details of specific commissions: information that can be found in any number of monographs. Similarly, my focus on film is thematic and concerned with content, and I do not delve into production details or film theory. I chose the architects I did because in one way or another they have become subjects of debate in recent years. There are many architects who are not included: Minoru Yamasaki, Victor Gruen, Eliot Noyes, Morris Lapidus, Bruce Goff, John Lautner, John Johanssen, Richard Neutra, and other West Coast modernists.

The book consists of three chapters. The first, "The Cult of Immaculate Form," explores the cultural and sociopolitical frameworks laid out for architecture in the 1950s by the magazine entrepreneur and political enthusiast Henry Luce, founder of *Time* and *Fortune*, and publisher of *Life* and *Architectural Forum*. Among these frameworks was the resurgence of New World imagery, which mixed ancient history and biblical myths with modern American ideals of democracy, as well as Americanized iterations of European discourses on "the need for a new monumentality" and "a new humanism." I illuminate how these frameworks informed representations of Bunshaft's showpiece projects of the 1950s: Connecticut General, Lever House, and his penthouse apartment in Manhattan House.

Architectural Forum called Connecticut General "pervasively complete." Bunshaft called it "a mirror building." Like Versailles, it was conceived as a cosmos in its own right, an ideal system with universal applications offering the world an endless series of representations of itself. Connecticut General's employees, pictured in publicity materials in various states of beatitude in an Arcadian corporate landscape, became advertisements for both the company's life insurance policies and the new managed way of life advocated in Luce's magazines. Such representations, I argue, engendered cultural fantasies of a war-torn world made immaculate. New widescreen cinema technologies such as Cinemascope and VistaVision, I further argue, produced similar kinds of representations. I interpret *The Robe* and *Helen of Troy* as allegories of beauty and freedom, while I interpret *Daddy Long Legs* as an allegory of the United States' chaste guardianship of European art and civilization.

In a new analysis of gender and modern architecture in 1950s, I argue that Luce's ideal of "pervasive beauty" also found expression in a fixed ideal of female beauty. Images of women looking at themselves in mirrors performing acts of self-maintenance became a dominant cultural trope, including the famous Marilyn Monroe mirror scene in *How to Marry a Millionaire*, the wives of management depicted in *A Woman's World*, and the cinched, pinched women with cigarette silhouettes on covers of *Harper's Bazaar*. Women shown in acts of self-maintenance, I further argue, not only represented the "superior engineering, attractive installation, and easy upkeep" of an advertised building product, such as modular toilet compartments, but also served as idealized representations of a self-sustaining "government under glass."

Chapter 2, "Architecture, Mass Culture, and Camp," traces the distinctive shift in style and taste as the corporate-poetic glass-walled world of the 1950s gave way to the soaring concrete and mosaic-tiled Shangri-La of the early 1960s. No longer merely the reflection of a materially rich and reverent good society, architecture and visual culture were now charged with representing democratic imperium, as outlined in President Eisenhower's 1958 State of the Union Address. In projects such as the new U.S. Air Force Academy on the Rampart Range, which was modeled on ancient Egyptian tomb cities and Greek oracle sites, architecture now aspired to emulate the imperial scale of the monuments of antiquity, especially their sense of epochal durability and existential security. Filmmakers such as D. W. Griffith and DeMille, and commercial architects and designers in the 1920s and 1930s, had already seized upon antiquity and transformed it into forms of mass entertainment and styles such as Art Deco. Revisiting debates about mass culture and camp sensibility, and exploring the architecture of Saarinen, Breuer, and Stone, the essays in this chapter explore what made these mid-century manifestations mesmerizing and remarkable.

The Mosaic Tile Company and Carduco Structural Wall Units used cartoons of the Egyptian pyramids, the Parthenon, and Byzantine mosaics to advertise their prefabricated, mass-produced products such as "Byzantile by Mosaic" bathroom flooring and "Great Walls." I argue that these advertisements, alongside architecture and the historical and mythological-themed movies of the era, constituted postwar America's materialization of the age-old "quarrel of the Ancients and the Moderns."

I present a more polemical interpretation of Saarinen's architecture than recent accounts. In his new headquarters for CBS in New York, nicknamed Black Rock (1965), Saarinen challenged both Frank Lloyd Wright's Prairie

Tower and Mies van der Rohe's Seagram Building to create what I term the "skyscraper colossus." Examining visual sources including CBS television specials from the 1960s ("The Golden Age of Greece" and "Elizabeth Taylor in London"), Lou Dorfsman's revolutionary print advertisements for CBS News, films such as *The V.I.P.s* (1963), and pulp romances such as Harold Robbins's *The Adventurers* (1966), I show how Saarinen's buildings contributed to narratives of ersatz empire for corporate America, wherein the American corporation was pictured as the guardian of world civilization and gateway to global resources.

In the 1950s and 1960s, Stone was fêted around the globe as the unofficial American Architect of State. Today, his reputation and his buildings are literally and figuratively in ruins. Using sources such as his memoir *The Evolution of an Architect*, Hartford's *Show* magazine, and the visual culture of Kennedy Camelot, I offer new interpretations of Stone's major buildings as well as his vast portfolio of unrealized designs. Stone's architecture was part of the "Cultural Revolution" defined in *Show*: for Hartford, Stone's buildings functioned as "the living mirrors of the nation's style." I argue that his buildings – like Jackie Kennedy's tastes in the arts, with which they were compared – became part of a new democratic narrative, the diplomacy of culture advanced by the Kennedy Administration. At the end of his memoir, Stone expressed grave concern about the durability of modern architecture, lamenting the spread of what he called "these mass-produced, catch-penny structures" as opposed to "permanent architecture." In doing so, I argue, he became an accidental theorist of the crisis in culture. On which side of history should his work fall? This is the question I seek to answer.

Chapter 3, "The Useless Monument," explores crises in the concepts of history, tradition, and national style, beginning with an analysis of Philip Johnson's architecture. I link Johnson to Arendt as a philosopher of uselessness. Our view of Johnson is the one he artfully crafted for himself beginning in the late 1970s: postmodern polemicist. In the 1950s and 1960s, however, in contrast to his contemporaries, Johnson refused to design buildings representative of American democracy. I argue that he fought against the democratization of culture by designing willfully antidemocratic and anti-utilitarian buildings. In new interpretations of his buildings, as well as his essays and lectures, I suggest that he transformed his early fascination with fascist spectacle and totalitarian aesthetics into a libertine architectural philosophy fueled by his libidinal obsessions with Prussian classicism and European aristocratic traditions. I show how he deployed his cynicism as a peculiar brand of wicked cultural and sociopolitical critique.

Believing modern architecture in America was on a wayward course, with troubling political implications, Vincent Scully offered a corrective by pointing to the recent work of Le Corbusier at Chandigarh, which he compared to that of the ancient Greeks. Cultural, political, and social thinkers such as Arendt, C. Wright Mills, and Stillman and Pfaff interrogated the dominant rhetorical and visual strategies of the era, focusing in particular on the opening up of a so-called "fantasy gap" in political thinking. Were there redemptive possibilities to be found in the example of the ancient Greeks (as Scully maintained), or in the postwar work of Le Corbusier and Louis Kahn? Or was the classical notion of the heroic anathema to a realist understanding of the postwar world?

1

The Cult of Immaculate Form

The age of the masters had passed. In his keynote speech at the 1957 centennial celebration of the American Institute of Architects (AIA), held in Washington, Henry Luce called on "editors and enlightened citizens," people such as himself, to make a new case for relations between architecture, beauty, and politics. The philosophical and political questions Luce posed, the "big questions," were whether architecture and beauty were in fact compatible with democracy. "Nearly all of majesty and beauty in architecture springs from imperial autocracy or from Aristocracy with a capital 'A,'" Luce noted, pointing to examples such as Versailles, the Taj Mahal, Mayan temple complexes, and England's ancestral stately homes.[1] If the United States was to establish itself as a "great civilization," its architecture had to speak symbolically, but by way of twentieth-century modernism: "we must say the old and the new in a new language." With nationalist zeal he lobbied the assembled architects to endow modern architecture with a quality of magnificence that would represent "the meaning of America."

Theorists of the modern movement had in fact grappled with these questions during and after the war. Throughout the 1940s, artists, architects, and historians debated whether and how the quality of monumentality could be reimagined and put to renewed purpose in the postwar world. The avant-gardes had rejected the bombastic monumentality of the nineteenth-century imperial monarchies, but the totalitarian regimes of the 1930s had not only revived this quality, they successfully joined it with the language of modern industry. Albert Speer's regimented romantic-classical colonnades and ashlar and marble palaces, such as Hitler's Reich Chancellery, laid claim to classical values in service of Nazi ideology, while Luigi Moretti's Foro Italico re-created the Roman forums of the imperial age in glory to the cult of Mussolini. Since monumentality in architecture was rooted in the ancient Egyptian and Greco-Roman worlds by way of the Renaissance and neoclassical movements of the eighteenth century, the debate about monumentality really revolved around the question of how the nature of the classical and the qualities of the eternal and symbolic could be purged of the taint of association with totalitarian fantasies, and imbued with the spirit of democracy.

THE NEW MONUMENTALITY AND A NEW HUMANISM

In their 1943 position paper "Nine Points on Monumentality," originally conceived as part of a volume on American abstract art that was never published, the historian Sigfried Giedion, the artist Fernand Léger, and the architect José Luis Sert, who had all fled Europe and taken refuge in New York, laid out themes that would preoccupy intellectuals throughout the postwar period. They prefaced their paper by pointing to the example of French cathedrals, remarking on the links between architecture, beauty, and faith in the symbolic life of the nation.[2] In their first point, they acknowledged that monuments are symbols that serve as ties "between the past and future," and further acknowledged the problematic nature of the concept of tradition in modernity. Just one example of how this theme resonated throughout the postwar era: in 1961, Hannah Arendt published a book of essays, *Between Past and Future*, in which she described "the perplexing crises" facing modern society, foremost among them "Tradition and the Modern Age," the title of the first essay.

Giedion, Léger, and Sert, in search of architectural forms that could express democratic ideals, made a case for the rediscovery of lyrical values. In their ninth point, they envisaged large-scale architectural ensembles encompassing art that could unite the ancient and the modern with the spiritual — natural elements "such as trees, plants, and water" and "the stones which have always been used" (the ancient) combined with "the new materials which belong to our times" (the modern) and "color in all its intensity which has long been forgotten" (the spiritual).[3] These materials, they argued, without elaborating, could be orchestrated to achieve "new architectural effects," especially "big animated surfaces with the use of color and movement," namely murals.[4]

Giedion, Léger, and Sert's interest in "mural language" was part of a wider artistic discourse in New York centered on the emergence of a new kind of abstract art, the "all-over" painting. To a certain extent exhibition architecture provided a model for what they had in mind. Sert had designed the Spanish Pavilion at the 1937 world's fair in Paris, where Picasso's *Guernica* was unveiled. His lightweight, modern, and vaguely classicizing pavilion served as a tension frame for the display of Picasso's mural, which galvanized antifascist sympathies and became a *cri de cœur* heard around the world. In 1939, after a European tour, Picasso's mural was installed at the Museum of Modern Art in New York, where it remained throughout the war, intensifying interest in the mural format, which had of course also been a fundamental component of Works Progress Administration (WPA)

sponsored projects in the mid- and late 1930s.[5] In New York, it inspired the emerging abstract expressionists, notably Jackson Pollock, Willem de Kooning, and Arshile Gorky, whose large-scale, mythically charged and symbolically laden canvases of the 1940s grappled with the effects of the war on the individual and collective psyche. Although they originally conceived of the nine points for a volume on American abstract art, Giedion, Léger, and Sert never referred to the work of specific artists or architects; but perhaps they had these artists in mind. Commissioned by Peggy Guggenheim and installed in her apartment on East 52nd Street, Pollock's *Mural* (1943), for example, a direct response to Picasso's *Guernica*, is contemporaneous with their position paper. Pollock later explained how his mural, with its spiraling and cascading arcs of green, white, yellow, and black paint, represented the wild animal energy of the American West.

Giedion expanded upon the nine points in his essay "The Need for a New Monumentality," which appeared in *New Architecture and City Planning: A Symposium* (1944). Organized by Paul Zanker, one of the most influential classicists of the twentieth century, the symposium, held in the Great Hall at Cooper Union in New York City, was nothing less than a wholesale reinvestigation of the foundations of architecture. In his introduction, Zanker acknowledged that functionalism had failed. The avant-gardes, he suggested, had become too preoccupied with questions of style, which sidelined their reformist dreams (this was not a novel argument: Walter Benjamin and Le Corbusier had come to a similar conclusion by 1929). Zanker proposed "general concepts of future layouts."[6] The most urgent problem facing architects in the coming postwar world, he maintained, was "the integration of architecture with the social aspect," and he therefore stressed the need to focus on "social function" over "stylistic form."[7] Zanker further argued against the incessant fixation on future-oriented theoretical proposals, staples of modernist activity. Launching a protest against the "house of tomorrow," for instance, he made the case for a more "integrated texture of life" in the present, and "the truthful expression of sociological conditions through form."[8] In this way, the symposium sought to reinvigorate the original animating impulses of the avant-gardes, but with a more realistic understanding of the actually existing conditions of the present. The symposium held sessions on specific building types, methods of construction, and problems such as housing. It ended with a call for reforms in architectural education. But the session on monumentality stood out as the philosophical heart of the enterprise.

Without the more optimistic voices of Léger and Sert, Giedion voiced his anxiety, returning again and again to the "dangerous" qualities of "pseudo-monumentality," which he identified with the fevered dreams of authoritarian regimes from Napoleon to Hitler, and inhumane theoretical "paper projects."[9] Juxtaposing the French Revolutionary-era academician Durand's imaginary scheme for a colonnaded museum with the Nazi architect Paul Troost's Haus der Deutschen Kunst in Munich (1937) and the American architect Benno Janssen's Mellon Institute in Pittsburgh (also 1937), he made a persuasive visual case for the inherently value-neutral quality of classical forms, which were ideologically mutable.

Like Zanker, but with an even stronger tone of regret, Giedion acknowledged the failure of the avant-gardes to realize an edifying architecture of social cohesion. In a series of open-ended questions, he wondered whether architecture could still in fact "instill the public with the old love for festivals, for the perennial predisposition for great representation?" This question constitutes one of his major contributions to the monumentality debate. First of all, he recognized the importance of festivals, and of spectacle – not merely as forms of political propaganda, but as sources of commonality, and of collective joy. Second, he posited great representation as a form of monumentality. On the one hand, he called for a new mural language (a concept taken from the nine points), large-scale semi-abstract murals as part of architectural ensembles, which could communicate shared civic ideals. But on the other hand, by the end of the essay he moved away from architecture altogether, advocating instead a completely ephemeral form of monumentality: firework displays. In so doing, however, he bizarrely overlooked Speer's "Cathedrals of Light," the mass Nazi rallies with military searchlights aimed skyward to form colossal virtual colonnades set against the black backdrop of night, which often ended in firework displays.

In the postwar American context, great representation and a new mural language found their supreme manifestation in an unexpected source, and one Giedion could not possibly have imagined: *movies* – Cinemascope and other widescreen-format films, whether sword-and-sandal films, romantic and social comedies, or Hollywood musicals – which, as I discuss below, experimented with epic modes of storytelling, and visualized ideas about beauty and authority in ways that moved the masses.

The young American architect Louis Kahn, in his contribution to the same Zanker volume, made a much more convincing case for the need for a new monumentality. Unlike Giedion, Kahn was able to separate classical forms, such as the colonnade, from classical values. His epigraph: "*Gold is*

a beautiful color. It is the color of sculptors."[10] Golden radiance: this is how Kahn begins his essay, simply titled "Monumentality." Pointing to the Parthenon and Gothic cathedrals, he urged his contemporaries not to "discard the lessons these buildings teach for they have the common characteristics of greatness upon which the buildings of our future must, in one sense or another rely."[11] Disavowing a purely functional approach to architecture, Kahn advocated marrying "new knowledge," meaning technical knowledge, with "basic principles," meaning the classical values of order and design (similar to Luce's maxim, "we must say the old and the new in a new language"), and he stressed the importance of the "spiritual quality inherent in a structure which conveys the feeling of eternity."[12] In schematic drawings of imaginary structures, Kahn showed how he was deriving a unique architectural exoskeleton from the examples of French Gothic buttressing and nineteenth-century steel frame construction. Directly following Giedion's essay in the Zanker volume, Kahn's inventive, even brilliant, vision shows how deeply melancholic Giedion's outlook was, marked by his experience of the war. Kahn, by contrast, expressed a real sense of wonder at how past and present can flow into the future.

Kahn's essay reinvested modern architectural exploration with the kind of "love of the world" (Arendt's phrase) that we see in Le Corbusier's and Bruno Taut's earliest writings. The Parthenon and the Gothic cathedrals are the same forms Le Corbusier and Taut fixed upon as inspirations for their architecture in 1911 and 1912, respectively. On the one hand, Kahn's invocation of the Parthenon recalls Le Corbusier's fiery revelation atop the Athenian Acropolis on his 1911 voyage to the East, which became the clarion call for his Purist program of the 1920s. On the other hand, his reference to the Gothic recalls Wilhelm Worringer's *Form in Gothic* (1912), which inspired Taut's Crystal Palace (1914) and *Alpine Architecture* series (1919) – these were cosmological, socialist-utopian fantasies, reimagined by Kahn through the lens of American pragmatism. Unlike Giedion, Kahn expressed genuine belief in a monumental architecture endowed with humanist values.

The European masters had already moved in the direction of a new monumentality on their own terms. In 1943, the same year as the "Nine Points," while working as a surveyor of bomb damage in Berlin by day, the German architect Hans Scharoun produced a series of visionary watercolor sketches by night: architectural fantasies for civic structures that reaffirmed, but also reimagined, ideas central to modernist expressionism and functionalism. Scharoun, like Kahn, returned to Taut's concept of the Stadtkrone, the city crown (1919), which was indebted to the cathedral, and transformed it into

an imaginary modern concert hall, church, or courthouse. In the watercolors, these structures are envisaged as colossal glass-walled sanctuaries, holistic interior landscapes with multiple meandering pathways, bathed in colored light. In these watercolors Scharoun destroyed the Nazi stranglehold on civic space and created new environments for individual discovery amid collective experiences in open structures. They anticipated his postwar projects: schools, apartment houses, and his masterpiece, the Berliner Philharmonie (1963).

In his Obus projects for Algiers (1931–1941) and the Unité d'Habitation in Marseille (1945), Le Corbusier had also begun to develop a new language for modern architecture based on a unity of ancient, modern, and spiritual themes, which he expressed in both his forms (the cell and the refectory, and the megastructure) and materials (rough-finished concrete).[13] The chapel of Notre-Dame-du-Haut at Ronchamp (1950–1954) rises out of a primordial mud that contrasts with the chapel's blazing white stone façade, which slices through the landscape. Contemporaneous with the chapel is Le Corbusier's final architectural treatise, *Poème de l'angle droit* (1955); the two are of a piece. In the frontispiece, the architect's hand (rendered in illustration) is shown drawing four right angles (which form a crucifix) over the horizon in the distance: the chapel consecrates this image in built form. Like the chapel, the *Poème* deploys a vast array of alchemical signs. It makes a case for imaginative inquiry into the mysteries of the cosmos, positing peculiar, often inexplicable links between nature, technology, and spirituality.

—

The desire for purification in Europe gave rise to a concomitant discourse on "A New Humanism." In the mid-to-late 1940s and early 1950s, German and French philosophers debated the fate of humanism in the postwar world. Karl Jaspers, who had survived the war in Heidelberg but had been removed from his teaching post at the university there by the Nazis, lectured widely throughout the German-speaking world on *The Question of German Guilt* (the title of his most influential book, published in 1946), the legacy of European civilization ("Is Europe's Culture Finished?," a lecture given in Geneva in 1946, published by *Commentary* magazine in English in 1947), and "Premises and Possibilities of a New Humanism" (included in *Existentialism and Humanism*, published in English in 1952), among other subjects.[14] Jaspers's lectures had transatlantic, if not global, reach. With Heidegger in disrepute due to his collaboration with the Nazis, Jaspers emerged as a titanic philosophical voice of authority in the immediate postwar years. Amid the still

smoldering ruins of European civilization, he asked: "what actual conditions govern humanity now?" and "what way of humanism seems possible to us?"[15]

The only way forward, Jaspers argued, was to bring technology, politics, and the traditions of Western civilization together in a way that would put the individual back at the forefront of human endeavor. Jaspers championed forms of freedom that insisted on the individual's ability to influence the collective spirit of society, arguing, for example, that "the moral power of the seemingly infinitesimal individual is the sole substance and the real instrumentality of humanity's future."[16] A new humanism, in other words, would wrest the individual out of the totalitarian mass and reawaken the world of ideas, the ethical impulses that had been smothered, but not extinguished, by the Nazis.

Like the new monumentality, Jaspers's new humanism rejected modernist functionalism, nihilism, and negation of the past, the "anti-historic trends in modern technology and politics," which led to "the disintegration of historic memory."[17] Jaspers made a case for the need to "broaden the idea of Europe into the idea of humanity." To this end, he imagined what he called a "Humanism of a European Museum," in which Europe would become the repository of "the life of the historical soul" and custodian of the "holy places of the West." Broadening the idea of Europe into the idea of humanity included acknowledging the significance of biblical religion, "the deposit of ten centuries of extreme human experience," which Jaspers saw as the basis for existentialist thought. In search of history's relation to politics, he pointed to the importance of Greco-Roman antiquity, biblical history, and the works of Dante, Shakespeare, Michelangelo, and Goethe, but he stopped short of calling for a program of study of specific canonical masterworks.[18] A new humanism would be fluid, open to Eastern philosophies. Warning against what he called "humanism of the literati," Jaspers argued that a new humanism was "essentially a matter of education," a general spirit of inquiry that "offers youth the deepest human contents in pure and simple form," tools for the conduct of public life and especially the fight for individual freedom in the face of the overwhelming technological forces in modern society.[19]

The new humanism was also staunchly anti-Marxist. Jaspers rejected the Marxist view of an "unhistoric human life in the present" and cast the emerging world order as a "great choice ... between conditions of tyranny and the freedom to take chances; the terroristic pseudo-stability of plodding along chaotically in unchanged thralldom [versus] ways that leave steps to freedom open by allowing for reform; between surrender to despotism and the security of a state of law."[20] This represented a sharp break in his post-World

War II writings from his former friend and interlocutor Heidegger.[21] Jaspers's interest in responsibility and political moralism were to a large extent part of a troubled discourse with Heidegger that would ultimately exert a profound influence on their former student, Arendt. In his "Letter on Humanism," written in 1946 at the behest of some of his French acolytes, and published in 1947, Heidegger not only rejected humanism, he rejected "man" in favor of "Being," and embraced Marxism. Jaspers called Heidegger's turn toward Marxism "lethal." The antitechnological, Marxist, melancholy Heidegger, who abandoned Western metaphysics and retreated into a mental universe of linguistic word games, gripped the imagination of France's left-leaning intellectual class, notably Jacques Derrida, who would pick up Heidegger's argument and continue this interrogation in "The Ends of Man." It was precisely the sort of "humanism of the literati" Jaspers inveighed against, but among intellectuals it did effectively eclipse his own much more cosmopolitan perspective, which appealed instead to more mainstream political elites in West Germany and the United States.

LUCE'S WESTERN CULTURE PROJECT

If I linger on Giedion's "The Need for a New Monumentality" and Jaspers's essays on existentialism and humanism, it is because I want to argue that Luce was making similar kinds of claims on beauty and history in relation to architecture and politics. At the same time as Jaspers was traveling across Europe giving his lectures on the embers of European civilization, Luce was bringing his own version of a new humanism to bear directly on American enterprise. In 1941, Luce had ended his now famous essay "The American Century" with the declaration that "we are the inheritors of all the great principles of Western civilization." From his perspective, the war validated this claim. In 1948, in a series of memos to his Time Inc. editorial teams, Luce outlined what he called a "Western Culture Project": "The drama of Western Culture culminates in the creation of the USA and this interpretation invites all Americans to take stock of American civilization at the moment of history when the United States has become the heir and chief guardian of the whole body of Western Civilization against the forces of reactionary neo-barbarism," he proclaimed.[22] This was part of a push outlined in the memos to reinvest his magazines with the concept of beauty and, on an even larger scale, to reinvest the world with wonder.

Luce was obsessed with epic modes of art and literature, and with the concept of greatness. As a teenager traveling in Rome, he echoed Goethe when he recorded in his own diary: "whether I wish or no the remembrances

and impressions of that great city will always hold their place in my memory ... I believe that I have carried away with me some parts of Rome that can never be taken from me."[23] As a student at Yale, he studied Greek and wrote poetry. In 1922, he and his Yale classmate Brit Hadden took the *Iliad* as the literary model for *Time* magazine, which they founded that year.[24] When he unveiled *Fortune* in 1929, Luce wrote: "*Fortune* is primarily a conception ... as follows: It will be as beautiful a magazine as exists in the United States. If possible the undisputed most beautiful."[25] These were the themes Luce reasserted in his 1948 memos, in which he asked his editors how his magazines could do a "much more vigorous job of pointing to the importance of the beautiful?" He directed them to produce "great stories" about business, and to treat business as a vehicle for spreading the ideal of free markets "at home and abroad."[26]

To return to Luce's 1957 keynote speech at the centennial celebration of the AIA: he asked the gathering of architects an extraordinary question: "Is real political freedom incompatible with pervasive beauty?" This phrase is entirely unique to Luce. What did it mean? First of all, it was a reformulation of his earlier, Depression-era concept of "abundant beauty." In "The Calculability of Abundance," a 1937 speech he gave at the Ohio Bankers Association, railing against New Deal policies that he believed were hindering industrial growth and lamenting the lack of confidence in "private capitalism," Luce had propounded what he called a *"new doctrine of potential abundance"*:

> The businessman who feels rightly that he is being thwarted, that he is being cheated of an opportunity to participate in a brilliant forward march of industry, the intelligent worker who feels that there should be out of all this machinery and capital and genius a solid $2000 a year for him, and the gullible old lady who feels that the skyscrapers of New York and the great mills of Pittsburgh and Cleveland and Chicago should somehow provide for her simple little wants – all these, as well as the theoretical socialist or the practical humanitarian whose soul is shocked by the spectacle of dire want in the midst of plenty – they are all responding in differing ways to a new thing in the world – and that new thing I call the calculability of abundance.[27]

By 1957, that abundance was no longer just a theoretical possibility; it had been achieved. Abundance was now pervasive. The war had liberated industry, allowing for freedom from want of material goods and an unparalleled mass distribution of wealth. While abundant beauty visualized the liberation of economic drives, pervasive beauty transcended economics. As Luce explained to the architects gathered at the AIA centennial, "You

47

The Cult of Immaculate Form

will be given the chance to transcend economics, the chance to express the non-economic, the more-than-economic character and aspirations of the American nation."[28] Why was this so important for this gathering of architects to understand? It was this transcendental quality that pointed to the fundamental significance of architecture in Luce's overall program: architecture, more than any other art, could reconcile the inner world of man ("the non-economic, the more-than-economic") and the outer environmental world of material richness ("machinery and capital and genius").

Pervasive beauty was a great conjunction of aesthetics, faith, and power. It encapsulated the eternal, spiritual dimensions that Kahn and Giedion considered the cornerstones of modern monumentality, as well as the ideals of freedom and transcendence that Jaspers considered the basis of a new humanism, translated of course into American terms. It was the symbolic expression of what the sociologist William Herberg described at the time as the "civic religion of the American way of life," and the religious scholar Martin E. Marty described as the "secular religion" of "America's humanistic nationalism."[29] Luce expressed all this in other terms when he said in his AIA speech: "we will succeed in creating the first modern, technological, humane, prosperous and reverent civilization."[30] Pervasive beauty was Western humanism joined with Luce's Protestant ethics, principles of corporate management, and technological positivism.

In 1957, at the same time as Luce gave the keynote speech at the centennial celebration of the AIA, Jaspers returned to the themes of his postwar lectures in *Die Atombombe und die Zukunft des Menschen*, first published in German, then in English translation as *The Fate of Mankind* in 1961. He now took a much more pessimistic, even despairing, tone when describing the hardening of humanist discourses into Cold War rhetoric. He lamented the extent to which, in the space of a decade, the concept of democracy in the West had become "sacrosanct," an *idée fixe*, and "an idol of our time."[31] "Democracy is an idea," Jaspers now argued. "This means that it cannot be perfect anywhere, that indeed its ideal form is beyond visualization."[32] Addressing Western European elites, Jaspers also struck at the heart of postwar American culture, and especially the cultural-political program laid out in Luce's magazines.

PRECISION IN PASTORAL

The historian Michael Augspurger has argued that *Fortune* "largely withdrew from the cultural field after 1948," but Luce's star turn at the AIA centennial suggests that this was not the case.[33] The political and social challenges of

the postwar era demanded a different kind of cultural intervention than the one *Fortune* had advocated in the 1930s, when it made a case for the importance of modern design and modern modes of representation for the success of American industry. In the postwar period, Luce advocated a broader and deeper engagement with what he termed at different times "the social art" and "the symbolizing art" – namely, architecture.[34]

In September 1957, a few months after Luce's keynote speech at the AIA, *Fortune* and *Architectural Forum* published profiles of Connecticut General Life Insurance Company, in Bloomfield, Connecticut, whose new headquarters were designed by Skidmore, Owings and Merrill (SOM). Connecticut General was literally, as *Fortune* proclaimed in its editorial, "A New Face for the U.S." A gloss on Luce's speech, it called on businessmen "to give continuing scrutiny to the face and form of our urban and suburban life," and predicted that the late 1950s would be a period of transition in which a new face would rise out of urban blight.[35] That new face had already begun to emerge in glass curtain wall buildings like Lever House in New York, but it was still largely hidden by the brown-brick nineteenth- and early-twentieth-century city. "Civilizations are known by their cities," the editorial explained, and wondered, with the move to the suburbs, what role the city would play in postwar America.[36] The process of "building a better America" provided the reason for what Luce, in his AIA speech, called "the greater sell": new advertising and marketing campaigns; the process provided moral clarity and political purpose. Everyone agreed that the process was political: "Building a better America becomes a substantial challenge to American democracy," *Fortune* explained, "and this particular political challenge finds its artistic expression in the challenge to architecture."[37]

Architectural Forum called Connecticut General "pervasively complete." In other words, it was the absolute architectural expression of pervasive beauty. How best to illustrate such an abstract ideal? The editors commissioned W. Eugene Smith to produce a photographic essay of the complex.[38] Unlike Ezra Stoller, Smith was not a professional architectural photographer. He made his career as a staff photographer at *Life* magazine in the 1940s, producing gritty but dramatic depictions of daily life among the working classes in times of seismic social change. Clearly, therefore, in commissioning Smith, the editors of *Fortune* and *Architectural Forum* intended to showcase "the integration of architecture with the social aspect," as Zanker had advocated in his introduction to the New Architecture and City Planning Symposium in 1944, and to highlight architecture as an active agent of social transformation, not merely a product of postwar wealth. Was Smith given

a picture script detailing the arrangement of specific scenes, a standard practice for *Time-Life* photographers, and one he particularly abhorred (he resigned from *Life* in 1954, but continued to receive commissions from Time Inc. editors as a freelance photographer represented by the Magnum Photo Agency)? The narrative composition of his photos as they finally appeared in *Architectural Forum* suggests a programmatic approach. Connecticut General hired a Madison Avenue advertising firm (Cunningham & Walsh) to coordinate public relations around the unveiling of its headquarters as part of a wider rebranding campaign, and they may also have had a say in the stage management of Smith's shoot.

My point is that Smith's photo is a mural, a form of "great representation," and communicates the desired ideal of pervasive beauty. A family grouping has gathered on a stone precipice above a small waterfall in a man-made lake on the Connecticut General grounds. It is a pastoralizing panoramic scene, a life insurance landscape. Arranged friezelike, in pairs or groups of three, they all have their backs to the viewer as they contemplate the scene of which they are themselves a part. Two women, maternal figures, flank the scene at one end. They gaze toward a father figure, with a child atop his shoulders, who flanks the scene at the other end. With an outstretched arm, he points into the distance, drawing the attention of the group toward the horizon. Peripheral to this central action, on the right, the Connecticut General headquarters recedes into the background on a diagonal; a crane rising at the rear signals that it is still under construction. Framing the scene from above is a sweep of clouds, creating an atmosphere of expansiveness and expectation.

In Smith's photo, a pastoral allegory of good governance (the return to family life after a period of global warfare, the fecundity of a freshly tilled landscape, and a solid sense of peace and security under a new regime) is joined with Enlightenment allegories of progress and the sublime (symbolized by the figures with their backs to us gazing out into the horizon). The pastoral themes can be traced back at least to the Ara Pacis and Virgil's *Eclogues* and *Georgics*, the artistic and literary monuments celebrating the end of the Roman civil wars, the creation of the Roman Empire, and the institution of Augustan rule. Scenes with figures with their backs to the viewer gazing out into the horizon were a staple of French Revolutionary-era art.[39] As an image that sensationalizes the act of looking, especially among children, it is an allegory of the birth of a new way of seeing the world. In the context of American history, Smith's figures are also New World pioneers recalling the myth of manifest destiny and the discovery of the continent as

1.1

Connecticut General Life Insurance Company,
Bloomfield, Connecticut, *Architectural Forum*,
September 1957, photograph by W. Eugene Smith,
© Collection Center for Creative Photography,
The University of Arizona.

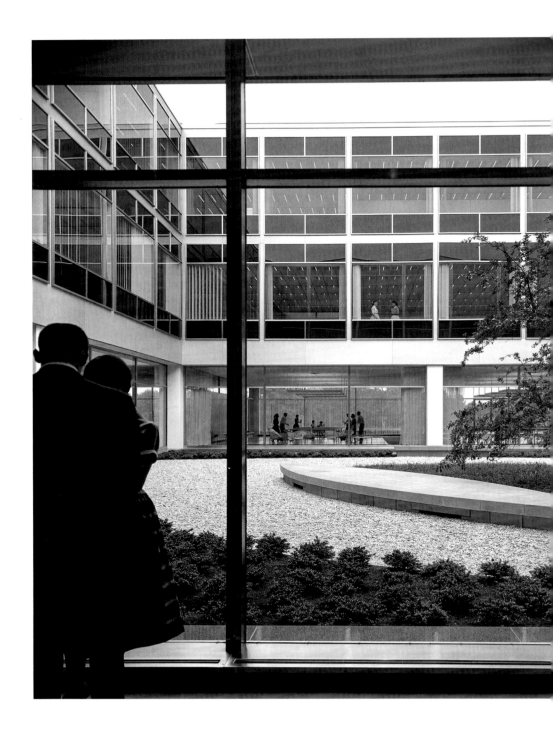

depicted in paintings by Hudson River School artists such as Albert Bierstadt. Bierstadt imbued the American landscape with spiritual wonder while also pointing to the rise of the natural sciences in the precision of his rendering of the natural world. Smith's photograph similarly seems to forge a union between the spiritual (the sky), the natural (the earth), and the technological (the building) worlds of man. The photograph quite literally illustrates the end point of the "brilliant forward march of industry," which Luce had prophesied twenty years before in his 1937 speech to the Ohio Bankers Association at the height of the Great Depression.

The most fervent descriptions of Connecticut General's architectural features still come from the architecture magazines. They capture the drama in what might otherwise appear to be banal office architecture (*Fortune* titled its profile "A Dramatic New Office Building"). *Architectural Forum* describes the complex of buildings as a mirage that "glitters but evades" as the visitor approaches, enters, and moves through a series of "receptive geometrical spaces, each one merging into the next."[40] The central rectangular block is likened to a "hard gem" like a diamond, with an emphasis on fine details or "facets," such as the way the stainless steel trim conceals the interlocking system where the glass wall panels are fixed into aluminum rails lined with neoprene skins.[41] As reflecting surfaces, these materials created an overall gossamer effect, melting away separations between spaces, but without effacing the prismatic quality of the underlying geometric plan. The "visual transition" from the "softly rolling landscape" to the "perfectly linear" building forms was "not stark, but gradual," mitigated by the softening effects of the four courtyards carved out of the central block.[42] In these courtyards (designed by Isamu Noguchi), patterned gravel and grass replicated the six-by-six- square floor tiles and modular partitioning of the office interiors, to create the impression of a union between the natural and the man-made.

1.2

Gordon Bunshaft/Skidmore, Owings & Merrill,
Connecticut General Life Insurance Company,
Bloomfield, Connecticut, 1954–1957,
© Ezra Stoller/Esto.

Frazier Wilde, president of Connecticut General, was one of the "enlightened citizens" Luce referred to his AIA speech. He was an executive pioneer in moving his corporation to the Connecticut countryside. In *Fortune*, he is portrayed as a postwar Founding Father, and in fact the architect Gordon Bunshaft, in an oral history, would later describe him in exactly these terms, as "sort of an old New England type."[43] The company's move from downtown Hartford to the bucolic Bloomfield suburb is presented as a response to organizational concerns; the building is presented as a product of Wilde's "gentle but highly effective" leadership skills, and the outcome of a meticulously detailed ten-year planning process.[44] (That process began in 1947, when Wilde was told the company would outgrow its cramped quarters in a 1920s Italianate building in downtown Hartford within ten years. Two hundred acres of Bloomfield farmland were purchased in 1950.) An early advocate of "team building," Wilde formed committees – a building committee and a directors' committee, and various junior subcommittees – to interview potential architecture firms.[45] In 1953, SOM, which had just completed Lever House on Park Avenue in New York, emerged in the top spot. The final design was approved in 1954 and the building was completed in 1957.

A profile of SOM in the January 1958 issue of *Fortune* entitled "The Architects from Skid's Row," a pun on the firm's name and costly corporate commissions, pointed out that it was "unique in being national and decentralized in character." In other words, the firm took the corporate structure to heart in the organization of its offices in Washington D.C., Chicago, San Francisco, and New York. It replicated the corporate committee structure in the design process, with at least two partners, an administrative partner and a design partner, paired on each project, with a number of junior associates participating in the production of renderings. This way of working created a system of checks and balances between aesthetic and economic concerns. In the case of Connecticut General, recognizing that vertical organization was ill suited to the circuitous assembly-line process of administering insurance policies, which were passed between departments before finally being filed away, Wilde embraced the concept, proposed by SOM, of a flexible horizontal block, the prospective size of which necessitated an open suburban site. In the realized design, a three-story main building, punctuated by four courtyards, fulfills the objectives of this clerical work. Executives, sensitive to their sense of privilege and desiring to impress prospective clients with expensive suites, settled on a separate five-story wing connected to the central block by a glass walkway. A third geometrical component, a pavilion cantilevered over a reflecting pool, functioned as a cafeteria. It further symbolized the social alms the company wished to foreground.

In the text accompanying Smith's photograph, *Architectural Forum* highlights the fact that "the architect renders himself almost invisible."[46] From an ideological standpoint, the success of the building depends on the invisibility of the architect. This allows any number of other figures to come forward: the editors of *Fortune* and *Architectural Forum*, Frazier Wilde, but especially the corporation itself, whose processes, as both magazines explained, shaped the building around its aims almost as if by immaculate conception. Regarding the architect, *Architectural Forum* elaborated: "When you look to find him, or his mark, in one particular spot, you find instead a view of the countryside, neatly framed, or if you stare down the long run of the large general office block, you don't see him there, but instead, diversions. ... Like the upstairs servants in an old manor house, this architect does not let himself get caught doing the job. ... The beds seem to make themselves."[47] Significantly, it is not just the architect that is rendered invisible, but also the labor process itself. This was a departure from architectural representations throughout the 1930s and 1940s, which stressed the heroic nature of labor — the subject, in fact, of many of Smith's earlier photo essays for *Life* magazine. Labor was now rendered invisible so that mutually reinforcing fantasies about beauty and leisure could emerge.

Such fantasies were showcased in countless magazine profiles. In the *Saturday Evening Post* (July 5, 1958), author Joe Alex Morris admits at the outset that his account is filled with "amusing legends," apocryphal tales that are "more fancy than fact."[48] One of these legends "concerns a young couple who met while both working for the company, got married and bought an old farmhouse almost within sight of the office." Pointing to a wide array of amenities and social spaces that were built directly into the central clerical block, he relates:

> They were so enchanted by their place of work that they decided to remodel their home along the same lines. Then, while the renovation was in progress, it was only natural that they moved into the office to live.
>
> They had three good meals a day at the snack bar or in the handsome cafeteria cantilevered over a big reflecting pool. They made use of the barbershop and the beauty shop. They availed themselves of the pick up service for laundry and dry cleaning. They purchased whatever they needed, from toothpaste to clothes, at the variety store. They played cards or read in the special lounges. Or in a more strenuous mood, they played shuffleboard or tennis or visited the twelve-alley bowling room. On weekends, they invited their friends and relatives to picnics on the company grounds. And at bedtime they retired to the infirmary. Life was so pleasant that, even after their new home was ready, they were reluctant to move in.[49]

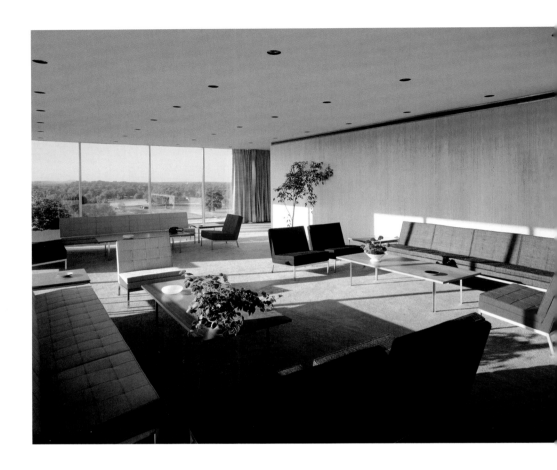

1.3

Knoll Planning Unit, Board of Directors' Conference
Room, Connecticut General Life Insurance
Company, *Arts & Architec*ture, March 1958,
© Ezra Stoller/Esto.

In *Architectural Forum*, this same tale is told in entirely visual terms in an aerial photograph, which juxtaposes the new headquarters in the foreground with the old farmhouse in the background. In this "enchanted" landscape, the Connecticut farmhouse, which presumably represents the eighteenth-century ideals of the American Revolution, is subsumed into the all-encompassing plan of the corporate headquarters, which represents the postwar administrative state.

Representations of the complex emphasized the disappearance of hierarchies, and appealed to fantasies of transcendence. In Stoller's photograph of the board of directors' conference room, which appeared in a 1957 advertisement for the Knoll Planning Unit (Knoll furnished the interiors), the executive suite becomes a democratic space devoid of hierarchical divisions. Stoller's oblique angle imparts a sense of depth and sweep, accentuating the conversation-piece placement of the furniture. The entire ensemble, including the unobstructed vista view through the glass window wall, suggests shared long-range objectives. Framed in the advertisement like a Cinemascope movie still, the boardroom becomes a cinematic stage set, a backdrop for both corporate power plays *and* domestic love scenes. The advertisement illustrates what Knoll calls "a new concept in boardroom planning." This new concept was that the boardroom looked like a living room. The tremendous success of the Knoll Planning Unit in the 1950s has been attributed to what the design historians Allen Tate and C. Ray Smith have described as "a deft manipulation of domestic scale for institutional spaces."[50] For male executives, the cinematic fantasy may have encompassed dreams of bureaucratic conquest; while for female employees it engendered fantasies of fashionability and social mobility.

Narratives of enchantment, fashionability, and sociability — Cinderella fantasies, makeover narratives — were deployed in the magazines to appeal directly to prospective female employees, as well as to homemakers, prospective Connecticut General insurance policy purchasers. In the *Saturday Evening Post*, one woman describes the transformation of a fellow female employee: "One girl who worked with me in town seemed to have very little interest in social or sports activities and almost literally had never been outside the state of Connecticut. We hadn't been in the new building six weeks before she was getting to know more people and taking part in the little theater. Now, of all things, she has just come back from a vacation trip to the West Indies and is taking tennis lessons from a professional. She looks and feels so different that I hardly recognized her as the same girl."[51] This was another legend, a parable of the pastoral power of the corporation to beautify the human body and soul.

Architectural Forum called this dynamic between the body, the soul, and the building "precision in pastoral." Like Versailles, Connecticut General was a closed system ("no cracks showing"), in which the repeated performance of ritualized behaviors (i.e., the processing of insurance policies in an assembly-line format) represented political and social perfection. At the Versailles of Louis XIV, life centered on the movements of the monarch's body through the social spaces of the court; "Life in General" (the title of Connecticut General's company newsletter), by contrast, revolved around the unending cycle of the corporation itself. Perfect geometries and standardizing ratios (everything was designed on a six-foot module), patterns in the design ("the patterns of rectangles – everything is rectangles – ranging from the minute to the mammoth"), and the reflection of those patterns in a multitudinous array of reflecting surfaces created an image of postwar America, in a para-disiac, beatific state. Free-span spaces with uninterrupted sight lines created a sense of endlessness, a fantasy of perpetuity, perpetual peace (another form of "pervasive beauty") – a life insurance company's calling card.

THE INVISIBLE ARCHITECT

In 1989, looking back over forty years, Bunshaft wonderfully described the mood of the moment, "optimism's zenith," and the courtlike corporate milieu of the immediate postwar years, where business executives, assuming a patronage role once exclusively ascribed to aristocrats, ushered in a new Golden Age:

> So in 1947, here you had these young men ready to go – a lot of them ready, a lot of them just getting into offices – and you had this boom of clients wanting to build buildings. It was easily more of a Golden Age than the Italian Renaissance with the Medicis. When I say clients, they were mostly corporations. The heads of them were men who wanted to build something that they'd be proud to have representing their company, whether it was a bank or whatever. In the corporations in those days, the head man was personally involved and personally building himself a palace for his people that would not only represent his company, but his personal plea-sure. They were the new Medicis, and there were many of them. The only thing that I find hard to explain, although I don't think it's too hard, is these people never questioned doing a modern building. There was never any selling of a modern building. I guess they wouldn't have come to us if there were. They would have gone to somebody else. I think the reason for that is that they wanted their company to be progressive.[52]

Bunshaft was one of those young men. Before going off to the war, where he served as an army engineer, he did "no real buildings."[53] It was only

after his return that he "was really primed to do something."[54] His place in the modern architectural canon was won, and still largely rests, on the handful of buildings he designed in the period from 1949 to 1960, including Manhattan House (1950) and Lever House (1952). When SOM received the commission for Connecticut General in 1953, it was entirely on the basis of these two recently completed buildings.

The son of Russian Jewish immigrants who grew up in Buffalo, New York, Bunshaft described himself as a shy, slow learner who finished high school at the age of nineteen and went to MIT because his childhood violin teacher had sent his two sons there.[55] His father, who had a wholesale egg business, lost most of his money in the stock market crash of 1929. Nevertheless, he bought Bunshaft a Chevy convertible in his sophomore year.[56] The pleasure Bunshaft takes in describing this car in an oral history conducted by the Art Institute of Chicago in 1989 is one clue to his early interest in design. When pressed, he speaks further about his early interest in construction, having spent his evenings and weekends in high school making his own furniture. Looking back on his education, Bunshaft never points to a specific set of foundational or transformational experiences. Between 1928 and 1934, the traditional Beaux-Arts training at MIT was rapidly giving way to the model of the European modernists, especially Le Corbusier.[57] But when Bunshaft saw Le Corbusier's buildings first-hand while on an MIT travel fellowship in 1935, he thought they were "peculiar," and was not terribly impressed: "We may have been in love with Le Corbusier, but we didn't really know what it was," he said; "all we knew was that it was simple and white and rectilinear and it had stilts."[58] Representations of Le Corbusier's early architecture in books made a stronger impression on Bunshaft than the buildings themselves. In recounting these early travels, he is frank about his relative indifference to the major figures of the day. He says he "knew very little about the Bauhaus" and "very little" about Walter Gropius.[59] While in Berlin, he "didn't pay much attention" when Albert Speer gave him a personal tour of the models for the 1936 Olympic Games and the master plan for Germania, the planned new capital.[60] He admits that he "had no awareness of anything special" happening in the atmosphere in Europe as the Nazis consolidated their power.[61]

He joined SOM in 1937, a year after the firm was founded, after short stints working for Edward Durell Stone and the industrial designer Raymond Loewy: Stone, who knew Skidmore, helped him get the job.[62] Based in Paris at the war's end, he visited Le Corbusier and gained a better appreciation of the master. He understood that Le Corbusier "wanted to be a Michelangelo" — what fascinates me about this statement is that it shows the degree to which Bunshaft's view of modernism was mitigated by his even greater love for the

Renaissance.[63] He saw Le Corbusier *vis-à-vis* the Renaissance rather than as an avant-gardist, and as an artist, like Michelangelo, whose architecture encompassed all of the arts. He repeatedly disavowed any notion of a radical, or risky, aesthetic in his own architecture, and credited his success to a "sort of logic, common sense," which served him well in the corporate milieu.[64]

Bunshaft's commonsense classicism was entirely in keeping with new humanist and new monumentality discourses of the immediate postwar years. Although he frowned upon any historical comparisons for his architecture, we can easily situate it in context. Lever House and Manhattan House, for instance, are contemporaneous with both Colin Rowe's essay "The Mathematics of the Ideal Villa" (1947) and Rudolf Wittkower's influential *Architectural Principles in the Age of Humanism* (1949). Did Bunshaft read these texts? Doubtful. But when he compares Le Corbusier to Michelangelo he makes the same case as Rowe, who broke with historians who located the theoretical foundations for Le Corbusier's early architecture in the work of French Revolutionary-era architects, and instead compared him to Palladio; Wittkower wrote of harmonic proportion and, like Rowe, reintroduced the principles of Alberti and Palladio.[65] Following Bunshaft's example, his biographer Carol Krinsky similarly repudiates ideological interpretations of his predilection for classical symmetry:

> For Bunshaft, modernism had nothing to do with political or economic ideology – a style in opposition to Hitler's classicism, or modernism as a means of corporate promotion. Philosophy, ideology, and theory never enter into Bunshaft's conversation now, either. If connections are there, they are coincidental, the result of someone else's interpretation. His interest lies in building well by embodying the virtues described by Vitruvius 2,000 years ago as utility, soundness, and beauty. ... Within the Vitruvian categories the important matters for Bunshaft are rationality (which must include consideration of a humane working environment), proportion, and the best use of carefully chosen materials.[66]

But: Bunshaft's affinity for Vitruvian categories, and his ability to mitigate the purely technological with a mirror-brilliant classicizing veneer rendered in a modern idiom, were key to his sense of singularity within the postwar corporate context; this ability is what distinguished him from the administrative partners at SOM. This is also the reason why his buildings are among the most elegant of the period: Bunshaft forged tangible connections between the classical language of architecture, the progressive modernism of the avant-gardes, and democratic ideals, all the while rendering himself "invisible." He put these historical allusions into play in the service

of American business, and thereby gave credence to Luce's claim that the United States was the heir to and guardian of the whole body of Western civilization in the postwar world.

THE GREATEST OPPORTUNITY ON EARTH

Giedion's other major contribution to the debate on monumentality was a link he made at the outset of his essay between monumentality and governmentality. Here is his essay's epigraph: *"Motto: Emotional training is necessary today. For whom? First of all for those who govern and administer the people."*[67] The need, in other words, was not necessarily for a new monumentality but, rather, a new emotional ground tone, a thoughtful reconsideration of the symbolic possibilities of monumental forms specifically as they related to the design of new systems of governance.

In the postwar American context, Luce took up this charge: *Fortune* existed to provide precisely this kind of emotional training. The Western Culture Project was connected to another project, also laid out in his 1948 memos, for the promotion of American business, called the American Enterprise Initiative, a kind of precursor to what would in our own time become known as "the ownership society," a new world of neoliberal governance that promoted ideals of liberty in entrepreneurship. *Fortune* translated complex ideas about liberal governance into terms the businessman and executive wife could easily understand. Freedom, for instance, became "the freedom to be enterprising," a catchphrase of American business in the 1950s.[68]

Luce's organization, moreover, became a feeder for government agencies. Eisenhower appointed to senior government posts men who worked in the top tier of Luce's organization. One notable example: C. D. Jackson, whom Blanche Cook Warren called "one of Henry Luce's leading apostles" and Walter Hixson called "the ultimate warrior of the Eisenhower team," joined Time Inc. in 1931, soon after graduating from Princeton.[69] From 1943 to 1945 he worked in the Office of Strategic Services, the precursor to the CIA, where he specialized in psychological warfare. After the war, he returned to Time Inc., where from 1945 to 1949 he served as managing director and publisher of *Fortune*. In the summer of 1952, Jackson was influential in helping to recruit Eisenhower to run for the presidency. Under the auspices of Time Inc., he led a series of conferences at Princeton University that brought businessmen and politicians together to discuss domestic and foreign policy plans that would in turn serve as the basis for the 1952 Republican Party platform; most of these ideas had in fact already been worked up in *Fortune*. Jackson wrote many of Eisenhower's campaign speeches. The Princeton

workshops, according to Walter Hixson, created "a political warfare blue-print for the conduct of the Cold War to be approved by Eisenhower in his first weeks in office," and indeed, in 1953 Eisenhower appointed Jackson first special assistant to the President on Cold War planning.[70] In 1960, after serving numerous roles in the administration, including as White House Chief of Staff, he returned to Time Inc. as the publisher of *Life*.

Russell Davenport, managing editor of *Fortune*, is less well known than Jackson, but more consequential for the development of corporate modern-ism. A classmate of Luce's and Hadden's at Yale, where he studied literature and philosophy, he joined them at *Time* in 1923, but left soon after to embark on a peripatetic journey that took him across the American continent, then to France, where he wrote poetry and a modernist novel, *Through Traffic* (1929). Returning to New York that same year, he joined Luce in his newest magazine, *Fortune*, and worked his way up the masthead to the position of managing editor.[71] These were the years of the Great Depression and the New Deal. In a climate highly antagonistic to big business, Davenport charted a middle course for the magazine, making the case for a liberated but reformed capitalism attentive to social welfare needs. Under Davenport's direction, *Fortune* investigated topics, many for the first time, that would go on to become touchstones of late-twentieth-century public policy debates, such as the healthcare and insurance industries, the quality and safety of air travel, the importance of public relations to corporate growth, and in-depth analyses of the inner workings of government agencies and labor unions as part the magazine's fundamental interest in how big organizations worked.

In 1939, he initiated a series of round-table talks at Time Inc. headquar-ters in New York, which again brought leading businessmen and politicians together to discuss public policy. It was there that he met Wendell Willkie, the corporate lawyer who became the Republican candidate in the 1940 presidential campaign, which focused as much on the fate of the New Deal as it did on America's possible entry into World War II. Willkie's campaign was launched when *Fortune* published a manifesto entitled "We the People" (April 1940) under his name, which Davenport had written. A summation of Davenport's years as managing editor, it was also an attempt to distill a coherent platform from these round-table talks. "We do not want a New Deal anymore. We want a New World," it declared. Davenport resigned his posi-tion to run Willkie's losing campaign.

In 1947, after returning from the war, Davenport set up another series of round-table talks — first at the University of Illinois, then at Time Inc. head-quarters in New York. In many ways, these round-tables revived the lost

cause of the 1940 presidential campaign, returning to that unfulfilled project with an even loftier goal in mind: to redefine the meaning of United States in the postwar world. Like the 1939 round-tables, the 1947 talks began by reexamining the founding documents of the United States, focusing particularly on the unalienable Rights of Man, the rights to life, liberty, and the pursuit of happiness in the Declaration of Independence. They went on to study the same set of public policy issues that had animated the earlier series of round-table talks. The outcome was another manifesto, "The Greatest Opportunity on Earth," published in *Fortune* in October 1949. The sum total of these round-tables (and the foundation for Jackson's conferences at Princeton in 1952), it was intended to be the defining document of a new American Revolution.

—

Connecticut General symbolized what Davenport, in this manifesto, called "an entirely new capitalistic adventure."[72] That a transparent, glass-walled building could represent ideas that went far beyond architectural modernism, encompassing New Deal and Cold War discourses, is a large part of its appeal for me today. The program put forward by *Fortune* throughout the 1930s and 1940s failed to capture the mainstream American imagination, or generate real cultural or political momentum, but the galvanizing experience of the war, the death of FDR, and disappointment with President Truman in the years following the war created an atmosphere receptive to other ideas. Davenport, working closely with Luce and C. D. Jackson, masterminded *Fortune*'s renewed sense of purpose and became a *de facto* architect (an intellectual architect) of the modern corporate campus.

In "The Greatest Opportunity on Earth," Davenport began by looking at the New Deal, but instead of decrying it as socialist and inherently un-American, as many Republicans did throughout the 1930s and 1940s, he took the possibility of the triumph of socialism in America seriously. He posed a number of fundamental questions: what was the appeal of the welfare state, was it part of a natural social evolution, and was there a way to satisfy the same demands without recourse to the authoritarian state?[73] He directed these questions not to politicians or to the general public, but to "enterprisers," businessmen, and posed them not as a dilemma, but as an opportunity to be "seized through clear thinking and bold action."[74] What he described was a realignment of business and government interests wherein the social aspects of the welfare state would be transferred to the corporation along with the enterprise initiative: as he later wrote in further explicating the

doctrine, it was *"the expansion of private initiative for social goals"* and "a new kind of social management."[75]

Davenport offered a novel interpretation of the unalienable rights of man as enumerated in the Declaration of Independence, "[entering] into their meaning in an open-minded way," he said.[76] He interpreted the right to liberty as a political right and the right to the pursuit of happiness as a spiritual right. His main innovation was to reinterpret the right to life as an economic right. At the time of the Revolution, it meant the right to go "unharmed unarmed," but violence no longer constituted the chief threat to life; that threat was now economic. The right to life was reinterpreted to mean "the right to earn a living," with the emphasis shifted from the security of personal property to job security.[77] *Fortune* called on businessmen to be political, to reclaim their economic right from the state and, in doing so, to make business autonomous, essentially dismantling the New Deal and ushering in an era of privatization: "to transfer the primary responsibility and therefore the initiative from government to private hands."[78] Corporations would in effect manage the rights to life, liberty, and the pursuit of happiness of their citizen-employees. Business would now assume "the heroic role" of running the modern administrative state.[79]

The goal was to turn socialism itself into a form of free-market sociability, what Davenport called "a way of life that can make material products worth while."[80] Assessing socialism's appeal, he wrote: "there is a demand for a social product," and business could create that product through "the humanization of industry," a designed environment that would endow citizen-employees with a sense of their worth.[81] Such a product, Davenport argued, "would at a single stroke cut though the socialist threat and open up a whole new vista of freedom."[82] It was, moreover, "a new solution for modern man, applicable not only in the U.S. but throughout the Western World."[83] Davenport was thinking in strikingly visual terms: the vista view through the glass curtain wall into the pastoral grounds of a corporate landscape was one of the most powerful images of the 1950s: W. Eugene Smith's photograph of the Connecticut General horizon and Ezra Stoller's photograph of the board of directors' conference room are in fact representations of Davenport's "whole new vista of freedom."

—

Bunshaft achieved this new kind of social design at Connecticut General, which included various social amenities built right into the clerical block: a mini-department store, a library, dry cleaners, a shoe repair shop, a beauty

parlor and barbershop, a walk-in medical facility, a dentist's office, locker rooms, club rooms with kitchens, lounges, an auditorium for dance, theater, and fashion shows, a bowling alley, and a meditation room. City and suburb, office and home, public and private intermeshed within the all-encompassing plan of Connecticut General. Such novelties would in and of themselves be "the talk of the town" (the title of a section in the *New Yorker*), but they also created an environment that encouraged socializing among employees. Employee gossip, in turn, generated narratives that Connecticut General could use in their advertising campaigns and their in-house newsletter, "Life in General."

Bunshaft had experimented with this "new kind of social product" in two earlier, now iconic projects: Manhattan House and Lever House. Manhattan House was developed by the New York Life Insurance Company as luxury housing for the mass market. It was situated at the juncture of two systems, "in knowing when to buy what and how to wear it against the backdrop of a surging consumer culture," as Herbert Muschamp once wrote.[84] In the realm of the luxury dwelling, this meant modern design features and postwar construction techniques combined with what in New York City real-estate parlance is known as "prewar" amenities: grand lobbies, palatial apartment configurations, often with six or seven rooms, working fireplaces, balconies, and living quarters for maids. Two circular driveways and an underground garage catered for the boom in car culture. Asked in his oral history if Manhattan House was "immediately desirable," Bunshaft answered: "You're goddam right."[85] Grace Kelly, whose father owned the company that manufactured the white bricks used on the façade, was an original tenant, as were Bunshaft and his wife, who moved there from Greenwich Village soon after the building was completed in 1950.

SOM was brought in specifically to provide a veneer of social chic. Built on the former storage site of one of New York City's most heavily trafficked elevated train lines, Manhattan House revitalized a neighborhood that had up to that time been on the margins of respectability. An older, established architectural firm, Mayer and Whittlesey, best known in New York for their twin-towered apartment building at 240 Central Park South (1941), had first pitched the idea of developing this site to the New York Life Insurance Company. According to Bunshaft, "The New York Life people ... weren't excited about their kind of architecture, and they asked SOM to see if we could work out a joint venture with Mayer and Whittlesey."[86] Bunshaft and his team ultimately devised the realized scheme: a Corbusier-inspired modernist slab spanning an entire city block between Second and Third Avenues and 65th

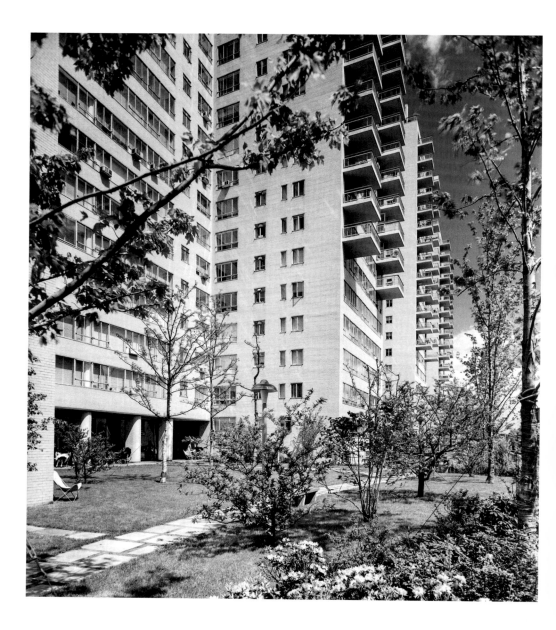

1.4

Gordon Bunshaft/Skidmore, Owings & Merrill,
Manhattan House, 1950, *Architectural Forum*,
July 1952, © Ezra Stoller/Esto.

and 66th Streets, rising twenty stories high, with ten wings, five each on the north and south sides.

Manhattan House looks back to the modernist slab blocks raised on pilotis, within parklike settings, that Le Corbusier first illustrated in his book on urbanism in 1925, as well as the residential redents of his Obus projects for Algiers from the 1930s and early 1940s, and the Unité d'Habitation in Marseille (1945). By widening the street, Bunshaft and his team set the building back in a small private garden. Despite the block's mammoth size, the building has a levity that come less from the glazed ground story than from the ten projecting wings and the long ribbon windows. Combined with the white-brick façade, these features effectively dematerialize the block. In the interplay of materials and recession and projection, we can already see the experimentation with visual transitions and patterning on a monumental scale, which Bunshaft would later orchestrate to different, even more nuanced, compositional effect at Connecticut General.

In one of the original publicity photos of Manhattan House published in *Architectural Forum* in July 1952, a stolid middle-class couple enjoys the view from their large terrace. Prominently displayed on their coffee table in the lower left-hand corner of the photograph is the sociologist David Riesman's best-selling book *The Lonely Crowd* (1950). Riesman was a professor of sociology at the University of Chicago, a member of the university's vaunted Committee on Social Thought, and wrote for the New York intellectual journal *Partisan Review*. The placement of the book in the photo is probably unintentional. But to return to Muschamp's point, it communicates that the residents of Manhattan House are in the vanguard of both cosmopolitan culture and intellectual thought: they may shop at Saks Fifth Avenue, but they *also* read the *Partisan Review*. A sociological critique of the new social types emerging in post-World War II American society, Riesman coined a number of *Zeitgeist* phrases. He argued, for instance, that in the "post-industrial" consumer society, in which "inner-directed" extended families working in the same trade had ceased to be the determining form of social organization, an "other-directed" individual emerged, whose identity was shaped by outside forces such as age group, peer group, and social class. He charts the rise of what he calls "false personalization," an excess of sociability encouraged by new lifestyle magazines, which, he believed, advocated too close a connection between styles of sociability at work and play.[87] "Enforced privatization," otherwise known as "the friendship market," inhibited the middle-class couple from expanding their friendships beyond a homogeneous peer group.[88] Surface sheen provided the psychological values attractive to the customer:

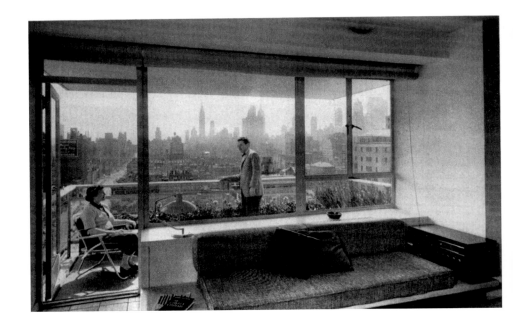

1.5

Manhattan House, *Architectural Forum*, July 1952.
In this photograph by Martin Helfer, notice
David Riesman's best-selling book *The Lonely Crowd*
(1950) on the side table in the foreground.

what he calls "supermarket institute values," namely, "the same traits we like in our friends ... cleanliness, up-to-date appearance."[89] In Riesman's terms, Manhattan House offered a form of "packaged sociability," or, to use Davenport's terms, "a way of life that made material products worth while."[90] What makes the appearance of Riesman's book in the publicity photo so ironic is that it is ultimately a critique of everything Manhattan House stands for.

Lever Brothers manufactured household and industrial cleaning products. Lever CEO Charles Luckman moved the company's headquarters from Chicago to New York in 1950, because, he later said, "the price one pays for soap is 89 percent advertising and the advertising agencies of America were there."[91] From the get-go, he wanted the new headquarters on a prominent site on Park Avenue to function like an advertisement. Lever's best-selling products had brand names such as "Lux Toilet Soap," "Silver Dust," Surf," and "Breeze": Lever House would wash across the surface of the sky like a wave of fresh water. Comprised of two slabs tightly wrapped in blue-green glass, set atop aluminum-covered pylons in a street-level plaza, the building's design was explicitly linked to Lever's cleaning products in a fantasy of individual and collective social transformation literally inscribed on a plaque on one of the pylons: "The mission of our company as William Hesketh Lever saw it is to make cleanliness commonplace, to lessen work for women, to foster health and contribute to personal attractiveness that life may be more enjoyable and rewarding for the people who use our products." The moral of the building is in fact a vague reformulation of the health-conscious modernist reform movements of the early and mid-1920s, linked now in the post-World War II American context to consumer products, and directed toward women. I call this the common sense of the glass curtain wall.

In his oral history, Bunshaft sets the record straight concerning the design of Lever House and Connecticut General, and at long last takes credit for them. With regard to Lever House, he explains how Owings, one of SOM's three founding partners, charmed Luckman and landed the commission. According to Bunshaft, Skidmore's noncontribution was a suggestion to include stores at the plaza level while the project was still in the model stage, a notion that Luckman vetoed, thereby rescuing the integrity of the original design. He gives credit to his design assistant, Manny Turano, who produced "beautiful drawings of the proportions and the mullion system and all that," and he shares credit with Bill Brown, the administrative partner on the project, who "headed up the research of being able to build a glass skin. ... It forced the glass industry to develop a spandrel glass and to find and get designed an outside window washer. That was the first real one that worked

in the world. Bill Brown, jointly with me, was the major person that handled the whole project."[92] In a typically roundabout way, he finally takes credit for the design.

Bunshaft depicts himself as the conduit through which the program put forward by the company was translated into architectural terms. They required a building for a thousand people, performing mostly clerical tasks, with specific departments grouped together on certain floors. Working within the zoning laws at the time, he and his team determined that the tower they wanted to build could occupy only twenty-five percent of the site. The placement of the tower slightly off-center was (despite his repeated disavowals) based on aesthetics: "We wanted to have some asymmetry."[93] With regard to the pilotis, a Corbusian motif, he simply said: "Of course, we wanted something new, so we put it on stilts." Looking back, he admitted that one "weakness of the scheme" was that it exposed "the side walls, the ugly stuff, and the empty space in between" the surrounding buildings. In fact, in 1955, in "Style and the International Style," a lecture at Barnard College, Philip Johnson criticized Lever House along these lines, pointing specifically to the irregularity of the spacing of the aluminum-clad columns in the plaza and the ugly fire stair.[94] Yet, at the time, the contrast between new and old served the purposes of Lever Brothers and SOM, as it dramatically amplified the building's impact, especially in photographs, and made the case for the modernity of both firms.

With its rippling ribbon windows, alternating daytime and nighttime façades, and expressive use of technological light to illuminate the building from inside out, Lever House draws more from Erich Mendelsohn's German department stores than it does from the playbooks of either Le Corbusier or Mies. As Kathleen James maintains in her study of Mendelsohn's architecture, his pioneering use of glass curtain wall construction and forms of lighting, derived from expressionist theater, heightened his architecture's fantasy function. James calls this "fantasy *as* function": buildings such as the Herpich Fur Shop in Berlin (1926) and Petersdorff department store in Breslau (1928) appealed to shoppers who could see themselves reflected in glazed glass façades, alongside the decked- out mannequins on display, inspiring reveries on fashion and movement.[95] Mendelsohn's dynamic functionalism, his buildings' immense curving corners, screen-like façades, and diffuse forms of lighting, had a cinematic quality that gave Berlin the look of a modern commercial metropolis (he also designed movie palaces, such as the *Universum* Cinema on the Kurfürstendamm). Upon its completion in 1952, Bunshaft's Lever House, which immediately became a backdrop for fashion spreads

in *Vogue* and *Harper's Bazaar*, and appeared in movies such as *The Best of Everything* (1959), engendered similar fantasies.

—

Davenport openly acknowledged the collectivist qualities inherent in the system he described, but if the three unalienable rights of "the American prospect," as he called it – life, liberty, and the pursuit of happiness, or economic, political, and spiritual – worked in harmony, they would create balance, which in this system became the hallmark of the good society, and of democracy. For Davenport, the strongest force countering the charge that this was just socialism with a happy face was the spiritual right embedded in the pursuit of happiness. Centered on the individual rather than the mass, this spiritual insight, as Davenport argued, was "an appeal to freedom beyond the law."[96]

In subsequent articles, Davenport and other lieutenants of Luce's magazine empire, as well as Luce himself, mapped out a moral history for American enterprise, focusing on the importance of the spiritual as it related to the economic. Their language became increasingly evangelical. No longer merely a pro-business agenda chipping away at the New Deal, the *Fortune* program became a full-blown "New Faith to combat the New Faith of communism," a crusade waged in economic-spiritual terms.[97] ("I will lead this crusade," Eisenhower said in his acceptance speech at the 1952 Republican Presidential convention.)[98] With the philosophical groundwork laid, *Fortune* turned its attention to the environmental factors that would transform employees into what Roscoe Pound, then the Dean of Harvard Law School, called "involuntary good Samaritans."[99] Luce brought the expansionist aims of the model into sharper focus when he prophesied "a vast Reformation in the world's way of earning a living."[100] "The economies of other countries must be linked with ours," he said; "great reforms must take place – somewhat in ours, mostly in theirs."[101] For John Knox Jessup, this business-government alliance presaged a "new federalism."[102] In the new commonwealth of corporations, he imagined, "individual citizens can work to produce wealth in harmony and to share rewards in a spirit of practical justice."[103] They were working up an image of a corporate rather than a Communist utopia, with ardent Christological overtones.

Those overtones came to the fore in *U.S.A.: The Permanent Revolution* (1951), a book that expanded upon these articles, authored by "the Editors of *Fortune* in collaboration with Russell Davenport." The radical nature of the experiment was made explicit in the title: the phrase "the permanent

revolution," as Davenport explains in the Introduction, was invented by Marx and brought to prominence by Trotsky. In full Cold Warrior mode, the editors of *Fortune* now attempted to rescue historical materialism from Marx. Communism was a godless ideology doomed to fail; the new American Revolution, by contrast, would succeed because it was rooted in the idea that "the human spirit, as revealed in Palestine by the founder of Christianity, is limitless."[104] The limitlessness of Christianity was explicitly linked to the limitless possibilities of free enterprise. Ultimately it is this limitlessness, I would argue, that is represented in the modular architectural plan and gorgeous faceted detailing at Connecticut General. What *Fortune* envisaged when it described "the good society within the corporation" was not merely a modern capitalist utopia where economic, political, and spiritual interests work in harmony to produce balance. Pushed to its ultimate ends, it was a vision of the Christian paradise itself, a reconstituted Garden of Eden.

Davenport died in 1954, but his most ambitious project appeared posthumously in 1955, when his notes from the *Fortune* round-tables of 1947 were published as a book entitled *The Dignity of Man*. In the ensuing years, under the auspices of the Ford Foundation, he had further worked up the ideas in "The Greatest Opportunity on Earth" and *U.S.A.: The Permanent Revolution* into a full-blown philosophy about the nature of the American spirit. He came to focus on the meaning of "pursuit of happiness" and the reasons why Jefferson had included it in the Declaration of Independence. While recognizing that the original meaning at the time of the "Pilgrim fathers" was inward-looking, Davenport wrote: "the idea of happiness that characterized Jefferson's time placed a far heavier accent on external blessings."[105] By the mid-twentieth century, following the Industrial Revolution and the age of the robber barons, he concluded, "the leading characteristic of American society is the externalization of human energies and human values."[106] He identified as a peculiarly American "moral challenge" and "philosophical trap" the denial of "the existence of an inner world, as distinct from an outer or environmental world."[107] Even the philosophical optimist, he argued, the one who searched for happiness in a private inner world, would have to admit that "the real values of life … are the outer ones after all, that can be measured, weighed, handled, and compared, without reference to the uncertainties of the individual psyche."[108] Herein, again, lies the supreme importance of architecture in the program laid out by *Fortune*: it reconciled these two things, the inner world of man and the outer environmental world of material richness.

GOVERNMENT UNDER GLASS

Government under glass was good government. The allegorical meanings of corporate modern architecture can often be found directly in magazine advertisements. "Government under glass" was actually a slogan used by the Pittsburgh Plate Glass Company to market their line of Spandrelite colored-glass window wall panels. There was a California company named Arcadia that mass-produced window walls for government buildings. In one of their advertisements a sheet of glass seen in cross-section hangs suspended in midair while the word Arcadia, the letters alternately colored red and blue on the white page (signaling American democratic ideals), floats through the pane. Significantly, the building on view in the advertisement is an elementary school. In a small side illustration a group of children can be seen inside the school, working beside the window wall. The window wall thus had the power to indoctrinate the tenets of the New Faith, to convert nonbelievers, to transform vision.

In his AIA speech, Luce spoke of transparency as "cheerful" and "welcoming," but in the Cold War context it had a sinister connotation as well. The window wall communicated a Cold War metaphysic. As a tensile structure, it embodied the "balance of terror," the nuclear standoff between the United States and the Soviet Union. It was an allegorical fault line in a game of "brinkmanship." The window wall reflected the conflicted duality of American foreign policy in the Cold War. On one side there was "containment," and on the other "the liberation concept." Containment was a policy intended to put barriers in the path of Communism, but government under glass cast the United States as a container inside of which there was "a way of life" (Davenport's words) to be protected, and intelligence that had to be sealed off from the world. But the window wall simultaneously had to serve as a shining beacon of the glories of liberated capitalism ("the liberation concept") to the outside world.

In its description of the four courtyards in Connecticut General's clerical block, *Architectural Forum* points to a concept with interesting interpretative possibilities: "Inside the inside." This is an apt metaphor for the organizations within organizations established by the National Security Act of 1947, which unified the military under a Department of Defense and created the CIA and the National Security Council. In going "inside the inside" at Connecticut General, *Architectural Forum* paints a serene picture of carefully composed see-through spaces, yet the concept could also easily provoke other sensations: agency panic, claustrophobia, and vertigo, cornerstones of conspiracy narratives, which became a staple of American culture in the 1950s and reached fever pitch in the 1970s.

Containment and the liberation concept were at the core of Eisenhower's New Look military doctrine, outlined in NSC 162/2 in 1953.[109] In speeches regularly published as articles in *Life* magazine, Secretary of State John Foster Dulles (a friend and ally of Luce) forged the political aesthetic that would dominate the public imagination for at least a decade. "The sword of Damocles remains suspended," he wrote in 1954, evoking the ancient world while describing modern military strategy.[110] Luce's friendship with Dulles had been forged in the 1930s and 1940s out of their mutual frustrations with FDR's administration. Like Luce, Dulles was the son of a Presbyterian minister, and both men had grown up mostly abroad: Luce in China, Dulles in Europe. Dulles came to national prominence during the 1944 presidential campaign, when Luce endorsed him in *Life* as a candidate for Secretary of State in a possible Thomas Dewey administration. In May 1952, *Life* published Dulles's foreign policy manifesto, "A Policy of Boldness," which called for an end to containment and the implementation of a military strategy based on nuclear supremacy and the threat of massive retaliation, combined with a diplomatic strategy that countered Soviet propaganda with a messianic appeal to people's yearnings for economic freedom and spiritual transcendence: this was the liberation concept – a distortion, to be sure, of Jaspers's new humanism.

This was the doctrine that C. Wright Mills, professor of sociology at Columbia University, railed against in his influential studies *The Power Elite* (1956) and *The Causes of World War Three* (1958). In features such as "The Military Businessman," *Fortune* advocated a return to elite leadership in profiles of high-ranking army officers stepping back into the business world and bringing their newfound operational expertise to bear on the reorganization of corporate institutions. General MacArthur, the new chairman of the Rand Corporation, was portrayed as a counterpart to Eisenhower (the general turned president) in the realm of business rather than government.[111] "This system is now a political economy intricately linked with a military order central to politics and crucial to moneymaking," Mills wrote, critiquing the paradigm.[112]

In *The Causes of World War Three*, an aphoristic, impassioned polemic, Mills defines the political aesthetic primarily as a military aesthetic and sums it up in the concept of "thrust": the rush to the brink, a metaphysic of violence.[113] The lack of an established civil service created a vacuum filled by military personnel returning first from World War II and then the Korean War. Mills called it a "civilian default of political power."[114] The military, uninterested in partisan politics, had its own agenda, he explained, which was the enlargement of the military establishment. In a militarist society, Mills further argued,

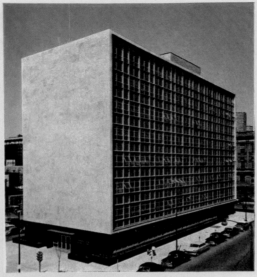

Architects:
King & King,
Syracuse, New York

Contractor:
W. E. O'Neil,
Construction Co.,
Chicago, Illinois

Government under glass

This is the Onondaga County Office Building, Syracuse, New York. The main elevations of this impressive structure are draped in blue-green polished SPANDRELITE® — beautiful *glass in color* — while the ends of the building are faced with white marble. The window areas are glazed with SOLEX® Heat-Absorbing Plate Glass.

Why SPANDRELITE
for curtain-wall construction?

SPANDRELITE is heat-strengthened glass with ceramic color fused to the back — specifically designed for the curtain-wall spandrel. SPANDRELITE is *strong*—it withstands impact and a wide range of temperature variations; SPANDRELITE is *durable*—it resists corrosion and severe weather conditions, is non-porous and non-absorbent; SPANDRELITE is economical—it is installed and maintained the same as ordinary glass.

SPANDRELITE is available in a caravan of eighteen standard colors, *plus* a vast range of custom colors. And, what's more, SPANDRELITE may be obtained in two finishes: *twill* and *polished*.

In sum, SPANDRELITE combines color with the time-eternal qualities of glass providing a structural material adaptable to almost any design.

Our Architectural Representative near you will be glad to assist you with your curtain-wall problems, without obligation on your part. Meanwhile, why not fill in and return the coupon for our free, four-color booklet?

Other Pittsburgh Glass Products used in this building include: PITTCO® Deluxe; HERCULITE®; TUBELITE® Doors and Frames; PENNVERNON® Window Glass.

SPANDRELITE
glass in color

PAINTS · GLASS · CHEMICALS · BRUSHES · PLASTICS · FIBER GLASS

PITTSBURGH PLATE GLASS COMPANY

IN CANADA: CANADIAN PITTSBURGH INDUSTRIES LIMITED

Pittsburgh Plate Glass Company
Room 9109, 632 Fort Duquesne Blvd.
Pittsburgh 22, Pa.

Please send me your full-color booklet on Pittsburgh Glass-Clad Curtain-Wall Systems reprinted from Section 3E of the 1959 Sweet's Architectural File.

Name ...

Address

City Zone

State ...

1.6

"Government under Glass," Pittsburgh Plate
Glass Company, *Architectural Forum*,
January 1959.

The Cult of Immaculate Form

morality is transformed (deformed, one could say) into morale, an essential component for the conduct of war (morale for the troops).[115] According to Mills, this transformation of morality into morale was occurring in the bottom tier of the power structure of postwar society: the masses.

There was a strange duality of morality at play in the national discourse. On the one hand, there was the morality of the elite, men like Luce and Dulles, with their moralizing messianic rhetoric of economic and spiritual crusades in the realms of domestic and foreign policy. On the other there was a lack, according to Mills, of a moral dimension on the part of the general populace: "the key moral fact about it is the virtual absence within ourselves of opposition to the definition of world reality."[116] On the one hand, Mills was genuinely astonished at the lack of moral outrage on the part of the public, but on the other he knew that the rise of elites was inextricably linked to the depoliticization of the masses. Politics was more pervasive (to use Luce's term) than ever, but inattention to politics was equally pervasive: "They are not radical, not liberal, not conservative, not reactionary. They are inactionary. They are out of it," Mills wrote, describing the public.[117] The corporate modern paradigm propagated in *Fortune* encouraged this state of being—recall the "amusing legend" recounted by Joe Alex Morris in the *Saturday Evening Post* of the young married couple who take up residence inside the Connecticut General headquarters and live there as if in a perpetual daze.

Mills located the origins of the public's unresponsiveness to acts of political immorality in their experience of World War II, in their presumption that moral atrocity and moral horror were now facts of life in a world transformed by totalitarianism: "the turning of this atrocity and this horror into morally approved conventions of feeling" leading to "the incapacity for moral reaction."[118] The transformation of people into spectators, he argued, was at the heart of their inability to properly react: "Man had become an object," he wrote; "in the expanded world of mechanically vivified communication the individual becomes the spectator of everything and the human witness of nothing."[119] Not only did this account for the growing complacency of the American public, it also summed up an essential difference between the American and European experiences of war: while Europe had ostensibly become a continent of witnesses, America had become a continent of spectators.

Was corporate modern architecture complicit in facilitating what Mills called "moral insensibility"? One could argue that "government under glass" concealed moral atrocity with the "window wall by Arcadia," which purged, purified, and transfixed. Despite the jolts of artistic countercultural movements

and oppositional voices of the period, such as abstract expressionism, the beat poets, folk music, the nascent civil rights movement, experimental cinema, film noir, the music of John Cage, the ecological thought of Rachel Carson, and the psychology of Erich Fromm, the widespread illusions cast by the window wall would not be shattered for good until the explosive civil rights riots of the late 1960s and nationwide opposition to the Vietnam War.

Mills offered himself up as a witness to what was happening in the United States. He concluded his polemic with a series of short essays entitled "Guidelines." These comprise a revolution different from "the permanent revolution" advocated by Davenport and the men of *Fortune*. Mills called for the awakening of the masses from their moral slumber, the imposition of restraints on the free market, and an American-led disarmament of weapons of all kinds from the world: "what the United States ought to do is abandon the military metaphysic and the doctrinaire idea of capitalism and, in the reasonableness thus gained, reconsider the terms of the world encounter."[120] There was, of course, no chance of this happening. In spite of his fame (mostly posthumous), Mills was branded a hysteric by commentators and scholars on both left and right for *The Causes of World War Three* and for his political pamphlet of 1960, *Listen, Yankee: The Revolution in Cuba*.

THE CORPORATION WIFE

Pervasive beauty found expression in a fixed ideal of female beauty. This ideal was part of the American Enterprise Initiative mapped out in *Fortune*. "The corporation wife" was recognized by business leaders as "the power behind the scenes," a new social type that warranted cultivation and study. In October 1951, as part of the same series of articles that began with Davenport's "The Greatest Opportunity on Earth," the sociologist William Whyte reported on "The Wives of Management." The corporation wife, according to Whyte, was "(1) highly adaptable, (2) highly gregarious, (3) realized her husband belonged to the corporation."[121] She was a "stabilizer," who mitigated the stresses of the office by cultivating a calming domestic environment. She was well versed in "the rules of the game," such as maintaining an attractive appearance, avoiding pernicious gossip, and having efficacious timing without seeming officious, especially with "superiors in rank." The corporation wife was part of the system of administration. She had a managerial role. It was her responsibility to manage her husband's as well as her own professional and social ambitions. A wife's desire for greater social rank or voracious appetite for more luxurious material goods at a pace ahead of her husband's position and salary could spell their downfall (the Madame Bovary

effect). Likewise, she was encouraged to recognize when his ambitions out-paced his skills, and to keep him on a proper path. The wife of management was something of an impossible construct: she was a mid-century modern mechanical doll suspended between office and home, both an active "social operator" and a passive presence, treading a very fine line in order not to become "a meddler," "a climber," or a pushy harridan.

The female body became the locus of a new kind of formal fantasy. The *New Yorker* critic Lewis Mumford pointed to it when he described Manhattan House's glass and white-brick façade in feminine terms as "chaste, elegant, entirely in the contemporary mode."[122] The architecture transformed a formerly industrial, smoke-filled, and derelict neighborhood into a sanitized, fashionable locale by cleaning it up, thereby rendering it "chaste." In a similar way, after the equalizing economic years of the Great Depression and the Rosie the Riveter iconography of the war effort, the female body was tidied up, squared away, straightened up. The new woman of the 1920s wore loose-fitting garments that allowed her body to move easily, even ecstatically. The notorious flapper, so filled with joy, so revved up by the mechanical power of the modern city, couldn't help but spontaneously burst into dance. She moved from uptown to downtown and from high culture to low culture and back again in the space of a single night. In the 1950s, by contrast, the fantasy moved in only one direction – up, as in upward mobility – and the preferred posture was rigid and severe.

In April and June 1952, Lever House appeared in *Vogue* and *Harper's Bazaar*, respectively, in the fashion editorials "Key to the City" and "The Time Has Come for Black." Models with pinched, cinched waists, all sharp points and metallic cosmetic enchantments, are set off against the building's aluminum-clad pilotis. They form beautiful still-life ensembles. The fantasy they engender is one of stability and respectability. Like the ladies of leisure on the cover of the February 1955 issue of *Harper's Bazaar,* these Lever House models represent "the well-spent dollar" and "a sound money's worth." One woman is a reflecting surface for the other, mirroring an ideal of thinness and weightlessness. In their meticulously tailored tweed suits, the *Bazaar* cover models, like Lever House itself, symbolize a perfect economy of form set against a backdrop that serves to further accentuate their attenuated and suspended silhouettes.

Building trade advertisements routinely equated rituals of feminine adornment with the beauty of mass-produced building products, such as glass curtain wall systems. In my favorite of the genre, a woman is poised on a cushioned stool in front of a wall-length mirror in a public restroom. She is the archetype of 1950s womanhood, a Kay Kendall-like figure provocatively

dressed in an off-the-shoulder, open-backed dress that tapers to a sharp point at her waist. Her face is radiant but vacant as she gazes at herself in the mirror. Her body pivots, one leg back, the other forward, while her arms are extended at a ninety-degree angle as she reaches to adjust a dangling earring.

What, exactly, is being advertised? The text reads:

> Mirror, mirror on the wall ... the choice of toilet compartments reflects the good judgment of the architect and builder, as well as the owner's concern for the opinion of building occupants. When Sanymetal compartments are specified, there is no question that the installation will be attractive, that it will last the life of the building, and that maintenance costs will be at a minimum. Whether you are looking for design and beauty, or engineering and quality of construction for savings, Sanymetal is fairest of all.

There is no question that this fantasy woman is symbolic of the good judgment of the architect and builder, the attractive installation, and minimal maintenance: she is depicted performing an act of self-maintenance. Reflected in the mirror is a symphony of modular systems: the modular toilet partitions that are in fact the actual subject of the advertisement, the floor and ceiling tiles, the tissue box, and the decorative diamond-pattern wall hanging. The ideal of pervasive beauty was modular, transparent (not only the mirror, but also her chiffon scarf), sharp (the diamonds, her extended arm, her waist and open V-backed dress, her shoes, the gloves), suspended (the partitions, the woman herself), and fixed (her arrested motion and frozen smile).

The image of a woman looking at herself in a mirror performing an act of self-maintenance became a pervasive cultural trope in 1950s America. Just one iconic example: in Jean Negulesco's Cinemascope masterpiece *How to Marry a Millionaire*, Marilyn Monroe assumes a *contrapposto* pose and coos at herself in a four-way mirror as she lifts her arm to fix her décolletage. Scenes of Monroe, Betty Grable, and Lauren Bacall at their toilette before embarking on their dates are repeated throughout the film. The point is that such images functioned as allegories of the self-sustaining corporate Arcadia: the corporation wife was a living embodiment of economic, political, and spiritual equipoise, a reflection (hence the importance of the mirrors in these images) of the new system of corporate administration.

1.7 (following pages)

"The Time Has Come for Black," *Harper's Bazaar*,
June 1952, photographs by Karen Radkai.

80

The Time Has
Come for Black

● Opposite: Two black silks. Left—that fundamental ⟶ black to put on any time, put anything on. Christian Dior hat. At the right—another to depend on, this with the specialties of the season, a big bow, side fullness. Both, by Aywon, in Maxwell Textile silk. Each, about $40. Both, at Best's; Joske's, San Antonio; Joseph Magnin. Crescendoe gloves. ● Below: Black velveteen, a coat dress that has a low neckline with a fencer's collar that stands away and a skirt with the fullness pushed to the sides. By Kane Weill, in Merrimack velveteen. About $70. At Best's; I. Magnin; Neiman-Marcus. The dubonnet velvet turban, by Christian Dior.

KAREN RADKAI

KAREN RADKAI

The Cult of Immaculate Form

1.8

"The Well-Spent Dollar," *Harper's Bazaar,* February
1955, cover photograph by Richard Avedon,
© The Richard Avedon Foundation.

The public display of feminine toilette rituals, especially the application of cosmetics, has served as an allegory of civilization going all the way back to antiquity, most famously in the Egyptian profile portrait bust of Queen Nefertiti. The history of European painting from the Renaissance through the nineteenth century is chockablock with these kinds of mirror images. For example, we could interpret the Sanymetal advertisement as the modern American equivalent of François Boucher's portrait of *Madame de Pompadour at Her Toilette* (1756). The art historian Melissa Hyde has shown how this portrait functioned as a multivalent allegory communicating ideas about art, beauty, fashion, gender, identity, sexuality, and the role of pictures at court. Pompadour is depicted in the act of rouging her cheeks. Hyde argues that due to "the analogies it posits between cosmetics and paint," specifically between Pompadour's suspended rouge brush, which is about to touch her face, and Boucher's unseen but imagined painter's brush, similarly suspended and about to touch the canvas, the painting renders the "conceptual ideal of pictorial practice" as feminine, "in which painting was figured metaphorically as Woman."[123] In the Sanymetal advertisement, architecture and industrial design assume the place once occupied by painting in courtly cultural discourses, and are similarly figured metaphorically as Woman.

Competition between companies that mass-produced glass curtain wall systems was in fact driven by the market's fixation on complexion beauty. The glass curtain wall was porous like skin, a membrane that expanded and contracted, and had to be treated with the architectural equivalent of cosmetics. Speaking of Lever House, Bunshaft later said that "the main point" was "the thin skin."[124] In May 1957, *Architectural Review* cataloged "the chief drawbacks" of curtain wall construction, and first among them were "the complexities involved in making allowances for expansion and contraction, weather proofing of joints and the experimental nature of some of the in-fill panels used."[125] There were various types of curtain walls – sheath versus grid, mullion versus spandrel types – and various kinds of cosmetics, such as welded versus chemically bonded seals to lock the mullions and spandrels in place. "Cosmetic lather is the secret," reads a 1956 Lever Brothers advertisement starring manufactured movie star Kim Novak. "New Lux lather has a beneficial cosmetic action ... actually helps your skin maintain balance. It's moisture balance, you know, that helps you keep your complexion fresh and glowing." The advertisement makes subliminal connections between the female face and the glazed wall. In either case the desired overall effect is the same: seamlessness, flushness, a technologically enhanced smooth surface.

The following text appears within the advertisement image:

Mirror...
Mirror...
on the wall

The choice of toilet compartments reflects the good judgment of architect and builder, as well as the owner's concern for the opinion of building occupants. When Sanymetal compartments are specified, there is no question that the installation will be attractive, that it will last the life of the building, and that maintenance costs will be at a minimum. Whether you are looking for design and beauty, or engineering and quality construction for savings, Sanymetal is fairest to all.

See Sweet's, or write for Sanymetal Catalog 95 (For Sanymetal representatives in most cities, look in the Yellow Pages under PARTITIONS).

LOOK FOR THIS

NAMEPLATE WHICH IDENTIFIES EVERY SANYMETAL INSTALLATION.

Sanymetal

PRODUCTS COMPANY, INC.
1687 Urbana Road, Cleveland 12, Ohio
In Canada: Westeel Products Ltd., Montreal, Toronto, Winnipeg

1.9

"Mirror, Mirror on the Wall," Sanymetal Products Company, *Architectural Forum*, January 1959, courtesy of Sanymetal.

1.10

François Boucher, *Jeanne-Antoinette Poisson,*
Marquise de Pompadour, 1750, with later additions,
oil on canvas, Harvard Art Museums/Fogg Museum,
Bequest of Charles E. Dunlap, 1966.47, Photo:
Imaging Department, © President and Fellows of
Harvard College.

The Cult of Immaculate Form

To him you're just as lovely as a movie star

As far as he's concerned—there's no one else quite as wonderful, quite as lovely as you! And to look your most attractive *always*, be sure your complexion is as fresh and glowing as Kim Novak's. Miss Novak, like 9 out of 10 Hollywood stars, uses new Lux every day... and regular Lux care can do as much for your skin as it does for hers.

Cosmetic lather is the secret

New Lux lather has a beneficial cosmetic action on your complexion... actually helps your skin maintain the proper moisture balance. It's moisture balance, you know, that helps keep your complexion fresh and glowing.

For the best results, use new Lux this way every day. First, massage the rich, creamy *cosmetic* lather into your skin gently. Rinse with warm, then cool water, and pat dry. The Hollywood stars find new Lux care wonderful —and we think you will, too!

New Lux is sealed in Gold Foil

... to protect its *cosmetic* lather, dazzling whiteness, wonderful fragrance. Only new Lux gives you both *cosmetic* lather and new Reynolds gold foil protection. You don't have to be a movie star to have a movie star's complexion—that's the beauty of new Lux in Gold Foil!

Kim Novak
starring in
"THE EDDY DUCHIN STORY"
A Columbia Picture in CinemaScope
COLOR BY TECHNICOLOR

1.11

"To him you're just as lovely as a movie star,"
 Lever Brothers, 1956.

The pressures incumbent on the corporation wife became in the 1950s a primary source of melodramatic narratives – sometimes masked as social comedy, sometimes as drama, and sometimes as film noir. In *A Woman's World* (1954), for example, Jean Negulesco's follow-up to *How to Marry a Millionaire*, the corporate world is revealed to be the domain of power-hungry, social-climbing, nervous wives. Three automobile executives are invited with their wives to their boss's country estate in the suburbs of Manhattan for a weekend. All three men are competing for the same promotion, and their various social interactions over the course of the weekend serve as a joint interview. The three couples, from the Midwest, Texas, and Philadelphia, represent a cross-section of American sensibilities. The social setting brings into sharp focus the strains of corporatism: each man is forced to confront his ambition as an executive, each woman her ambition as a wife, and each couple their idea of marriage and family life. In the climactic scene, the avaricious Texas wife offers herself to the boss in exchange for her husband getting the promotion. He rejects her, and when her husband finds out, he leaves her. In the end, he gets the job because, according to the boss, he had the "courage to get rid of his handicap," namely his wife. It is a chillingly misogynist message, but one in keeping with the perils described by Whyte in his seriocomic analysis of the wives of management.

In Fielder Cook's *Patterns* (1956), based on a play by Rod Sterling, a brittle young executive wife (wonderfully played by Beatrice Straight, who made a specialty of this kind of role) slyly plots to get her husband a promotion over a much older, more experienced company man, who kills himself as a result. Ashamed of his wife's schemes and his own ambition, he resigns, but in a twist ending his boss admires his integrity and offers him an even higher-level promotion. He ultimately compromises his moral ideals and accepts the position. In Gerd Oswald's film noir *Crime of Passion* (1957), Barbara Stanwyck plays a successful San Francisco journalist who gives up her career to become the Los Angeles housewife of a midlevel police detective. Frustrated by his lack of ambition, and her own diminished social standing, she plots to push him up the police ladder by having an affair with his superior officer, whom she kills in a crime of passion. Her husband solves the crime and arrests her, restoring social and marital order.

At the start of Negulesco's *The Best of Everything* (1959), the camera glides through the empty offices of Fabian Publishing, on the penthouse floor of the newly completed Seagram Building, before the working day starts. Glinting in the dim early-morning light, the office is a pastel-hued fantasia of

mid-century modern furniture, patterned cubicles, and corner offices. The perfect stillness of this tableau is disrupted by the arrival of the secretarial pool, which tumbles out of the elevators and bursts through the office's glass doors. In an iconic image that would later be appropriated by Cindy Sherman for her series of film stills, Hope Lange, playing aspiring career girl Caroline Bender, looks up at the Seagram Building, with Lever House in the background, while holding the classified listing for her prospective job at Fabian Publishing.

On the one hand, the building represents the "the best of everything," but on the other it functions as an ominous totem foreshadowing the tragic fates of the film's three main protagonists. Repeatedly, and especially at climactic moments, the three young women at the center of the story look up at the Seagram Building from the corner of Park Avenue and 52nd Street yearningly, as the embodiment of all their aspirations to upward mobility, but in these Cinemascope views the building also appears as a totally opaque black-and-bronze patterned screen, a symbol of the inscrutable corporate world they inhabit.

Recent graduates of the best women's colleges, they are fresh-faced and hopelessly naïve. Gregg Adams, played by the 1950s supermodel Suzy Parker, aspires to be a Broadway actress, while April Morrison, played by Diane Baker, will end up a doctor's wife. Over the course of the film the women will have all their illusions shattered. Gregg gets caught up in a sado-masochistic affair with a ruthless director, aptly named David Savage; succumbing to a nervous breakdown, she falls (or jumps, it's unclear) from his fire escape to her death. Caroline's suave college fiancé cavalierly runs off with another woman, who comes from a wealthier family; she finds a soul mate in Mike Rice, a cynical alcoholic senior editor. As Caroline makes her own way up the corporate ladder, she compromises both her femininity and her humanity (as the film progresses, her loose blonde hair will be swept into a tight chignon, while her girlish dresses and hats will be replaced by tailored business suits and sophisticated veils). A playboy named Dexter Key seduces April, the most vulnerable of the three: when she gets pregnant he insists she have an abortion, but she loses the baby when she jumps from his car in despair. In a subplot, a successful editor, Amanda Farrow, played with arch intonations by Joan Crawford (who easily walks off with the film), lives a glamorous city life in a beautiful modern apartment in a building just like Manhattan House, where she hosts elegant dinner parties for a bohemian crowd; but she quickly reveals herself to be jealous of the girls' youth, beauty, and marriage prospects. Unhappy in an affair with the married publisher (who

sexually harasses April), she abruptly quits to move out west as a mail-order bride to a widowed rancher, but when that arrangement quickly fails she returns to resume her career in her corner office. In the end, as Caroline and Mike leave the Fabian offices arm in arm, with the Seagram Building looming above and the melancholy Johnny Mercer title track in the air, the promise of the best of everything is revealed to be a farce.

These and other 1950s narratives of corporate disenchantment feature people who come up against the soul-destroying perfectionism of pure administration. These characters, for one reason or another, cannot be made to disappear into "the supports of the frame." They reveal what was really "inside the inside" of corporate modern "mirror buildings." Chasteness existed in tension with its opposite: defilement. The women in these films are riven by sexual drives. Disheartened by the small daily betrayals of the corporate mindset, they are not happy, harmonious consumers of the material products that make life worthwhile. Whiteness existed in tension with its opposite, blackness: *Brown v. Board of Education*, Eisenhower sending troops to Little Rock to enforce the Supreme Court ruling on the desegregation of schools, the march in Selma: these were also mirror images concealed by window walls by Arcadia.

THE POLITICS OF PASTORALIZATION

In May 1958, Bunshaft's Manhattan House apartment was profiled in *Contract Interiors* magazine, described as a space where "an architect and his wife live among beautiful possessions in a chaste setting." The headline recalls Mumford's description of Manhattan House as "chaste, elegant," in the *New Yorker* seven years before. This profile of Bunshaft and his wife is another corporate parable, akin to the contemporaneous legends related in the *Saturday Evening Post*. Another enchanted landscape, the postwar modern luxury apartment in New York had the power to render art immaculate. The fantasy here has less to do with the human body, and everything to do with art: Bunshaft and his wife are depicted as beneficent custodians of an "extensive, eclectic collection" spanning the historical spectrum from "Etruscan antiquity" to "a Saarinen chair": "On the wall are two Légers; on the cabinet, a Giacometti bronze, a tiny Gallo-Roman bronze, a pre-Columbian terracotta female, and a little figure from Cyprus ... paintings by Afro, Miró, Nicholson, Dubuffet, and Picasso; sculpture by Bertoia, Calder, Modigliani and unknown artists of Chinese, Japanese, Mexican, African, and Etruscan antiquity – sparkle among furnishings that are in themselves works of art, and were collected in somewhat the same fashion."[126] The point is that

Bunshaft's collection is encyclopedic. It forges new relations between Old World and New World cultures.

Echoing *Architectural Forum*'s descriptions of Connecticut General, *Contract Interiors* stresses the seamless slick surfaces in Bunshaft's apartment, and the custom-made furniture he designed for his living and dining rooms. For example, a long stainless steel, black Formica, and Carrara marble divider cabinet designed by Bunshaft and produced by the company Custom Bronze is described as being "welded into one piece to eliminate even such minor flaws as hairline joints ... and all surfaces are so accurately flush that the word gains a whole new meaning."[127] The finish on the cabinet is "so fine — it is polished stainless, not chrome — that it completely obliterates the joint between the panel and the upright supports of the frame."[128]

The art, too, displayed in this custom-designed setting is devoid of flaws, i.e., its former ideological and ritual significance is "completely obliterated." Emptying art, and especially modern art, of its social and political import as part of a formalist mode of interpretation was by this time standard operating procedure at the Museum of Modern Art. But connected to the corporate cosmology mapped out in *Fortune*, with its overt Christological associations, the *Contract Interiors* description of Bunshaft's apartment, and especially the display of art, points to something even more extreme: I call it "the cult of immaculate form" and "the politics of pastoralization."

—

Purification through pastoralization was a form of global denazification and an article of the New Faith: faith in democracy. As European civilization went up in flames, American leaders debated what role the United States should play in postwar reconstruction campaigns. In 1943, postwar planning was already under way. Roosevelt's cabinet secretaries circulated competing plans for a "suggested post-surrender program for Germany."[129] The plan put forward by Henry Morgenthau Jr., Secretary of the Treasury, was the most punitive, but also the most imaginative from a historico-mythological perspective. With the aim of eliminating Germany's potential to wage war forever, he proposed "converting Germany into a country primarily agricultural and pastoral in character."[130] According to this plan, Germany would be deindustrialized, demilitarized, and dismembered, with large swaths of land ceded to Poland, France, and Russia and the remaining portion broken up into small territories where people would be encouraged to engage in subsistence farming. Morgenthau (like Jaspers, who would express similar sentiments three years later in his book on guilt) held the entire German

nation responsible for the war, but believed it could be redeemed through a process of near-total pastoralization. This was not a viable foreign policy, but it was an awesome concept that exerted a powerful pull on the American imagination.

In the internecine battles of Roosevelt's wartime cabinet, rival secretaries pushing their own agendas condemned Morgenthau's plan on economic and humanitarian grounds. Henry Stimson, the Secretary of War, persuasively countered that a deindustrialized Germany could never pay the reparations that would fund the rebirth of Europe. He advocated an international tribunal (the eventual Nuremberg trials) and a robust American-led economic recovery (the eventual Marshall Plan). But within the realm of visual culture, pastoralization undeniably became the preferred mode of representation, and it came to encompass all of Europe as well as the United States, not just Germany.

In American magazines, movies, and even cookbooks, European nations were routinely divested of their former claims to modernity and returned to pastoral states. In 1946, for example, the Curtis publishing company launched a new magazine, *Holiday*, which catered to the new class of victorious American travelers. On the cover of the May 1948 Paris issue, whole swaths of the city are literally stripped away, leaving only symbolic monuments drained of their former ideological power, turned into illustrated scenic motifs. The French are given a holiday from their history, especially the recent Vichy past, and transformed into clichéd characters performing stereotypically French acts in an entirely emblematic landscape. Red, white, and blue are the colors of the French flag, but in this illustration they signal the liberating force of American pastoral power and the unalienable rights of the Great American Tourist to pursue life, liberty, and happiness abroad. Similarly, the Rome on view on the April 1952 cover is not the defiled, fetid and sordid Rome of the recent Fascist past (on view in Roberto Rossellini's *Rome, Open City*, 1945, and vividly described by Edmund Wilson in *Europe without Baedeker*, 1947), but "Eternal Rome," the Rome that belongs to every new conquering power.

1.12 (following pages)

"For epicureans: fine art, immaculate forms:
An architect and his wife live among beautiful
possessions in a chaste setting," *Contract
Interiors*, May 1958.

For epicureans: fine art, immaculate forms

An architect and his wife live among beautiful possessions in a chaste setting

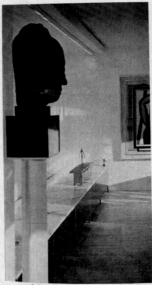

photographs, both pages, alexandre georges

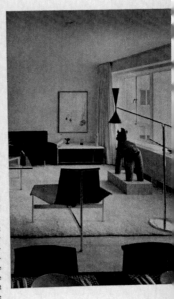

The apartment of Mr. and Mrs. Gordon Bunshaft, high on the south face of Manhattan House, makes hash of the idea that the machine age is incapable of fine craftsmanship. Mass production expediencies and built-in obsolescence may blur the focus of some modern interiors, but not this one. Planned by its owners and executed under their close surveillance (the *schwertseite* of this family is partner-in-charge of design in the New York office of Skidmore, Owings & Merrill) the completed project has a prismatic perfection compounded of incredibly meticulous detailing. Since much of the work was done by men whose milieu is the construction trades, the conclusion is inescapable. Craftsmanship is also a matter of clientele: the age of stainless steel also has pride and patience and respect for materials—given an appreciative patronage. Our pictorial argument for this conclusion (here and overleaf) centers on a living-dining area of almost classic rectangular proportions. Of two deviations, one is removed entirely, the other has become visual asset. The first, a structural extension of the foyer wall bracketing the dining area, is now replaced by a long divider cabinet designed by Mr. Bunshaft and made by General Bronze, McGowan Marble Company, and John Langenbacher (a collaborative partnership responsible for all the cabinetry). Like its counterparts across the room—the low radio-sound system cabinet beside the couch is actually the prototype model—this piece is of stainless steel, black Formica, and gray-veined white marble. And the workmanship is fantastic. The stainless steel frame is solid, not hollow; its edges are T-square sharp; its horizontal and vertical members are wherever possible welded into one piece to eliminate even such minor flaws as hairline joints. Stainless steel pulls are handmade and hand-set; marble veinings match exactly on sectioned tops; and all surfaces are so accurately flush that the word gains a whole new meaning. Perhaps most incredible of all is the mirror-brilliant finish on the cabinet's steel end panel, a finish so fine—it is polished stainless, not chromed—that it completely obliterates the *(continued overleaf)*

joint between the panel and the upright supports of the frame.

The room's second deviation from pure rectangle is the long shallow cove formed by intruding structural column. Eschewing elaborate camouflage the Bunshafts have simply slung a false beam, flush with the column, across the cove and inserted into it a strip of light—stock model tubular incandescent bulbs behind an eggcrate grid. The illumination is dimmer-controlled and spreads evenly over the back wall to create an occidental tokonomo. On the wall are two Legers; on the cabinet, a Giacometti bronze, a tiny Gallo-Roman bronze, a pre-Columbian terra cotta female, and a little figure from Cyprus. A large stone Siamese Buddha stands in front of the erstwhile offending column on a white-painted metal pedestal, a modified residential version of one developed by James Sweeney for the Guggenheim Museum.

Other works of art from an extensive, eclectic collection—paintings by Afro, Miro, Nicholson, Dubuffet, and Picasso; sculpture by Bertoia, Calder, Modigliano and unknown artists of Chinese, Japanese, Mexican, African, and Etruscan antiquity — sparkle among furnishings that are in themselves works of art, and were collected in somewhat the same fashion. Only the Laverne dining chairs are new, and only these and the Knoll couch in a black Rancocas tweed are stock models. The large Laverne chair is a custom model of an experimental design; the Mies chairs were made from drawings borrowed from Hans Knoll before the chair was in production. A pair of beautiful Italian lamps—one in the living room, one in the study—were two of six imported by a small shop no longer in business. As delicately balanced as stabile sculptures, their long arms pivot in a full circle and so do their shades, their electrical wiring apparently conforming by miraculous design. Background to it all is white walls, a cream-beige travertine floor, and a cream-beige Moroccan rug.

Softer in focus but equally perfect in detail, the book-walled, V'Soske-carpeted study is also furnished in collector's pieces—a Saarinen chair, Breuer's history-making chrome and cane chair, a small chairside table with slender half-inch square chrome legs and chrome-framed walnut burl top. In this room too is a massively handsome teak architect's chest acquired by Mr. Bunshaft in the early days of his practice. In its way it is introit and coda to a remarkable interior design.—B.D.

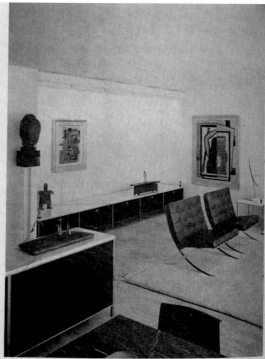

photographs, both pages, alexandre georges

1.13

Holiday, Paris issue, May 1948.

Americans traveling abroad discovering newly pastoralized European landscapes became a whole genre in the postwar period. Unlike nineteenth-century narratives in which oil and steel tycoons traveled to Europe to acquire vast troves of art, and unlike early-twentieth-century narratives in which rich Americans traveled to Europe as part of an international jet set, the social types in post-World War II narratives are solidly middle-class and often Midwestern, like Jean Arthur's Idaho congresswoman in Billy Wilder's *A Foreign Affair* (1948), Gene Kelly's former G.I. in Vincente Minnelli's *An American in Paris* (1950), and the three young secretaries who work for the U.S. Distribution Agency in Rome in Jean Negulesco's *Three Coins in the Fountain* (1954). In all of these films, the Americans play beneficent roles in fantasy landscapes. In *A Foreign Affair*, Germany is a lair of seductive moral ruin while in *An American in Paris* and Stanley Donen's *Funny Face* (1957), France is a fashion fantasyland.

One film in particular finds strong parallels with *Contract Interiors*' rep-resenation of art in Bunshaft's Manhattan House apartment. In Negulesco's *Daddy Long Legs* (1955), Fred Astaire plays Jervis Pendleton III, a millionaire bachelor who falls in love with a young woman in a French orphanage, played by Leslie Caron. Based on a 1912 novel that had already been adapted for the movies three times before, once in 1919 and twice in the 1930s, the nar-rative of a rich bachelor who secretly underwrites the education of a young orphan girl became the backdrop against which each respective era could project its prurient cultural, political, and social fantasies. In 1919, it was a comedy of manners based on class, while in 1931 it was a social welfare narrative. The 1955 film, written by the husband and wife team of Henry and Phoebe Ephron, is a whimsical but pointed allegory of the Marshall Plan, the American economic aid program for the rebuilding of Europe, which went into effect in 1948 and lasted until 1952.

Jervis's Manhattan townhouse, seen in the opening sequence, is a museum of world culture — just like Bunshaft's apartment. The Beaux-Arts classicizing marble foyer serves as a museum of European painting, while his living quarters, hidden behind chinoiserie French doors, are decorated with mid-century modern furniture. His house thus joins old and new: the industrial wealth of the robber barons (the mansion's exterior, the Beaux-Arts foyer) is the foundation for the postindustrial world of the postwar era (the spare, yet rich living quarters). The open-span wood-paneled room with luxurious black-veined marble accents serves as backdrop for his extensive, eclectic collection of African art and Greek sculpture, which harmoniously coexists with his fiberglass Eames chair.

In this film, Cinemascope produces a mural effect, a variant on Giedion, Léger, and Sert's mural language. It is especially noticeable in Jervis's living quarters, which contain gold mosaic murals of the ancient Roman Forum. Fred Astaire is seen standing in front of these murals as if he is floating among the ruined monuments: the Arch of Titus and the Arch of Constantine are rendered in simple black outline on a brilliant gold background (which brings to mind Kahn's invocation of "gold" at the very beginning of his essay on monumentality). The gold mosaics in Jervis's hybrid mansion may symbolize a new form of imperial authority; but Astaire, with his characteristic exuberance, embodies the spirit of wonder.

In the opening scenes, Jervis is so filled with ecstasy by his own good fortune that he spontaneously breaks into song and dance, giving his butler an impromptu lesson in the "history of the beat." The beat is the mainstream jazz rhythm of postwar New York, a musical melting pot of indigenous American styles: "I shall now begin / To instruct you in / What the jazz elite / Call the modern beat / A complete anthology." Like his house museum, which comfortably accommodates artifacts representative of world culture, from the earliest ancient sculpture to the most modern industrially produced piece of furniture, the beat levels history out into a pulsating narrative of progress (from "ragtime ... through Sugarfoot and Dixieland ... from the cotton fields away").

Jervis is sent to France by the State Department on an unnamed economic mission similar to the Marshall Plan. While driving through the French countryside outside Paris, the huge American Cadillac carrying the State Department contingent gets stuck in a ditch, a sardonic comment on the implementation of the Marshall Plan, which also foreshadows the subsequent plot point, as Jervis will get stuck on Caron's Julie André. Ditching his compatriots, he walks through the picturesque countryside to find help. He comes upon the orphanage, which looks like an illustration in a Charles Perrault fairytale: turreted, crumbling, and overgrown with wild weeds. The France on view in the film is clearly not the capital of nineteenth-century modernity, home of the early-twentieth-century avant-gardes. Decorated with fading fleur-de-lis wallpaper, the orphanage, named Jeanne d'Arc, is symbolic of postwar France, where all the French are orphans (or, as the fictional American ambassador in the film says, "unwanted children"). Julie has been there since infancy, for exactly eighteen years – in other words since 1937, the start of hostilities in Europe.

Jervis impetuously decides to anonymously sponsor Julie's education at an all-girls' college in New England. In other words, she (representing France) will be reeducated in the precepts of American democratic ideals

(represented by the New England college). She is first seen painting little wooden dolls and serving lunch to the younger gingham-glad orphans, who imagine that their unappetizing gruel is juicy American hamburgers and ice-cream sodas. When she learns from the matron of her anonymous bene-factor's plans, she wistfully but readily departs for the New World. Her pan-oramic view of New York from the airplane, a gleaming vertical wonderland, contrasts sharply with the fairytale French countryside she has left behind.

Throughout the film, President Eisenhower's real-life foreign policy doc-trine of "mutual aid, mutual trade" becomes a political romance depicted as mutual fantasy. In musical daydream sequences, Jervis and Julie liter-ally enact the delicate dance of diplomacy: his is an American victory dance, while hers is more the "dance mania" of the postwar "dreamland" state when, as the cultural historian Wolfgang Schivelbusch has argued, the depression of defeat gives way to the euphoria of liberation.[131] In her own mind, she becomes a schoolgirl ballerina straight out of one of the denuded French impressionist paintings he has hanging in his majestic foyer museum, while in his mind, he becomes a Texas oil millionaire and debonair New World dandy. Julie daydreams about Jervis watching her perform, while Jervis daydreams about how Julie sees him. They fantasize, in other words, about the images they are projecting to each other in the letters they exchange.

In the film's best and biggest dance sequence, one of Julie's daydreams, Jervis watches her perform a ballet from an opera box with binoculars – his own private Cinemascope lens – as the entire history of French painting is transformed into a performing art. In Julie's dance through the history of French art, which is rendered in a children's picture book style of illustra-tion, she morphs from Degas schoolgirl to Toulouse-Lautrec *femme fatale* to blue-period Picasso Pierrot, revealing her confusion – and thus France's confusion – about who she is meant to be in the postwar world. But the political point of the dance is clear: she is alienated from her own cultural tradition, which he will rescue and help to preserve.

When Jervis first proposes his sponsorship scheme, the American ambassador to France questions the purity of his motives. He voices the prurient interpretations likely to be put about by more lurid minds. The ques-tion of purity, however, hinges on art, not on sex. Jervis's relationship with Julie is entirely chaste. French civilization, defiled by the Nazis, will be made immaculate under the chaste stewardship of the United States. His money is clearly inherited and devoid of any vulgar associations. In fact, his money is never mentioned, only referenced by his extensive collection of art. He is not merely a collector, but a savior of art. The question of purity hinges on

education: Julie will be re-educated in the ideals of the American Revolution at that New England college, and thus made ideologically pure.

In the film's final scene, Julie, invited to Jervis's house by his busybody secretary, sees his cubist portrait by Picasso – emptied of any avant-garde, psychological, or sexual charge, transformed into a pure expression of the modern beat – in his foyer museum. His identity is finally revealed. He suavely watches her looking at his cubist visage hanging beside ancestral portraits by Whistler and John Singer Sargent. In a final mutual fantasy, a revisionist spin on beauty (French civilization) and the beast (American power), he proposes marriage as they dance among the artworks.

ALLEGORIES OF BEAUTY AND FREEDOM

Cecil B. DeMille framed *The Ten Commandments* (1956) in explicitly new humanist terms. In the original long-form trailer, DeMille himself is shown seated in a wood-paneled study, with red quilted leather chairs, in which he has assembled a gallery of reproductions of the Moses legend: Renaissance Bibles, a Flemish baroque painting by Anthony van Dyke, and Gustave Doré's Bible illustrations. Speaking directly to the audience, he makes a case for the rediscovery of ancient geography, history, language, law, and texts, while presenting the film as a spectacular visual synthesis of Western art history. Echoing Jaspers, who made a case for the importance of biblical history as the foundation for a new humanism, DeMille explains: "We're still fighting the same battle Moses fought," and asks: "Are men to be ruled by God's laws, or are they to be ruled by the whims of a dictator like Rameses? Are men the property of the state, or are they free souls under God?" DeMille's film is akin to Luce's Western Culture Project: the biblical tale becomes an allegory of the rule of law versus the tyranny of fascism.

Movies were more successful than architecture in engaging humanist themes. This is especially true of the biblical epics, which became vehicles for the dramatization of contemporary discourses on domestic politics and foreign policy, and the quest for peace as the United States consolidated its role as a superpower on the world stage. In almost all these films, an old hierarchical, tyrannical order is giving way to a New World. Whether it is the Philistines in Judea or the Romans in the time of Christ, the imperial powers are always given traits attributable to the Nazis or Soviets. In *Quo Vadis* and *The Robe*, the emperors and the Roman aristocracy are cynical, depraved, filled with greed, motivated by a grotesque form of materialism. The emerging Christian order, by contrast, is identified with oppressed slaves whose homespun goods ("the products of peace") are linked to an ideal of happiness rooted in spiritual transcendence.

In *The Robe*, the plain rustic tunic worn by Christ on his way to the Crucifixion is one such product of peace. When the Roman tribune Marcellus, who is sent by the emperor Caligula to oversee the Crucifixion, comes into physical contact with the robe, it sets off the internal struggle that will lead to his spiritual awakening and rejection of Roman rule. In the final scene, a variation on the mystic marriage, he is joined by his steadfast love, Diana, who has also converted to Christianity. Together they go from the imperial hall to be martyred. In the final frame, their heads are seen against a boundless sky, with serene expressions, as they ascend into (to use Davenport's terms) the "whole new vista of freedom" to a chorus of Hallelujahs.

Yet these movies also dramatize, as the film scholar William Fitzgerald has persuasively argued, the "antagonisms and ambiguities within American culture itself."[132] Highly mutable in their allegorical associations, they interrogate as much as ratify the "American proposition," as *Fortune* termed the program it laid out, often warning against the dangers of "thralldom" (Jaspers's term) and the excesses of mass society. Mass consumption, mass entertainment, the allure of luxuriously rich material goods, the appeal of militarism, and McCarthyism, all features of postwar American society, are identified with imperial (totalitarian) Roman rule; but they are simultaneously contrasted by the quiet (democratic) virtues of family and faith, which triumph in the end. As Fitzgerald shows, the tension between these two opposing forces is almost always resolved by reasserting the primacy of core democratic values.[133] Fitzgerald further argues that sword-and-sandal movies allowed audiences to experience the ideals of the American Revolution, which are explicitly identified with the political and spiritual struggle of persecuted Jews and Christians against entrenched, reactionary powers, in ways that reaffirmed their vitality in the postwar world.[134]

What most interests me about these films is how they present ideas of beauty, of belief, and of power in ways the everyday moviegoer could understand. In DeMille's *Samson and Delilah*, female beauty is a corrupting force, which literally blinds Samson and leads to the destruction of society. In *Quo Vadis* and *The Robe*, female beauty is identified with wholesome democratic virtues. In *The Robe*, Diana (representing beauty) refuses to be corrupted by Caligula (representing power). She remains a true believer in the innate goodness of Marcellus as he struggles between duty (to power) and belief (in the divinity of Christ and the new order he represents). Beauty in these films is sometimes the beauty of ideas. *The Robe*'s central message is communicated by the invalid Miriam, an early Christian convert, in an exchange with Marcellus at a crucial moment halfway through the narrative. He comes upon

her in a country courtyard, where she is weaving a basket while reclining under a tree. She explains to him that Christ's death "was a beginning" and an opportunity "to build a new world" on concepts such as charity. "Worlds are built on force, not charity, power is all that counts," he counters. "Perhaps we have something better than power," she answers, "we have hope." While weaving, the art (according to Plato) of the politician, she teaches him how to believe in the beauty of ideas over the power of force.

Films set in ancient Greece were surprisingly rare – the least successful of the genre. Why? In his discussion of director Robert Wise's *Helen of Troy* (1956), the film historian Jeffrey Richards argues that the Greek epics, with their themes of "divine vengeance, malign fate, and tragic grandeur," were not as well suited to modern politics.[135] In fact, films set in ancient Greece function more as cautionary tales than the Roman-themed movies. *Alexander the Great* (1956), for example, is a cautionary tale about a young, ambitious, and idealistic leader who is ultimately corrupted by a cult of the self, inadvertently ushering in an era of endless war. He thus fails to realize the beauty of his idea of One World. (Wendell Willkie's book *One World* [1943], which was part of the *Fortune* program, revived Alexander's dream of one world united through trade and corporate administration.)

Wise began his career as a film editor, but had already proved to be one of the most socially astute directors of the postwar period. In movies such as *The Day the Earth Stood Still* (1951) and *Executive Suite* (1954), he used popular genres – science-fiction fantasy and corporate melodrama, respectively – to address fears of social engineering, and the pressures of the corporate ladder. While Wise would later say that he was attracted to *Helen of Troy* for the opportunity to experiment with Cinemascope, he brought a new humanist sensibility to bear on the retelling of Homer's *Iliad*. Wise's humanist approach is often overlooked in analyses that focus too fixedly on the film's production details.

The storyline is freely adapted from Homer's epic by screenwriters John Twist and Hugh Grey, who had earlier written the screenplay for *Quo Vadis*. In the opening sequences, Troy is depicted as a gleaming citadel on a distant shore where, as the narrator explains, "in the palace square and busy streets the industrious people were enjoying the works of peace," meaning commodity goods. Troy, in other words, is a stand-in for the postwar United States. While the people in the square trade their artisan wares, inside the palace Priam and his sons (the "royal council," the ancient Trojan equivalent to the American National Security Council, which was a new creation of the 1947 National Security Act) debate what course of action to take with

the warring Greeks. While the United States finds its historico-mythological counterpart in Troy, the Soviets find theirs in the Greeks, who are depicted as aggressive, belligerent, and motivated by a base desire for spoils. (Richards blames the film's failure partly on the fact that the bad guys win.) In the council, Paris, the voice of reason, steps forward to argue against a policy of continued isolation, which has sowed resentment among Troy's neighbors, and persuasively makes the case for foreign engagement. He sails to Sparta to convince the Greek states that "Troy's power makes a treaty advisable" and "to spread civilization" by means of trade.

Helen of Troy has two great existential and humanist themes: the centrality of foreign affairs to national existence, and the role of beauty in relation to politics, either as a product of a beneficent power or as a cruel and mercurial destabilizing force. When Paris awakens on the Spartan shore after his ship is wrecked, and sees Helen walking toward him out of the waves, her beauty diverts him from his cause. Although the Greeks launch what they call "a righteous war of defensive aggression" disregarding all ethical concerns, Troy is depicted as just as culpable for its own demise. The Trojans are described in the opening narration as "a happy people in love with beauty," a characteristic the Greeks will strategically exploit. In the final sequence, as the Trojans wheel the Greek-made wooden horse through their city gates in the lull before the apocalypse, Helen, looking down from the ramparts, wistfully remarks on their obsession with the "great and perfect thing," which blinds them to the malevolent force concealed in the belly of this beautiful object. The film is a morality tale about a nation (Troy, the United States) too in love with beautiful things, an extreme form of cultural and political narcissism that leads to the destruction of its civilization.

Beauty is equated with political freedom, but it is also a harbinger of doom. Helen embodies both: as a prisoner in Sparta, her liberation by Paris converts her to freedom's cause, but her arrival in Troy tips the balance on a cosmic scale. Welcomed in the throne room of the Trojan palace, she is seen framed between marble statues of Aphrodite, the goddess of beauty and peace, and Athena, the goddess of wisdom and war, indicating the precarious position into which Troy has been tossed. This mythological positioning finds a direct parallel in early- and mid-1950s Cold War discourses on brinksmanship and the balance of terror, which were defined by John Foster Dulles, President Eisenhower's Secretary of State, as "the ability to get to the verge without getting into the war."[136] Although Cassandra warns that "her name means death," Helen is embraced as "an enemy of oppression" and a thing of beauty. Troy sees its own image in her reflection and, like Paris, becomes

1.14

Jacques Sernas as Paris and Rossana Podestà as
Helen, representing philosophical ideals of
peace and beauty, in Robert Wise's *Helen of Troy*
(1956). Courtesy of Photofest.

transfixed. It is only when the Greeks' indifference to her beauty and their intention to loot the city are revealed after the start of the war that Priam finally bestows on her his benediction: "Helen, you will be a princess of Troy," thereby sealing Troy's fate.

Exploiting the Cinemascope format, Wise isolates the faces of his two lead actors on either side of the screen. This was a departure from films such as *The Robe* and its sequel, *Demetrius and the Gladiators* (1954), in which the comprehensive widescreen concept was used to capture elaborately staged set pieces. These films are comprised mostly of medium shots, scenes shot from a middle distance in order to create vast perspectival panoramas. Wise, by contrast, composed in widescreen as he had in the older, smaller frame, using over-the-shoulder angles to give one character's point of view of another. Framing his two leads against stark monochromatic backdrops, flickering colors in the distance, he brought the philosophical meanings of these mythological characters to the forefront of the narrative. For a war epic, it is exceptionally spare.

Throughout the film, Paris and Helen speak to each other of their doubled selves. She is aware that she is a slave to her own image. She refers to "the queen" in the third person as someone, something, outside herself. When Paris first meets Helen, she is visiting her old nurse on the shore, where, concealing her true identity, she pretends to be "the queen's slave" and "the queen's shadow." Caring for her old nurse, she embodies domestic working-class virtues, but as queen she symbolizes high political ideals. She is both an immaculate figure, like the shining marble goddess statues in the Trojan palace, and a tainted phantom haunting the Trojan landscape "looking for shadows." Coming upon her in a palace courtyard moments before he is killed, Paris sees her reflection rippling through a shallow pool. "Helen, how perfect," he says. In response, she both asks and instructs: "The girl you fell in love with? Always keep that image with you, Paris." The film ends soon after on a close-up of Helen's face bleeding into the Aegean Sea.

The young Aeneas, who makes a brief but prominent appearance in the film, will of course be the one to keep that image with him. In Roman mythology, he is the hero who carries the Trojan ideals of beauty and peace across the seas to Latium, where he founds Rome, the descendant of Troy. Rome will forge a New World on the foundations of Trojan civilization. If, as Simone Weil argued in 1943, "the true hero, the true subject, the center of the *Iliad* is force," then Virgil's *Aeneid*, which tells the story of Aeneas's founding of Rome, is a justification of the power of Rome, which binds the pluralities of people scattered across Europe in the aftermath of the Punic Wars

together through a new system of alliances.[137] Wise's film clearly points to this outcome. Paris's vision of peace through "the understanding of nations," elaborated in the royal council scene at the outset, eventually comes to pass in the world forged by Rome, but in the post-World War II context it finds an analogy in the new order ushered in by the American-led victory and the establishment of the United Nations and NATO.

The film introduced mass audiences to mid-1950s ideas about foreign policy. In her 1955 lecture "Introduction *into* Politics," which is contemporaneous with the film, Hannah Arendt looked for analogies in the classical past in order to better understand what was happening in the present, and she fixed upon the Trojan War.[138] She saw in Homer's "grand impartiality," his surveying of the Trojan landscape from an eagle's-eye view, favoring neither Hector nor Achilles, neither the Greeks nor the Trojans, a key to decoding the Greek understanding of war. The Greeks, she argued, did not desire to transform war into anything other than "historical recollection." They never transformed it into a political weapon: "war, and the brute force it entailed, was ... entirely excluded from what was truly political, which arose and had its validity among the citizens of the polis."[139] The Greeks turned war into epic narrative, and reified its heroes as exemplars of glory. Both the conqueror and the conquered — Hector and Achilles — were of equal stature, and equally deserving of praise.

By contrast, according to Arendt, the Romans interpreted the same event in an entirely different way: "They deliberately traced their political existence back to a defeat, from which came the founding of a new city on a strange soil — not the founding of something new, but a renewed founding of something old, the founding of a new homeland and a new home for their penates, the gods of Troy's royal hearth that Aeneas had rescued before fleeing across the sea of Latium."[140] In founding Rome, Aeneas undid Hector's defeat and the destruction of Troy. It was a story of rebuilding at the heart of which were not heroes but rather the importance of alliances that bound together the pluralities of people left scattered after the epic battles had ended. In other words, Virgil's *Aeneid* — in contrast to Homer's *Iliad* — was a political narrative, not an epic narrative. "For the Romans, politics began as foreign policy, that is, as the very thing the Greek mind had completely excluded from politics. Likewise, although the political realm itself could arise and endure for the Romans only within the scope of the law, this realm arose and expanded when different nations encountered each other. The encounter itself occurs as war ... but this war is not the end but rather the beginning of politics, or of a new political sphere arising out of peace treaties

and alliances."[141] Whether we agree with Arendt's analysis is, I think, beside the point. I believe she was commenting on the newfound fascination with foreign policy in postwar America, the new system of alliances the United States was forging around the world, which were being communicated to the masses in movies such as *Helen of Troy* and by figures such as Dulles, whose accessible, mythicizing articles appeared regularly in *Life* magazine.

By aligning the United States with Troy, and thus with Rome, *Helen of Troy* focuses on the beneficent (rather than tyrannical) aspects of the Roman Empire, which will create a "great civilization." It raises questions about national survival that were as central to post-World War II audiences as they were to European kingdoms from the Middle Ages through the Enlightenment, which cyclically returned to the fall of Troy and the founding of Rome as the ur-allegory of civilizational inheritance and political legitimacy.

As conversion narratives, the biblically themed movies visualize in dramatically thrilling ways the rise of a new pastoral bureaucracy. In films such as *The Big Fisherman*, *King of Kings*, and *The Greatest Story Ever Told*, postwar audiences could see and experience the spread of a new system of spiritual administration. The spread of the early Christian church in the ancient world serves as an allegory for the spread of democracy in the post-World War II period. The United States is portrayed, by inference, as the modern incarnation of an ancient pastoral bureaucracy, a revolutionary new belief system with universal appeal, winning hearts and minds through the exchange of ideas rather than militant force.

ARENDT: BEAUTY AND JUDGMENT

Why Arendt? She was one of the few thinkers to attempt to make sense of the postwar American obsession with beauty, its connection to democracy, and its implications for politics. Very briefly, some background: a student of both Heidegger and Jaspers in the 1920s, Arendt fled Germany in 1933 and settled in Paris, where she worked as a journalist writing about (and working for) Jewish refugee causes. In 1941 she moved to the United States, where she lived in Manhattan and taught at the New School for Social Research, while also giving lectures on politics and philosophy at the University of Chicago. Beginning in 1945, Arendt resumed her correspondence with Jaspers. The two profoundly influenced each other's thinking about the state of the postwar world. In many ways, their books parallel each other, so that Jaspers's *The Fate of Mankind* (1957), for example, finds resonant echoes in Arendt's *The Human Condition* (1958), and vice versa. In these later years it is often difficult to know who had the greater influence on whom. Another

important point: Arendt was a public intellectual, a widely read figure, not an obscure professor of esoteric ideas speaking to cloistered academic audiences. *The Human Condition* was published as a pocket-sized paperback by Doubleday Anchor Books and reviewed in the *New Yorker* by her close friend, the best-selling writer Mary McCarthy, who praised Arendt's "combination of tremendous intellectual power with great common sense."[142]

The importance of Arendt for my argument is that she emerges at the end of the 1950s as a quizzical voice commenting on what she perceived to be deeply troubling tendencies in American cultural and political life. In *The Human Condition* (1958), in the essays collected in *Between Past and Future* (1961), and in *On Revolution* (1963), she offered, as I interpret it, a correction to the misappropriation of age-old concepts such as beauty, freedom, humanism, and truth, which were being reinterpreted through the lens of the "secular religion" of "America's humanistic nationalism" (to use Martin E. Marty's words again): the entire Christian-corporatist ethos popularized in Luce's magazines. Arendt made a strong case against the glazed illusions of the window wall by Arcadia and various mass culture allegories of beauty and freedom. In response to these illusions she asked basic, though not necessarily simple, questions: "What is Authority?" and "What is Freedom?" In dense, digressive, and often-meandering analyses, she investigated the etymological roots of these concepts, often journeying back to the Greco-Roman world and the early Christian era to show how removed modern understandings were from their ancient origins. She was clearly not an originalist arguing for a return to ancient interpretations; rather, she was perplexed and sometimes alarmed by such changes in meaning. In these three books, she painted a rhetorical picture of a world turned inside out.

Point by point, Arendt dismantled the philosophical underpinnings of Davenport's "The Greatest Opportunity on Earth." In contrast to Luce's notion of "pervasive beauty," she wrote of "elaborate beauty."[143] There is an underlying functionalist fantasy determining Luce's idea of beauty: technological supremacy allowed American architects and enterprisers to make the world itself seem otherworldly – this was the basis of the public relations campaign around Connecticut General Life Insurance Company's Bloomfield headquarters. Arendt invokes the Gothic cathedrals of the Middle Ages and argues, in opposition, that they made the otherworldly seem tangible in the world. The cathedrals were the products of man's ingenuity, literally the work of his hands: the engineer, the stonemason, the glasscutter, and so on – the exquisitely detailed ornament of Gothic style may have symbolized the divine, but it was clear, she argues, that they were of the earth.[144] The

"pervasively complete" building and "precision in pastoral" (to use *Architectural Forum*'s phrases), by contrast, were not necessarily to be understood as the product of man's work — that which, according to Arendt, creates the "worldly stability of the human artifice"; they were intended, rather, to be seen as the product of an invisible, mystical process — and in fact, recall that *Architectural Forum* marveled at how the architect rendered himself invisible at Connecticut General.

Some of the most poetic passages in *The Human Condition* are those in which Arendt expresses her alarm at the aestheticization of the labor process. The point of the architectural design at Connecticut General was to divide the labor process up "into its minute particles until it has lent itself to division where the common denominator of the simplest performance is reached," as Arendt says, so that all resistance is eliminated, enabling endless repetition; thought itself is eliminated as an obstacle.[145] Arendt argues: "a complete victory of society will always produce some sort of 'communistic fiction,' whose outstanding characteristic is that it is indeed ruled by an 'invisible hand,' namely, by nobody" — and it is precisely this "communistic fiction" that was reiterated in the "amusing legends" about "Life in General" in the magazine profiles of Connecticut General.[146]

Davenport wrote of "the good society within the corporation," a notion that Arendt investigates. In *The Human Condition*, she writes: "Goodness in an absolute sense, as distinguished from the 'good-for' or the 'excellent' in Greek and Roman antiquity, became known in our civilization only with the rise of Christianity."[147] In Aristotelian thought, she argues, good works were an activity removed from the public realm; the very nature of their goodness derived from the fact that they were private, not public: "goodness can exist only when it is not perceived ... whoever sees himself performing a good work is no longer good, but at best a useful member of society."[148] Her remarks speak to the "Good Design" ethos, which was being propagated by the Museum of Modern Art and the Chicago Furniture Mart, and a plethora of new shelter magazines, which instructed readers in how to be good consumers. The point is that the concept of goodness had been turned into yet another trivial and empty "truth," devoid of real political or religious meaning. Furthermore: politics now seemed to exist in order to secure the "good life" of the household, to safeguard private life — a reversal of ancient political philosophy which, in Arendt's interpretation, excluded household concerns from public affairs.

Davenport's philosophical-political program ultimately came to rest on the concept of happiness. Arendt also addresses the pursuit of happiness in

The Human Condition: "The outcome of what is euphemistically called mass culture, and its deep-rooted trouble, is a universal unhappiness, due on one side to the troubled balance between laboring and consumption and, on the other, to the persistent demands of the *animal laborans* to obtain a happiness which can be achieved only where life's processes of exhaustion and regeneration, of pain and release from pain, strike a perfect balance."[149] The system that Davenport had described in 1949 in "The Greatest Opportunity on Earth" was predicated on the perfect balance that would be struck between the economic, political, and spiritual drives. Writing in 1958, Arendt acknowledged that it had in fact resulted in the opposite, in imbalance and unhappiness.

—

The culture of life insurance fed on fear. Postwar American society feared for its own early extinction. People wanted to believe in the illusions, because their fears were real. As Morris Dickstein explains in his study of American culture in the 1960s, "behind material growth hovers a quiet despair, whose symbols are the bomb and the still-vivid death-camps."[150] Threats of extinction gathered on more than one front: on the home front in an unbridled cycle of production and consumption that threatened to devour the good things of life, and the natural world along with them; and on the international front from the Soviet Union and the constant threat of nuclear war. Those threats came to a head just as Connecticut General was completed, in the fall of 1957, with the launch of the first Soviet Sputnik satellite and the onset of the worst recession since the Great Depression. This was the flip side of the Arcadian images through the window wall: a landscape of total annihilation, pure scorched earth.

2

Architecture, Mass Culture,
and Camp

In June 1959, the American Academy of Arts and Sciences and the Tamiment Institute in New York, the leading think tank at the time for progressive politics, jointly sponsored a two-day study conference on Problems of Mass Culture and Mass Media. Framed in gloomy terms, the symposium's basic concern was that the liberal dream of "social betterment" had been hijacked by mass culture. The growing middle class, with both more leisure time and more money, was watching TV rather than cultivating high-minded pursuits. A diverse range of people from the worlds of academia, culture, and media were invited to address this issue, including Frank Stanton (president of CBS), Edward Shils (a professor on the Committee of Social Thought at the University of Chicago, and muse to the writer Saul Bellow), the writer James Baldwin, the poet Randall Jarrell, and scholars such as Hannah Arendt. This ensured a variety of conflicting viewpoints – what Norman Jacobs, president of the Tamiment Institute, called at the outset "a mutual confrontation" between three camps: "optimists," "pessimists," and "meliorists."[1] Such categories highlight the reductive nature of this confrontation, as well as the impulse to categorize that informed the wider intellectual debate about mass culture at mid-century.

The symposium was in part a response to the publication of Bernard Rosenberg and David Manning White's trendsetting study *Mass Culture: The Popular Arts in America* (1957), a collection of forty-nine historically significant essays from the nineteenth century to the present. It included sizeable excerpts from de Tocqueville's *Democracy in America*, Walt Whitman's poetry, Clement Greenberg's essay "Avant-Garde and Kitsch," and contemporary cultural analyses by Marshall McLuhan and David Riesman, among others. The book's sheer heft signaled the consolidation of mass culture as the dominant cultural category of the age around which intellectual work in the public realm now revolved. To that end, the central question posed by Rosenberg and White was whether intellectuals should reject mass culture, or give it critical support? The general scheme they devised (like the 1959 conference) predictably split intellectuals into two camps, pessimists and optimists. The debate in fact was most interesting when it focused on

transformations of traditional definitions of culture as a result of the post-World War II pressures of mass society.

Rosenberg and White's book contained sections on literature, pulp fiction, comic books, magazines, movies, television, and advertising, but not architecture. But simultaneously, architectural critics engaged in their own investigations of transformations in culture, especially as they unsettled accepted definitions of modernism. This debate played out in trade magazines such as *Architectural Forum* and *Progressive Architecture*, and in essays such as Vincent Scully's *Modern Architecture: The Architecture of Democracy* (first delivered as a lecture in 1957, and published as a book in 1961). The debates about mass culture and modern architecture paralleled each other. They were riddled with a similar edgy, uneasy tone; both debates, moreover, were taxonomic enterprises characterized by often frenzied sociocultural diagnoses, a restless compulsion to name even the tiniest shifts in style.

As the social art and the symbolizing art, architecture was an integral part of mass culture. It appeared regularly in movies, magazines, and on television. On Sunday June 22, 1963, for example, CBS aired a special entitled "Lincoln Center Day," which commemorated the opening of Lincoln Center in New York. It was paired in a back-to-back line-up with "The Golden Age of Greece," the second in a new series called "The Roots of Freedom." CBS News correspondent Eric Sevareid toured the Acropolis with the recently reinstated king and queen of Greece (who were about to be deposed yet again). They introduced audiences to the meaning of the Parthenon, whose "noble proportions reflect the social, political, and artistic ideals and way of life of the Age of Pericles, forerunner to modern democracy." CBS Director of Design Lou Dorfsman's full-page advertisement for the two programs in the *New York Times* linked the two cultural-political complexes: the Parthenon, with its monumental Doric colonnade, represents "The Heritage" and looms over the trio, who are shown descending its ruined staircase on the top two-thirds of the page; below, Avery Fisher Hall (designed by Max Abramovitz), with its white travertine colonnade of tapered piers, represents "The Promise." It is depicted as the modern incarnation of the ancient Athenian temple and "the enduring values of art as a true measure of civilization." The first special in the series explored Egypt in the age of the pyramids, while the third, "In Defense of Rome," which aired in June 1964, investigated the meaning of ancient Rome for postwar America.

Eero Saarinen and Edward Durell Stone were routinely featured in mass-market magazines as the two architects whose buildings were most expressive of the age – and both had glamorous wives who were successful journalists

and public-relations mavens who aimed to expanded the reach of their work to mass audiences through publishing and television. Aline Saarinen had studied art history at Vassar College, and was an art critic and editor for the *New York Times* when she married Saarinen in 1954. She ran public relations for his office and in 1962, after he died suddenly from a heart attack at the age of 51, became a correspondent for NBC's *Today Show*, a platform that allowed her to burnish his legacy. Maria Elena Torch was a fashion journalist when she met Stone on a flight from New York to Paris in 1954. By his own account, she pushed him to widen his profile beyond architecture circles into mass-cultural outlets following the example of his idol, Frank Lloyd Wright (Wright was a master of all means of mass communication). Stone appeared on the cover of *Time* (March 1958), was profiled in the *New Yorker* ("From Sassafras to Branches," January 1959), and was a regular guest on television talk shows in the late 1950s. Maria Elena was probably the mastermind behind Stone's memoir, *The Evolution of an Architect*, published by Horizon Press in 1962, which was a calculated attempt to capitalize on his celebrity.

Architectural critics writing in the 1950s and 1960s were not necessarily concerned about architecture's deep entanglements with mass culture. They were perplexed – and, more often, troubled – by the endless permutations of modernist architectural forms: what Thomas Creighton, editor of *Progressive Architecture*, characterized as a divergence from "any imposed disciplines."[2] Saarinen and Philip Johnson, reliable culprits, were habitually portrayed as architectural adolescents. One critic argued that Saarinen was too "chaotic," too "undisciplined," while in "The Mies-less Johnson," another claimed that Johnson's earlier adherence to Mies's design principles had anchored him, but that in his recent "Mies-less" projects, his lavish profusion of historical allusions was getting out of hand.[3] (To some extent, conflicting media with their differing messages – mainstream magazines and television on the one hand, and a more cautious trade press on the other – contributed to the sense of chaos.) But this strain of criticism was not limited to the second generation; it applied to the European *émigrés* as well. Creighton was bewildered by Mies's Seagram Building when it was completed in 1958, and wondered whether "it is formalistically or stylistically, the end of an era, the beginning of an era, the first of the skyscrapers of weighty solidity or the last of the skyscrapers of weightless transparency?"[4]

Other critics embraced the mass appeal of Saarinen's buildings, which they connected to a vague sense of egalitarian pluralism – his careening shapes were "communicative form-expressions" (Saarinen's father, the architect and educator Eliel Saarinen, used this holistic phrase in *The Search for Form in Art and Architecture*, published in 1948, and it became

closely associated with his son's work). Writing in 1962, for example, soon after Saarinen's death, the critic Allan Temko described the Gateway Arch in Saint Louis, Missouri (still only a proposal, not yet constructed), as a symbol of his "fulfillment of the search" and "the destiny of the nation and the world, and this selfless spirit of discovery, by men for other men."[5] Critics also embraced the enigmatic skyscraper model ushered in by Mies's Seagram Building. In a Sunday *New York Times Magazine* cover story in December 1957, Ada Louise Huxtable concluded that the prefabricated glass curtain wall was "less limited in the richness of its effects than was the familiar and beloved classical style."[6] Pointing to the airy, metallic beauty of the "steel-framed blue, green, or grey-tinted glass" towers of what she dubbed "The Park Avenue School of Architecture," she all but gushed over the avenue's "glamorous and glittering new look."

Beginning in the late 1960s, however, historians of modern architecture began to censure architects such as Saarinen and Stone – not merely along formalist lines, but for what they perceived to be the complicity – or, worse, duplicity – of their architecture as an *instrument* of mass culture, and symbol of Pax Americana. Saarinen and Stone fell into disrepute, while Johnson reinvented himself as a postmodern polemicist. Marcel Breuer – a veritable poster-boy of glossy shelter magazines in the 1950s, and one of the most prolific architects of the 1960s – was all but forgotten after his death in 1981, except by design connoisseurs who prized his early Bauhaus-era furniture designs at the expense of his later architecture. In more recent years, historians have focused their attention on postwar architects who "experimented" with mass-cultural genres (i.e. advertisements, comics, science-fiction fantasy), but in ironic, detached, and analytical ways intended to signal their neo-avant-garde affiliations. This interest in "alternative genealogies" has led to studies on an international range of architects and collective groups, such as Archigram, the Japanese Metabolists, the Situationists, the Italian Radicalists, the Smithsons, Bernard Rudofsky, and academic postmodernists (Robert Venturi, the Whites and the Grays).[7] Designers who experimented with mass media – especially early video and computer technologies, and the visualization of data – are not only seen as being more advanced in their manipulation of the medium but more radical, more sober, and more important. Charles and Ray Eames have thus long been considered avant-garde designers, even though they produced propaganda films for IBM and the U.S. government that were far more didactic than anything Saarinen or Stone ever built.[8]

Architectural Forum / the magazine of building January 1959

FORUM

Building for the community

2.1

Architectural Forum, January 1959.

Architecture, Mass Culture, and Camp

Saarinen, Breuer, and Stone pushed far beyond the quaint notion of "the good society within the corporation" in their projects of the 1950s and 1960s. Saarinen's General Motors Research Center in Warren, Michigan (which *Life*, picking up his nickname for the project, dubbed "The Versailles of Industry"), the U.S. Embassy in London, the Miller House in Columbus, Indiana, and Black Rock (the CBS skyscraper in New York), all contributed to narratives of ersatz empire and communicated new forms of corporate imperialism. His corporate commissions were no longer advertisements for a company's consumer products, like Bunshaft's Lever House, but rather symbolized civilization itself: the corporation (whether GM or TWA or CBS) was envisioned as a gateway to the world's cultural treasures and boundless resources, which existed to be exploited, just as Saarinen exploited the possibilities of epic form in his manipulation of new building materials and technologies.

But these buildings were not merely overloaded symbols of indomitable American power. They were symptomatic of a crisis in culture, and of an increasingly manic investigation into the qualities of greatness and historic achievement. Architects were participants in the wider cultural reckoning that was unfolding at precisely this moment in every sphere of intellectual activity. "Can a democratic, capitalist country like the United States create a great civilization?" asked *Architectural Forum* in a January 1959 special issue devoted to new civic and government buildings. On the cover, a nineteenth-century French academic print of a Roman column, its Corinthian capital and base bathed in majestic purple, floats on an opulent black background. The question encapsulates the climate of incredulity that defined this moment, while the peculiar *mélange* of ancient, modern, democratic, and imperial motifs conveys the essential strangeness of the architecture that emerged. The column signifies civilization. For centuries, it was the form on which Western civilization was ordered and built. "Forum" in vermillion red, all capital letters, evokes the ancient Roman Forum, but also connotes a forum of ideas, the magazine itself, where this question would be debated and hammered out.

ABSTRACTIONS AND TOTALITIES

The pastoral glass-curtain-walled world was giving way to a mosaic-tiled and reinforced concrete Shangri-La. Changes in architectural scale and ornamental detailing moved in synch with political developments. Presidential State of the Union speeches are highly formal, bloated, and symbolically burdened affairs, but they do register shifts in national style while ostensibly outlining domestic and foreign policy agendas. In his January 1958 address, Eisenhower officially ushered in a new era of absolutes and totalities:

The threat to our safety, and to the hope of a peaceful world, can be simply stated. It is communist imperialism.

This threat is not something imagined by critics of the Soviets. Soviet spokesmen, from the beginning, have publicly and frequently declared their aim to expand their power, one way or another, throughout the world. The threat has become increasingly serious as this expansionist aim has been reinforced by an advancing industrial, military and scientific establishment.

But what makes the Soviet threat unique in history is its all-inclusiveness. Every human activity is pressed into service as a weapon of expansion. Trade, economic development, military power, arts, science, education, the whole world of ideas – all are harnessed to this same chariot of expansion.

The Soviets are, in short, waging total cold war.

The only answer to a regime that wages total cold war is to wage total peace.

This means bringing to bear every aspect of our personal and national lives upon the task of building the conditions in which security and peace can grow.[9]

Under the rubric of security and peace, Eisenhower summarized the structure of a countervailing democratic imperialism. This was the moment when the ground rules for the Cold War were firmly established – and when the policy of containment, which had guided American foreign policy since the proclamation of the Truman Doctrine in March 1946, blossomed into something much more florid: the waging of "total peace."[10] In a time of challenges at home and abroad, the impulse was to fortify the image of the new face of the U.S., to make even broader claims on tradition. Arcadian representations of a chaste and immaculate world now gave way to unambiguous images of sovereignty.

The parallels between architectural and political discourses at the time are fairly blatant: architects began to speak of "tension structures," "total forms," and "structural totals."[11] Herb McLaughlin, a Yale architecture student, charted the rise of abstractions in architecture along at least two fronts: first, the glass box was being enlarged and attenuated, stretched thin to the point where human-scale proportions were lost and the quality of abstract geometry became paramount; second, precast concrete construction was moving architecture in a more "structural direction," especially "the abstraction of elements repeated in a pattern," such as grilles, sunscreens, and patterned fabrics built into the architecture or used as wall and window coverings – Stone was infamous for his use of grilles and trellis screens, so much so that Johnson dubbed him "the screen decorator," while Saarinen, in

his collaborations with the textile genius Alexander Girard, became known for his use of patterned fabrics – "their function," usually as shading devices, and spatial dividers, "was secondary to their comprehension as forms" – forms, moreover, that specifically recalled themes and motifs in ancient architecture.[12]

On the one hand, architecture had its own internal development: second-generation modernists were still responding to formal and structural innovations in new buildings by Le Corbusier, Mies, and Wright, among others. On the other hand, tensions between figurative symbolism and political abstractions placed enormous pressure on architects, and the masters were hardly immune: this new style, with its penchant for absolutes, total forms, and curious lack of scale and proportion, was exemplified for many critics at the time by Mies's Seagram Building. Assessing Wright's recent work in 1961, two years after his death, Vincent Scully wrote: "Wright's spaces themselves were not intended to celebrate or encourage the human act but to mesmerize the individual through the total unity of the environment in which he is placed"; he described the epic spiral of the Guggenheim Museum (1959), Wright's last masterpiece, as a monument to "the mobile, mass-moving aspect of American democratic mythology."[13] But this was in keeping with an environment in which "every aspect" of life was being mobilized in service to an abstract and totalizing worldview.

The new Air Force Academy at the base of the Rampart Range of the Rocky Mountains in Colorado Springs (1954–1958), designed by Walter Netsch of Skidmore, Owings & Merrill, was the absolute architectural expression of the waging of "total peace."[14] Lawrence C. Landis, a member of *Fortune*'s editorial board, called it "a new national monument in the west" and a symbol of "a daring new concept of war."[15] In his State of the Union address, Eisenhower marshaled explicit symbols. ("I want to wage the Cold War in a militant, but reasonable, style," he said to Senator Styles Bridges in late 1957.)[16] On the one hand, the "chariot of expansion" was the first Soviet Sputnik satellite (rocketed into orbit in October 1957), but on the other hand it was also the ICBM, the intercontinental ballistic missile. The balance of terror ("the sword of Damocles remains suspended," Secretary of State John Foster Dulles said) between the United States and the Soviet Union would be maintained through the advancement of "new weapons systems," especially missiles. Like General Motors' 1958 Chrysler Imperial, one of the best-selling cars of the year, they were given archaizing names, such as Jupiter, Atlas, Atlantis, Dynasoar, and Thor.[17] These "weapons of expansion" were the sacrament of the New Faith, democracy; and of the New Look doctrine, which privileged air power over traditional land and sea forces.[18]

In terms of scale and siting, the Air Force Academy's architectural ante-cedents were ancient Egyptian burial temples like Queen Hatshepsut's tomb at Deir el-Bahari, Greek oracular sites like the Sanctuary of Apollo at Delphi, and the Athenian Acropolis. *Architectural Forum* put it this way: "Dramatic earth forms dominate not only the background, where the Ram-part Range of the Rockies climbs darkly up behind the buildings, but also the foreground, where architects Skidmore, Owings & Merrill have shaped the slopes as powerfully as the Babylonians, the Incas, and the Greeks once did."[19] Owings called the academy "our modern acropolis," while congress-men called the efforts of the firm "Olympian."[20] These were numinous sites of death and mysticism. Christian Norberg-Schulz has described the Tomb of Hatshepsut (1511–1480 BC) as "the full materialization of axially organized orthogonal space."[21] A series of ramps leads up to a sequence of sizeable terraces embedded in the mountain of Deir el-Bahari: "vertical axiality is unified with the theme of the longitudinal path in an expressive synthesis."[22] Vertical and horizontal thrust meet at an imaginary 90-degree angle inside the tomb, linking it to the greater forces of the universe. The façade is nes-tled into the base of the mountain, and comes into view as one travels up the ramps. Its unadorned posts and lintels form a "highly ordered and formalized" system of rectangular bays on two stories.[23] The stark repetition of posts and lintels creates a sense of "spatial abstraction," signaling – and this is the important point – "an eternal order in symbolic form"; unlike the pyra-mids of an earlier age, at Hatshepsut's tomb "existential security is no longer symbolized by means of indestructible masses, but in terms of a repetitive abstract order."[24]

The Air Force Academy is similarly organized in a sequence of expansive terraces that lead to daunting frontal confrontations with abstract, opaque façades. It is divided into three plateaus separated by the site's natural series of mesas. Visitors drive up past two service-and-supply areas before reaching the academy itself, which is enclosed by a high retaining wall and secluded by a bluff – a ceremonial approach indicating the rarefied ritual atmosphere at the top. All seven of the academy's buildings are constructed of glass, aluminum-clad steel, and white marble. At the center stands a cha-pel with seventeen soaring faceted steel and glass bays, which synthesizes themes drawn from multiple historical examples including Charlemagne's Palatine Chapel at Aachen (805 AD) and the royal chapel of Sainte-Chapelle in Paris (1248).[25] On the academy buildings the repetitive rhythm of glass, aluminum, and marble panels creates the same sense of existential security and dread as at Hatshepsut's tomb. The chapel is a temple to the techno-

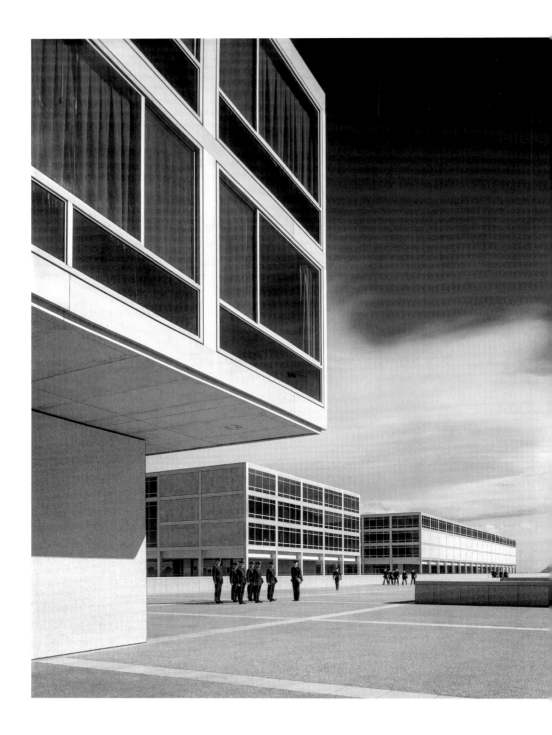

2.2

Walter Netsch/Skidmore, Owings & Merrill, U.S.
Air Force Academy in Colorado Springs,
Colorado, 1957, Hedrich-Blessing, © Chicago
Historical Society.

2.3

Tomb of Hatshepsut, Deir el-Bahari, Egypt,
1511–1480 BC, © Allan Langdale.

logical sublime. The site also embodies the mythology of the American West, the cowboy's loner status, America's historic moral isolation from the world – "the loneliness of world leadership," as Dulles wrote in "Our New and Vaster Frontier," a manifesto published in *Life* magazine in December 1957 as part of the build-up to Eisenhower's State of the Union speech. The remoteness of the site sets the moral tone for one's encounter with the architecture.[26]

The chariot metaphor, meanwhile, reverberated throughout mass culture. It was carried to its ultimate ends in an unexpected source: *Ben-Hur* (1959), William Wyler's Oscar-winning remake of Cecile B. DeMille's silent film from 1925, which was based on Lew Wallace's novel *Ben-Hur: A Tale of the Christ* (1880). The chariot race sequence (which takes up nearly ten minutes of screen time and required a small army of second-unit directors) is a Cold War cultural touchstone. Unjustly condemned to slavery by his childhood friend turned arch-nemesis Messala, commander of the local Roman garrison, Ben-Hur (played by Charlton Heston) is tossed across the Mediterranean world and taken up into Roman society, where he becomes a champion charioteer. After returning to Jerusalem, and believing that his mother and sister (who were unjustly imprisoned and have been condemned to a leper colony) are dead, he agrees to race against Messala as a form of revenge. An intoxicating mix of ambition, animus, lust, and power, the race is both the narrative and cinematic climax of the film. It begins with a minutes-long pageant of the charioteers and their quadrigas around the arena. Messala drives a red chariot emblazoned with profligate gold ornament (symbolizing the Soviet "chariot of expansion") drawn by four black stallions with red harnesses, while Ben-Hur drives a pure white chariot adorned with gold latticework joined by circles (symbolizing "total peace") drawn by four white stallions. At the peak of the race, as Ben-Hur strains his neck to look back at the carnage, barely in control of his chariot, which nevertheless glides on, the terrifying serrated blades on the hubs of Messala's wheels suddenly twist inward (like his warped soul) and consume his own chariot. Soon after, Ben-Hur witnesses Christ's Crucifixion and experiences a divine awakening, while his mother and sister, with whom he has been reunited, are miraculously healed.

The government aimed to attract the attention of the public by treating the Air Force Academy as a VistaVision cinematic spectacle, which, like the sword-and-sandal films, mixed ancient tales with modern ideals. There was in fact a direct link between the academy and the films: DeMille, in the midst of directing *The Ten Commandments* (1956), was hired by the government as a consultant on the project.[27] John Jensen, one of many designers who

worked with Edith Head on the movie's costumes, designed the entire array of winter, spring, and summer cadet uniforms. Because the academy was inaccessible to the public, the sense of spectacle had to be communicated in photographs. "The purpose of photographing these buildings," wrote Akiko Busch, "was not simply to record the built world; rather, the visual document acted almost as a treatise, clarifying and elucidating not only the physical facts of the architecture, but its less material truths as well."[28] This was especially true of the academy, which embodied the "industrial, military and scientific" metastasis that Eisenhower first described in his 1958 State of the Union speech, and later warned the public about in his 1961 Farewell Address to the Nation, in which he coined the concise but more menacing neologism "the military-industrial complex."[29]

In economic terms, the corporate model of growth envisaged by the men of *Fortune* in the late 1940s and early 1950s had borne fruit, giving rise to multinational corporations. The Man in the Gray Flannel Suit gave way to "The Biggest Broker in the World" – the title of a Merrill Lynch profile in the August 1960 issue of *Fortune* – while the wife of management became his "Swan," Truman Capote's infamous term for the brittle but supremely elegant wives of New York's mass-media tycoons (such as Babe Paley, wife of Bill Paley, the broadcasting visionary and chief executive of CBS, who took a small chain of ragtag radio stations and built them into one of the world's biggest communications empires). Middle-class executives and their suburban homes were now dwarfed by the power-brokers who had become staggeringly rich, and the totemic business fortresses they were building for themselves. "With its immense and continually growing operations on the Big Board and other exchanges, the company faces an ever growing traffic problem," *Fortune* said, explaining the need for bigger skyscrapers and corporate campuses.[30] With this already phenomenal rate of growth, it predicted "still huge profit-making potential," and listed the places where Merrill Lynch was expanding its business: "Zanesville, Hong Kong, Castro's Havana, in Grand Central Station, and under tents at county fairs."

Describing the construction of the new CBS skyscraper in his memoir, Paley says: "Anyone who has ever become involved in building his own custom house will understand the agonies, the indecisions and the decisions involved."[31] In other words, this was *still* the democratizing narrative of *Mr. Blandings Builds His Dream House* (which began life as a 1946 article by Eric Hodgins in *Fortune*, as part of the same series of articles as Russell Davenport's "The Greatest Opportunity on Earth") – only now the house was a skyscraper colossus. Paley describes receiving granite samples for the

façade as if he were an ancient potentate accepting gifts from supplicant peoples: "we had people sending us pieces of granite from all over the world, from Africa, Japan, Norway, Sweden, Germany, France, Spain, Portugal, Canada, and the United States ... granite would retain its beauty as long as the building stood ... the building would be built to last a hundred years."[32] Saarinen played right into this narrative when he nicknamed the building "Black Rock," as if it were something out of a science-fiction fantasy set in the Dark Ages (it was Canadian black granite from Quebec, which in a certain light has a grayish-pink tint).

These tales also help to account for the popularity of mosaic murals at the time: you can find them on both masterpiece projects and suburban supermarkets. The underside of the noble, classicizing canopy on the Seagram Building is a luminous gold mosaic; as are the undersides of the arcades of the three main theater buildings at Lincoln Center. Victor Gruen's more quotidian City National Bank (now Bank of America) in Palm Springs, California (1959), sports a jubilant turquoise mosaic wall, which curves around a thick corner to meet a vibrant yellow mosaic wall on the other side – Gruen modeled the bank on Le Corbusier's chapel at Ronchamp. Less than a decade earlier, glass- curtain-wall banks such as Manufacturers Trust on Fifth Avenue in New York (1948) had served as symbols of the transparency of American democracy; now "The Face of Finance," according to the Mosaic Tile Company, which mass-produced mosaic tiling systems for both residential and institutional buildings, was the "Mosaic Medley" on the façade of First National Security Banks nationwide. In antiquity, the mosaic was an "international style"; it flourished in the Hellenistic period, and later, after the Roman Empire split in two, it served as a link between the Eastern and Western Imperial courts. Revived in the post-World War II American context as both corporate high style and suburban vernacular, mosaics linked the present to the past via the continuation of a great artistic tradition. Mosaics signified the multinational character of banking, but they also represented national security and epochal durability: the proverbial thousand years.

AMERICA ENTERS THE CERAMIC TILE AGE

Beginning in the late 1950s, companies that mass-produced marketed building products forged surreal conjunctions in their advertisements between ancient artifacts and modern technologies. Explicitly emphasizing textures and sensuous surfaces, these products transformed ancient architecture and sculptural objects into various forms of visual décor: wall and floor appliqué. The advertisements turn ancient monuments into cartoon abstractions

whose value is decorative and existential, rather than spatial or structural. They make visible the tremendous anxiety around the issues of artistic timelessness and beauty and permanence that were at the heart of Arendt's diagnosis of a crisis in culture. At the same time, seen through a "camp eye," they attempt to do something extraordinary: to reify ancient works of art and architecture into the prevailing system of mass production, to achieve a state of being timely as well as timeless.

"Byzantile by Mosaic" was a special branded line of tiles manufactured by the Mosaic Tile Company advertised as "elegance for moderns" and "the newest in architectural spirit derived from age-old inspiration." "America is Entering the Ceramic Tile Age," proclaimed another of their advertisements on the back cover of the upscale *Arts & Architecture* magazine (which sponsored the Case Study House Program) in 1958. Another company, Semastic, marketed their "Vinylex Decorative Tiles" with an illustration of the Hall of Pillars in the funerary temple of Sethos I, circa 1312–1298 BC, and the slogan: "HISTORY has been built upon tiles. In all the old civilizations, in cultures long lost, one still finds evidence of the tiled floor." One ancient civilization stands in for all: the products collapse characteristics common to "every great civilization."

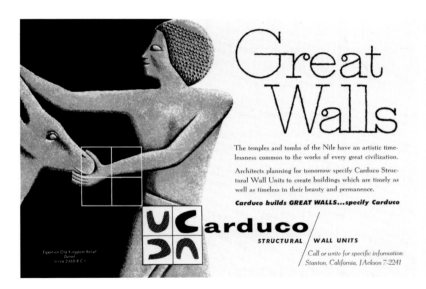

2.4

"Great Walls," Carduco Structural Wall Units,
Arts & Architecture, February 1958.

One advertisement in Carduco's "Great Walls" campaign showcases an Egyptian Old Kingdom relief from around 2460 BC. Another sports a cartoon of a relief sculpture depicting an Assyrian winged being offering a pomegranate branch (825 to 820 BC), while in yet another – the best of the bunch – a miniature Parthenon floats in a sea of white space amidst Carduco's "Harlequin Textured Units," which replicate the Doric colonnade on the deeply shadowed Parthenon portico as a boomerang pattern.

The ancient Egyptian portrait bust of Queen Nefertiti turns up again and again in a series of advertisements for Virginia Metal Products, which produced "Permacolor Mobilwalls," brightly colored partitions for corporate offices. In "Color that defies time," a full-page grid of eight pastel color blocks is superimposed over the bust; the color cues come from the bust, but the company boasts that its industrially produced hues are "far more rugged than the colors that still shine vividly on this head of Queen Nefertiti after some 3300 years." The bust appears twice in a double-page spread for "Accent Monoline Mobilwalls," first in a thumbnail image placed above a geometric abstraction, which reveals the quality of "utmost unit flexibility" hidden in the bust's ageless, obdurate form. A colossal dollar sign hovers ominously above, implying cost-effective design solutions; but the juxtaposition of bust and dollar sign signals a conflation of timeless artistic values and modern industrial values – the true subject of the advertisement. On the second page, the bust is placed on a pedestal at center rear, seen in deep perspectival view framed by a succession of mobile window walls as if it were a piece of sculpture on display in an executive's corner office. Flexibility becomes a metaphor for the way the ancient bust moves freely through post-World War II American culture, sign of a civilization in flux (in reality, it was on view in the Egyptian Museum in West Berlin). In these advertisements, it is literally in the process of being reoriented, actively reframed by an industrial economy that sees only dollar signs when it looks at art and ancient artifacts.

–

2.5

"New Harlequin Textured Units,"
Carduco Structural Wall Units, *Arts &
Architecture*, June 1958.

2.6 (following pages)

"Furamic Styling," Virginia Metal
Products, *Architectural Forum*,
September 1959.

FOR A FRACTION
OF FORMER COST
Furamic Styling
in Permacolor
brings you utmost
unit flexibility

FURAMIC STYLING sets an exciting new fashion with new

accent
MONOLINE MOBILWALLS

accent on thrift, accent on style, accent on mobility

Office designer and company controller talk the same language . . . when they talk in terms of new VMP Accent Monoline Mobilwalls. Here is the smartness of modern, fully-flush partitioning, with a subtle accent line between panels. Here is the time-defying beauty of VMP Permacolor. Here is matchless unit flexibility.

But here, too, is a new engineering simplicity to make possible a first and last cost far below that of any comparable product. A simplicity that permits panels to be interchanged without "jackknifing" or disturbing whole runs of partition. For example, a single panel may be changed in

just five minutes. Or a door installed between offices in as little time. Or if a new office arrangement is needed your Accent Monoline Mobilwalls may be quickly relocated by your building maintenance crew.

Ask your VMP Representative to show you the capabilities of new Accent Monoline . . . in Furamic Styling that lets you specify color, arrangement, accessories to fullfill *your* concept in mind.

VMP
VIRGINIA METAL PRODUCTS, INC.

Orange, Virginia · Offices or Representatives in All Major Cities
A Subsidiary of Chesapeake Industries, Inc.

SEE SWEET'S 1959 ARCHITECTURAL FILE (22a/vi) for 60 pages giving specifications and design advantages of all standard VMP Mobilwalls . . . and suggesting some possibilities of Furamic Styling in Permacolor. "Mobilwalls designed with your concept in mind."

Architecture, Mass Culture, and Camp

Arendt was not a mass culture theorist, like Walter Benjamin, Theodore Adorno, or even Dwight Macdonald. In *The Human Condition*, she mentions mass culture in passing as a symptom of (what she perceived to be) the widespread sense of unhappiness in a consumer society, at the pit of which was a growing hunger that could never be gratified. She was not included in Rosenberg and White's volume, but she did participate in the Tamiment symposium. Her contribution, "The Crisis in Culture: Its Social and Its Political Significance," was part of her wider investigation into tradition in the modern age, and an extension of her inquiry into the capacities of thinking and judgment. What was at stake for Arendt in the transformation of "culture" into "mass culture" was nothing less than "the objective status of the cultural world," and the way in which cultural objects "give testimony to the entire recorded past of countries, nations, and ultimately to mankind."[33]

Arendt depicted the mass-cultural landscape as a holocaust of art, and echoed Benjamin when she darkly intoned, again and again, the "tremendous shattering of tradition" – this is the refrain of his epoch-defining 1936 essay "The Work of Art in the Age of Mechanical Reproduction," which Arendt would later include in *Illuminations* (1968), the first selection of his writings translated into English, which she edited and introduced. She was concerned about the erosion in a consumer society of the concept of "use-value" and the inherent durability of those things that gave meaning to man's presence on earth (what she called "the human artifice").

"The Crisis in Culture" was Arendt's entry into an already well-established genre of mandarin cultural criticism that took a categorically dim view of mass culture. To a large extent, she rehashed arguments by Clement Greenberg and Dwight Macdonald, while also drawing on Benjamin. The customs of cultural philistinism as they had been understood since the eighteenth and nineteenth centuries had changed: "this society [mass society] is essentially a consumer's society where leisure time is used no longer for self-perfection or acquisition of more social status, but for more and more consumption and more and more entertainment."[34] In order to appease the "gargantuan appetites" of the masses, Arendt says, "life itself reaches out and helps itself to things which were never meant for it. The result is, of course, not mass culture, which, strictly speaking, does not exist, but mass entertainment, feeding on the cultural objects of the world."[35] Her essay builds to an agitated, apocalyptic crescendo, which is satisfying from a literary standpoint, but acutely alarmist: "Mass culture comes into being when mass society seizes upon cultural objects, and its danger is that the life process of society (which like all biological processes insatiably draws everything available into the

cycle of metabolism) will literally consume the cultural objects, eat them up and destroy them."[36] Moreover: "The point is that a consumer's society cannot possibly know how to take care of a world and the things which belong exclusively to the space of worldly appearances, because its central attitude toward all objects, the attitude of consumption, spells ruin to everything it touches."[37]

What was she talking about? One possible answer is the building trade advertisements – not the advertisements themselves, but the ethos they exhibited, a disrespectful attitude toward the work of art and a conflation of timeless artistic values with cost-cutting economy and industrial utility. For Arendt, like Benjamin, the work of art was imbued with "creativity and genius, eternal value and mystery," which the industrial-economic ethos liquidated.[38] He was interested in changing *modes of perception*; she, by contrast, was interested in *modes of consumption*. In the epilogue to "The Work of Art in the Age of Mechanical Reproduction," Benjamin describes a surplus of the means of production: "the vast discrepancy between the means of production and their inadequate utilization in the process of production," which, he argued, would result in one thing: "the horrible features of imperialistic warfare," which feeds on "human material," a "human stream."[39] Arendt sees a similar surplus of the means of production, but significantly, in the post-World War II period, the process of production had caught up, and it was now feeding on culture.

One of the conclusions to come out of the Tamiment symposium was the acknowledgement that the tensions within mass society would have to be worked out from within mass culture; that extreme forms of intervention were no longer really a possibility in the postwar American context – neither the old aristocratic class distinctions nor the historical avant-garde could be reconstituted; there were now only different forms and levels of accommodation, degrees of compromise. Both Arendt and Greenberg turned to Immanuel Kant as guide for a possible way out of the crisis in culture. In his influential essay "Modernist Painting," first delivered as a radio broadcast by Voice of America in 1960 and later widely anthologized, drawing from Kant's analysis of "method" and "discipline" in the *Critiques*, Greenberg developed the idea of "medium-specificity" as a way for art to reassert its "autonomy" and save itself from being subsumed by other forms of culture; painting, in particular, would now focus exclusively on attributes that were unique to the medium. This represented a kind of retreat: the artwork would now turn in on itself, and the art critic, in assessing its value, would focus solely on those qualities that were intrinsic to its production. Greenberg thus sought

to revive and to save the avant-garde's emphasis on artistic "techniques" and "devices" while jettisoning its engagement with the actually existing conditions of society.

In the second half of her essay, Arendt digs through the dense thickets of the Roman origins of the concept of culture, and offers an exegesis of Kant's third *Critique*, on judgment. Echoing Karl Jaspers's invective against "humanism of the literati" in his essays on existentialism earlier in the decade, she criticizes self-styled "experts": "The truth is we all stand in need of entertainment and amusement in some form or other, because we are all subject to life's great cycle, and it is sheer hypocrisy or social snobbery to deny that we can be amused and entertained by exactly the same things which amuse and entertain the masses of our fellow men."[40] This was a not so veiled critique of critics such as Greenberg on the one hand, and Macdonald (who, in his 1960 essay "Midcult & Masscult," first published in the *Partisan Review*, made a case for what we today would call "niche audiences") on the other: highbrow critics who ignored mass culture altogether, and middlebrow critics who waded through the mass-cultural muck, but pined for a return of High Culture. In the end, again echoing Jaspers, she champions the figure of the humanist who is interested in everything, but who, through the exercise of judgment, can make necessary, reasoned distinctions, and thereby bring the concepts of beauty and culture back to bear on the political in a more balanced way. But Arendt could not identify who that figure was in a democratic mass society.

Susan Sontag's "Notes on Camp," first published in the *Partisan Review* in 1965, appeared at the tail end of these debates, and was a critique of earlier analyses. "Outraged humanists, please note. There is no need for alarm," she declared in "One Culture and the New Sensibility" (1965), a kind of coda to her essay on camp, while going on to explain to her elders in the New York intelligentsia how mass culture was ushering in a greater range of "sensations" and "a new, more open way of looking at the world and at the things in the world, our world."[41] This was probably an answer to Arendt who, in *The Human Condition*, expressed grave concerns about "The Thing-Character of the World." The subversive, even radical charm of camp sensibility, as Sontag defined it, was that it illuminated the tensions in mass culture in profane but playful ways; it responded to mass culture in ways that could potentially offset its more catastrophic effects, but without being strictly speaking avant-garde.

—

Sontag was an acolyte of Arendt. In "Notes on Camp," she reveals the limits of Arendt's argument and pushes beyond them. In the prologue to *The Human Condition*, Arendt held that there was "no class left, no aristocracy of either a political or spiritual nature from which a restoration of the other capacities of man could start anew."[42] Sontag answered: "Aristocracy is a position vis-à-vis culture (as well as vis-à-vis power), and the history of Camp taste is part of the history of snob taste, but since no authentic aristocrats in the old sense exist today to sponsor special tastes, who is the bearer of this taste? Answer: an improvised self-elected class, mainly homosexuals, who constitute themselves as aristocrats of taste."[43] She identified the new social type who understood where to find beauty and how to judge it amidst the quickly shifting planes of mass production and consumption. "Camp is the answer to the problem: how to be a dandy in the age of mass culture," she declared, and almost as if in direct response to both Benjamin *and* Arendt, she added: "Camp – Dandyism in the age of mass culture – makes no distinction between the unique object and the mass-produced object. Camp taste transcends the nausea of the replica."[44] The camp dandy was a new humanist.

Camp sensibility had a rigorous period-specificity. (It was not the free-floating catchall concept it has become today.) "Unmistakably modern, a variant of sophistication," it was a mode of sociability operative "among small urban cliques," mainly in New York in the late 1950s and early 1960s.[45] Sontag responded to the avalanche of critics who labored to give every new stylistic tendency a name: in writing about camp she sought to "draw its contours," to "be tentative and nimble," elliptical rather than exacting.[46] In the course of her fifty-eight theses, she modifies and qualifies camp's meaning many times.

The practitioner of camp was more performance artist than expert. He reenacted the Arendtian dialectic between "care for the world and the things in it" and "the attitude of consumption [which] spells ruin to everything it touches" as a form of performance art. He took all those useless unique durable objects and put them back into circulation as beautiful but bizarre fetish objects. Mannerist paintings by Pontormo and Il Rosso, rococo churches, Art Nouveau, and Balanchine's ballets are all named as choice samplings in the camp treasury.[47] Such things were not inherently camp, they were innocent, "naïve," "serious"; it was the "camp eye" that had the power to discover the camp quotient in them.[48] My point is that the camp dandy enacts the same process as the building trade advertisements, fixing on ancient, obdurate works of art, which are connected to dead ideologies and obsolete social systems, and making them useful by linking them to a

new lingo: the language of mass production and consumption. The camp practitioner plays with concepts of "utmost flexibility" and industrial utility, timeliness and timelessness, just like the advertisements. In this way, he transforms a debased process into a new form of ecstatic experience.

Camp is the descendant of Surrealism. Sontag's "small urban cliques" who practice "a certain mode of aestheticism" are the heirs of the surrealists, whom Benjamin described in his 1929 essay "Surrealism: The Last Snapshot of the European Intelligentsia" as "a closely knit circle of people pushing the 'poetic life' to the utmost limits of possibility."[49] Sontag's repeated emphases on camp sensibility's "double sense," its susceptibility to "a double interpretation,"[50] recalls Benjamin's description of "the dialectical kernel" at the core of surrealist art.[51] The surrealists fixed their gazes on "the outmoded": "the first iron constructions, the first factory buildings, the earliest photos, objects that have begun to be extinct, grand pianos, the dresses of five years ago, fashionable restaurants when the vogue has begun to ebb from them."[52] For Benjamin, the surrealists were "the first to perceive the revolutionary energies" embedded in these decaying artifacts, and "to bring the immense forces of 'atmosphere' concealed in these things to the point of explosion."[53] His essay rings with the sound of explosions, because he hoped surrealism would spark a revolution in bourgeois consciousness. Sontag's camp dandy similarly focuses his gaze on "old fashioned, out-of-date, démodé" objects, and releases the ecstatic potential locked inside them.[54] Benjamin called this "profane illumination" and described it as "a materialistic, anthropological inspiration"; Sontag's camp eye is similarly inspired.[55]

Sontag at first argues that camp is "apolitical": "It goes without saying that the camp sensibility is disengaged, depoliticized – or at least apolitical," she writes at the outset of the essay, but in its insistence on "double interpretations," camp points to the kind of "poetic politics" Benjamin described.[56] If the aim of camp is to "transform experience," how could that not ultimately lead to a transformation of society? Sontag modifies her apolitical understanding of camp when she concludes her essay: "the connoisseur of camp sniffs the stink."[57] What was the stink? The stink of affluence, for, as she argues, "Camp taste is by its nature possible only in affluent societies, in societies or circles capable of experiencing the psychopathology of affluence."[58] On the one hand, the camp sensibility revels in the pluralism of mass society; on the other hand, however, Sontag's critique of affluence points to the problem of "surplus" that both Benjamin and Arendt diagnosed. She wants to turn this surplus into a well of feelings, an excess of new sensations. But what comes after the electrifying rush of discovery? The realization that

"it's good *because* it's awful."[59] Pop Art, by contrast, was "more flat and more dry, more serious, more detached, ultimately nihilistic" – an avant-garde stance. Although it is a "tender feeling," camp may also be ultimately nihilistic in the way it reenacts, as performance, "the destructive, cathartic aspect, that is, the liquidation of the traditional value of the cultural heritage" (Benjamin's wonderful phrase) in the consumer society.

–

The mid-century eye was a camp eye. I mean this literally in that there is "a materialistic, anthropological inspiration" at the heart of the building trade advertisements in the way they seek to illuminate the talismanic essence of a specific material form – such as mosaics. More broadly, mass culture was not the amorphous blob the mandarins feared, and the democratization of culture that the camp eye implies did not result in the holocaust of art that Arendt and others envisaged. On the contrary, it resulted in what Huntington Hartford rightly called an "arts renaissance" in his "Publisher's Note" in the October 1961 inaugural issue of *Show*, the magazine he founded to celebrate the arts in America.[60] The cliques ("mainly homosexuals") Sontag described included people such as Leonard Bernstein and Stephen Sondheim, Lincoln Kirstein, Jerome Robbins, and Rouben Ter-Arutunian (who collaborated with Balanchine on scenic designs for New York City Ballet) – some of the most talented writers, designers, directors, choreographers, and composers of the age. Through their work, camp sensibility crossed over (via new mass-media outlets) into the mainstream and became "the New American Style" (Hartford's lofty term). Sondheim's 1962 Broadway musical *A Funny Thing Happened on the Way to the Forum* took a vaudeville joke, joined it with ancient Roman farces, and spoofed the sword-and-sandal genre, but it was serious theater (and won the Best Musical Tony that year). The camp dandy, moreover, was as much a connoisseur of mass culture as of the Old Masters: he saw beauty in the artifice that resulted from the conjunction of high style and mass-cultural values; he could detect the glitter among the ruins.

Arendt was one of the first critics to recognize that "the highly non-respectable literature of science-fiction" was worthy of serious study inasmuch as it was "a vehicle of mass sentiments and mass desires," as she wrote in the prologue to *The Human Condition*.[61] "The Crisis in Culture" picks up this theme, and sounds at times like a science-fiction scenario. But it was Sontag, again, who took up this charge in her essay "The Imagination of Disaster" (1965), about science-fiction films of the 1950s and early 1960s. Science fiction is camp on a global scale. Like camp, it aestheticizes a catastrophic

cycle of mass production and consumption, only now it is not the unique cultural object that is destroyed and reified as a beautiful, bizarre fetish object, but civilization itself. Science fiction is analogous to camp in another way: the transformation of the world into visual decor: "a greater range of ethical values is embodied in the decor of [science-fiction films] than in the people ... things, rather than the helpless humans, are the locus of values because we experience them, rather than the people, as the sources of power."[62] Viewed through this lens, most of mid-twentieth-century American architecture can be construed as a form of science-fiction fantasy because of the way it was represented: eerily still photographs of corporate office interiors and suburban homes that highlight furniture and appliances at the expense of the people who presumably use them; but these people, with their prurient emotions and messy lives, have all mysteriously vanished.

Sword-and-sandal films produce the same compulsively thrilling sensation as science-fiction films — that is, as Sontag writes in "The Imagination of Disaster": "this intersection between a naive and largely debased commercial art product and the most profound dilemmas of the contemporary situation." This is yet another definition of camp sensibility, perhaps the most succinct, and it also speaks to the peculiar dialectic on view in the building trade advertisements.[63] Is there a better example of the transformation of culture into mass entertainment, and of a stylishly commercialized variant of camp sensibility, than *Cleopatra*, director Joseph L. Mankiewicz's infamous 1963 epic starring Elizabeth Taylor, Rex Harrison, and Richard Burton, which bankrupted Twentieth Century Fox and nearly ruined Mankiewicz's career?

Cleopatra looks at civilization through the largest camp eye imaginable: filmed in 70mm Todd-AO (an even larger widescreen process than Cinemascope), it synthesizes the histories of Plutarch, Suetonius, and Appian and plays by Shakespeare and Shaw, and crosses them with contemporary geopolitical concerns. Ancient Alexandria is a mid-century modern fantasia: John DeCuir's Oscar-winning sets look as if it they were constructed from Carduco's "Great Walls." Mammoth fluted Doric columns with giant lotus capitals, vast trellis screens with tiny lotus rosettes, continuous textured wall surfaces with Greek key reliefs, and other sculptural details, proliferate, along with massive slabs of travertine and endless mosaic-tiled walls and floors. (It could be argued that the film helped to create a market for ancient-inspired building trade products.)[64] At the end of the gorgeous title sequence, a crumbling Roman mural in vivid (almost lurid) colors by DeLuxe (orange, gold, indigo) suddenly springs to life and places us in the middle

of the action: Caesar has defeated Pompey, and dead Romans are strewn across the battlefield. Rex Harrison's Caesar speaks of "smoke and burning Roman dead," the blackness and the stink, recalling for 1963 audiences, even if indirectly, the smoking, burned-out cities of Europe at the end of the Second World War. Pompey has fled to Egypt, Cleopatra and her brother Ptolemy are at war, and Caesar has to sort it out.

Director and star knowingly zigzag from high to low, and between the serious and the frivolous. Taylor was already in on the joke when she demanded a million dollars (a record-setting sum at the time) to star in the film, and Twentieth Century Fox accepted. Most accounts of the production depict Mankiewicz as overwhelmed to the point of exhaustion as everything spiraled out of control, resulting in an "oddly formal, lifeless" film (as the British scholar Michael Wood wrote in 1975). But repeated viewings of the restored film and a more attentive interpretation of Mankiewicz's interviews reveal a director who turned the film's gaudy expansiveness into a critique of mid-century American affluence. Without pandering to the audience, he gives us the titillation of seeing Taylor naked in a milk bath (Mankiewicz was quoting DeMille, who had already staged this scene with Claudette Colbert in his 1931 version of the film), and literally ripping up the scenery in her on-screen tirades against Burton; but the film also offers surprisingly deep insights into post-World War II geopolitics, and the nature of both sovereignty and tragedy.

Late-Republican Rome equals might, while Alexandrian Egypt equals knowledge. There are lessons for America in both examples. The Romans here are the "barbarians," an insult Taylor's Cleopatra repeatedly hurls at Caesar in a barbed, shrill tongue. When they set fire to the Egyptian fleet, and accidentally – but indifferently – burn the Great Library to the ground, she offers a fiery defense of humanist learning. A proponent of historical preservation, Taylor's Cleopatra is a modernizing monarch and an illuminating force. At the end of her first encounter with Caesar (after she is unrolled from inside a Persian carpet and begins her wily seduction of him), as the Roman guards escort her to her chambers, she instructs them: "The corridors are dark, gentlemen, but you mustn't be afraid, I am with you." She advocates – and convinces Caesar of – the importance of modern map-making, technology, the natural sciences and mathematics, architecture (the legacies of both the Greek and Egyptian worlds are preserved in Alexandria's architecture), and new methods of governance.

Caesar and Cleopatra are often shown in profile, seated or standing in front of each other in debate. Cleopatra attempts to convince Caesar of the

necessity of taking up Alexander's dream of a "grand design" and, through the union of Rome and Egypt, finally making it a reality: "One World, one nation, one people on earth." The greatest of these scenes takes place in front of Alexander's tomb, a translucent marble funerary monument illuminated from within, situated in an indeterminate black box space and set against enlarged but fragmented sections of the famous Alexander Mosaic in the background (a Roman floor mosaic originally in the House of the Faun in Pompeii, now on view in the Naples National Archaeological Museum). Taylor wears a regal breast-baring purple tunic flecked with gold thread, and a gold headdress, while Harrison wears golden armor with breast-plated sculptural reliefs (DeCuir's design and Renié's costumes are the stars of this scene). If the film were staged as an opera today, critics might praise this scene for its conceptual, experimental approach. It is the climax of the first half of the film, when Cleopatra/Taylor, "mixing politics and passion," gains the upper hand and completes her seduction by revealing that she is pregnant with Caesar's son, who will "carry the cloak of Alexander and the sword of Caesar, and the name of Caesar."

In what now seems to me a hilarious coincidence, the young, brilliant Sontag who schools the mandarin critics in "One Culture and the New Sensibility" sounds a lot like Taylor's Cleopatra trying to convince Caesar of the promise of a more plural world. In this essay, Sontag offers a much more didactic analysis of the crisis in culture, but recapitulates the central argument of her essay on camp: "What we are witnessing is not so much a conflict of cultures as the creation of a new (potentially unitary) kind of sensibility. This sensibility is rooted, as it must be, in *our* experience, experiences which are new in the history of humanity."[65] Camp was a sensibility that substituted enjoyment, "a kind of love, love of human nature," for interpretation.[66] Sontag's point, again, was precisely that "established distinctions within the world of culture," such as those between "form and content, the frivolous and the serious, and … 'high' and 'low,'" perhaps also culture and entertainment, were being washed away.[67] The camp sensibility, the new sensibility, was one that could take in *everything* – through either sincere love of the beautiful, or a joyful form of cynicism.

THE SKYSCRAPER COLOSSUS, AND AMBASSADORS EXTRAORDINARY

By his own admission, in his only skyscraper – CBS's New York headquarters, on Sixth Avenue and 52nd Street (1961–1966) – Saarinen sought to rival or surpass both Mies's Seagram Building and Frank Lloyd Wright's Prairie Tower. In this building, he achieved a "total" synthesis of the two ideals of

architectural beauty in the 1950s and early 1960s: the limpidity of the glass curtain wall is joined with the imperial majesty of ancient monolithic architecture. Unlike the Seagram Building, which is set back from the street and raised on a platform, the CBS tower rises straight out of the ground, without a base, from a sunken plaza. Just before his death in 1961, Saarinen wrote to Bill Paley and Frank Stanton (Paley's deputy): "I think I now have a really good scheme for CBS. The design is the simplest conceivable rectangular freestanding sheer tower. The verticality of the tower is emphasized by the relief made by the triangular piers between the windows. These piers start at the pavement and soar up 424 feet. Its beauty will be, I believe, that it will be the simplest skyscraper statement in New York."[68] From certain angles the massive triangular piers disappear and the façade appears to be all dark glass, while from other angles the piers obscure the windows and the façade appears to be solid stone.

The primary and pastel color schemes of the early and mid-1950s are banished. On the interior, the Knoll Planning Unit devised a Byzantine color palette of gold, russets, whites, olives, azures, and vermillion reds. In the lobby, black granite slab floors are counterpoised with white Roman travertine walls. Saarinen's concept was that every office should be a corner office, so the offices are column-less free-span spaces, but ironically, according to one employee, although "the consolidation at Black Rock was supposed to integrate operations ... it became a divisive element. Black Rock was intimidating."[69]

The CBS tower was one of an army of new skyscrapers that ascended on Sixth Avenue directly behind Rockefeller Center, beginning in 1957 with the new Time & Life Building. Situated diagonally across the street from CBS, the Time & Life skyscraper was designed by Wallace Harrison (Saarinen and Girard designed the lobby restaurant, La Fonda del Sol). When it was originally built, in the 1930s, Rockefeller Center turned its back on Sixth Avenue. The conglomerate that controlled Rockefeller Center had wanted to develop its west side as early as 1939, when the elevated subway there was demolished; in 1945 Sixth Avenue was renamed Avenue of the Americas in an attempt to make it more attractive to prospective occupants, but it was only after Luce moved his headquarters there that development began in earnest.[70] Harrison, the chief architect of Rockefeller Center, was a link between the old and new buildings, but unlike the earlier effort, there was no master plan tying the redevelopment of Sixth Avenue together. The towers at Rockefeller Center form a jazzy Art Deco ensemble; each building on Sixth Avenue, by contrast, would exist in isolation as a colossus in its

own right. It came to be called the "Media Corridor" because the new towers mainly housed new mass-media empires, the counterpart to "The Park Avenue School of Architecture" across town, where the new skyscrapers housed beverage and petrochemical companies, and investment banks.

These buildings were as much visual phenomena as structural edifices. This was in fact how Thomas Creighton described Mies's Seagram Building which, he felt, destroyed Park Avenue's proportions.[71] Writing in a similar vein, the British architect Peter Smithson, foreshadowing Manfredo Tafuri's later criticism, characterized the Seagram Building's refusal to participate in the everyday life of the city: "375 Park Avenue is a fragment of a city of towers. But this city does not exist. What does exist is a corridor street called Park Avenue with its own 1958 life and therefore some right to continuing existence. Does the fragment communicate the dream, at the same time coming to terms with reality, or does it in any way not meet these requirements either by intention or default?"[72] For Smithson, the Seagram Building was not as real as Rockefeller Center, which was also a dream city of towers, but not "over-built" like Seagram.[73] Rockefeller Center's towers soared, but they still created a streetwall with shops, a space for pedestrian hustle and bustle. At Rockefeller Center, the reality of the street met the dream city at the top of the tower in the Rainbow Room. By contrast, Mies pushed his building fifty feet away from the street and framed the plaza with gigantic perimeter walls topped by green marble monoliths. As pedestrians walk past on either side of the plaza, the streets sink as the walls rise up higher.

The fashion magazine *Harper's Bazaar* perfectly captured the aesthetic of these skyscrapers in its caption for a Richard Avedon photograph on the cover of one of its annual beauty issues: "Massed shimmer." If the Seagram Building exudes an air of refusal, it may be in the spirit of "elegance is refusal," the fashionable *bon mot* that legendary editor Diana Vreeland stole from Coco Chanel. In fact, Louis Kahn critiqued Mies's building exactly along these lines in the talk he gave at the Congrès Internationaux d'Architecture Moderne (CIAM) in 1959. Kahn described it as a coy, sophisticated lady: "I can worry about the Seagram Tower," he said. "She is a beautiful bronze lady but she is all corseted inside. ... She is a beautiful bronze lady but she is not true"—just like the haughty-eyed, bronze-tinted "Swan" on the cover of the *Harper's Bazaar* beauty issue, clad in silver fox and silk turban, and dripping with diamonds.[74] Kahn's critique also finds an unlikely moral parallel in *The Best of Everything* (1959), which reveals the Seagram Building and the glamorous and glittering corporate world it represents to be a façade.

Bunshaft's Union Carbide building (1957–1960), a few blocks south of the Seagram Building, and Pepsi-Cola headquarters (1958–1959), a few blocks north, are usually given short shrift compared to Lever House, but they achieve a richness of effects that rivals, if not surpasses, Seagram. At Union Carbide, the slab block is no longer a billboard advertisement, like Lever House, but a manifestation of the power of petrochemicals on the surface of the earth: the company produced chemical products for the manufacture of plastics. The tower fills its entire site, rising fifty-two stories and taking up an entire city block. As the scale increases, the glass curtain wall expands and achieves a state of grand translucence. As the sheets of glass become larger, the aluminum rails covering the mullions that lock the sheets in place become thin silver pinstripes. Pepsi-Cola is more of a pavilion than a skyscraper, but nevertheless achieves a similar effect: the thinnest of all possible frames—strips of glinting brushed aluminum—supports huge panes of glass. Floor-to-ceiling metallic vertical blinds on the interior function as part of the façade, creating an iridescent impression on the exterior. Bunshaft brought the immense scale and rich ornamental detailing of Union Carbide and the delicacy and shine of Pepsi-Cola together in his design for Chase Manhattan Plaza (1957–1961) near Wall Street, the model for Minoru Yamasaki's World Trade Center (1966–1974).

—

2.7 (following pages)

Mies van der Rohe, Seagram Building, New York, 1958, © Ezra Stoller/Esto.

2.8 (following pages)

Harper's Bazaar, "Beauty Issue," October 1954, Cover photograph by Richard Avedon, © The Richard Avedon Foundation.

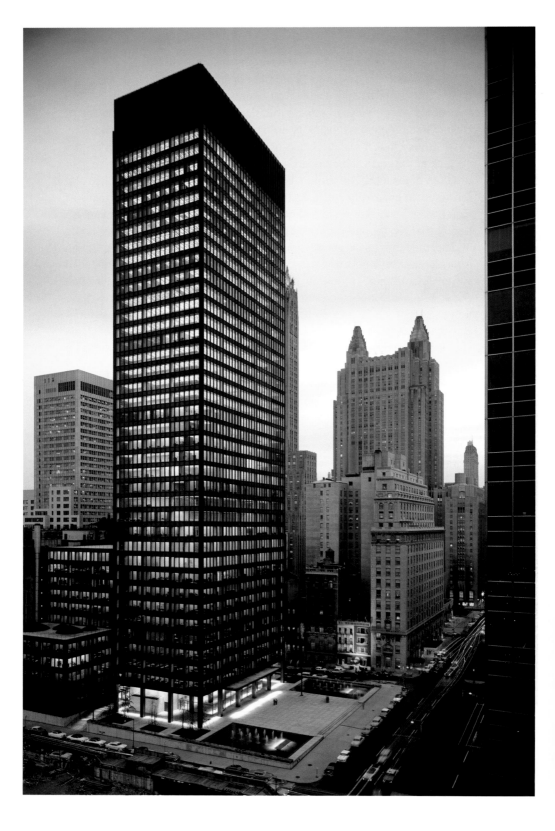

Architecture, Mass Culture, and Camp

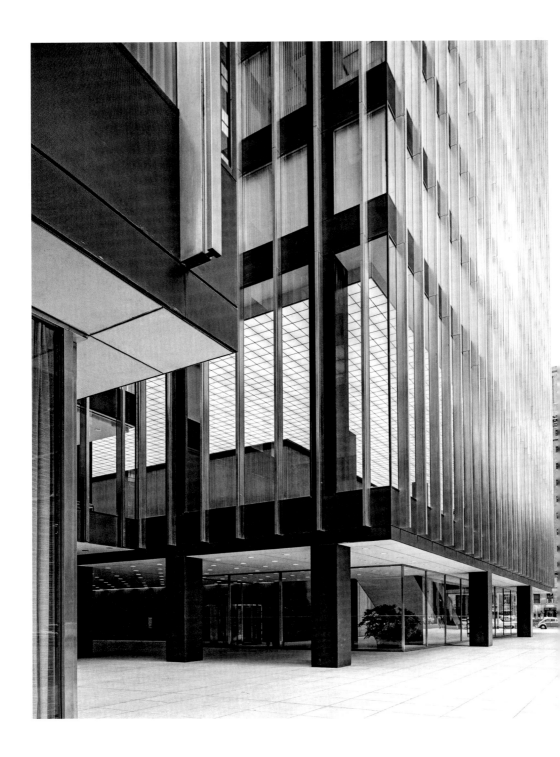

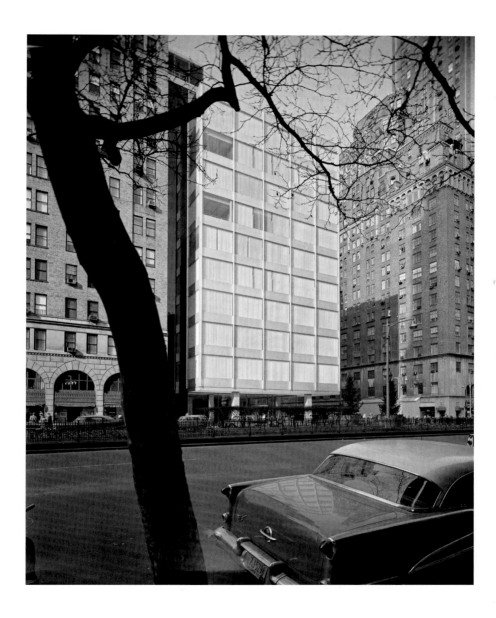

2.9

Gordon Bunshaft/Skidmore, Owings &
Merrill, Union Carbide, New York, 1961,
© Ezra Stoller/Esto.

2.10

Gordon Bunshaft/Skidmore, Owings &
Merrill, Pepsi-Cola, New York, 1960,
© Ezra Stoller/Esto.

Saarinen's U.S. Embassy in London (1956) was one of the first of the new embassies commissioned by the State Department's Foreign Building Office in the postwar decade to be completed. The State Department stipulated, predictably, that the embassy must "create goodwill by intelligent appreciation" of modern American design, while also maintaining the historic character of the Grosvenor Square site. Saarinen's concession to the spirit of the city was his anachronistic use of Portland Stone, a building material not used since Victorian times. Despite its giant Tic-Tac-Toe façade, the embassy looked, to young British architects, like a repudiation of their progressive-minded new brutalism. Reyner Banham called it "monumental in bulk, frilly in detail": "Observe, apart from the classical symmetry, the gold-anodized aluminum fins on the ends of the diagrid beams, the acres of marble so pure it looks like plastic, the ridiculous defensive 'bund' topped by a gilded fence and backed by a ditch that is rumored to be scheduled for filling with poison ivy, that lies all around the ground floor – a nice way to compliment an ally!"[75]

In the fall of 1963, CBS debuted a new documentary series: the era's biggest movie stars (Elizabeth Taylor, Sophia Loren, Grace Kelly) introduced American TV audiences to the foreign countries of their birth or residence. In "Elizabeth Taylor in London," Taylor serves as an ambassador to the British capital, introducing its cultural treasures and way of life. Dorfsman's advertisement for this program shows Taylor in ennobling profile in the foreground, with the Houses of Parliament in the background. A one-hour documentary, it nevertheless had the high production values and epic sweep of *Cleopatra*. John Barry composed the score, a symphonic poem intended to evoke scenes from British history and of British life ("English Garden," "Queen Elizabeth at Tilbury," "London at Dawn"; it was released by Columbia Records as an Original Television Soundtrack Recording). Fade in on the Houses of Parliament at dawn, the sun casting a golden glow in the London sky, like a Turner landscape painting. Cut to the dew-drenched streets and monuments such as St. Paul's Cathedral and London Bridge seen in silhouette. We hear Taylor before we see her: as she recites the opening lines of Wordsworth's poem "Upon Westminster Bridge" (1802), she slowly comes into view in flowing white chiffon, seen in profile, standing on the penthouse balcony of the Dorchester Hotel. The images we have been seeing are her own early-morning views from her perch high above the city. Slowly turning to the camera, she explains that she remembers London as a child, "larger than life, full of magic, full of wonder." The program, in other words, will not show us Swinging London, but, rather, a child's pastoralized view. Cut abruptly to a commercial for the program's sponsor, Chemstrand, an Alabama company founded

in 1949, "makers of fibers for the way we live today, Acrilan acrylic fiber, and nylon." It is as if Chemstrand has inherited the mantle of artists such as Turner and produced the colors of this radiant sunrise; and as if Chemstrand, multinational entity, has sent Taylor to Britain as "star diplomat."

Henry Luce's second wife, the celebrated playwright Clare Boothe Luce, was rewarded for her longstanding contributions to the Republican Party and to Eisenhower's 1952 and 1956 Presidential campaigns with two of the most glamorous ambassadorial appointments: Italy (in 1953) and Brazil (in 1959; although she was confirmed by the Senate, she declined the second appointment, due mainly to controversy surrounding her increasingly far-right views). Alden Hatch described Boothe Luce's appointment in a 1956 biography:

> In the whole history of diplomacy since the first Cro-Magnon chieftain sent his fastest talker to negotiate with the foreigners in the caves across the walls – for 50,000 years or more – no woman has held so important a diplomatic post as Clare Boothe Luce, Ambassador Extraordinary and plenipotentiary to the Republic of Italy. For Rome, always the center of the Mediterranean world, has become the court of courts at a crisis of history, since it is there that Communism comes closest to tipping the hairline balance of power between East and West. A slip on the part of the American Ambassador sends tremors though the fragile fabric of alliance of free nations. Complete failure on her part could lose the world.[76]

In fact, in the Italian press she was portrayed as a modern-day Cleopatra meddling in Roman politics.[77] She also came under fire from the Foreign Service establishment – not because she was a woman, but because she was an amateur (in fact she had served two terms as a Congresswoman representing Connecticut's 4th District, and was a seasoned orator). In 1957, before the confirmation hearings convened for the Brazilian post, Boothe Luce published a defense of her service entitled "The Ambassadorial Issue: Professionals or Amateurs?" in the policy journal *Foreign Affairs*. She attempted to discern the "merits of the amateur ambassador as opposed to the merits of the professional."[78] Here she showcased her true talent, which was as a playwright: all political speech is in quotation marks, as if it were a weird dialect.

2.11 (following pages)

Eero Saarinen, U.S. Embassy, London, 1960,
© Wayne Andrews/Esto.

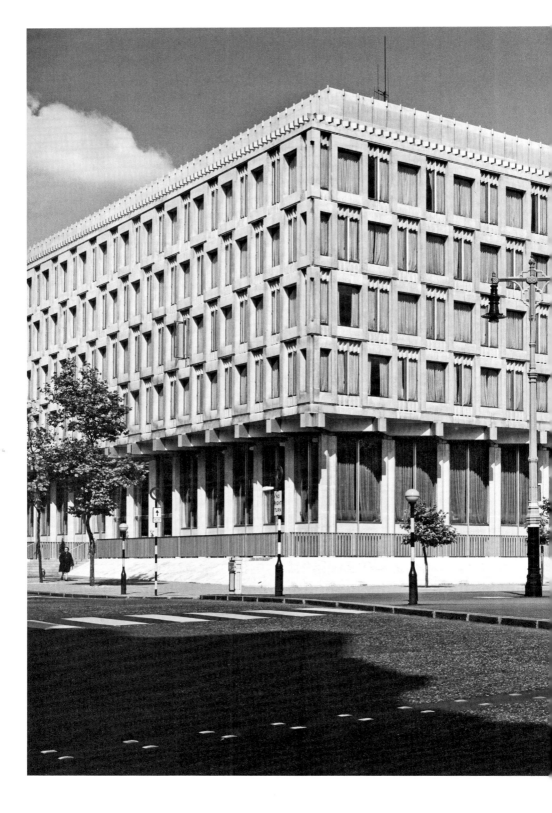

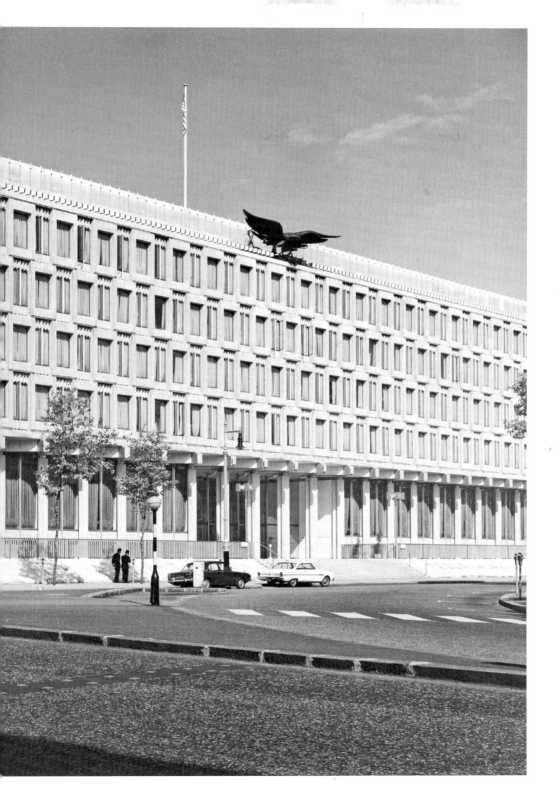

Reviewing the history of U.S. ambassadors abroad, beginning in 1893, Boothe Luce cataloged the posts traditionally granted to career Foreign Service officers and those granted to amateurs, and predictably, the amateur posts were the most prestigious: London, Paris, Bonn, Rome, New Delhi, and Madrid. She further cataloged who the amateurs were: all men, with the exception of one other woman, from the world of industry and finance, who, she argues, were experts in foreign affairs due to their extensive world travels. Listing the necessary skills, she argued that if speaking a foreign language were an essential trait — a charge that must have been leveled at her — "there would be no summit meetings" and "the United Nations would be forced to close its doors."[79] She laid bare the fact that these appointments were rewards for financial contributions, and further argued that they had to be given to people who could afford to subsidize the paltry appropriations granted by Congress to entertain foreign dignitaries and world leaders in a style befitting the new image America wished to project abroad. Most importantly, she pointed to Department of State Directive No. 6420, which described "the American ambassador today" as someone who "has to enact many roles on a very broad stage and in relation to a cast of great number and variety."[80] The ambassadorial post was part of the "drama of diplomacy"; the "diplomatic role" required a star, and was therefore better suited to the amateur. For Boothe Luce, diplomacy was literally a "foreign affair," as if that were the title of one of her smash Broadway plays, with arrivals and departures, wealth, romance, and the issuing of policy directives and declarations of intent.[81]

In *The V.I.P.s* (1963), a minor film (but a surprise hit) that opened a few months after *Cleopatra*, Elizabeth Taylor plays an international socialite married to a business tycoon, played by Richard Burton. She paces anxiously in the VIP lounge of London's Heathrow Airport, because she is running off with her young lover, a gigolo. All the characters are stereotypes of the new global order: there is a self-made Australian industrialist who must be in New York the following day to arrange for a loan that will enable him to prevent a giant multinational conglomerate from taking over his firm. Orson Welles plays Max Buda, a Fellini-like film director scrambling to escape the continent by midnight in order to evade a ruinous income tax bill; he travels with an entourage of hangers-on, including the bombshell in his newest film, played by Elsa Martinelli. A dense fog delays their takeoff. In this mid-century comedy of manners, fortunes are made and lost and lives are irrevocably changed while waiting in the airport lounge en route to various world capitals. In the end, their dilemmas are resolved in ways that allow them to maintain

their VIP status, usually by striking another multinational deal. The film holds little cinematic value — "Elizabeth Taylor in London" is visually more inspired — but then again the point was to portray these new jet-setting social types in the airport environment (in the 1930s the film would have been set on an ocean liner).

This is the world Saarinen envisaged when he designed the careening waiting halls in the TWA Terminal at Idlewild (later renamed JFK) Airport in New York, with their sea of vivid red velvet carpeting and circular marble islands out of which spring small marble-topped pedestal-tables and plantings. At TWA, the age of the robber barons, symbolized by the bulleted leather swivel chairs, met the Space Age, symbolized by the building's forceful sculptural body and curving glass curtain walls. Like the Air Force Academy on the Rampart Range, the TWA Terminal concretized middle-class movie fantasy.

Saarinen is sometimes depicted as an avant-gardist because of his attitude toward style, but was he a revolutionary? What Peter Smithson, writing in 1961, *contra* Temko, said about Saarinen's design for the embassy could be said to hold true for his *œuvre* as a whole: "We wanted it to be revolutionary, and we are puzzled why you ... should accept such frozen and pompous forms as the true expression of a generous egalitarian society?"[82] When Smithson characterized Saarinen's architecture as frozen and pompous, he was arguing against the grain of the mainstream American press, which saw Saarinen as the architect of a revived expressionism for an advanced technological age. In its heaviness the embassy embodied negative attributes of power. The structural details — the fact that the grille was weight-bearing, allowing for a column-free interior on the upper floors — were lost on critics like Banham, who were repelled by the jumbled exterior forms. A caricature of the building showed the monumental gilded American eagle perched atop the cornice taking flight, happily whisking the building away as its façade fell apart.

2.12 (following pages)

Eero Saarinen, TWA Terminal, Idlewild/JFK Airport, 1962, © Ezra Stoller/Esto.

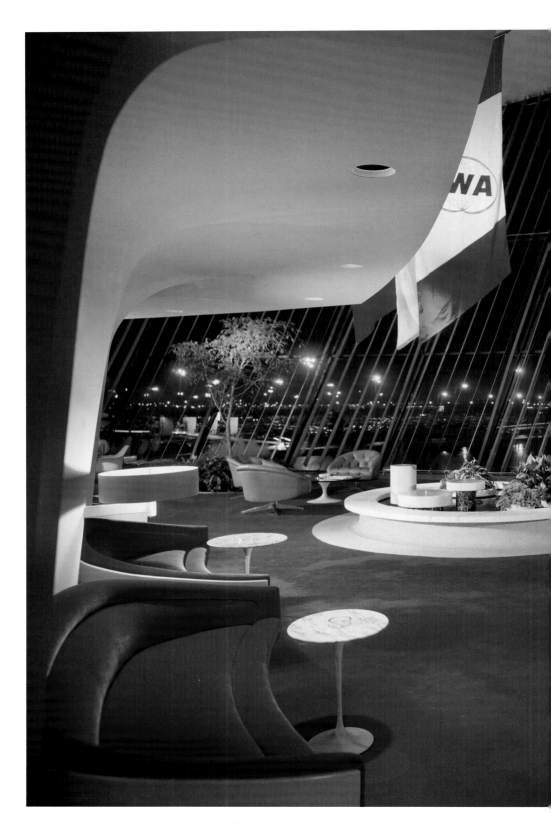

MARCEL BREUER BUILDS FOR HIMSELF

Marcel Breuer had achieved the passing success that came with being a designer of glamorous houses for suburban CEOs, but in his book *Sun and Shadow: The Philosophy of an Architect*, published in 1956, he revealed that he wanted to be a great architect, and to be a great architect one had to build on an epic scale: "We are interested here not in passing 'success,' but in historic achievement," he wrote. "We are interested in long-range improvement, in long-range progress – and not in passing successes that are achieved by the shortcuts of narrow action. This is not a problem characteristic of our period only. It is a problem forever. It is always the problem of great architecture." Historic achievement meant imitating "builders of the past," and great architecture meant the monuments of the ancient world: "the Egyptian pyramid ... the Roman arch ... Greek temples set up on stones."[83]

After his acrimonious break with Walter Gropius in 1941 – they shared a joint architectural practice while leading Harvard's Graduate School of Design – Breuer turned to shelter magazines to launch his solo career as an architect in America.[84] Joachim Driller and Isabelle Hyman have documented the numerous projects Breuer submitted to magazine-sponsored competitions in the early 1940s, all of which were oriented toward the design of affordable housing for the "average young American family" in the suburbs.[85] In these plans, Breuer sketched out what would become his signature "bi-nuclear" or "double-box" house, and argued that postwar man would "more than ever appreciate privacy and his intimate, complete milieu."[86]

Breuer offers a case study of an artist forged in the crucible of modernism who, in the post-World War II period, became entwined in the milieu of mass-market American shelter magazines; and who then sought to extricate himself from that compromising context. This is the story that emerges from my interpretation of *Sun and Shadow*. A child of the Austro-Hungarian Empire, Breuer came of age at the Bauhaus. He left in 1928, after the putsch that forced Gropius out. He briefly ran his own design studio in Berlin, traveled around Europe and North Africa, and lived in London for a few years before arriving in 1937 in the United States, where he joined Gropius at Harvard. In 1945, he moved to New York and opened his own architectural office. My point is that Breuer personified an ideal of worldliness that his American clientele – mainly Northeastern executives and entrepreneurs educated in the precepts of modern art – wanted to emulate. He was both "teacher and architect" (as *House & Home* said in May 1952), and could design both their homes and their lives.

Breuer was often depicted in the magazines as his own ideal client. In "Marcel Breuer Builds for Himself," an October 1948 profile of his house in New Canaan, Connecticut (the first of two), *Architectural Record* described how he mixed materials and textures: "Painted plywood throughout, except the ceiling of the living-dining entrance space, which is cypress boarding, and the larger bedroom, which is natural gum plywood. Floor surfaces are Haitian mattings, bluestone and black asphalt tile."[87] Breuer's "appeal" (as the magazines repeatedly stressed) derived from his ability to convert natural materials into luxuriously rich and evocative reflecting surfaces. His houses combined bourgeois affinities with worldly aspirations, high style with easy living — a kind of arch-aestheticism of practical relations. When his clients Helen and Preston Robinson wrote to Katherine Murrow Ford, editor of *House & Garden*, in 1947 to explain why they chose him over other architects (including Frank Lloyd Wright, whom they dismissed as "too totalitarian") to design their summer house in Williamstown, Massachusetts, they wrote of "the general feeling of well-being you have in his interiors (that we have to have). Furthermore ... there is also strong evidence of an evolutionary process going on."[88] In his distillation of natural materials, Breuer mimicked "man's metabolism with nature" and made his clients feel at home in the world.[89]

—

In *Sun and Shadow*, Breuer consolidated his experiences with one purpose in mind: to reorient his practice away from houses to corporate and government projects. It was his declaration of independence from the shelter magazines. This is the only way to account for the philosophy sections of the book, in which he responds, and seeks to deny, earlier magazine representations of his work. Renouncing "the intimate, complete milieu," and the self-reflexive images and profiles, he now declared: "Architecture is not the materialization of a mood ... it should not be a self-portrait of the architect or the client, though containing elements of both."[90] *House & Home* had stressed the simplicity of his design philosophy, but he now asserted, in a seemingly aggrieved tone: "It is certainly easy to oversimplify, to go in one direction and achieve a certain effect. We know that, we are exposed everywhere to specialized propaganda — salesmanship which stresses only one aspect of a product to the exclusion of everything else. It sells automobiles, even some architecture, but it does not tell the whole story." What was the whole story? "I like to think of the most luxurious house I have built as an experiment to find solutions applicable for general use. Again, I have found

155

Architecture, Mass Culture, and Camp

that my most individualist clients are receptive to this idea; they like to contribute to the social aspect of architecture."[91] The houses, in other words, were laboratories for design in which he could develop architectural solutions applicable to large-scale projects.

Further on in *Sun and Shadow*, Breuer does battle with the word that clung to him in the magazine profiles: "compromise." Clients such as the Robinsons chose him over other architects because he forged compromises between his aesthetic and their desires, between their dreams of sophistication and their children's daily lives, between modern life and the natural world. Now Breuer bristled at the very mention of the word: "Neither one-sided over-simplification, nor tuned-down compromise offer a solution, the real impact of any work of art is the extent to which it unifies contrasting notions – the opposite points of view. *I mean unifies, and not compromises,*" he emphasized.[92] Following the philosophical essays, each section of the book is a photographic essay on a specific building part: stairs, fireplaces, sunshades, and furniture. Photographed under extreme conditions of light and shade, and dramatically cropped to showcase the interplay of materials and textures, each form is turned into an abstract element in a photomontage. Breuer, the *Bauhausler*, momentarily reemerges to shatter the notion that the milieu he created in his guise as an American architect was a relaxed site for family leisure: the houses were experiments in form.

In 1955, when Breuer received the Compasso d'Oro from the Italian banking institution La Rinascente, the Italian art historian Giulio Carlo Argan was commissioned to write an essay to accompany an exhibition of Breuer's work at the company's headquarters in Milan. Argan's short monograph was part of his larger reevaluation of the Bauhaus: he had recently published a well-received book entitled *Gropius and the Bauhaus* (1951). When he first wrote to Breuer in November 1955, *Sun and Shadow* was just about to be published for the holiday shopping season. Breuer replied that he was pleased, but cautioned Argan that he "ought to see this book before [your] further decisions are made."[93] He wanted Argan to translate *Sun and Shadow* into Italian rather than write his own book; he wrote to his publisher, Edward Dodd of Dodd, Mead, Inc., to request that Argan be sent a copy of the book for "(possible Italian translation)."[94]

In the meantime, *Sun and Shadow* was published, and flopped. In January 1956, Breuer's close friend and client Rufus Stillman wrote to Dodd to complain about the lackluster marketing campaign: "To date, I have seen no advertising – but worse I haven't seen a single review of the book except a piece in *Newsweek* which was written by a personal friend of mine."[95]

Breuer's co-author Peter Blake, who was an associate editor at *Architectural Forum* at the time, wrote to Francis Brown, editor of the *New York Times Sunday Book Review*, and asked him to assign the book for review.[96] Dodd replied to Stillman: "the promotion of that Breuer book has been a rather exasperating problem for us," and blamed "Mr. Breuer himself."[97] Breuer then wrote to Dodd to take issue with this characterization.[98] In reply, Dodd told Breuer that he had "plenty of other causes" to worry about than arguing about his book.[99] Breuer told Stillman to drop the issue, but Stillman nevertheless wrote to Dodd again to say that he expected the book to be delivered into the hands of reviewers, "otherwise your efforts, and I think the book is beautifully published, and those of Mr. Breuer, Blake and Brodovitch are for naught."[100] Dodd ended this cycle of acrimonious correspondence by saying that everything that could be done was being done.[101]

Argan, alone among European and American critics alike in the 1950s, recognized the closed circuit around Breuer that this cycle of correspondence implies. He stripped away the self-affirming narratives that had been scripted by and for Breuer in the shelter magazines. He now also had Breuer's book in hand, and his monograph is more a response to *Sun and Shadow* than an analysis of his architecture. In a mocking tone that cruelly turns Breuer's words against him, Argan exposes the narcissism in Breuer's posturing about "transparency" and "opacity" and "backgrounds" and "backdrops" and "reflecting surfaces": "There is nothing in any way unworthy in conceiving a setting in transparent and crystalline terms, one which in some way mirrors the image of its owner and reassures him as to his own efficiency and excellence. For who of us in speaking does not at times experience a certain pleasure in catching unawares his own image reflected in the looking glass?"[102] But Argan did not stop there. He went further:

> Perhaps Breuer's ideal man is the modern professional man who, in all the activities of a busy day, is able to leave on those activities a clear mark of distinction, intelligence and taste, just as in his hours of leisure he is able to enjoy a good book or to choose a Picasso or a Matisse for the walls of his study. A taste for simple and indeed vaguely rustic forms is, like his taste for functional and technically perfect forms, an aspect of his frank, unprejudiced personality. But both these tastes are not so much the expression of artistic inspiration as they are the highlights of the portrait of a society, which he depicts against the backdrop of his own surroundings.[103]

Argan's analysis points to a possible camp reading of Breuer's houses. There is, first of all, his faux-rusticism, his conversion of local natural materials into rarefied textures, "a vision of the world in terms of style" (one of the

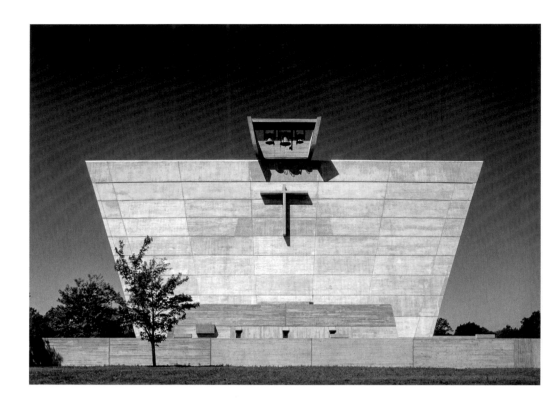

2.13 and 2.14

Marcel Breuer, St. Francis de Sales church in
Muskegon, Michigan, 1966, Hedrich-Blessing,
© Chicago Historical Society.

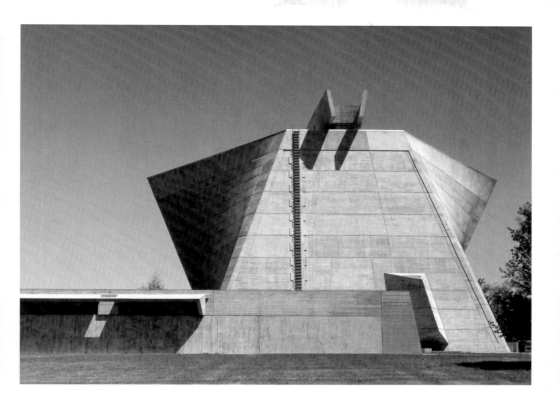

Architecture, Mass Culture, and Camp

defining characteristics of camp, according to Sontag). On the one hand, the pastoral quality of Breuer's suburban houses was of a piece with *Fortune*'s Arcadian image of the modern corporate landscape, but on the other hand the "urban pastoral" was indicative of camp. Breuer's "ideal man" shares with the camp dandy his aristocratic posturing, his self-conscious awareness of his own "distinction," and the self-satisfaction he experiences from having his tastes affirmed by a small, self-selected society. Argan reveals the absurdity of Breuer's earnestness in philosophizing about lifestyle as if it were a form of "artistic inspiration." By casting a camp eye on Breuer's architecture, Argan turns it against itself, and offers a critique of postwar American affluence.

—

In 1964, in his introduction to *Égypte*, a short monograph on Egyptian architecture with photographs by the French photographer Jean-Louis de Cenival, Breuer articulated a newfound fanaticism for "Pharaonic architecture," and discovered "inner similarities" and "comparable instincts" between his philosophy and the "Pharaonic one." It is worth quoting at length:

> There is a quality in Pharaonic architecture which fascinates us more and more—despite our twentieth century. ... Our society, our beliefs, our methods, our culture, seems utterly different from those of ancient Egypt. The attraction their pyramids and monoliths and temples hold for us is, consequently, not easily explained by some interrelated trends of the social backgrounds.
>
> ... Surprisingly enough, we discover some roots we have in common with those ancient builders. We might conclude that in some important aspects, their architecture is "modern."
>
> Analyzing our instinctive empathy, we perceive that both cultures have a similar responsibility towards the *material* of construction. Both tend to create characteristic, basic, and unmistakable expressions of their technology, both exploit to the utmost the laws and the potential form of their available material.
>
> ... And another creative drive: the rough rock next to the rectangular composition of monolithic architecture; the geometrical negative void of hewn-out space next to great organic forms; carved out figures so different from and so completely integrated with architecture and the basic medium: the rock. We are directly interested in this art of the great and simple statement, composed of elements of primitive force, but also with an unsurpassed sophistication of detail: fine, sensitive bas-reliefs and hieroglyphs completely subordinated to the architectural flat surface; sculptured portraits and figures of wisdom and grace.[104]

Earlier, in *Sun and Shadow*, Breuer had written of "the social aspect of architecture"; but there is no longer any real "social meaning" here, since all "responsibility" is now directed toward "the *material* of construction." There is no longer any balance between high style and easy living, as there was in his houses of the 1940s and 1950s, because "aesthetic fulfillment" is now found in "physicality itself." We are no longer in the realm of quaint contradictions: Breuer's real desire is to combine "primitive force" with "unsurpassed sophistication of detail." Anything that is "fine, sensitive" will now be "completely subordinated to the architectural flat surface." This modern-Pharaonic architecture is all negative space ("the geometrical negative void of hewn-out space") and unbound, unrelenting "continuous texture" surfaces. Breuer's mania for scale blinded him to the inhumanity of this overall vision: what he describes is a desolate, post-apocalyptic landscape. Yet, at the same time, this was a perfectly reasoned summation of the New American Style of the early and mid-1960s: "the rough rock next to the rectangular composition of monolithic architecture" was an exact description of SOM's Air Force Academy on the Rampart Range, a commission Breuer was disappointed not to have won; while his emphasis on "the great and simple statement" and his invocation of "the rock" vividly recall Saarinen's Black Rock.

Beginning in the mid-1950s, Breuer won prestigious commissions from major corporations such as IBM, the U.S. government, hotels, and universities. These projects often demanded a tabula rasa, and he found a clean slate to build on in the northernmost parts of the United States: in northern Michigan, Minnesota, and North Dakota. The commissions he received in these landscapes were almost all from religious communities. St. Francis de Sales Catholic Church in Muskegon, Michigan (1966) defies easy description in its attempt to monumentalize complex geometries – two hyperbolic parabolic sidewalls rise from a rectangular base to create a trapezoidal roof structure, masked by the façade, which is itself a giant trapezoidal, reclining wall. At Muskegon, Breuer set out to surpass the ancient Egyptians, manipulating modern materials and methods of construction to erect a variation on the Sphinx at Giza. At St. John's Abbey in Collegeville, Minnesota (1958–1961), a Benedictine community, Breuer developed the entire architectural program, including monastery and school, around the idea of the triumphal approach. A campanile, in the form of a concrete slab, lifts off a base of concrete parabolic arches, which serve as a gateway to the church's entrance portal. The façade of the church is a Corbusian *brise-soleil*, but there is no Corbusian Modulor proportional system to mitigate the vast sense of scale. On the side elevation, a corrugated concrete shell creates the kind of "geometrical

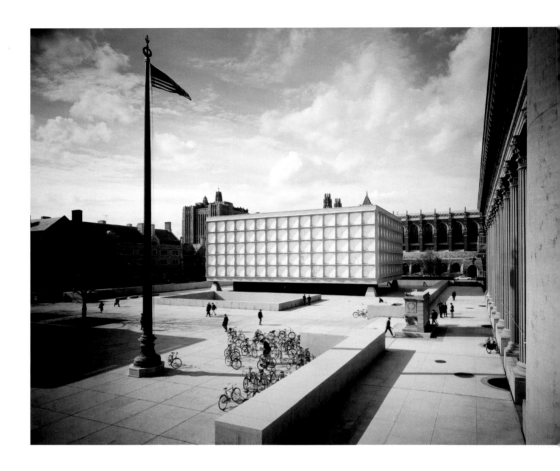

2.15 and 2.16

Gordon Bunshaft/Skidmore, Owings &
Merrill, Beinecke Rare Book and
Manuscript Library, Yale University,
New Haven, 1961, © Ezra Stoller/Esto.

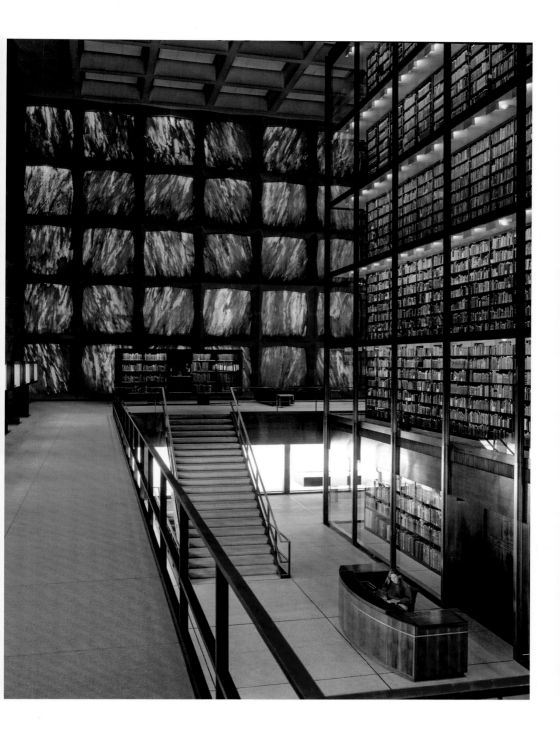

Architecture, Mass Culture, and Camp

negative void of hewn-out space" that Breuer admired in Egyptian architecture. Even Hyman, Breuer's greatest champion, who wrote a monograph focusing on his late work, finally admits that his monolithic buildings have a "deadened" effect.[105]

By way of comparison, at the Beinecke Rare Book and Manuscript Library at Yale University (1963), Gordon Bunshaft reimagined the fabled library of Alexandria, using modern materials and construction methods. A glass vault enclosed inside a white marble box, the library is part homage to ancient architecture and part Moon-landing science-fiction fantasy. Outside, the building's steel frame is covered with stone and inset with marble panels. Inside, two wide bronze stairs lead to a mezzanine. A book tower – a miraculous mini-skyscraper inside the building, centrally located and rising fifty feet high – is separated from the hall, which is also fifty feet high, by a glass curtain wall. The ceiling is coffered, like the Roman Pantheon. All four sides of the interior offer a negative impression of the exterior: the white marble panels on the outside catch and filter sunlight so that they take on a gorgeous muted golden glow inside. Saarinen's Stiles and Morse colleges, also on the Yale campus (1962), with their rambling rock-speckled façades, have an archaic look, but the charm of a small medieval Italian hill town. Breuer, by contrast, walled the Whitney Museum (1964–1966) off from the elegant hubbub of Madison Avenue. Instead of an icon it became an institutional headache and a contextual riddle that defeated both Michael Graves and Rem Koolhaas, whose complicated plans for expansions were scuttled in 1989 and 2003, respectively. In the end, the Whitney abandoned the building for a new museum designed by Renzo Piano on the High Line in downtown Manhattan.

The self-conscious qualities that characterize Breuer's houses are monumentalized in his later work in a misguided quest for profundity. His fixation on materials and textures, which is mitigated in his houses by the smaller scale, the needs of children, and the desire for a friendly aesthetic, becomes outright ideological in the Whitney, where even the stairwells, with their interplay of bronze, wood, and stone, are stunning. But when Breuer pushes his materials to the ultimate degree, he leaves no room for lyricism. Complexes such as the Flaine Hotel Ski Resort in the French Alps (1969) and Tech II on New York University's University Heights campus in the Bronx (1970) find their best parallels in Eastern Bloc brutalism: physically imposing structures with melodramatic visual impact that impress on the viewer the superhuman power of the ideological entity that brought them into being, as well as the architect's ambition to defeat gravity. Lewis Mumford summed up Breuer's

late career work best when he called the UNESCO headquarters in Paris (1953–1958) "the stale tags of once-modern-modernism."[106]

EDWARD DURELL STONE'S "FLIGHTS OF FANCY"

In the late 1950s, Edward Durell Stone set the standard for the architect as jet-setter: "When I am not at my drafting board, I am in a jet plane," he wrote in his memoir *The Evolution of an Architect*, published in 1962.[107] His redis-covery of history at this time was connected to his extensive travels, which he depicts in the memoir as an unending honeymoon with his "explosively Latin" (his words) second wife, Maria Elena, whom he met on a transatlan-tic flight from New York to Paris in 1954. London and Paris are pit stops for their journeys to Rome, Cairo, Athens, Istanbul, and Baalbek: "our life is devoted to architecture," he says.[108] Stone adopted the narrative tropes of popular fiction for his autobiography, depicting himself as a character in a pulp romance novel – if not a "polo-star diplomat" like Dax, the hero of Harold Robbins's *The Adventurers* (1966), then a star-architect diplomat. But there is an element of truth in this, since Stone integrated his far-flung travels into his architectural designs, which were, in turn, exported abroad in some of the most widely publicized state-sponsored projects of the decade.

Earlier on he cast himself as rugged American, a Tom Sawyer type from Fayetteville, Arkansas, which he called "the Athens of the Ozarks."[109] He fol-lowed his older brother to Boston, where he took courses at Harvard and MIT in the 1920s; like Bunshaft, he trained in the Beaux-Arts style. In the early 1930s he went to work for Wallace Harrison, and was assigned to the team of architects designing the two theaters at Rockefeller Center: the Center Theater and Radio City Music Hall. Through his association with Harrison, Henry and Clare Boothe Luce hired Stone to design a modern plantation house, the Mepkin Plantation in Moncks Corner, South Carolina (1936). Soon after, he became the junior architect but primary designer of the Museum of Modern Art's International Style building on 53rd Street, off Fifth Avenue, which was completed in 1938.

In 1940, he made pilgrimages to Taliesin and Taliesin West, and befriended Frank Lloyd Wright. In the 1940s he mainly designed houses that married Wright's Usonian style with International Style motifs. Stone's houses exhibit a suburban elegance; they are less severe than Breuer's houses, for instance, and more spacious than Wright's, while also smoothing out the rugged char-acter of Wright's stonework. His houses display a playful confidence; it is clear that Stone was experimenting with form, but unlike Breuer he never veered off into archness or self-consciousness. The undulating open brick wall in

the indoor garden at the W. T. Grant House in Greenwich, Connecticut (1948) is whimsical but functional, and wholly unexpected next to the living-room window wall. But it was only when he received the commission for the U.S. Embassy in New Delhi, India, in 1954 that Stone found his signature style. This was preceded by his chance meeting with Maria Elena. In his memoir, Stone conflated these two events in the story of his late-in-life success: she was the one who rescued his design for the embassy from the waste-basket, and thus from the dustbin of history.[110]

A rectangular glass box elevated on a platform and sheathed on the exterior by a terrazzo grille of concrete accented with marble, the embassy was completed in 1958. Thin steel columns wrapped in gold leaf support a canopy separated from the ceiling by several feet. Offices on two stories were organized around an interior garden courtyard with fountains and islands of plantings; the courtyard ceiling, a screen open to the sky, produced striated patterns of light. In his memoir, Stone says he followed the example of the architects of the Mogul emperors by placing a circular pool in front of the building, so that its effects could be multiplied in reflection.[111] He called the embassy a temple — one ascends a grand ceremonial staircase to the entrance — and delighted in the fact that it was built by hand, as in ancient days. Photographs of the embassy's construction published in *Time* show the building clad in bamboo scaffolding, with Indian women in native dress carrying building materials to the site in baskets balanced on their heads. In comments that offer an insight into American business dealings in developing countries in the 1950s, Stone cheerfully remarks:

> Mohan Singh, a patriarchal religious leader with several million followers, and his son Daljit, were chosen as builders. They are great friends of the United States: Mohan has the Coca-Cola franchise in India, and I recall telling him that Coca-Cola was as good as oil and not as messy, and that he would one day have as much money as the Maharajahs. Mohan's skills in fabricating the building materials on the site were a source of real gratification for us. He moved his workers and their families to the site where they built their straw matting houses. At one time as many as 1800 Indians lived there, and during the four years of construction, dozens of children were born on the site.[112]

For Stone, this scene, related in picturesque terms, adds to the allure of the embassy. He illustrates it with snapshots of Mohan Singh touring the site with the Indian Prime Minister.[113]

By contrast, the architectural historian Ron Robin has asserted that the Foreign Building Office's stipulated use of local styles in foreign countries

without compromising American building technologies was patronizing at best and colonialist at worst: "They presupposed the fundamental inferiority of other nations by trivializing the customs and traditions of others and at the same time celebrating an exclusive American control over technological security of the future"; Stone's embassy, like the other new U.S. embassies abroad, was built through a credit system whereby free local labor and materials were credited toward debt forgiveness.[114]

Stone's style, to a large degree, was the International Style with gilded trellis screens instead of curves, sheets of travertine marble instead of glass, and Wright-inspired Mayanesque exterior tilework (similar to Carduco's "Great Walls"). He was hardly the only architect using the trellis screen, but it became the leitmotiv of his work—so much so that in 1958 Philip Johnson nicknamed him "the screen decorator."[115] Stone, however, continued to see the screen in functional rather than decorative terms. As if in reply to Johnson, in his memoir Stone says: "I think that the practical purposes which these grilles serve are sufficient answer to those who have considered them elements of decoration only, without understanding the many architectural problems they solve," principally providing shade, serving as spatial dividers, and offering a degree of privacy in open structures.[116]

After receiving the embassy commission, Stone became the unofficial architect of state. In 1956, while it was still under construction, he was hired by the State Department to design the U.S. Pavilion for the 1958 Brussels world's fair. When a commissioner was appointed and an exhibition designer came on board, a power struggle ensued; as a result, there was an odd disconnect between the architecture and the exhibitions. The exhibition, "Society in Ferment," presented a documentary history of social unrest in the 1950s, while the pavilion—a mirage of "unified white and crystal with gold accents" (as Stone described it) modeled on "the Rome Colosseum"—was a blazing embodiment of American materialism.[117] Monumental but ephemeral, the façade was comprised of a gold metal lattice screen covered by a clear plastic panel with gold-painted escutcheons placed at the intersections of the diagonals; a giant order of thin golden bronze columns marched along the circumference. A colossal gilded eagle hung over the entrance, a sister to the eagle perched atop Saarinen's U.S. Embassy in London.

World's fairs registered political realignments. The theme, "A World View—A New Humanism," perpetuated the dominant but illusory philosophical and political ideals of the decade, suggesting a false sense of plurality in the year when the standoff between the United States and the Soviet Union was at its most virulent up to that date. The U.S. and Soviet pavilions were purposely placed directly across from each other (like the German and Soviet pavilions in Paris in 1937), physically and spatially reenacting the balance

of terror. The worldview in 1958 was not that wide: it focused on the two superpowers.

—

Stone embraced the new sensibility of the 1960s. He began his contribution to the "Words to Live By" column in *This Week* magazine in May 1960 with an epigraph from Riesman's *The Lonely Crowd* (pointing again to the tremendous influence of this book in the decade after it was published) on "the power of individuals to shape their own character." He went on in his own words to warn against dogma, extolling the importance of an open mind: "Our lives would be enriched if each person's flights of fancy found receptive audiences and everyone was encouraged to be an individual."[118] This is an extraordinarily unpretentious celebration of the creative spirit. Elaborated into a philosophy of architecture, "flights of fancy" expresses a sense of exuberance that was anathema to modernist doctrine: both the pragmatic American functionalism of Louis Sullivan, and certainly the ideological functionalism of the European *émigrés*. But it was more than mere "architectural sentiment" or "surface mannerism," as Winthrop Sargeant wrote of Stone's architecture in the *New Yorker* in January 1959.[119] In the *New Yorker* profile, entitled "From Sassafras to Branches," Stone, drawing on his southern heritage, calls it "moxie," a form of derring-do, risk, and rule-breaking, essential to the formation of character.[120]

The notion that Stone was "in conflict with many of the progressive architectural doctrines of the past thirty or forty years," as Sargeant wrote, was a total canard perpetuated by profiles such as the one in the *New Yorker*.[121] Stone was always an individualist: he absorbed the "progressive doctrines" but never subscribed to a hardened theory; although he designed MoMA's International Style building, he was never part of the institutional-cultural elite. Perhaps Stone's true contemporaries are not the modernist architects of his day but, rather, production designers, scenic designers, and film directors such as Cedric Gibbons, Vincente Minnelli (who began his career as art director at Radio City Music Hall, which Stone designed), and Jean Negulesco, largely self-educated and self-made men whose creative sensibilities led them into the performing arts. Stone's colloquial "moxie" brings to mind Wright's uniquely American persona, rooted in the nineteenth-century myth of the "Open Road," but Stone, though inspired, lacked Wright's uncompromising genius.

Following the publicity blitz surrounding the Brussels world's fair, Stone drafted at least forty-seven projects, most of them between 1957 and 1959.

Huntington Hartford's Gallery of Modern Art at 2 Columbus Circle in New York (1958–1964) was one of the few to be realized. The building's Venetian palazzo style was partly inspired by Stone's Venetian sojourn after completing the Brussels pavilion, but it also paid homage to Wright's Guggenheim Museum. Marooned on a small irregularly shaped traffic island feeding into Columbus Circle, with cars flowing around on all sides, Stone's solution was a concave tower, eight stories tall, made of poured concrete and clad in smooth concrete tiles, lifted on an arcade of whimsical piers with inset red medallion capitals (which Ada Louise Huxtable likened to lollipops). Iconic for its façade, the building's elevation was the true showstopper: since the site was too narrow for spacious galleries, Stone turned the interior into a grand staircase, similar to Wright's spiral in the Guggenheim. Hartford's paintings were exhibited on the wood-paneled landings; four small circles were wedged from the two outermost rows of tiles on the façade, forming windows, a functional and decorative solution that became one of the building's defining features. Atop the staircase one reached a Polynesian restaurant on the arcaded penthouse floor: the Gauguin Room.

In 1961, Hartford launched *Show: The Magazine of the Arts*. Like his museum, *Show* was a culturally astute but short-lived endeavor. Hartford seized the opportunity to fill the void left by the demise of the old *Vanity Fair*. In a "Publisher's Note" in the October 1961 inaugural issue, he presented it as a magazine born of the "great renaissance of the fabulous fifties."[122] As evidence of that renaissance he pointed to "the new television industry, more than seven hundred art cinema houses throughout the country, some five thousand community theaters, the National Cultural Center in Washington and Lincoln Center in New York, the various legislative measures designed to support the arts." *Show* made connections between art, media, and politics, and charted the nexus between Hollywood, Washington, and New York.

"Washington, in short, is becoming civilized, or at least relatively so," wrote the social critic Karl E. Meyer in a 1962 issue of *Show*.[123] Stone received the commission for the National Cultural Center in Washington (later renamed the John F. Kennedy Center for the Performing Arts) in 1958, at the same time as the commission for Hartford's museum. Congress voted to donate land, an eleven-acre site in a park on the Potomac, and Stone quickly devised two different plans for the project — the first an enormous but elegant rotunda with coffered walls and ceiling, and a giant order of pencil-thin columns; the second the simpler but still stately rectangular plan that would eventually be built almost twenty years later, when Congress finally appropriated the funds necessary to realize the project.[124] In his memoir, Stone compares

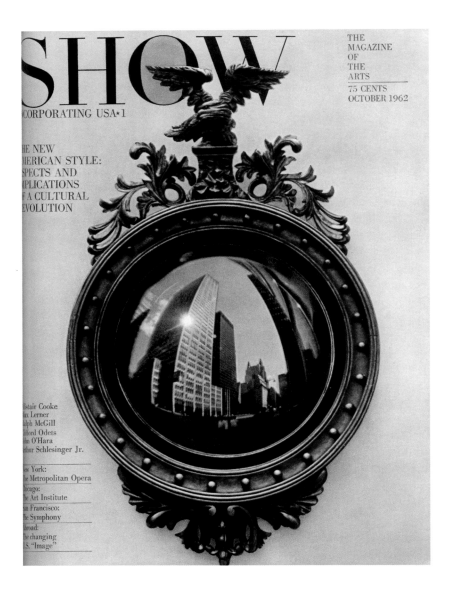

2.17

"The New American Style: Aspects and
 Implications of a Cultural Revolution,"
 Show, October 1962.

the commission in significance to the Houses of Parliament in London and the Doge's Palace in Venice. A project that originated in Eisenhower's embattled second term, it came to embody the cultural ideals of the Kennedy Camelot, at least in model form. Kennedy campaigned on the idea that the United States should celebrate its national cultural heritage, and give greater support to the performing arts. In snapshots in his memoir, Stone is seen showing the same model to General and Mrs. Eisenhower in retirement in Gettysburg and to Jackie Kennedy in Washington.

At Kennedy's inauguration, the poet Robert Frost prophesied "the glory of a next Augustan age." The cover of *Show*'s first-anniversary issue, in October 1962 — like the January 1959 cover of *Architectural Forum* — mixes "ancient" and modern: a Colonial-era, Federal-style convex mirror reflects the new skyscrapers on Park Avenue, only now the magazine no longer questions the status of the United States as a cultural powerhouse; rather, it proclaims "The New American Style: Aspects and Implications of a Cultural Revolution." Hartford described why the revolution exploded:

> This issue of *Show* is dedicated to the fact and the importance of the New American Style. "Style" we define in its widest sense — as a "characteristic bearing," a "mode or fashion of life," a "manner." A nation's style projects its culture and defines it. ... An emerging new style and an alert citizen leadership in this style lies behind all the statistics about the "culture boom" or "arts renaissance" that we hear about. There is a new sense of maturity in this country's desire to speak clearly, and in a unique voice, to the world around it. There is a new and widespread sophistication in our concern with manner. It is a concern, born of the most over-communicated age in history, that shows itself in politics as well as the arts — not many presidential elections in our past have been decided, as the 1960 election was, on the basis of a candidate's "style." The arts are the living mirrors of a nation's style. ... For our urge to participate in them, rather than merely to look on, is part of the same concern that makes us worry over national goals in politics and attempt to think our way back to a shared national morality.[125]

Hartford's definition of the New American Style sounds a lot like Sontag's later definitions of camp and the new sensibility. Culture was now being defined *as* style regardless of content. He perpetuates the mirror metaphors of the 1950s: these "living mirrors" reflect the changing national style, just like the "mirror, mirror on the wall" Sanymetal advertisement from 1959. Now even the "citizen leadership" was educated in style: the real revolution was in marketing and selling the candidate's style through the manipulation of new mass-media technologies. The candidate's style, consumed by the masses,

would become the national style, part of "a shared national morality." The face reflected in the mirror was no longer an idealized female face with a flawless complexion: the masses would now see themselves reflected in a candidate.

The metaphor of the face still had great cultural resonance. In 1963, *Show* posed the question "Too Many Kennedys?" and illustrated it with a Warhol-inspired silkscreen of Jack and Jackie: rows of Jack in blue alternating with rows of Jackie in red, all on a white background. In an article entitled "The Public Face of John F. Kennedy," Alistair Cooke depicted Kennedy as a mid-century Helen of Troy: "the president's face has set some forces in motion that are now clearly beyond his contrivance or his control ... the new publicity has extended the area of permissible public curiosity and therefore invaded the area in which the pulp and scandal sheets usually score their scoops."[126] But JFK's face was not necessarily the face that most captivated the masses. In countless tabloids it was Jackie who crossed over from one side of the government under glass to the other. In the mass-cultural arena, Jackie was the new face of the U.S.

It was Jackie's taste that would now determine what was beautiful. Richard Schickel, then a critic for *Show*, astutely gauged the importance of her appeal: "In short, the country in general, and the Eastern seaboard in particular, abounds in women who share Mrs. Kennedy's interests in the arts, and, as she does, keep them in balance with the rest of their lives."[127] What interests me here is the emphasis on balance. In terms laid out by Arendt at the end of "The Crisis in Culture," Jackie's exercise of judgment brings culture back into the proper realm of the political. This was the purpose of her famous televised tour of the White House on February 14, 1962. In hesitating, hushed tones, Jackie explained to CBS News correspondent Charles Collingwood the painstaking work of restoring all the unique cultural objects in the various rooms in the White House, at times differentiating between originals and reproductions. She demonstrates an encyclopedic knowledge of provenance and period styles. She draws the viewer's attention to distinctive wallpaper patterns and textiles, and even to the original placement of furniture in specific rooms. In other words, the Jackie who performs the White House tour is First Lady as camp dandy.

Schickel's description of Jackie's taste could just as well have been a description of Stone's architecture: "Her taste does tend to be 'lyric and poetic' rather than realistic, with a distinct leaning away from the harsh, the brutal, the startling. It may be said of her that, in a very specific way, she likes the finer things – the delicate, the carefully wrought, the finely etched. Hence

her liking for Debussy's 'La Mer' and 'Fleurs des blés.' ... It's obvious that Mrs. Kennedy is the member of the family most likely to respond to the romantic quality of the ballet. But ballet is by no means her principal artistic interest."[128] The ballet metaphor found architectural expression in Stone's "flights of fancy": the pencil-thin colonnades in his two designs for the National Cultural Center, the tapered white marble fins on the National Geographic Society's new headquarters in Washington (1963), and the red-stone-dotted Venetian arcade at 2 Columbus Circle. Jackie's taste, like Stone's architecture, was part of a new democratic fantasy: not the Christian-corporate utopia of *Fortune* magazine but, rather, the Kennedy diplomacy of culture.

Stone's memoir is filled with more unrealized designs than completed projects. One complements the other: the paper projects seem to render the realized buildings more transitory, more like paper constructions themselves. Nevertheless, Stone saw his buildings as "permanent architecture" and contrasted them with what he called "these mass-produced, catch-penny structures."[129] In describing the kind of architecture he abhorred, Stone offered a description that could – and would – be used by his critics against his own work:

> Our case is further damaged by the striving of some architects to employ their entire repertoire in a single building. Not content with a simple solution to a problem, they design self-conscious buildings, shocking the sensibilities of the average beholder ... a great building should be universal, not controversial. ... In the search for novelty, sensational effect and modish styling, the result seems contrived rather than an object of natural beauty.[130]

Stone's buildings were neither shocking nor self-conscious, but he did strive for novelty. Where he aimed for sensational effect, as at 2 Columbus Circle, he married it with a highly innovative and functional design solution. Projects that appeared eccentric at the time, such as his charming little community hospital in Carmel, California (1963), tucked into a cove off the scenic 17-mile drive through Pebble Beach, with its whitewashed Mayan-tiled façade – another homage to Wright – have aged remarkably well. There is a delicacy in the hospital's siting and scale that mitigates its institutional function, and it became the jewel in a larger complex as the site expanded in subsequent decades. The Ponce Museum of Art in Puerto Rico (1961–1965) rivals contemporaneous museums by Mies and Philip Johnson, but remains much less well known. Stone's remarks about "permanent architecture" and "natural beauty" echo Arendt's remarks about "elaborate beauty" and her

concerns about the permanence of the work of art in *The Human Condition.* That is to say, Stone was an unwitting philosopher of the crisis in culture.

THE GREAT AGE OF WORLD ARCHITECTURE

Vincent Scully spent the year from August 1957 to July 1958 living in Greece and studying Greek sacred architecture. Following his return, he completed two monographs for the Masters of World Architecture series published by George Braziller, the first on *Frank Lloyd Wright* (1960) and the second on *Louis Kahn* (1962), while his experiences in Greece culminated in a third monograph, *The Earth, the Temple, and the Gods: Greek Sacred Architecture* (1962).[131] In 1961, he published *Modern Architecture: The Architecture of Democracy*, an expanded version of a lecture he had first given in 1957. The modern entry in Braziller's Great Ages of World Architecture series, the title implied that modern architecture came of age with democracy, and that democracy was the defining idea of the modern era.

Scully's book presents the history of modern architecture as a mystery plot. The ancient Greek world, the eighteenth century, and his own 1961 moment are connected in an interlocking puzzle. Each epoch contains a key to the truth about "the architecture of democracy." In Scully's account, French Revolution-era architects such as Boullée and Ledoux had glimpsed, but failed to grasp, the meaning of Greek architecture. They created shadow images of Greek buildings without also replicating the sculptural principles underlying Greek architecture. They thus obscured the meaning of the classical language, and set modernism on a wayward course. For Scully, Le Corbusier is the figure that will unlock the mystery. He alone sees through the imitative "romantic-classicist" and "romantic-naturalist" façades erected in the eighteenth century and perpetuated for 150 years. In doing so, he reveals the truth of Greek architecture and reclaims its lost treasure – the foundations of democracy – and sets modern architecture on its proper course. But in a scholar-subject conjunction it is really Scully who solves this riddle, providing an answer to the crisis in culture.

Wright is the villain in the drama Scully scripts, as opposed to Le Corbusier, the hero. His text resounds with Arendtian themes, such as the problem of permanence, man's endeavor to create a durable world, and architecture as a form of human action. Wright survives the transition from the nineteenth century to the twentieth, but he does so "isolated and alone."[132] Scully sees Wright's architecture after 1930 as especially troubling: "he was not looking for an image of the human body or the human act. Instead, he sought the images of nature's permanence, and he found them in the monumental

weight of Mayan architecture."[133] He refers to Wright's "Cretan forms" and wonderfully describes the Johnson Wax building (1936–1939) as "a true Calypso cavern of relaxation and security."[134] Drawing from De Tocqueville's *Democracy in America*, Scully sees destabilizing currents running through American democratic mythology, springing from the wide expanse of the continent and the "mobile, mass-moving" forces that want to sweep cultural and regional differences away. He connects these currents to Wright's fondness for continuous, voluminous spaces. By the end of his discussion of Wright's late work, it is clear that he is privileging an idea of democracy based on *individual action* rather than *mass movement*, a distinction that corresponds to his analysis of *sculptural* versus *spatial* systems of architectural organization.

In Scully's account, Mies offers the second generation an attractive alternative to Wright's misguided model: a renewed emphasis on "the humanist traditions of the Renaissance," on forms such as "the pavilion" and "the court," as well as the return of the vertical tower and sculptural articulation of Louis Sullivan's curtain walls.[135] But the Miesian curtain wall, though sculpturally defined, was far too tenuous a prototype: imitators either flattened out the subtle sculptural tendencies (i.e., Bunshaft) or aggregated baroque typologies onto the Miesian box (i.e., Johnson).

The second-generation modernists – Johnson, Saarinen, Stone – occupy shaky ground in Scully's story. On the one hand, they get mixed up in the mystery plot linking the ancient world, the late eighteenth century, and the present. On the other, they get caught in the titanic struggle for dominance between the models of Wright, Mies, and Le Corbusier. Johnson's Synagogue for Port Chester, for example, he says, "decidedly recalls both Ledoux and the eighteenth century publications of Greek architecture, while its plan and its hung vaults reveal the influence of Rome, again most particularly of Hadrian's Villa at Tivoli."[136] He describes their buildings as "containers," which express a certain "tightness and thinness of forms," with walls, as at Saarinen's General Motors Research Center "stretched into membranes."[137] Their work was indicative of an "impatient formalism," "neoclassic reduction," and "the superficial decoration and embellishment of the pavilion," which, according to Scully, achieved its most vulgar formulation in Stone's lightweight but giant terrazzo grilles.[138] The hybrid qualities of this "new classicism" are not explored in great depth; for Scully they represent what he calls "a period of rest, or of reassessment, in the general development of architecture."[139]

Scully presents Le Corbusier as an unexplored discovery. Le Corbusier emerges at the end of the book as a Greek-god-like figure. Scully was writing mostly about the recently completed Capitol Complex with its High Court, Secretariat, and Legislative Assembly in Chandigarh, India (roughly 1951–1955). The point for Scully is that in these buildings Le Corbusier dramatizes an ancient, tragic view of humanity as it exists in relation to nature. In Scully's interpretation, Le Corbusier's architecture becomes an allegory of man's perennial battle to create a durable world against the brutal, mercurial forces of nature: "The human act is balanced by the natural world and its laws, which is separate from the human self and with which man carries on a reciprocal communication and a finally hopeless contest all his life."[140] In other words, Le Corbusier understood that the true nature of Greek architecture was about "reciprocal action between opposites," and that the Greek temple was "conceived not as a purely human gesture in the landscape but as the body of a god who was himself the embodiment of a certain kind of potential action."[141] Finally, Le Corbusier "intuitively understood what [Greek architecture] was meant to be": "He recognized that it was not intended to shelter human beings, but to stir them to recognition of the facts in relation to which they must act themselves."[142]

–

Presented as an introduction to modern architecture that is accessible to students, Scully's book was really part of a fervid debate about the future of architecture that raged among architectural historians in the late 1950s and early 1960s. Scully totally rejects the version of history that Sigfried Giedion had put forward in his extremely influential book *Space, Time and Architecture*, which had defined the interpretation of modern architecture for a generation (since its publication in 1941). By the late 1950s, it became readily apparent to a younger generation of scholars, notably Scully, Bruno Zevi, Alison and Peter Smithson, and the members of Team X, that Giedion's history was deeply flawed, and ill-equipped to account for new developments. As early as 1949, at the time of CIAM 7, Zevi, the Italian-born, Harvard-educated disciple of Frank Lloyd Wright, noted the omission in *Space, Time and Architecture* of the Arts and Crafts movement, the work of Erich Mendelsohn, and a whole generation of American and Scandinavian architects he saw as being allied to Wright's principles of organic architecture and spatial continuity.[143] Zevi couched his 1953 book, *Saper vedere l'architettura*, published in English in 1957 as *Architecture as Space*, as a corrective to Giedion's myopic focus on German functionalism. In 1959, CIAM was formally disbanded,

in large part because the factions of second-generation modernists that had developed within its loosely structured ranks vehemently disagreed about how to best tackle the mounting problems facing modernism.

Giedion's history had to be dismantled if a new history was to be written. About this, Scully and Zevi agreed, although Zevi articulated it more pedantically at the beginning of *Architecture as Space*: "Much remains to be done. It is the task of the second generation of modern architects, once having overcome the psychological break involved in the birth of the functionalist movement, to reestablish a cultural order. The moment of ostentatious novelty and avant-garde manifestos has passed and modern architecture must now take its place in architectural tradition, aiming above all at a critical revision of this very tradition."[144] But Zevi failed to present a story of comparable depth. Scully adopted the idea of democracy as the underlying concept for his investigation of architectural tradition from the ancient to the modern world, and used it to create distinctions between different kinds of spatial consciousness, which, he argued, had real political consequences. Zevi's argument never progressed beyond the idea that architecture simply was space.

Scully and Zevi, both critics of Giedion, were nevertheless diametrically opposed. Scully wants architecture that holds space in check with strong sculptural solids; Zevi argues for pure unadulterated space: "The most exact definition of architecture that can be given today is that which takes into account interior space. Beautiful architecture would then be architecture in which the interior space attracts us, elevates us and dominates is spiritually."[145] (The two scholars were, to some extent, replaying an argument that went back to the eighteenth century, which pit Winkelmann against Piranesi, and Greek against Roman architecture.) Scully champions Greek buildings, while Zevi calls them non-architecture: "The Parthenon is a non-architectural work," he asserts, dismissively calling it sculpture; by contrast, Zevi exalts Roman buildings for their internal space "on a grand scale," their "grand, daring, and truly architectural inspiration."[146] But Zevi in effect confirms the moral clarity of Scully's argument when he concludes: "essentially, official Roman building is an affirmation of authority, a symbol dominating the mass of citizens and announcing that the Empire *is*, that it embodies the force and meaning of their whole lives. The scale of Roman building is the scale of that mythos, later to become reality, still later nostalgia, and it neither is, nor was it intended to be, the scale of man."[147] Zevi's history differs from Scully's in that it is Wright rather than Le Corbusier who appears in the end as the godhead offering a new testament for modern architecture.

In both books, the central drama of Western architectural history is the struggle for dominance between space and solids, between "spatial (environmental) and sculptural (active) qualities."[148] The drama is further heightened by repetitive cycles of revelation and concealment: moments of balance between space and solids are achieved, only to be swiftly obscured by "academic adjustment," until, in Scully's account, they reach a final reckoning in the architecture of Le Corbusier.[149] For Scully, the perpetuation of Roman-baroque forms was antithetical to democracy, yet this was the model that American architects were adopting. His book, a *cri de cœur*, attempted to chart another path.

Literary, lyrical, and intensely poetic, Scully's interpretation had almost nothing to do with Le Corbusier's architecture in India. Rather, it had everything to do with his own recent sojourns in Greece. His mythopoetic monograph *The Earth, the Temple, and the Gods: Greek Sacred Architecture*, a highly idiosyncratic interpretation of Greek temples, was published a year after *Modern Architecture* and rejected by architectural historians, archaeologists, and classicists alike. While other critics attempted to categorize, identify, and name the minutest shifts in style, Scully escaped into a mystical architectural fantasyland of his own invention. He invested Le Corbusier's recent architecture with all the atmosphere of ruined Greek temples seen against craggy southern Mediterranean landscapes. Yet in its focus on an imagined Greek antiquity, Scully's book was totally in keeping with the wider cultural reinvention of the ancient world in Cinemascope sword-and-sandal films, philosophical studies such as Arendt's *The Human Condition*, and movements in postwar American architecture. He did offer an absorbing interpretative model. Following his example, the Smithsons traveled to Greece with Rex Martienssen's *The Idea of Space in Greek Architecture* (1956) and A. W. Lawrence's *Greek Architecture* (1957) in hand. They grappled with what they called "the Doric Order *as metaphor*."

CODA: MIDDLE CAMP, HIGH CAMP, AND ENTIRELY CAMP

In 1973, when *Modern Architecture: The Architecture of Democracy* was reprinted in a new edition, Scully added a coda entitled "The Age of Irony." He acknowledged that his heroic tone in the first edition "carried the hubris of its own destruction with it."[150] In the intervening time, he says, "the most influential nation of the modern world was brought to the edge of moral, and hence social and political, disaster," meaning the civil and social upheavals of the 1960s, Vietnam, and the first inklings of Watergate.[151] And he further acknowledged that the imitation of Le Corbusier's brutalist forms in American

governmental and institutional buildings had resulted in "unfeeling images of sterile power," going so far as to say: "indeed, the most purely governmental monuments of 'modern architecture' in the States in more recent days have all become unmistakably totalitarian in character."[152] This signaled a tremendous about-face: modern architecture as "the architecture of democracy" was now modern architecture "totalitarian in character."

Scully did not give examples of specific buildings, but he was writing on the cusp of the great age of conspiracy thrillers in American cinema: *The Parallax View* (1974), *Three Days of the Condor* (1975), *All the President's Men* (1976), *Network* (1977), and *Rollover* (1981), to name just a few. In these films, icons such as the Space Needle in Seattle, the architecture of "Official Washington," the World Trade Center in New York, and skyscraper colossi along the Sixth Avenue "Media Corridor," also in New York, became lodestars of a rich visual culture of catastrophe, and narratives of agency panic that tapped into the public's growing fears about the exploitation of natural resources, metastasizing mass media, and ballooning, but inscrutable government bureaucracies. Characters in these films exist in architectural and urban landscapes that they try, but ultimately fail, to navigate, and from which they cannot escape. Sinister architectural forms, combined with technological interfaces such as the clicking and clacking of computers, usually prefigure death.

Also in 1973, the British architectural critic Charles Jencks reassessed recent American architecture in his book *Modern Movements in Architecture*. He had read Sontag's "Notes on Camp." He took what he termed "the attitude of camp" as a generalizing tendency by which to organize the architecture of the postwar decades into two categories: "camp" and "non-camp."[153] Jencks's analysis is pervaded throughout by a staunch, moralizing tone, one that disapproves of what he calls "the permissively plural camp attitude."[154] His tone reveals the degree to which he completely misunderstood both Sontag's essay and camp sensibility. The brittle phrase "the attitude of camp" does away with the more enthusiastic aspects of Sontag's original emphasis on "sensibility," which had its roots in eighteenth-century dilettantism and nineteenth-century dandyism. "Permissively plural camp attitude" disdains the pleasures of pluralistic pop culture, but it also has a nasty gendered connotation due to camp's origins in queer cliques. He deploys the word "camp" against the architecture as a pejorative.

Jencks maps out camp cosmology, which he calls an "exclusive classification" system, unknowingly replaying, as parody, the excessive taxonomic enterprises of the crisis in culture. For Jencks, all architecture that appears

"expressly metaphorical" and "scaleless," an "overblown kind of architecture that fails from a serious point of view since it relies so heavily on a univalent statement of effects," should be dismissed as camp.[155] On the basis of that criterion, he defines three subcategories: "Middle Camp," "High Camp," and "entirely Camp." Middle Camp is not necessarily bad architecture, but it is riddled with disturbing signs: most of all, what he sees as the renunciation of the modern architect's supposed moral obligation to society. What troubles Jencks is the transformation of the social politics at the core of European modernism into a mere "social gesture." So, for instance, quickly reviewing the work of Paul Rudolph, which he classifies as "the apotheosis of Middle Camp," and pointing specifically to Rudolph's controversial Yale Art & Architecture Building (1963), he sees only "the grand gesture, the defiance of convention, honest arrogance, the connection with mass media," as well as the signs of a "personality cult," "unalloyed pursuit of fame combined with exotic taste."[156] He completely misses the optimistic but undefined social-democratic vision at the heart of Rudolph's architecture: the new kinds of aggregate housing solutions Rudolph proposed, and his positive view of technology. The critic Sibyl Moholy-Nagy had drawn attention to these aspects of Rudolph's work three years earlier in her monograph *The Architecture of Paul Rudolph* (1970). Jencks could have bolstered his argument for a Middle Camp classification by pointing instead to Breuer's architecture and the many mass-media representations of Breuer's work in middlebrow shelter magazines, but Breuer is absent from Jencks's analysis.

High Camp is work that sincerely aspires to greatness, but utterly fails to reach that status. The High Camp aspect is lodged in the "gap between pretension and performance."[157] The primary offender: Stone. Yet, as a performance, architecture in the High Camp mode does produce what Jencks calls a "cathartic" or "sublime" or "ridiculous" response on the part of the viewer. What seems to trouble him about such architecture is that it conflates the "philistine" and "the avant-garde" in the same way as other forms of mass culture (i.e., the sword-and-sandal films). Jencks is completely dismissive of Stone's architecture, but I see a silver lining in his analysis: Stone becomes the opposite of Mies, as if they existed at the two poles of postwar modernist activity, but two highs, rather than high and low. And that is the point of camp: there are no lows, only highs.

Somewhere between Middle and High Camp Jencks places "the independent mid-western architects," such as Bruce Goff, Helmut Greene, and Paolo Soleri, architects whose work, he argues, is a postwar American version of Art Nouveau in its mania for "organic" forms created through almost

wholly artificial, technological means. He sees their buildings as peppered with "clichés," resulting in forms of "overcommunication."[158] In this group he also places Saarinen, who, he argues, produced multivalent works that transcended the danger of "self-assertion," but almost always overcommunicated. Also in this middle ground are works by SOM and Wallace Harrison, which Jencks links to the tradition of American pragmatism joined with modernist functionalism. In the "non-camp" category he includes the recognized postwar innovators, such as Kahn, and academic postmodernists such as Venturi, the Eameses, and Charles Moore. No surprises there.

Finally, he eviscerates Johnson, whose work he dismisses as "fatalistic" and "entirely Camp." But, again, Jencks missed both the subversive charm and the radical potential of camp sensibility—specifically as it related to Johnson's architecture. In Johnson's case, it was one component of a supremely sophisticated aesthetic and philosophical enterprise equipped to do battle with democratic mythmaking—an approach, moreover, that looked beyond the obsolete model of the avant-gardes.

3

The Useless Monument

In *Between Past and Future* (1961), Hannah Arendt described the present as "the gap" between past and future, and wrote of a break in tradition, a tear in the fabric of civilization that had its origins in the Second World War: "throughout the thousands of years that followed upon the foundation of Rome and were determined by Roman concepts, this gap was bridged over by what, since the Romans, we have called tradition. ... When the thread of tradition finally broke, the gap between past and future ... became a tangible reality ... that is, it became a fact of political relevance."[1] The widespread awareness of this gap contributed to the crisis in culture. The need for a new monumentality and its relevance to a new humanism; Henry Luce's Western Culture Project; Vincent Scully's quest to reconcile historical architectural and democratic traditions; and the return of romanticizing and historical motifs (which rattled modernist doctrine) were all attempts to deal with this break, to close the gap.

Philip Johnson did the opposite: he mined the break. Although Johnson had founded the architecture department at the Museum of Modern Art in 1930, and introduced New York's elite to European modernism in the "Modern Architecture: International Exhibition" of 1932, he first decided to become an architect following his tragic foray into fascist activism in the mid- and late 1930s. His first building of real significance was his Glass House in New Canaan, Connecticut (1949). In other words, he turned to architecture in the postwar period as a means of expressing ideas that he felt he could no longer achieve in politics, or as a curator and interpreter of other people's work. The break in his own life ("my life was in ruins" he later said about the years right before he entered Harvard's Graduate School of Design in 1940) coincided with the break in tradition diagnosed by Arendt. My point is that Johnson was more attuned to the consequences of the break than his contemporaries. Architecture was his way of working through the ruins.

Political scientists in the early 1960s also spoke of the opening up of a "fantasy gap" in political thinking, at the heart of which was a "credibility" problem, and the increasingly elastic concepts of democracy and totalitarianism. Johnson's entire architectural enterprise in the period from 1945 to

1965 offers a keyhole into these gaps. His architecture and writings bring notions of queer oppositionality and subversion to bear directly on issues of political ideology, specifically the role of postwar architects in promoting ideals of American democracy.

In "Philip Johnson, The Constancy of Change," a 2006 symposium at Yale University and the first major effort to reassess Johnson's life and work after his death in 2005, scholars such as Beatriz Colomina and Detlef Mertins argued that Johnson participated in the democratization of culture. For example, Colomina compares his Glass House with the television set.[2] By contrast, I believe that Johnson raged against the democratization (and corporatization) of culture in the postwar decades, and that his antipathy toward democracy was right there on the surface for all to see. He flaunted his camp eye as a form of critique, mocking the hypocrisies of democratic mythmaking and the widely propagated social taboos and political fears of the age. He designed willfully anti-utilitarian buildings, first on his estate in New Canaan, then on the national stage. I call them "useless monuments."

In his essays and lectures, Johnson excoriated the architecture of his contemporaries while construing narratives for his own buildings that either purposefully confused their cultural and political meaning, or completely divorced them from the postwar American context. His self-positioning as acolyte, heir, and interpreter of Mies van der Rohe's architecture played an important role in this project. Johnson's self-avowed "passion for history," and the way he dramatized it in his architecture, worked to undermine narratives of corporate modernism. He orchestrated historical forms, references, and motifs in such a way as to expose, rather than perpetuate, the fantasy that the United States was the heir to and guardian of Western civilization in the aftermath of the war. His aristocratic posturing *vis-à-vis* culture and power was an expression of camp sensibility – but a darker, perhaps more authentic version of camp than the one Sontag popularized. Johnson's camp persona came to focus on the concept of failure, which was undoubtedly rooted in his homosexuality.

Architecture for Johnson was part of greater processes of aesthetic idealization and erotic projection. Was he a "patrician esthete," as the architect Peter Eisenman argued at the Yale symposium, or did his queer subjectivity as woven through his work and his various "platform personas," as Robert Stern once called them, put him at a remove even from the class whose ideals he seemed to best express? Although he seems to have been the ultimate insider, was he in fact the ultimate outsider (like comparable figures such as Warhol, and the British art historian and Soviet spy Anthony Blunt)?

Johnson's powerful cynicism, and his thoughts on uselessness, spring from thorny dynamics such as these.

THE PASSION OF PHILIP JOHNSON

Johnson was born in Cleveland, Ohio, to Homer H. Johnson, a well-to-do lawyer, and Louise Pope Johnson. His family traced its roots in America back to the mid-seventeenth century. He attended the Hackley School in Tarrytown, New York, and in 1923 he enrolled at Harvard University, where he studied philosophy. In 1924 Johnson's father divided his estate, assigning to his son stock in the Aluminum Company of America (popularly known as Alcoa). This became the basis of Johnson's sizeable personal fortune, which immediately gave him a great degree of liberty in his intellectual pursuits, as well as access to elite circles in New York and abroad. His studies were prolonged by bouts of depression and travels to Europe. He graduated in 1930, by which time he had already become involved in the new Museum of Modern Art in New York.

It was during his travels to Europe in the mid- and late 1920s that Johnson became an enthusiast of modern architecture. Through his Harvard connections – notably his friendship with Alfred Barr, Jr., a graduate student in art history who became the first director of MoMA – he became part of the group that founded the museum in 1929. He launched the department of architecture and design, the first of its kind in an American museum. Despite the success he enjoyed at MoMA, in the mid-1930s the rightward shift of his political sympathies took him in an unexpected direction. In 1934 he resigned his position to campaign for the Louisiana demagogue Huey Long. Johnson became a full-fledged political activist. He attempted to launch his own fascist party from the living room of his New York apartment with his friends Lawrence Dennis and Alan Blackburn (in 1936, Dennis published a book entitled *The Coming American Fascism*). In 1938–1939, the high point of his political activity, Johnson glowingly reported on the fifth anniversary of Adolf Hitler's rise to power and the German invasion of Poland for Father Charles E. Coughlin's right-wing newspaper *Social Justice*. In October 1940 he was featured as one of "The American Fascists" in *Harper's* magazine, along with Charles Lindbergh.

While he addressed the subject obliquely over the course of his life, Johnson never spoke at length about the depth of his fascination with fascism or his attraction to Nazism. For decades, this "inglorious detour," as his biographer Franz Schulz termed it, was excised from studies of his work.[3] It was exhumed by Schulz in his 1994 biography and, more recently, by Joan

Ockman. But Johnson's activism has long been dismissed as a combination of folly and naïveté: the line established by Schulz and followed by later historians is that Johnson "proved to be a trifler, the dilettante he earlier feared himself to be, a model of futility," and that the entire episode, born out of frustration and restlessness, resulted in "total failure."[4] In 2006, Scully reinforced this view when he brushed off Johnson's "unsavory political alliances" of the 1930s as "essentially harmless," while Ockman called him "undoubtedly a political dilettante in the 1930s."[5] Is the diminishment of Johnson's political activities mere apologia, or more highly charged? It does point to a stereotype, pervasive in mid-twentieth-century American culture, of the arrogant but ultimately ineffectual, intellectual homosexual representative of a perverted, unproductive form of masculinity, as detailed for instance by Philippa Gates in her study of film noir, which routinely used queer characters to dramatize abnormal subjectivities.[6]

The level of Johnson's success or failure in politics seems to me not only immaterial, but far less interesting than the question of what happened to his political passions after 1940, when his infatuation with activism waned, and at the age of thirty-four he reenrolled at Harvard, entering the Graduate School of Design, where he studied architecture under the tutelage of Gropius and Breuer. A sign of how Johnson's wealth differentiated him from his contemporaries: he actually built his Harvard thesis project, the Ash Street House in Cambridge, Massachusetts (1943), which was derived from recent Miesian models. Upon receiving his degree in 1943, he was drafted into the U.S. Army despite an FBI file documenting his earlier activism. "Where there are political passions, it is easier to have architectural passions," Johnson said at an informal talk at the Architectural Association in London in 1960.[7] In the post-World War II period, therefore, did his political passions simply dissipate, or did they manifest themselves in a new way?

The general consensus, articulated by Schulz and reinforced at the 2006 Yale symposium, is that after the war Johnson distilled his fascism into "an unconquerable esthetic impulse."[8] With his failure in politics, Schulz argued, Johnson turned his attention to aesthetics, to the representation of power as revealed in an impossibly high ideal of art. Ockman similarly argues: "Johnson's veneration of beauty and his belief in this *Lebensphilosophie* were the fundamental values by which he set his compass."[9] But how can his aesthetics be separated from his politics? Isn't the quest for an ideal form of beauty at the core of most political ideologies, including Luce's "pervasive beauty?" Along these lines, should Johnson's veneration of beauty and deployment of a specific kind of aesthetics in the postwar period be

construed as political acts? Surely, his continuing belief in a Nietzschean will to power makes it extremely unlikely that he suddenly became an apolitical proponent of art for art's sake.

Following the war, politics gripped the imaginative life of the nation, and almost all architects were working under its sway in one way or another. As we have seen, very specific claims were being made about beauty in relation to architecture and politics. These were best expressed not by established theorists of the modern movement, such as Giedion, or by the architects themselves, but by proponents of big business, namely Luce and his lieutenants, such as Davenport. Contrary to the long-held view that, beginning in the mid-1940s, Johnson self-consciously distanced himself from politics in order to rehabilitate his image, he was one of the only architects to actively oppose the business model of architecture. In his postwar curatorial work at MoMA, his essays and lectures, and his architecture, Johnson sought an escape from this context while simultaneously expounding a trenchant critique of democratic capitalism.

When Johnson returned to New York in 1944, it was through his former connections at MoMA, where he resumed his position as head of the Department of Architecture. The Rockefellers provided social absolution for his political sins. Unlike his contemporaries, Johnson did not seek out era-defining government commissions and was not yet an architect of corporate identities. Following the dictum of Voltaire, he cultivated his own garden, adding pavilions to his Connecticut estate, which served as models for the small-scale cultural and residential commissions he received throughout the 1950s and early 1960s, mainly through the largesse of the Rockefellers. His work presents us with a much different – and more sophisticated – synthesis of beauty, history, and politics than the work of architects such as Bunshaft, Breuer, Saarinen, and Stone.

His first major postwar undertaking was a retrospective of Mies's architecture, which took two years to complete and opened in September 1947. What was the significance of this project for Johnson? It allowed him to eschew the triumphalism of the immediate postwar years and return – mentally, at least – to prewar Germany, where he could indulge his obsession with Prussian classicism. The main theme of the monograph accompanying the exhibition, which presented a comprehensive overview of Mies's career up to and including the IIT campus in Chicago, is the uninterrupted continuity of the German romantic spirit in Mies's architecture. The buildings Johnson lavishes with praise are not Mies's canonical modernist works connected to the International Style, which informed American thinking.

Quite the contrary: he lingers over Mies's earliest, Schinkelesque projects, such as the Kröller-Müller House (1912) and the Bismarck Monument (1912), which prefigured Nazi prestige planning in the severity of their massing, the proportioning of their colonnades, their attenuated fenestration, and their taut decorative detailing. In the catalog, he accords seminal importance to Mies's proposal for the Nazi Reichsbank competition (1933). In effect, he revisits his 1933 essay "Architecture in the Third Reich," in which he concluded that this project would "clinch [Mies's] position" in the new regime.[10]

Eschewing the postwar American context, Johnson connects the structural, spatial, and decorative system on view in the new buildings Mies planned for IIT back to these earlier, Schinkelesque designs. My point is that the Mies on view in Johnson's monograph is not the recent *émigré* and Chicago transplant, who may have wished to move beyond the troubled decade of the 1930s. Rather, it is the Mies who, as Sibyl Moholy-Nagy later persuasively argued, had "an affinity of convictions" with National Socialism, as documented in his writings and buildings of the late 1920s and 1930s.[11] The exhibition served as a proxy for Johnson's abortive foray into fascist cultural politics.

The Glass House (1949), realized two years after the Mies retrospective, was an extension of that project. From its inception, it was more manifesto than dwelling; a veritable architectural declaration of independence from the dominant cultural-political drives of the postwar period. In contrast to the modern Christian-corporate utopia imagined by Luce, it was a utopia of "absolute form" and "absolute shapes" (Johnson's own terms) that had its basis in aristocratic European architecture of the baroque period and the Enlightenment.[12] In "House at New Canaan, Connecticut," the essay he published in *Architectural Review* in 1950, Johnson espoused a theory of historical synthesis that mixed the modern and the baroque with Mies as a starting point. On the one hand, he cites Mies's IIT buildings and Farnsworth House. On the other hand, lurking in the background is the Mies of the Nazi Reichsbank proposal, which he praised in the MoMA monograph as the most modern, but also the most monumental, of the early Nazi projects, "with a grand staircase worthy of a baroque palace."[13] Among the twenty-two sources cited, he refers twice to Schinkel's Casino at Glienicke (1926), the inspiration for Mies's Kröller-Müller House design. Calling his own house "Neo-Classic Romantic," he positions himself in a line of "intellectual revolutionaries from the Baroque," namely Schinkel and Ledoux.[14]

This revolutionary fervor had a real political charge in that both the house and the essay knowingly made a mockery of the postwar suburban domicile

and the shelter magazine. Reading Johnson's essay, it is easy to forget that Mr. Blandings of Eric Hodgins's *Mr. Blandings Builds His Dream House* (1946), which began life as an article in *Fortune* magazine, was his fictional neighbor in New Canaan. In this novel of manners, suburban Connecticut is depicted as a new Garden of Eden, where the neocolonial house out-fitted with modern technological conveniences serves as an allegory for the integration of American Revolutionary ideals into the postwar National Security state. Ironically, the formerly revolutionary modernist *émigrés* often used shelter magazines to transform themselves from ideologically suspect European designers into placid American personalities. Breuer, Johnson's real-life neighbor in New Canaan, was a master of this means of assimila-tion. In profiles such as "Marcel Breuer: Architect and Teacher," from the May 1952 issue of *House & Home*, Breuer translated his Bauhaus ideals into friendly tips for the upwardly mobile middle-class executive, while present-ing his own houses as new models of cosmopolitan town-and-country living. Johnson does the opposite, transforming himself from an American archi-tect into a European libertine whose absolutist architectural forms not only defy assimilation but strike at the heart of democratic mythmaking.

In his essays and lectures, Johnson the curator, the disciple, the *philo-sophe*, and the wit created a context for Johnson the architect. He summed up his age by opposing it. At an informal talk to students at Harvard in Decem-ber 1954, which was published as "The Seven Crutches of Modern Architec-ture" in the 1955 issue of Yale's *Perspecta*, he railed against everything Luce advocated: "cheapness," meaning architecture driven by an "economic motive," the crutch of serving the client, and "the crutch of utility, of Useful-ness."[15] In contrast, he championed the architect's "act of creation," and, quoting Nietzsche, argued that architecture is "man's will to power assuming visible form. ... Architecture is a veritable oratory of power made by form."[16] This was a truly shocking statement for an American architect to make in the mid-1950s, when "oratory of power" still vividly recalled Hitler's spellbinding filmed orations set against architect Albert Speer's Valhalla-themed, Étienne-Louis Boullée-inspired architectural backdrops, such as the Nuremberg party rally grounds. When *Architectural Forum* profiled Connecticut General in 1957, for example, it explicitly highlighted the fact that "the architect ren-ders himself almost invisible," and, barely mentioning Gordon Bunshaft by name, praised him for allowing the corporate client to take the spotlight.[17]

Johnson's views on these matters only intensified over the course of the 1950s and into the early 1960s. In the speech he gave at the annual Ameri-can Institute of Architects conference in 1962, the "seven crutches" became

"The Seven Shibboleths of Our Profession." With increased amplitude, he declared: "The shibboleth of *Democratic Capitalism* can be a danger," and attacked "*the idea that our buildings be democratically acceptable.*"[18] He took aim at both the organizational model of architecture espoused by firms such as SOM ("we have organization charts, all the paraphernalia of big business. ... The head of the firm can no longer design or practice architecture in any sense. Instead he flies around the country 'selling' jobs") and the magazine culture fostered by Luce ("At its worst this virtue leads to a vanity about magazine and book popularity which can be disgusting").[19] Simultaneously, he made a case for "prima donna" architecture and the useless monument.[20] Architecture for Johnson was by its nature authoritarian, and therefore had no social imperative. He completely rejected the emerging field of "Environmental Studies," and along with it the notion that architecture should serve the forces of "*Social Progress.*"[21] In doing so, he rejected the modernist notion of the architect's responsibility toward society, architecture by committee, and design as a process mediated by many hands. Architecture's purpose was to elevate the soul, not to educate the masses or make life more agreeable.

The useless monument was Johnson's greatest contribution to modern architecture in the postwar era. The Moon-Viewing Pavilion, which he added to his estate in 1962, was such a monument. Like the Glass House, it was a manifesto project, the architectural counterpart to his shibboleth lecture. In the essay he published on the pavilion in *Show* magazine, also in 1962, he described it as a folly in the tradition of aristocratic European garden architecture, which was connected to eighteenth-century philosophies of character and sensation in the feelings buildings aroused. "My pavilion is full scale false scale, big enough to sit in, to have tea in, but really 'right' only for four-foot-high people. Change of scale like this is a harmless and pleasant joke on serious architecture. And yet it is serious architecture," he explained.[22] I will explore the queer implications of this "full scale false scale" philosophy, and the idea that the pavilion was really "right" only for people who looked at the world from an unusual perspective, in greater detail below.

3.1

Philip Johnson, Moon-Viewing Pavilion,
New Canaan, Connecticut, 1962,
© Ezra Stoller/Esto.

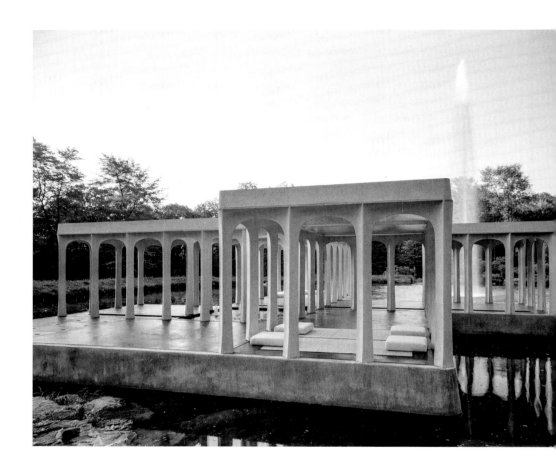

3.2

Philip Johnson, Roofless Church,
New Harmony, Indiana, 1960,
© Ezra Stoller/Esto.

My point here is that a useless monument was not, technically, useless. It served a political purpose, like propagandistic showpiece projects such as Connecticut General, but to opposite effect. Johnson deployed it in fanciful commissions such as the Roofless Church in New Harmony, Indiana (1960), as well as significant international projects such as the Nuclear Reactor in Rehovot, Israel (1960), as a means of commenting on the era's political fears. Johnson cheekily described these two projects as among his most impor- tant religious works, even though they had nothing, or very little, to do with religion. I see them as a critical commentary on the rise of democracy as a new religion, with atomic weapons as its talismans. The Roofless Church, which he nicknamed "the Shrine of the Rose," since "the symbol of the town is the rose," and described as "a shrine out in Indiana for a Texas lady," is a giant folded canopy of wood shingles rising sixty feet high and fifty feet wide, set on ten-foot-high limestone megaliths.[23] Restraint and release, ten- sion and suspension, are orchestrated to perfect effect to create a form that uncannily recalls the mushroom cloud of nuclear mythology. At Rehovot, his massive, jagged Nuclear Reactor rises ominously above a classical court- yard with a peristyle colonnade of reverse-tapered piers (bringing to mind Mies's Kröller-Müller House design and Bismarck Monument). The perimeter walls, mammoth at the Macedonian-style entrance gate, disappear diminu- tively into the desert hills in the distance. I see this project as Johnson's architectural retort to SOM's new Air Force Academy on the Rampart Range. There was no better architectural metaphor for postwar Western civiliza- tion's precarious position under the volcano.

JOHNSON AND HISTORY

In the spirit of the Western Culture Project outlined by Luce, architects such as Saarinen and Stone cast themselves as modern-day counterparts of figures like Bernini. Louis Kahn, who spent a year in Rome in 1950–1951 as a fellow at the American Academy, rediscovered the architecture of antiquity via the prints of Piranesi. Paul Rudolph, in his Sarasota houses and projects such as the Jewett Arts Center, found inspiration in Renaissance Venice. Breuer, in his late phase, developed a mania for Pharaonic architecture. Johnson's ideas about history diverged from those of his contemporaries, and his use of historical forms was often more fraught. On the one hand, he participated in a large-scale state-sanctioned symbolic project such as Lincoln Center, which celebrated the performing arts as an embodiment of American civilization, and positioned New York as the capital of culture for the postwar world; while on the other, in smaller-scale projects such as

the Proctor Institute in Utica, New York (1960) and the Sheldon Memorial Art Gallery in Lincoln, Nebraska (1963), he seems to have wielded historical forms to combat the democratization of culture. Throughout the 1950s and early to mid-1960s, his passion for history repeatedly found an outlet in museum projects which, taken together, constitute a disquisition on art, culture, history, and society: a kind of architectural corollary to Arendt's essay "The Crisis in Culture."

In addressing the subject of history, Johnson had to do battle with a monster of his own making: the International Style. As he recognized, it had become a crutch or, worse, a crutch-encompassing category, a straitjacket for architectural thought. In "Style and the International Style," a speech he gave at Barnard College in 1955, Johnson averred: "A style is not a set of rules or shackles, as some of my colleagues seem to think. A style is a climate in which to operate, a springboard to leap further into the air."[24] Singling out Bunshaft's Lever House (1952), he lamented the misapplication of the Style, pointing specifically to the irregularity of the spacing of the aluminum-clad columns in the plaza and the ugly fire stair.[25] In contrast, he showed a rendering of the Seagram Building (1958), which he compared to "the buildings of other Golden Ages — Egypt, Rome, Byzantium."[26] The Seagram Building, he clarified, was not an example of the International Style but, rather, of "an accepted style," by which he meant a skeletal steel structure, the use of glass, and a colonnade of "noble piers."[27] Style was to be found in the exactness of the detailing (i.e., the "stiff bronze edging" of the corners), which signaled the ineffable: the architect's sense of invention.[28]

When Johnson invoked history in "Style and the International Style," and declared: "our Golden Age of Architecture is only beginning," he did so with an entirely different intention than Luce.[29] The distinction is essential to an understanding of Johnson's architectural enterprise in the postwar decades. There is no indication in his writings that his preoccupation with "the buildings of other Golden Ages" was in any way intended to serve "Democratic Capitalism." For Johnson, history served other masters. Through his passion for history, he removed himself from his American context and put himself into dialogue with other architects across the centuries. More pointedly, Johnson brandished history to expose the modern corporate Arcadia as nothing more than a shallow veneer. This is precisely the point of the comparison he makes between Lever House and the Seagram Building in "Style and the International Style": history comes forward in the Seagram Building with a real vengeance to expose Lever House and everything it represents as a fraud. He says as much in a lecture he gave at Yale in 1959, "Whither Away —

Non-Miesian Directions," in which he dryly recommends substituting history "for the debacle of the International Style, which is now in ruins around us."[30]

In Johnson's view, the Seagram Building was inviolate. As acolyte and interpreter, he created a narrative for Mies's architecture that made Mies seem far more remote from mass culture than was the case. There was no real ideological conflict between American discourses on democratic capitalism and the German *émigrés*, who anxiously reframed their earlier principles to accord with American beliefs. Despite the *cause célèbre* that erupted over the Farnsworth House, the flames of which were fanned by Elizabeth Gordon, editor of *House Beautiful*, Mies's architecture was as easily absorbed into mass culture as Saarinen's new headquarters for GM and TWA. The Seagram Building plays a starring role in Jean Negulesco's film *The Best of Everything* (1959). It plays a similar role in *Breakfast at Tiffany's* (1961), in which a kittenish Audrey Hepburn seduces George Peppard while sitting on the green marble balustrade framing the Seagram Building Plaza, an iconic image that will forever mitigate the view of the plaza as a negative void later proffered by Tafuri.[31] It was Johnson's main contribution as junior partner on the project, his design for the Four Seasons Restaurant (1959), with its Schinkelesque reimagining of the imperial Roman triclinium, that resisted easy assimilation into the mainstream commercial imagination.

As his conduit to Schinkel, Mies was at the core of Johnson's worship of history. He was obsessed with the clipped quality of the Prussian box and the cool majesty of Prussian decoration. In "Schinkel and Mies," a lecture he gave in the Congress Hall in West Berlin in 1961, he aligned himself with these two masters as the third of a trinity of romantic classicists. In this lecture, momentarily disengaged from an American context that inspired only his cynicism, he was at his most technical. In Berlin, Johnson was on hallowed ground. In a somber tone he explained: "All my architectural designing has been influenced by the work and example of two men, two men who both had years of their best work in this city," affirming that his desire to become an architect was the outcome of his own experiences in that city.[32] Focusing his intellect on the two things he loved most, architecture and history, the twin figures of Schinkel and Mies emerged "unaccented" from "the whole continuum of architecture," except for the sense of divinity he accorded them in his role as artistic heir.[33] Johnson presents Schinkel and Mies as academic architects, although, he argues, they both grappled with the revolutionary work of their contemporaries – in Schinkel's case Boullée, Gilly, and Ledoux; in Mies's case Lissitzky, Mondrian, and Picasso. In championing their academicism, he made a case for his own historicism and distinguished himself from his (truly visionary) contemporaries, Rudolph and Kahn.

In proudly placing himself in a genealogy of romantic classicists, John-son took an ideologically charged position in a historical debate with signifi-cant import in the postwar context. Giedion had coined this term in his first book, *Late Baroque and Romantic Classicism* (1922), to describe the birth of modern architecture in the period of the late Enlightenment. Emil Kaufmann had further elaborated on the relationships between the architectural fan-tasies of the Enlightenment revolutionaries and the early-twentieth-century avant-gardes in *Von Ledoux bis Corbusier. Ursprung und Entwicklung der Autonome Architektur* (1933). Published in the year the Nazis seized power, Kaufmann's book was prescient in terms of the kind of modern, yet monu-mental, vastly volumetric, and highly ordered architecture the Nazis would realize. As critics such as Scully later recognized, Ledoux's fantasies found an end point not in Le Corbusier's villas but in Speer's endless colonnades. Horrified by Hitler's perversion of history and of modernism, Giedion repudi-ated his own earlier thesis: first in the Charles Eliot Norton lectures he gave at Harvard in 1938, and then in *Space, Time and Architecture* (1941).

According to Schulz, Johnson was obsessed with Kaufmann's book: he invited Kaufmann to speak to a group of students and faculty in the house he built for himself on Ash Street in Cambridge while a graduate student at Har-vard. Kaufmann's book was still atop his reading pile in 1947–1948, at the time of the Mies retrospective at MoMA and the design of the Glass House.[34] In "Schinkel and Mies," Johnson adopts Kaufmann's argument, but shifts the comparative emphasis from Ledoux and Le Corbusier to Schinkel and Mies, making the case, as he did in the 1949 Mies retrospective at MoMA, that vital Enlightenment polemics found their full realization in Mies's architecture, pointing especially to Mies's Nazi-era projects. Johnson's self-conscious revival of romantic classicism, with its well-known connection to Nazi archi-tecture, was another means of attacking the political narratives impinging on postwar American architectural discourses.

In his museums of the 1950s and early 1960s, Johnson substituted his own unique formulation of romantic classicism and a *revanche* idea of history in place of American democratic ideals. The Amon Carter Museum in Fort Worth, Texas (1960) pays homage to Schinkel's Altes Museum in Berlin; while the Proctor Institute pays homage to Ledoux's Maison des Gardes Agricoles at Maupertuis, which he cited as a source for the Glass House. The Sheldon Memorial Art Gallery has a multiplicity of referents: Hellenic in the shape of the building, Byzantine and Islamic in the ceiling system, Gothic in the flattened curves of the arches, and late baroque in the grand anodized gold scissor stair (which is undoubtedly Johnson's

homage to the "stair worthy of a Baroque palace" in Mies's Nazi Reichsbank proposal). Describing the gallery, Johnson said: "the challenge was severe," a sentiment that, as he explained, also deliberately applied to the visitor's experience of the building.[35]

There is no discernible humanist impulse in these buildings, as there is in Kahn's Yale Art Gallery (1953). They do not glorify technological materialism, as do contemporaneous works by Saarinen; nor do they engage ideas about cultural materialism, as do later works by Rudolph. There is certainly no populist impulse, as there is in the architecture of Morris Lapidus, which appealed to the mass audience's "gargantuan appetites" (Arendt's phrase) for glamour and exoticism. By pointing back to the romantic classical architecture of Schinkel and Ledoux, Johnson reignited the most polemical aspects of the Enlightenment "quarrel of the Ancients and the Moderns," hypothesizing an ultimately irreconcilable gap between the past and the present. Beneath the "noble simplicity and quiet grandeur" of his façades flows the same sublime, stupefying encounter with history that runs through Winckelmann's *History of the Art of Antiquity* (1764). This was no mere showy embellishment of the International Style, but an even more "severe" form of abstraction than Breuer's buildings in an Egyptian mode. As such, it became the subject of acidic criticism.

3.3 (following pages)

Philip Johnson, Sheldon Memorial Art Gallery, University of Nebraska, Lincoln, 1963, © Ezra Stoller/Esto.

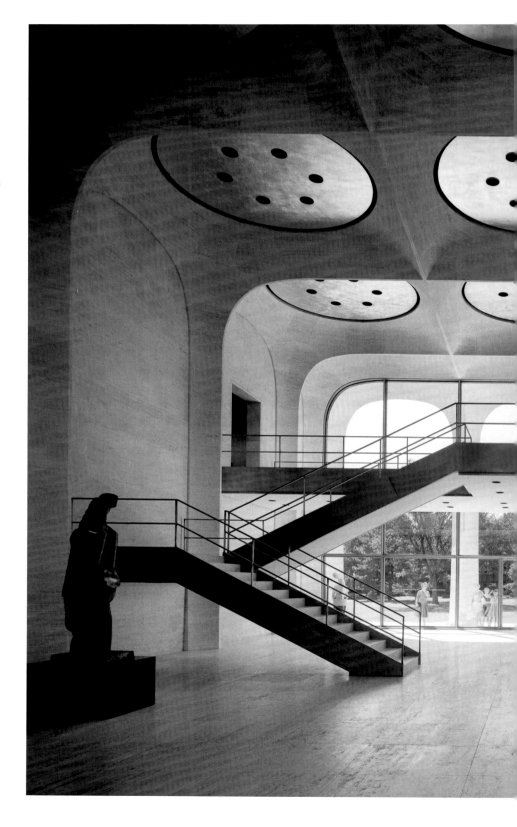

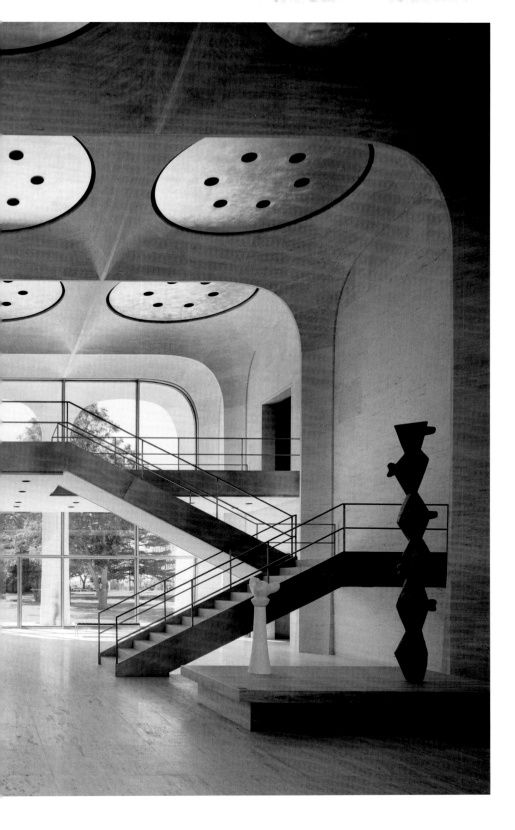

Johnson's architecture, treated as an accessory to his homosexuality and his politics, has long been met with expressions of revulsion. Charges of perversity, stylistic confusion, formal "chaoticism," and destructive disregard for morality characterize the criticism. In his 1973 book *Modern Movements in Architecture*, for example, Jencks characterized Johnson's architecture as sheer sexual-historical provocation: "a demonstration of his impeccably perverse taste and motivated by historicist allusions."[36] For Jencks, Johnson's architecture was not only amoral but "fatalistic," "destructive of the public domain which depends on both personal sacrifice and morality."[37] More than two decades later, in a 1995 review of Schulz's biography, Hilton Kramer characterized Johnson's career as "a series of brilliantly performed cha- rades in which other people's ideas, other people's taste, and other people's styles have been appropriated, exploited, deconstructed and repackaged to advance the prosperity of his own reputation and influence"; Kramer dis- missed all his major works as "failed buildings."[38]

Failure is, in fact, the proper lens through which to view the queer sub- text of Johnson's architecture. Queer theorists such as Judith Halberstam and Lee Edelman have recently argued for the significance of failure as it relates to the political positioning of homosexuality.[39] They interpret the fail- ure to participate in the normative structures of marriage, child-rearing, and domestic family consumption in contemporary capitalist society (Jencks's "personal sacrifice and morality") as a productive political stance of nega- tion signaling the possibility of alternate regimes. Seen through this lens, all of the qualities that Jencks and Kramer identify in Johnson's architecture, which continue to get under the skin of modern architectural historians, can be interpreted as focused, determined queer acts of negation. It is not that complicated: Johnson's "full scale false scale" philosophy knowingly flaunted failure as a primary feature – the defining feature – of his architecture: the useless monument was by definition a failed building.

In *Modern Movements in Architecture*, Jencks dismissed the body of Johnson's postwar work as "entirely Camp."[40] He had read Sontag's (then still recent) essay "Notes on Camp" (1965), but missed her point. Camp is in fact a useful category for exploring Johnson's queer sensibility because of its complex engagement with culture, history, politics, sexuality, style, and taste at a specific moment in the early and mid-1960s. To call Johnson a "camp dandy" seems both unacceptably reductive and anachronistic; he was a master of the sensibility long before Sontag ever described it. Camp "con- verts the serious into the frivolous": Johnson converts the seriousness of his

1933 essay "Architecture in the Third Reich" into the frivolousness of "Wither Away – Non-Miesian Directions" from 1959, but it is the same piercingly critical avid eye. He cast a camp eye on the dominant political and social regime, illuminating its anxieties particularly around issues such as durability and productivity. Camp objects, as Sontag describes them, are analogous to the useless monuments Johnson designed. Like Sontag, who argued against moral interpretations of art, Johnson argued against a moral imperative in architecture. "In place of a hermeneutics we need an erotics of art," Sontag wrote at the end of "Against Interpretation" (1964), a prelude to her "Notes on Camp."[41] The camp sensibility provided such "an erotics" by joining adoration of outmoded styles with love of beautiful objects and varieties of cynicism. Johnson imbued his architecture with similar erotic values.

Kramer, like Jencks, grossly misrepresented camp sensibility, especially its emphasis on various modes of performance. Johnson hints that he conceived of his pavilions as a form of drag performance, architectural *tableaux vivants* in which he could adopt improper attitudes (like Emma Hamilton and her infamous "Attitudes") and try on a multiplicity of styles. Floating on a lake, the Moon-Viewing Pavilion was a make-believe Cythera where one could slip into a girlish persona and play at being a coquette. In "Full Scale False Scale," he writes: "My pavilion I should wish to be compared to high-style, high-heel evening slippers, preferably satin – a pleasure-giving object, designed for beauty and the enhancement of human, preferably blond beauty."[42] He describes one of the four open-air rooms in the pavilion as a boudoir, as if it were modeled on the boudoirs in Jean-François de Bastide's *La petite maison* (1758). In this novella of architectural seduction, the libertine Trémicour seduces the coquette Mélite by guiding her through the rooms in his folly of a house, with a succession of boudoirs, one leading into the next; during dinner, at one of many climatic moments, he flips a switch and the dining-room ceiling swiftly rolls back, opening to the sky: inside becomes outside, and vice versa. Johnson's pavilion also recalls Le Camus de Mézières's treatise *Le génie de l'architecture, ou L'analogie de cet art avec nos sensations* (1780), a guidebook for the proper interior decoration of the aristocratic Parisian townhouse, in which he says the boudoir should be adorned the same way a fashionable woman is dressed. Johnson's boudoir reference speaks directly to the way camp sensibility turned aristocracy itself inside out, toying with antiquated notions of class and taste.

Johnson's pavilion was thus a site of political, sexual, and social inversions symbolizing unpredictable, mercurial ideals – certainly at odds with the prevailing corporate aesthetic of fixity and rigid solidity. The pavilion was

an allegory for falsity as a state of being in the world: "it is pleasant to be in a false scale," Johnson says.[43] The point of the arches was that they were demonstrably false: "it is obvious these arches are not truly structural – not honest."[44] This was more than a mid-1950s expression of the "epistemology of the closet" (Eve Kosofsky Sedgwick's pioneering phrase), or a Tennessee Williams-like displacement of his gay subjectivity into a female persona. Johnson sought to cast into sharp relief the artifice of the construction of architectural norms, just as the drag queen, through illusive performance, revealed the artifice of the construction of gender norms. As he makes clear: "I wanted to deliberately fly in the face of the 'modern' tradition of functionalist architecture."[45]

Johnson's digressive, witty performance style in his public lectures displayed a distinctive discursive mode. In describing the backstage world of the performing arts in mid-century New York, headed at its apex by Johnson's friend Lincoln Kirstein, the poet Wayne Koestenbaum has described the character on view in Johnson's lectures: he is the "gay virtuoso gabber – creature of lists, parentheses, digressions, apostrophes, opinions, contradictions," all of which were a part of the syntax of "pre-Stonewall gay argot."[46] In a similar vein, in describing "the writing of modern homoerotics," the literary critic Kevin Kopelson, drawing on the work of Foucault, has stressed the significance of "reverse discourse" in "gay self-articulation," defined as "subaltern speech that transfigures dominant ideology": in other words, the purposeful misappropriation of dominant discourses in such a way that they are turned back on themselves as a means of attack.[47] Johnson deploys precisely this kind of subversive reverse discourse in projects such as the Moon-Viewing Pavilion, where "the form of the design – the grammar – is frankly 'modern,'" but "the idea of the arch is, of course, contrary to 'modern' design."[48]

In his essay on the Glass House, Johnson wrote about "the grammar of architecture," stressing the peculiar importance in his work of syntax.[49] His architectural vocabulary and his decorative and spatial system may have come from Mies, but his sharpened syntax had a pointed inflection, which resulted, as he himself recognized, in a "totally different compositional effect."[50] Johnson's syntax was not "fussy" – a charge leveled at Rudolph's initial designs for the Jewett Arts Center at Wellesley College (1955), which looked back to the Doge's Palace in Venice.[51] Even a project as decked out as the Four Seasons Restaurant, with its metallic drapes hanging like dripping jewelry, is characterized by a rich, but spare, decorative detailing. The queerness of Johnson's architecture lay in his oppositional approach to the

practice of architecture and the overall "compositional effect," not in fussy decorative motifs, which in the 1950s were often connected to effeminacy.

When Rudolph, who was also openly gay, left the chairmanship of Yale's School of Architecture (which he had taken up in 1957) in 1965, he said: "I suppose the Yale chairmanship made me a member of the Establishment, being accepted or something. I now understand that I can never belong to these things and that I'll always be attacked as an outsider."[52] Johnson presents an even more interesting case study, because he *was* member of the Establishment. It was their open "defiance of convention" (Jencks phrase) and iconoclastic attitude (if you want to call that "honest arrogance," Jencks again) toward modernist doctrine that enabled them to devise revolutionary architectural vocabularies (Rudolph's megastructuralism, and Johnson's postmodernism, *avant la lettre*).

Johnson and Rudolph upend 1950s critiques that equated ornamental architecture with social pathology. Such critiques were usually connected to critics' fears about the impact of conspicuous consumption on modern architecture. Neither Johnson nor Rudolph worked in the realm of commercial design, like an architect such as Lapidus. In any case, criticism of Lapidus — as well as Saarinen, Stone, and others — often came from critics, including Douglas Haskell and William Jordy, who weirdly lagged behind the public (and the architects themselves) in their understanding of shifts in taste. As Alice Friedman has shown, Lapidus's swanky hotels were understood by most "to fit squarely within postwar modernist trends toward an expanded palette of forms and emotional possibilities — it is clearly modern architecture that was shaped by the desires and aspirations of American glamour."[53] Johnson and Rudolph worked on the periphery of mass culture, and were actively subverting modernism from within, in their respective ways.

In Johnson's case, this subversion was motivated by a sense of difference that was most radically expressed in his political activism of the 1930s. He never broke with orthodox modernism, as some critics posited in the 1960s (e.g., William Jordy's "the Mies-less Johnson"); on his travels in Europe in the early 1930s he saw that the avant-gardes themselves were already moving on from the purism of the 1920s. In 1933, before he even became an architect, he welcomed the move toward monumentality and historical synthesis that he saw in the earliest Nazi prestige projects.

Like his architectural libertinism, Johnson's cynicism was a result of his political misadventure as much as a response to the degradations of mass culture. With the rise of postmodernism, he knew enough to turn his cynicism into celebrity, which is also to say that he saw celebrity as a form of

cynicism. In this he was a trailblazer and a true contemporary of Warhol, with whom he collaborated on the façade of the Theater of the New York State Pavilion at the 1964 world's fair. When postmodernism exploded in the 1970s, he was hailed as a prophet. His grinning visage on the cover of *Time* in 1979, soon after the unveiling of his controversial AT&T Building, represents the apotheosis of his cynicism and his historicism. The AT&T Building pointed back to the vengeful notion of history he developed in his lectures of the 1950s: by 1979, Johnson was no longer decrying "the shibboleth of democratic capitalism" because it had finally come around to his way of thinking: big business no longer desired "democratically acceptable" buildings; it now aimed to express totalitarian fantasy.

THE BREAK IN TRADITION

According to Arendt, for almost all of recorded history politics had worked in the service of tradition. Rome itself had been founded not to forge a new civilization, but to preserve the traditions of a lost civilization — that of Troy — and later to preserve the traditions of the civilizations it conquered and absorbed. Tradition — "the basic assumptions of traditional religion, traditional political thought, and traditional metaphysics" — had been challenged, she believed, by the romantics in the nineteenth century and by Kierkegaard, Nietzsche, and Marx, but it was during the Second World War that the break with tradition became definitive, a theme she returns to again and again in *Between Past and Future* (1961):

> This sprang from a chaos of mass-perplexities on the political scene and of mass-opinions in the spiritual sphere which the totalitarian movements, through terror and ideology, crystallized into a new form of government and domination. Totalitarian domination as an established fact, which in its unprecedentedness cannot be comprehended through the usual categories of political thought, and whose "crimes" cannot be judged by traditional moral standards or punished within the legal framework of our civilization, has broken the continuity of Occidental history. The break in our tradition is now an established fact. It is neither the result of anyone's deliberate choice nor subject to further decision.[54]

She had in fact put this another way in the preface to the first edition of her *magnum opus, The Origins of Totalitarianism*, in 1951 over a decade earlier: "The subterranean stream of Western history has finally come to the surface and usurped the dignity of our tradition. This is the reality in which we live. And this is why all efforts to escape from the grimness of the present into nostalgia for a still intact past, or into the anticipated oblivion of the future, are vain."[55] But, as Arendt makes clear in *Between Past and Future*:

"The end of a tradition does not necessarily mean that traditional concepts have lost their power over the minds of men. On the contrary, it sometimes seems that the power of well-worn notions and categories becomes more tyrannical as the tradition loses its living force and as the memory of its beginning recedes; it may even reveal its full coercive force only after its end has come and men no longer even rebel against it."[56]

Three "indisputable" facts, all interrelated, come together to create a crisis in the concept of history: the introduction into the world of the phenomenon of totalitarianism, the concomitant break in tradition, and the ascendance of a perpetual present that no longer has recourse to a "useable past" and which therefore becomes "a fact of political relevance," or the sole focus of politics. As a result of the break in tradition, furthermore, there is a sudden scramble to find new meaning in traditional concepts. This helps to explain the crazy mania for naming on the part of intellectuals in all fields in the 1950s and 1960s. New meaning, however, is no longer rooted in the deep past, but rather in the recent experience of the Second World War. Tradition — drained of its living force, and refracted through this new foundational moment — becomes both coercive and banal. Concepts such as "freedom and justice, authority and reason, responsibility and virtue, power and glory" become what Arendt calls "empty shells" — much like the postwar American buildings Scully and others endeavored so strenuously to describe.[57] With the Moon-Viewing Pavilion, Johnson literally designed an empty shell, an *ipso facto* ruin.

In *Modern Architecture: The Architecture of Democracy* (1961), Scully attempted to place postwar American architecture within historical architectural and democratic traditions. He marshaled an extraordinary array of references, but he ultimately revealed the extreme degree to which it was estranged from history. He singled Johnson out as the architect *par excellence* who best theorized the break with tradition. I am not convinced that Scully liked Johnson's architecture, but Johnson appealed to him precisely because he turned the relationship between past and present, usefulness and uselessness, and totalitarian and democratic aesthetics into organizing principles for his architectural investigations.

With his Nuclear Reactor at Rehovot, Johnson visualized in dramatic architectural form the precariousness of Western tradition *vis-à-vis* nuclear power. In Arendt's "Introduction *into* Politics," a lecture she gave often throughout the mid-1950s, the role of nuclear technology in cementing the break in tradition comes into focus: "When the first atomic bombs fell on Hiroshima, preparing the way for an unexpectedly quick end to World War II, a wave of

horror passed over the world."[58] In the last chapters of *The Origins*, Arendt wrote of the emergence of "some radical evil, previously unknown to us," which leads to "the realization that something seems to be involved in modern politics that actually should never be involved in politics as we used to understand it."[59] (She would later amend the concept of "radical evil" in her book *Eichmann in Jerusalem: A Report on the Banality of Evil*, published in 1963; but, as she makes clear in both *Between Past and Future* and the *Eichmann* book, the quality of banality, especially as it related to inculcation of evil into the bureaucratic complexes of modern life, was in fact radical.) Arendt compares the effects of the concentration-camp system and the atomic bomb: "for a victory of the concentration-camp system would mean the same inexorable doom for human beings as the use of the hydrogen bomb would mean the doom of the human race."[60] The "something ... involved in modern politics that ... should never be" is the use of technology for the atomization, dehumanization, and ultimately the annihilation of masses of people, whether in concentration camps or through the deployment of nuclear weapons: both achieve the same end through different means.

At the end of *The Origins*, she offered a series of warnings, statements of foreboding, prophecies, about where the new knowledge of "radical evil" might lead. Here she linked "uselessness" to hitherto unknown processes of mass production and consumption:

> The danger of the corpse factories and holes of oblivion is that today [she was writing this around 1950], with populations and homelessness everywhere on the increase, masses of people are continuously rendered superfluous if we continue to think of the world in utilitarian terms. Political, social, and economic events everywhere are in a silent conspiracy with totalitarian instruments devised for making men superfluous. The implied temptation is well understood by the utilitarian common sense of the masses, who in most countries are too desperate to retain much fear of death. The Nazis and Bolsheviks can be sure that their factories of annihilation which demonstrate the swift solution to the problem of overpopulation, of economically superfluous and socially rootless human masses, are as much of an attraction as a warning. Totalitarian solutions may well survive the fall of totalitarian regimes.[61]

She added: "it may even be that the true predicaments of our time will assume their authentic form – though not necessarily the cruelest – only when totalitarianism has become a thing of the past"; that is to say, after totalitarianism has been absorbed into the world's consciousness.[62] Arendt was making frightening claims, almost all of which proved true, as our

unending fascination with the Nazi extermination camps and more recent fixation on "weapons of mass destruction" demonstrate. But her main point was that political, social, and economic events everywhere were "in a silent conspiracy with totalitarian instruments devised for making men superfluous." Nuclear weapons were a totalitarian instrument, but so were postwar modes of mass production and consumption.

For Arendt, President Eisenhower's waging of "total peace" to combat "total cold war" was another of the ways in which totalitarian solutions had survived the defeat of Nazi Germany. The concepts "total war" and "total peace" were products of totalitarian ideology:

> This concept of what is now called "total war" originated, as we know, in those totalitarian regimes with which it is inextricably linked; a war of total annihilation is the only war appropriate to a totalitarian system. Total war was first proclaimed by nations under totalitarian rule, but in doing so they inevitably forced their own principle of action onto the non-totalitarian world. Once a principle of such vast scope enters the world, it is of course practically impossible to limit it, for instance, to a conflict between totalitarian and non-totalitarian nations. This became clear when the atomic bomb, which was originally produced as a weapon against Hitler's Germany, was dropped on Japan. A cause of outrage, though not the sole cause, was that although Japan was indeed an imperialist power, it was not a totalitarian regime ... total war was now a fait accompli.[63]

She began to ask another set of questions: Why was the world enthralled by the idea of the war of total annihilation? Why had America obscured its own glorious revolutionary tradition by fixating instead on the much more recent Russian and Chinese revolutions?

Arendt addressed these questions in *On Revolution* (1963). Much in the same way that she searched for the original meanings of concepts such as tradition, authority, and freedom in *Between Past and Future*, in *On Revolution* Arendt sought to rediscover the meaning of the American Revolution. It was a rebuke to *Fortune*'s *U.S.A.: The Permanent Revolution* (1951). Directly addressing the ethos of the *Fortune* program, she argued that it was in fact the conflation of freedom with "free enterprise" that had most obscured the true meaning of the American Revolutionary tradition, which was freedom itself: "When we were told that by freedom we understood free enterprise, we did very little to dispel this monstrous falsehood, and all too often we have acted as though we too believed that it was wealth and abundance which were at stake in the postwar conflict between the 'revolutionary' countries of the East and the West."[64] In *On Revolution*'s final essay, "The Revolutionary

Tradition and Its Lost Treasure," she remarked on the ubiquity of revolutions in the late 1950s and early 1960s "in the political life of nearly all countries and continents," especially in Latin and South America; yet the American Revolution was not integral to worldwide discourses on revolution, while revolutionaries "knew by heart the texts of revolutions in France, in Russia, and in China."[65] Arendt's interest in a "lost treasure" connects her investigation to Scully's search in *Modern Architecture* for the lost tradition of Greek architecture, which, he felt, had been obscured via "academic adjustment" by later architects in other nations.

KEEPING THE PROPAGANDA IMAGE INTACT

The political commentators Edmund Stillman and William Pfaff recognized America's coming to maturity as marking a historical turning point, encapsulated in the title of their 1961 book *The New Politics: America and the End of the Postwar World*. To their way of thinking, the American claim to greatness in winning the Second World War was losing its hold over the world. Their sense of the world *circa* 1961 was that it was straining to be released from the bipolarity of the postwar years: "the first period of the nuclear era – the era of the polarization of strength – has drawn to a close, and the second, the period of the diffusion of power, is beginning."[66] This engendered a sense of disenchantment, but also a sense of possibility. Like Scully, who characterized this moment as "a period of rest, of reassessment," Stillman and Pfaff saw it as a moment for America to reexamine faulty foreign policies and accommodate "the rise of a plural world."

For Pfaff and Stillman, "The Question of National Significance" – the title of their conclusion – was whether or not the United States could dispense with its "penchant for absolutes."[67] The problem, they predicted, would increasingly become one of maintaining credibility *at home*. Would the country continue to buy into an ever-widening set of illusions? They spoke of "an American addiction to illusion": the illusion of imperium, a messianic foreign policy, "politics as crusade – as a moral undertaking directed to a morally conceived end," a misguided mission "to solve history's riddle and bring time to a stop."[68] Or would the country accept the demands implicit in reality?

Sharp-eyed power brokers were in fact looking for a way out of the stifling emphasis on abstractions and totalities that characterized 1950s foreign policy. Nuclear weapons and the threat of massive retaliation created a credibility problem *abroad*. Not only did the prospect of nuclear retaliation deflate the traditional meaning of victory in war, it put America in the position of fearing rather than using its own power. In 1957, Henry Kissinger,

then a professor at Harvard and director of the Rockefeller Brothers Fund, a Republican think tank, published *Nuclear Weapons and Foreign Policy*, which addressed these subjects from the opposite end of the spectrum than Arendt. Kissinger, who identified with Talleyrand, admired Metternich, and saw himself as their heir, viewed nuclear weapons as a threat that had to be leveraged to better effect. Dislodged from the core of foreign policy, held in check as a bargaining chip, they could be used as a tool of diplomacy. The Soviets, Kissinger argued, would soon find it implausible that America would be willing to step over the brink in each minor crisis. As Jonathan Schell (a student of Arendt's) explained, summarizing Kissinger's argument: "the policy [of massive retaliation] threatened to transform every small crisis into a major nuclear crisis, and it left the United States without 'credible' instruments of force in situations where the stakes were too small to justify any risk of 'suicide.'"[69] Kissinger made the case for a policy of "limited war," a return in some ways to the "cabinet wars" of the eighteenth century. The strategy of limited war, Schell explains, opened up new fields of action, new "active elements" in American military strategy.[70] "Credibility" was the new psychological objective – the United States could show the "will," "determination," and "resolve" to engage in limited wars, with massive retaliation as the backdrop against which those wars could be fought. Kissinger was "rescuing force from nuclear paralysis ... making the world safe again for war";[71] critics, such as Schell, would read Kissinger's argument in retrospect as part of the build-up to the Vietnam War. In the meantime, Kissinger would have to restate his case in yet another, equally weighty tome: *The Necessity for Choice*, published in 1962.

Taking up the illusion of imperium, Pfaff and Stillman stipulated that "even enlightened imperium" was not in the true mode of the United States: "such a policy demands a discipline of life, an austerity of national style, a political hardness which are not ours."[72] They cited American "impatience" with grand plans, an ingrained aversion toward ideology, a fondness for common sense among the diverse American population. They looked for a way to wiggle out of using the word: "This besieging of the Sino-Soviet world is something else again, and very large," they said, and asked, rhetorically: "would it be permissible, in the American postwar case, to speak of a 'denatured imperialism' which invokes the phrase 'world defense' instead of 'world dominion,' an addiction to international responsibility without the concomitant addiction to the arts of war?"[73] They tried to transform the imperialist impulse and the case for limited war into what would forty years later, in the 1990s, become so-called limited humanitarian-military operations.

Although the policy of credibility released the U.S. from the stranglehold of the balance of terror, opening up new fields of action, it did not do away with the problem of illusions. Credibility merely created a different set of images, and treated politics as even more of a mind-game. In "Truth and Politics" (in *Between Past and Future*), Arendt acknowledged at the outset that truth and politics had never kept good company, and asserted that lying in politics was a legitimate means to an end. But she saw "the relatively recent phenomenon of mass manipulation of fact and opinion as it has become evident in the rewriting of history, in image-making, and in actual government policy" as something different — a novel form of propaganda.[74]

> National propaganda on the government level has learned more than a few tricks from business practices and Madison Avenue methods. Images made for domestic consumption, as distinguished from lies directed at a foreign adversary, can become a reality for everybody and first of all for the image-makers themselves, who while still in the act of preparing their "products" are overwhelmed by the mere thought of their victim's potential numbers. No doubt, the originators of the lying image who "inspire" the hidden persuaders still know that they want to deceive an enemy on the social or the national level, but the result is that a whole group of people, and even whole nations, may take their bearings from a web of deceptions to which their leaders wished to subject their opponents.[75]

The web of deceptions, the onslaught of images and lies, also overwhelms tradition — if not purposefully, then as an unintended consequence. The images and lies, rather than tradition, serve as the foundation from which everything else springs: "What then happens follows almost automatically. The main effort of both the deceived group and the deceivers themselves is likely to be directed toward keeping the propaganda image intact, and this image is threatened less by the enemy and by real hostile interests than by those inside the group itself who have managed to escape its spell and insist on talking about facts or events that do not fit the image."[76] Those who have managed to escape the spell of the images and lies become Cassandra figures ("whistleblowers" in today's parlance), but are inevitably labeled conspiracy theorists, hysterics, and traitors. Reality becomes just another "field of action" that can be acted upon, rather than a state of being to be recognized or assessed (a.k.a. "the reality of the situation"): "we can take almost any hypothesis and act upon it, with a sequence of results in reality which not only make sense but *work*. This means quite literally that everything is possible not only in the realm of ideas but in the field of reality itself."[77] Reality, in other words, could be made to conform; reality could be made to "fit the image"; this, for Arendt, was the most destructive form of conformism.

—

In the political climate of the late 1950s and early 1960s, perhaps only cynicism could counter illusion and expose truth. Among his contemporaries, only Johnson, through his cynicism, retained a kind of distance from the propagation of democratic narratives; by contrast, the architecture of Bunshaft, Saarinen, Breuer, and Stone worked in one way or another to "keep the propaganda image intact." Even Johnson's later postmodern projects – the Crystal Cathedral in Garden Grove, California (1977–1980), Republic Bank Center in Houston (1981–84, now Bank of America Center), PPG Place in Pittsburgh (1981–84) – in which he purportedly adopted the dictates of corporate capitalism, seem like wry, biting commentaries on the state of American democracy with its unending flow of images and "web of deceptions" (these buildings, moreover, all have latticework mirrored façades).

On the one hand, cynicism was part of camp sensibility as Sontag defined it: "Camp is generous. It wants to enjoy. It only seems like malice, cynicism. (Or, if it is cynicism, it's not ruthless, but a sweet cynicism.)"[78] But Arendt articulated the effects of cynicism differently than Sontag: "it has frequently been noticed that the surest long-term result of brainwashing is a peculiar kind of cynicism – an absolute refusal to believe in the truth of anything, no matter how well this truth may be established."[79] I am not sure if Johnson practiced architecture as a "mode of enjoyment, of appreciation," despite the multiplicity of homage in his buildings. His cynicism did have a sinister side: I do not mean to suggest that he was "brainwashed," but his sense of political disenchantment, and his clearly expressed sense of disgust at the economic, political, and social illusions of the postwar era, point more toward Arendt's "refusal to believe in the truth of anything." Yet in the end, this is something apart from Jencks's and Kramer's assessments that Johnson's entire architectural enterprise was "fatalistic" and "destructive." In the climate in which he worked, the refusal to believe in the truth of anything can be construed as another political stance of negation.

Arendt's critiques of postwar American political discourses in *The Human Condition*, *Between Past and Future*, and *On Revolution*, articulated in dense and highly idiosyncratic comparative analyses, while widely read, were largely misunderstood. In any case, they were completely overshadowed only a few years later (in 1963) by the sensational controversy surrounding the publication of her dispatches from the Adolf Eichmann trial, first in the *New Yorker* and then as *Eichmann in Jerusalem*. In another line of critique, feminist scholars lambasted her for her admiration for the ancient Greek polis, which excluded women from the public realm – it seemed bizarre to them

The Useless Monument

that she seemingly idolized a culture that would have excluded her from the things she loved most, and at which she succeeded (whether or not Arendt's interest in the classical past constituted a form of lionization is still up for discussion). C. Wright Mills, who attempted to break the spell in his impassioned pamphleteering, became one of those Cassandra figures and was labeled a hysteric. Stillman and Pfaff had an air of diplomatic gentility; Pfaff expatriated to Paris and became a highly respected figure in the foreign policy establishment, with a widely read column in the *International Herald Tribune*. Johnson, however, struck a nerve, and remained an *enfant terrible* to the ripe old age of 98.

Epilogue

In *The Human Condition*, Arendt provides analysis, not answers: "This book does not offer an answer."[1] In her reconsideration of the human condition, she instead identifies concepts worth revisiting, fixing especially upon the concepts of natality, plurality, and action. Against a backdrop of increasing ideological rigidity and the immobilizing politics of fear, she writes of the possibility of new beginnings. Men are beginners, she says in the section on action, paraphrasing St. Augustine, "by virtue of birth."[2] Arendt evokes "the character of startling unexpectedness inherent in all beginnings and in all origins," notably the birth of new ideas and "the ability of men to begin something new on their own initiative."[3] This is the kind of statement that would easily be put to use in service of questionable new technologies in slick advertising campaigns. Significantly, in the book's closing paragraphs she clarifies it, singling out not scientists or "so-called statesmen" as the true revolutionaries of the age, or artists or architects, but rather philosophers, storytellers, "the privileged few" who engage in thought as "a living experience."[4] Arendt offers a quote from the modern mystic storyteller Isak Dinesen as an axiom for the section on action: "All sorrows can be borne if you put them into a story or tell a story about them." The book's last lines are a defense of thought as the most active of all the activities within the *vita activa*. For Arendt, in the end, thought alone, thought that has "the ability to produce stories and become historical, which together forms the very source from which meaningfulness springs into and illuminates human existence," is the ultimate action. Despite her misgivings about the state of things in the world, and her familiarity with "dark times," she still envisioned a politics of glory wherein "men show who they are, reveal actively their unique personal identities and thus make their appearance in the human world" – through their words.

As alluring as Arendt's arguments are – and I have quoted from her texts liberally throughout this book – she failed to adequately address the peculiarities of postwar American culture. I wish she had had a more generous view of what she dismissively called "mass entertainment." Sword-and-sandal movies – the epitome of mass entertainment in the 1950s and 1960s – were

among the strangest, but most successful, attempts to grapple with the break in tradition. They wrestled with the possibilities of epic form, questions of existence, and themes of truth as searchingly as art. The sword-and-sandal films uniformly acknowledge the break in tradition – they display a thoughtful awareness of their belatedness, as it were, in the history of Western civilization, and they take the world's new knowledge of totalitarianism as their starting point. One of the astonishing things about these films from today's perspective is their utter lack of cynicism or irony. They take history seriously – as seriously as Arendt.

These films offer answers. They attempt to bridge the break in tradition by linking past and present. The equivalent of history painting, they cast ancient stories in contemporary costume, and similarly serve as allegories of good government, sacrifice, and hope. How do you build a new world amidst the embers of a ruined civilization? How could Western traditions be reconstituted in a world dominated by two new competing superpowers always on the brink? The films join conservative and liberal viewpoints: they stress the need for a strong belief system, they show how beliefs are embedded in familial structures, but they also simultaneously propagandize liberal principles of collective welfare. They all ultimately come to focus on the individual's struggle to achieve various forms of enlightenment.

Storytelling in these films operates on a multiplicity of levels – visual, to be sure, experimental in their treatment of cinematic form, but also lyrical. The films lack the fervid ideological charge of magazine manifestos; they are surprisingly nimble in their treatment of moral and political problems. One final foray into the world of the movies to make this point: following the enormous success of *The Robe* in 1953, Twentieth Century Fox production chief Darryl Zanuck set his sights on *The Egyptian*, a massive historical novel by the Finnish writer Mika Waltari set during the reign of Pharaoh Akhenaten, 1335 BC. Published in 1945, the novel became a best-seller when it was translated into English in 1949, but it had been languishing on a shelf at Fox. Fast-tracked, it went into production, with Michael Curtiz assigned to direct. Curtiz practically invented the swashbuckler at Warner Brothers, where he worked for decades, but with the splintering of the studio system he became a freelancer. *The Egyptian* was his first post-Warner Brothers movie. It was an opportunity to experiment with Cinemascope, but he was also in a reflective mood. The finished film (written by veteran screenwriters Philip Dunne, who had also written the screenplays for *The Robe* and its sequel *Demetrius and the Gladiators*, and Casey Robinson, who had worked with Curtiz for years at Warners) is as much an allegory of Hollywood as a

commentary on domestic politics and foreign policy. Waltari's visionary novel provided the superstructure. It addresses contemporary issues such as the survival of the individual spirit when beset by the immense pressures of groupthink, transposed into a narrative about ancient Egypt.

The protagonist, Sinuhe, is a proto-Moses figure cast adrift as a baby on the Nile in a small reed boat tied with fowlers' knots. Raised by a physician, he learns the intricacies of brain surgery and the mysteries of the human mind. A loner, he later enters the "School of Life," a kind of Grande École where young men from professional families are trained for the highest positions. There he meets Horemheb, who will become a warrior and politician, and Merit, a poor servant girl. Horemheb represents brute force, while Sinuhe, who constantly asks "why?," represents the life of the mind. While out on a chariot joyride one day, Horemheb saves a man praying alone in the desert from a lion, while Sinuhe aids the man, who has a sudden seizure. It turns out this curious stranger is the newly crowned Pharaoh, Akhenaten. When Horemheb and Sinuhe are brought before the Pharaoh in the palace throne room, a colossal hall with monumental mural relief sculptures, he appoints Horemheb to his Royal Guard and Sinuhe as Royal Physician.

Initiated into court life, Sinuhe becomes enthralled by a callous Babylonian courtesan, Nefer, who bankrupts him both morally and financially. It is the experience of obsession, more than Nefer's charms, that enchants him. In some of the film's best scenes the couple merely sit in her gilded eyrie and talk about the nature of exile. In a state of delirium, Sinuhe foolishly signs his livelihood away, giving her his copper surgery tools, his house, and even the tomb his adopted parents have built for themselves. Aggrieved, they commit suicide, but in a final note forgive him. In order to repay in labor the costs of their embalming, he goes to work in "the house of death," a descent into the underworld inhabited by the condemned, where he learns about the mysteries of death.

Thoroughly disgraced, Sinuhe goes into exile. But before he embarks on this part of his journey, Merit, Nefer's foil, and his true love, asks him: "Can't you believe in a love that asks for nothing?" This question becomes part of his wider search for "the nature of wisdom." His travels take him "to the ends of the earth," and he becomes a famous and wealthy physician serving the ruling elites of the civilizations he visits. After an encounter with a Hittite general, he returns home (with a Hittite sword in hand, thus introducing iron to Western civilization), where he finds Egypt embroiled in a civil war. Akhenaten has created a new religious cult that worships "One God," Aton, a precursor of the monotheistic religions to come. Gentle Merit, who has given

birth to Sinuhe's son, is a convert. Horemheb, now Lord Commander, is in cahoots with the priests of the old religion, who plot to murder Akhenaten and destroy his cult. They convince a reluctant Sinuhe to frame the murder as a mercy killing.

The twist: as he dies, Akhenaten converts Sinuhe to his cause through the power of his words ("The others lied to me Sinuhe, but I think you really loved me"). In yet another twist, Sinuhe turns out to be Akhenaten's half-brother, their mother's illegitimate son. The film's crosscurrents build to a magnificent final speech in which Sinuhe forsakes power for love – love of humanity. Horemheb is Pharaoh, and Sinuhe comes before him in chains: "We live in the twilight of our world," he says. Pharaohs and nations rise and fall, monuments crumble into dust. I summarize the details of his journey because it leads to this revelation: "Only a thought can live." He speaks of truth: "Only a great truth can grow and flourish, and a truth cannot be killed, it passes in secret." At the very end of his journey, he assumes the vocation of the storyteller: "I will go among the people and answer the questions that burden their hearts." Derived from Waltari's novel, the film thus expresses an Arendtian ideal.

The Egyptian is typified by its relative lack of outward action, its anti-hero protagonist, and its emphasis on thought. Melodramatic turns of events, including suicide and mercy killing, are either unseen or depicted in under-stated ways. Internal states of mind are suggested by gesture and silhou-ette, and by Alfred Newman and Bernard Herrmann's shimmering, numinous score. This is an instance where the filmmakers have improved upon the source material by condensing the narrative, while elaborating on the land-scape of the story. Visually, flat mural planes with relief sculptures fill the Cinemascope frame, serving as backdrops for the characters' meditative conversations. Curtiz manipulates Cinemascope, blocking out the scenes to create a film that moves as if it were an ancient mural relief sculpture or a scroll painting. All the actors serve the story, speaking in slow, mea-sured tones. There are no star turns or extreme characterizations, although Gene Tierney shines as the steely, calculating warrior princess Baketamun, Akhenaten's and Sinuhe's sister, barred from ruling herself, while Edmund Purdom captures Sinuhe's vague, but ultimately impassioned, soul.

As an allegory of Hollywood, Sinuhe is a stand-in for the Hungarian-born Curtiz: an exile, a foreigner, tempted by the allures of beauty, fame, and fortune. The film functions as a *vanitas* warning about the fleeting nature of worldly attainments. When Sinuhe returns to Egypt, Nefer comes to see him shrouded in a black veil, ravaged by a consumptive disease. Beauty fades

and so does its power, as opposed to the beauty and power of ideas. Like many other sword-and-sandal films, it is also an allegory of McCarthyism: brought before a court-like tribunal at the end, Sinuhe refuses to be cowed, or to conform, or to be ashamed. He is an embodiment of "the moral power of the seemingly infinitesimal individual [as] the sole substance and the real instrumentality of humanity's future," as Karl Jaspers wrote in *Existentialism and Humanism* (1952), expressing his belief in the possibility of the human spirit's renewal in the wake of Nazism.

But the film's more general allegory is one of thralldom – political, religious, and scientific. Each character is enthralled by something, be it beauty, force, power, riches, learning, or the One God. Sinuhe moves through a cycle of enthrallment to all of these things, and he emerges at the end as a proponent of pure thought and speech. The film is about the movement toward speech – the kind of speech by which, as Arendt hoped, "men show who they are, reveal actively their unique personal identities and thus make their appearance in the human world" – the kind of speech that has the character of action.

–

Architecture at its absolute best is also a form of storytelling. Among American architects working at mid-century, Louis Kahn grappled with tradition, integrated it into his architecture in tangible ways, but transformed it, giving it new life. I see Kahn as a Sinuhe-like figure. Like Arendt, he was a philosopher of origins. It was Vincent Scully, in his monograph on Kahn, who said that by 1955, with the design for the bathhouse at the Trenton Jewish Community Center, Kahn had worked himself back to the beginning.[5] In Kahn's work of the 1950s, Scully said, architecture began anew.[6] For Scully, Kahn's architecture was revelatory, giving a new shape to the world. In fact, Kahn's largest and most visionary projects remained on paper or in construction throughout the 1960s and 1970s and beyond, providing inspiration to a later generation.

A major difference between Kahn and his contemporaries is that today there is little doubt about his reputation, or the place of his work in history. He and his work are not in need of reevaluation, restoration, or revival, as is the case with Bunshaft, Breuer, Saarinen, Stone, and Johnson. The language used to discuss Kahn's architecture in the 1950s and 1960s had nothing to do with glamour or timeliness, and instead addressed the categories of order and design. Kahn's rough, tactical, and poetic relationship with form, and his sense of the universal potential of design, differed from Bunshaft's

sleek modular organizational systems and Breuer's magazine-ready surface-level effects. His famously slow working methods belied the expediency that characterized Stone's work. Although he labored to win major corporate commissions, Kahn's architectural language lacked the powerful commercial symbolism that made Saarinen's architecture so attractive to CEOs. Ironically, what made Kahn's work marginal in his own time also made it enduring.

It is a commonplace that visionaries are misunderstood in their own time. Kahn was. When Scully published his monograph in 1962, Kahn had realized only a handful of buildings (which adumbrated but did not fully exhibit his genius), but it was already clear by that point that he would emerge as the only one of his contemporaries to be considered a master builder along the lines of Frank Lloyd Wright, Mies van der Rohe, and Le Corbusier.

Kahn was more often recognized for his tousled physical appearance than for his architecture. His story begins with childhood hardship, a staple of visionary legends going back to Judeo-Christian mythology. His artisan parents — his father, a craftsman in stained glass, and his mother, a harpist — immigrated with the young Kahn to turn-of-the-century Philadelphia from an island in the Baltic Sea, an outpost of the Russian Empire, then still under the Tsars.[7] They lived in poverty, yet encouraged Kahn's early gifts as a musician and painter.[8] His childhood facial disfigurement, the result of the rising steam from hot coals carried in an apron, became a mark of difference.[9] Scully, whose monograph remains one of the best account of Kahn's ideas, quotes Kahn on his discovery of the city: "A city is a place where a small boy, as he walks through it, may see something that will tell him what he wants to do with his whole life."[10] Aside from the insight this provides into Kahn's later interest in city planning, it shows that he was attuned to elemental images, advocating, through a childlike way of seeing the world, a return to first principles.

The years from 1924, when Kahn graduated from the School of Architecture at the University of Pennsylvania, until 1950, when he won a Rome Prize, were years of partnerships and stylistic experimentation. In the legends about him, the year he spent at the American Academy in Rome is characterized as a transformative experience, the kind of artistic rebirth that is more the hallmark of figures from romantic art, like Piranesi and Goethe, than of twentieth-century American architects. Kahn integrated his experience into his architecture. His rediscovery of antiquity during his year in Rome — as shown in his sketches of Karnak, Aswan, the Athenian Acropolis, Paestum, and Hadrian's Villa at Tivoli — was totally different from Stone's rediscovery of antiquity on view in his sketches of the same sites reproduced in his memoir,

The Evolution of an Architect. Stone was awed by the majesty of the monuments and by the image of imperium they projected. Kahn, like Piranesi, was curious in an archaeological way, excavating in his mind the spatial relationships, building techniques, and underlying principles of ancient architecture (and its relation to religion and the state) in such a way that they altered his consciousness. Kahn, who hung a copy of Piranesi's Campo Marzio print above his desk, no doubt saw himself walking in Piranesi's footsteps.[11]

Although Kahn was working within the same symbolic system as his contemporaries — with his interest in antiquity and his use of Roman forms — it was clear to observers that something distinct was emerging in his work. This was evident, for instance, in the Yale Art Gallery (1953), the first project he realized after his return from Rome. Outside it appeared to be a Mies-inspired steel frame, brick, and glass-walled box, but inside it was a plate from Piranesi's *Carceri* come to life, the ceiling "a braced beam system" of "tetrohedronal elements" made of concrete "poured in place," somewhere between "rough" and "crystalline," but "not muscular," wrote Scully.[12] The main staircase, reaching up to a circular clerestory made of glass blocks and spanned by a concrete triangle, was a reformulation of the domes of Francesco Borromini and Guarino Guarini.

Kahn was reducing form to its most basic or archaic elements. He carried this process even further at the bathhouse of the Trenton Jewish Community Center (1955), where he used cheap concrete cinderblocks in their natural state to re-create on a modern, suburban scale the bathhouses of ancient Rome. The bathhouse, like the later Richards Medical Center at the University of Pennsylvania, was visually unattractive but spatially innovative. Kahn did not fit easily into the bifurcated spatial system Scully had worked out in *Modern Architecture: The Architecture of Democracy*, wherein, in the simplest terms, Greek forms were considered sculptural and good, while Roman forms were considered spatially engulfing and bad. Kahn used Roman forms in a sculptural way, reducing them to their essence and then building them back up — just like Piranesi, who in his prints multiplied forms, spaces, and structures. By the time of the bathhouse, it was also clear that Kahn's architecture could never be adapted to the mainstream political culture in the way the work of his contemporaries could. There was no way the bathhouse, for instance, was going to make it into the pages of *Fortune* magazine. It was not even particularly well suited to the economic-industrial ethos of *Architectural Forum*. Unlike Johnson's architectural *études*, the bathhouse was not picturesque, even though it was similarly comprised of a series of pavilions.

Kahn became more of an academic architect, publishing his unrealized designs in journals such as Yale's *Perspecta*. Yet he was fully engaged in trying to shape the real world on a daily basis, as demonstrated by his grueling involvement with the Philadelphia City Planning Commission, which repeatedly rejected his designs for a new city center.[13] Kahn conceived a model city for modern mass democracy, attuned to the needs of automobile and pedestrian alike. He spoke of the need for a new "viaduct architecture," an architecture "of the street, the expressway, and the garage" that would be "more respectable," more responsive to its purpose as a grand framework for civic life.[14] Seemingly inspired by Piranesi's *Campo Marzio* print, with its vast, massive geometrical forms framing an intricate urban pattern, Kahn conceived of colossal circular garages, which also served as triumphal gateways into the city center. The architecture in the center, in contrast to the viaduct architecture, would be "gossamer," as can be seen in his project for a new city hall with its diaphanous latticework structure.[15] Although Kahn argued that "the sense of patriotism of the city can be given by giving great place to the city instead of one stream of commercial enterprise," the commercial appeal of corporate modernism ultimately prevailed in Philadelphia.[16]

Kahn's unrealized design for the U.S. Consulate and Chancellery in Luanda, Angola (1959–1962) met a similar fate. In their high-profile embassies of the 1950s and 1960s, Bunshaft, Breuer, Saarinen, and Stone, following U.S. Foreign Building Office directives, emphasized American might, while offering only token references to local customs.[17] Neither Kahn's design nor the language he used to describe it in a 1961 interview reflected official American ambitions, intentions, or interests – Kahn made the mistake of envisioning a truly regional architecture. In the African equatorial context, with its hot, blinding light, Kahn spoke of "developing a warm architecture ... which somehow tells the story of the problems of glare."[18] From Foreign Building Office memos detailing the planning of Saarinen's embassy in London and Stone's embassy in New Delhi, we know that this was not a story the FBO was interested in telling.[19] Moreover, in this project, Kahn wanted to devise "an architectural expression for the problems of glare without adding devices to a window"[20] such as masonry grillework, which by this time had become the trademark of the American embassy program (as seen on Saarinen's and Stone's embassies). What Kahn devised was a system of layered walls to modulate sunlight, with long vertical and *serliana*-style openings cut in. "I thought of wrapping ruins around buildings; you might say encasing a building in a ruin so that you look through the wall which had its apertures by accident."[21] In this way, he expressed "desire for light, but still an active

fighting of the glare."[22] He devised a similar system for the top: twin roofs, six feet apart, one for sun and one for rain:

> I feel that in bringing the rain roof and the sunroof away from each other I was telling the man on the street his way of life. I was explaining the atmospheric conditions of wind, the conditions of light, the conditions of sun and glare to him. If I used a device – a clever kind of design device – it would only seem like a design to him – something pretty. ... I did not want anything pretty; I wanted to have a clear statement of a way of life. And those two devices I feel very proud of as being strong architectural statements from which other men can make infinitely better statements. These are really crude statements. ... They're actually done with almost the feeling that they should be primitively stated first rather than in a high degree of taste.[23]

This was a truly extraordinary statement for an American architect to make in 1961 – the year President Kennedy, symbolizing the triumph of "the New American Style" as described by Huntington Hartford in *Show*, was inaugurated. Light, glare, sun, rain, whether occupants turned toward the walls while they worked, the wind, and whether the air-conditioning would always work – it was an architecture of the elements shaped by the human mind, without overpowering nature with technology. It was a "way of life" worlds away from both Davenport's "way of life that makes material products worth while" and Breuer's "direction of living which is worth investigation." It was what Arendt meant when she spoke of "the human artifice."

The talk Kahn gave at the Congrès Internationaux d'Architecture Moderne (CIAM) in 1959 aligned him with Arendt as a philosopher of origins. Arendt, as we have seen, wrote about "the character of startling unexpectedness inherent in all beginnings and in all origins."[24] In a similar vein, Kahn said: "the spirit of the start is the most marvelous moment at any time for anything. ... A thing is unable to start unless it can contain all that ever can come from it. That is the characteristic of a beginning."[25] Kahn's talk was not only the concluding lecture at CIAM '59, but also of CIAM itself, which soon disbanded. At the end of the strain of modernism CIAM was founded to advance, Kahn focused on the architect's ability to realize new beginnings.

But Kahn did not think of himself as part of an avant-garde. He thought of himself simply as an architect, and from his lectures one can see that for him the architect was a citizen of the world through his calling to art. He did not adopt the CIAM mode of discourse, the prevailing conventional wisdom of a fading avant-garde. He began his CIAM address by observing that in the projects he had seen at the conference, "almost everyone started with

the solution of the problem" rather than with the "sense of realization of the problem," which is to say that they began from a prescribed theory, rather than with a problem that might not be solvable.[26] It was this sense of realization that most closely aligned him with Arendt's concept of natality: "I believe that man must realize something before he has the stimulation within himself to design something."[27] He defined realization as the coming together of thought and feeling in "a sense of order."[28] Kahn was speaking about intangible things. This sense of order is "a state of comprehension about existence," a sense of "the existence-will of something," or, in other words, "what the building wants to be," perhaps his most famous formulation.[29] For Kahn, the architect, like the musician, possessed an unusually developed sense of the order of things, which allowed him to draw his realizations from "the very nature of things."[30]

For Kahn, architectural programs derived from a politicoeconomic ideology of any stripe were irreconcilable, even anathema, to architecture. They represented a "false beginning."[31] Preset programs "will give you many things which will help the practitioner make a pretty good profit out of his commission by following the rule of rules. But this is not an architect at work," he said, critiquing the current state of the discipline.[32] He thought that every city is made up of institutions: schools, city halls, chapels, houses, streets, garages – each a specific kind of thing, a specific kind of place, unique, with its own "existence-will." For Arendt, a "polis" was not defined by its walls or by any specific preset image of an architectural enclosure, but rather by citizens gathered together in common cause. Similarly, for Kahn, the definition of a school was not a building with window walls and wide corridors and uniform classrooms, but any "realm of space" where students congregated around a teacher and discussion took place.[33] In approaching the problem of the school, Kahn began with "a realm of spaces where it is good to learn."[34]

Since Kahn saw beauty in beginnings, he spoke with admiration about archaic Greek sculpture and the paintings of Giotto. He saw latent in both the idea of the typology – he called it "pre-form," which, he said, was beautiful to the eye of the artist for being "the form before beauty as we know it sets in."[35] Like Arendt in "The Crisis in Culture," Kahn rejected the ideology of "pervasive beauty" as defined by Luce. He summed up all that was troubling about Luce's conception of beauty, particularly as it applied to architecture, in his description of Mies's Seagram Building as "a beautiful bronze lady" with a false façade: "she is not true. She is not that shape on the inside."[36] He was responding to the formal rigidity and material richness of Mies's building, but, more significantly, he was accusing Mies's architecture of being overly

concerned with external values. Kahn's conception of beauty, by contrast, was rooted in the architect's realization of what the building wanted to be – in the process of form's coming into being.

With regard to Yale Art Gallery, Kahn said: "the realization there was something which was not fully understood by me."[37] But he further admitted that once introduced into the world, the realizations were there for others to pick up on their own initiative: "the designs belong to him [the architect], but the realizations do not."[38] Kahn's realizations – as well as those of Le Corbusier, whom he explicitly invoked in this scenario – were taken up by other architects who often misunderstood them, obscuring through "academic adjustment,"[39] as Scully would say, the beauty of the realization itself.

"In its need for beginners that it may be begun anew, the world is always a desert," wrote Arendt.[40] Describing forms of alienation, disaffection, and disenchantment endemic to modern mass society, she further wrote: "the modern growth of worldlessness, the withering away of everything *between* us, can also be described as the spread of the desert."[41] She enumerated the stratagems people developed to endure life in "the desert." One was consumerist psychology, the rise of advertising and marketing as behavioral sciences, and the explosion of shelter magazines that instructed people on how to conform to prescribed lifestyles: "it helps us 'adjust' to those conditions, taking away our only hope, namely that we, who are not of the desert though we live in it, are able to transform it into a human world" through "the conjoined faculties of passion and action."[42] The architecture of corporate modernism – which worked on the psyche through fixed images, advertisements, and promises of an easy and longer life – was desert architecture.

Kahn was an architect who lived partly in what Arendt called "the oasis in the desert," "those fields of life which exist independently, or largely so, from political conditions":

> What went wrong is politics, our plural existence – and not what we can do and create insofar as we exist in the singular: in the isolation of the artist, in the solitude of the philosopher, in the inherently worldless relationship between human beings as it exists in love and sometimes in friendship – when one heart reaches out directly to the other, as in friendship, or when the in-between, the world, goes up in flames, as in love. Without the intactness of these oases we would not know how to breathe. ... The oases ... are not places of "relaxation" but life-giving sources that let us live in the desert without becoming reconciled to it.[43]

Kahn inspired friendship, love, and reverence. Scully acknowledged Kahn's ability to move people in the way Arendt describes when he wrote:

"the American architects who revere him form a roster of diversity and distinction. … The beginning of a special comradeship can be sensed among them, not, I think, a local school, but a more general movement, magnetized by Kahn."[44] In contrast, an architect like Breuer, who in magazine profiles was billed as an architect who "built for himself," inspired mainly social emulation. Scully further echoed Arendt's belief in man's ability to reveal his true self through actions and words, and inspire others, when he concluded his monograph on Kahn with the simple maxim: "One recognizes a man."[45] But love, as it relates to Kahn, takes on a tremendous poignancy in light of the revelations about his personal life in his son Nathaniel Kahn's 2003 documentary film *My Architect*. True to what Arendt says about the artist-philosopher, in spite of the people Kahn drew near to him he remained elusive, unable to anchor either his personal or professional relationships. Those closest to him seemed to have had no real idea of who he was; they attempted, like the rest of us, to understand him through his architecture and ideas. On the one hand, Kahn was a figure who had integrated his experience to such an extent that he seemed at home in the world; on the other hand, he was a figure who was revealed to have been lost in the world. Perhaps this is a lesson – that it is unwise or impossible to live, as Arendt says, independently, or largely so, of political conditions.

In her monograph on Paul Rudolph, published in 1970, the architectural critic Sibyl Moholy-Nagy depicts him as an iconoclast, one of the few American architects who was able to break away from the model of Bauhaus functionalism that fueled so much of mid-twentieth-century modern design. From the start, she casts him as an epic hero, whose birth in 1918, "a key date in world history," set him up to become a kind of global figure, one whose "tendency toward nonattachment and cool pragmatism," as she says, gave him a steady footing on "the collision course of many emerging new worlds."[46]

Moholy-Nagy contrasts Rudolph's southern provincial upbringing, and his early architectural training at the Alabama Polytechnic Institute in Auburn, with the more cosmopolitan milieu he entered when he enrolled in the master's program at the School of Architecture at Harvard, where he studied under Gropius and Breuer. In the trajectory Moholy-Nagy maps out, Rudolph's few years at Harvard are a kind of errant pit stop. For instance, she sees his time in the Navy during World War II, which interrupted his studies, as much more significant than his Harvard education in his synthesis of a uniquely American sense of derring-do, practical know-how, and fundamental architectural ideas and engineering principles.

In 1947, Rudolph left the northeast, bastion of corporate liberal ideology, and returned to the south, where he set up a joint office with the architect Ralph Twitchell in Sarasota, Florida, a small coastal town on the Gulf of Mexico. In Sarasota, Rudolph designed small beach cottages. In these projects – working literally on the periphery, on the boundary between land and sea – he experimented with form, material, space, and structure on what Moholy-Nagy calls "the suprapersonal level," meaning that he was released from the social mores that informed so much of suburban residential building in the late 1940s and 1950s, as represented in the pages of glossy shelter magazines.

Rudolph took what he learned working on these beach cottages and put it to use in the two high schools he designed in Sarasota: Riverview High School and Sarasota High School. In these projects, with their exposed steel frames, thin beams, and suspended, cantilevered planar canopies, the functionalist vocabulary breaks up and rearranges itself before our very eyes. Rudolph's two Sarasota high schools visualize a process of emergence, the sense of realization before form itself sets in – to use Kahn's terminology. These are strangely tensile structure: you can see the tension between Rudolph's use of existing forms and his yearning for a new language of his own making.

Moholy-Nagy points to a remark Rudolph made in the late 1950s, soon after he assumed the leadership of Yale's architecture school, as illustrating what she rather beautifully calls his "existential liberation from the restrictions of his professional education."[47] It is also a remark that, in my view, aligns him with Arendt and her view of action: "Action has outstripped theory. The last decade has thrown a glaring light on the omissions, thinness, paucity of ideas, naïveté with regard to symbols, lack of creativeness, and expressiveness of architectural philosophy as it developed in the twenties."[48] This was a dismissal (a "total repudiation," according to Moholy-Nagy) of the functionalism of the 1920s and its progeny, corporate modernism of the 1950s.

For Moholy-Nagy, this one remark explodes with the full power of a manifesto. She sees that power concretized in what many regard as Rudolph's architectural declaration of independence: the Yale Art & Architecture Building in New Haven (1963). For Moholy-Nagy, this building is literally explosive – she calls it "a most spectacular form explosion" – in that it blows up existing architectural theory along with the existing New Haven cityscape, and "creates a new one."[49] This theory, which Rudolph would later describe as megastructuralism, became the foundation for all his later work: "after Mies, the megastructure."

While the Yale Art & Architecture Building was going up, Rudolph designed a campus for the Southern Massachusetts Technological Institute in Dartmouth. In *The Human Condition*, Arendt critiques the disappearance of "the distinction between a private and a public sphere of life … which have existed as distinct, separate entities at least since the rise of the ancient city-state," and the rise in their place of "the social realm." In her monograph on Rudolph, Moholy-Nagy describes Rudolph's design for these buildings: "The startling 'sky lobbies' of the academic buildings reestablish an ancient dichotomy between anonymous and public scale, so often forgotten in America and so essential to the understanding of personal and communal goals."[50] In this and later projects – such as the Orange County Courthouse, and most notably the Graphic Arts Center project, part of his much larger Lower Manhattan Redevelopment Scheme – Rudolph did not merely provide an alternative to the model of corporate modernism he had rejected outright. He designed a new kind of environment, one that offered a corrective to the ideological-spatial damage corporate modernism had caused. Moholy-Nagy calls them "focused environments."[51] Significantly, many of Rudolph's realized projects of the late 1950s and 1960s are for schools or college campuses. They were linked to the education of a new generation. They signaled a new beginning.

Moholy-Nagy's monograph on Rudolph, like Scully's monograph on Kahn, concludes with humanist aplomb: "If he achieves a new link in the long chain that binds urban past to urban future by welding industrialization to design without submitting to the fascist dictatorship of technological systems control, he will be the genius of a new human environment"[52] – a veritable Arendtian call to arms! But alas, Rudolph, like Kahn, was not an architectural Messiah.

—

We may marvel or recoil at the anecdotes that bring mid-twentieth-century American modernism to life: Bunshaft's glamorous commonsense classicism, Stone's "flights of fancy," Breuer's megalomaniac monoliths, Saarinen's Flintstone expressionism, and Johnson's cynical but seductive historicism. In the last analysis, anecdote may be all they have to stand on. Kahn and Rudolph remained outsiders. Although recognized as geniuses today, their philosophies, and their work, have not made as great an impact as critics at the time hoped. While they remain magnetic figures, there are no schools around them, much less movements. In the realm of architecture, and certainly in the wider realm of design, technological systems control is now fascistically omniscient. We search frantically for the oasis in the desert.

Notes

Introduction

1. Hannah Arendt, *The Human Condition* (New York: Doubleday, 1958), 6.
2. Ibid., 3.
3. Ibid., 6.
4. Hannah Arendt, *Between Past and Future* (1961; New York: Penguin, 1993), 205, 207.
5. Ibid., 211.
6. Ibid.
7. Ibid., 207.
8. C. Wright Mills, *The Causes of World War Three* (New York: Simon and Schuster, 1958), 124.
9. Edmund Stillman and William Pfaff, *The New Politics: America and the End of the Postwar World* (New York: Harper and Row, 1961), 11, 12.
10. Sigfried Giedion, "The Need for a New Monumentality," in Paul Zanker, ed., *New Architecture and City Planning: A Symposium* (New York: Philosophical Library, 1944), 552–553. Giedion's turn toward monumentality and interest in symbolic architecture resulted, twenty years later, in an eccentric tome, *The Eternal Present: The Beginnings of Architecture*, first delivered as the A.W. Mellon lectures at the National Gallery of Art in Washington D.C. in 1957, and published by Oxford University Press in 1964.
11. Vincent Scully, "Archetype and Order in Recent American Architecture," *Art in America* (December 1954), 252.
12. Edward Durell Stone, *The Evolution of an Architect* (New York: Horizon Press, 1962), 145.
13. Marcel Breuer, "Beyond Ages," in *Marcel Breuer: New Projects* (New York: Praeger, 1971), 13.
14. In fact, Hawks had wanted to make a film about the construction of an aerodome in China during World War II, which proved unfeasible. He transferred his interest in modern labor, design, and construction to the ancient world of *Land of the Pharaohs*. See <http://kinoslang.blogspot.com/2009/03/hawks-at-work-making-of-land-of.html>.
15. "A Discussion with the Audience of the 1970 Chicago Film Festival," in Joseph McBride, ed., *Focus on Howard Hawks* (Englewood Cliffs, NJ: Prentice-Hall, 1972), 14.

16. Henry Luce, "The Architecture of Democracy," *Journal of the American Institute of Architects* (June 1957), 150.

17. "Building for Community," *Architectural Forum* (January 1959), 68.

18. Michael Wood, *America in the Movies* (New York: Columbia University Press, 1975), 176.

19. "House in Pittsburgh," *Architectural Forum* (March 1941), 160–171.

20. Ibid.

21. Vincent Scully, "Modern Architecture: Towards a Redefinition of Style," *Perspecta*, no. 4 (1957), 5. The lecture was commissioned by the Museum of Modern Art as a sequel to Henry-Russell Hitchcock's and Philip Johnson's "Modern Architecture: International Exhibition," 1932. According to Neil Levine, MoMA's sponsorship of the project did not survive the submission of Scully's first draft when it became clear that his "historical schema was ontologically grounded in the modern idea of democracy as the underlying social force of the era." See Scully, *Modern Architecture and Other Essays*, ed. Neil Levine (Princeton: Princeton University Press, 2003). The lecture was delivered at the January 1957 meeting of the College Art Association and subsequently published in *Perspecta*, no. 4 (1957), 4–10; *College Art Journal*, no. 2 (1958), 140–159; and in Susanne K. Langer, ed., *Reflections on Art* (Baltimore: Johns Hopkins University Press, 1958), 342–356.

22. Thomas Creighton, "The New Sensualism II," *Progressive Architecture* (October 1959), 184.

23. Ibid.

24. Philip Johnson, *Writings* (New York: Oxford University Press, 1979), 76.

25. Ibid., 85.

26. Ibid., 230.

27. *Saving Corporate Modernism: Assessing Three Landmark Buildings by Gordon Bunshaft of Skidmore, Owings & Merrill* (New Haven: Yale School of Architecture, 2001). Yale had a vested interest in championing the work of SOM: the Yale campus is home to a number of SOM buildings, including the Beinecke Rare Book and Manuscript Library, the School of Forestry and Environmental Science, and the School of Organizational Studies. David Childs, the leading partner of the firm at the time and a speaker at the conference, was trained at Yale.

28. The main building was often referred to in the *Hartford Courant* as "the Wilde building," after Frazier Wilde, President of Connecticut General, who commissioned it from SOM in 1954. In addition to the main building, CIGNA, the company that bought out Connecticut General, planned to demolish a second, less distinguished building on the site, called Emhart, designed by SOM in 1963. The campaign to save Connecticut General was local news, chronicled religiously in the *Hartford Courant*. Twelve articles appeared on their op-ed page between February 2001 and April 2002, the period encompassing the exhibition and symposium at Yale, and the height of the controversy: Tyler Smith, "CIGNA Destroying a Landmark: Two Masterpieces, Two Fates," February 25, 2001; "CIGNA, Spare Those Buildings," editorial, February 27, 2001; Daniel Stark, "CIGNA Building Is a Dump," March 3, 2001;

"To Save Wilde Still Time to Preserve CIGNA Landmark," editorial, June 3, 2001; Carol Krinsky, "Destroying the Wilde Is Like Trashing the Atheneum," June 12, 2001; Tom Condon, "Fighting to Save the CIGNA Campus," June 26, 2001; "A Boost for the Wilde Building," editorial, June 27, 2001; Laurence Cohen, "Wilde Building: An Old Piece of Junk," August 5, 2001; Robert Campbell, "A Corporate Icon That Should Be Preserved," August 12, 2001; "Wilde Building Is Still in Danger," editorial, January 28, 2002; Edward Stockton, "CON: Redevelop the Land," April 7, 2002; Wendy Nicholas, "PRO: Save the Wilde," April 7, 2002. The building was ultimately saved: Tyler Smith, "How the Wilde Was Won," May 21, 2006.

29. Quoted in Tom Wolfe, *From Bauhaus to Our House* (New York: Washington Square Press, 1981), 122; see also Robert Stern, *New York 1960* (New York: Monacelli Press, 1995).

30. Statements from my notes; see also Stern's preface in the exhibition program in *Saving Corporate Modernism*, n.p.

31. Peter Blake, "Slaughter on Sixth Avenue," *Architectural Forum* (June 1965); Peter Blake, *Form Follows Fiasco* (Boston: Little, Brown, 1977).

32. On the postfeminist reinvention of the housewife, see Diane Negra, *What a Girl Wants? Fantasizing the Reclamation of Self in Postfeminism* (New York: Routledge, 2009); Stephanie Harzewski, *Chick Lit and Postfeminism* (Charlottesville: University of Virginia Press, 2011).

33. Daniel Mendelsohn, "The Mad Men Account," *New York Review of Books* (February 24, 2011), <http://www.nybooks.com/articles/2011/02/24/mad-men-account/>.

34. Ibid.

35. Ibid.

36. Molly Haskell, "In Response to 'The Mad Men Account," *New York Review of Books* (March 24, 2011), <http://www.nybooks.com/articles/2011/03/24/mad-men-account/>.

37. In Stone's case, the battle actually began when the house he built for A. Conger Goodyear, the founding president of the Museum of Modern Art, in Old Westbury, Long Island, in 1938, was threatened with destruction in 2001. The short-lived battle over the Goodyear House, which was ultimately saved, and the attention it brought to the once-famous but now largely forgotten Stone, served as a precursor to the battle that would erupt over 2 Columbus Circle. Just as the battle over Connecticut General played out in a local paper, the battle over Stone's building at 2 Columbus Circle played out in the *New York Times*. The articles in the *Times* appeared in the Arts and Leisure section, the Real Estate section, and finally, on the op-ed page, a progression that shows the increasing importance of, and growing audience for, the debate. See Dana Shaman, 'Unloved Masterpieces," March 4, 2001; Julie Iovine, "Modern Long Island Icon Is on the 'Endangered' List," October 15, 2001; John Rather, "Consortium to Preserve Threatened Landmark," December 30, 2001; Celestine Bohlen, "Oregon Firm to Design for Museum," November 5, 2002; David Dunlap, "A New Look for a 10-Story Oddity," April 1, 2003; Fred Bernstein, "Litchfield Looks Back at Its Past, and Its Architecture

of the Future," June 29, 2003; Michael Lewis, "The World: About Face; Glass Walls to Bunkers: The New Look of U.S. Embassies," July 27, 2003; Tom Wolfe, "The Building That Isn't There," October 12, 2003; Tom Wolfe, "The Building That Isn't There, Cont'd," October 13, 2003; James Barron, "Groups Sue to Prevent Sale of Columbus Circle Building," November 8, 2003; Robert Worth, "Embracing a Father's Creation, if Not His Tastes," November 20, 2003; Herbert Muschamp, "A Building's Spirit, Clad in Marble and Controversy," November 24, 2003; Joyce Purnick, "A Building Still Looking for Respect," December 15, 2003; James Barron, "Sale of 2 Columbus Circle Advances," April 16, 2004; Joyce Purnick, "Lollipops and Circles of Influence," June 3, 2004; Anemona Hartocollis, "Preservationist Chic: What Would Tom Wolfe Do?," July 4, 2004; Nicolai Ouroussoff, "Taming the Beast from 1965," October 4, 2004; David Coleman, "Expressive Dishes for an Opinionated Table," December 9, 2004; "Museum to Buy Contested Site," Arts editorial, May 26, 2005; Robin Pogrebin, "2 Columbus Circle Makes Group's List of Threatened Sites," June 21, 2005; "The Case of 2 Columbus Circle," editorial, June 29, 2005; Sherida Paulsen, "The Black Hole of Columbus Circle," July 30, 2005; David Dunlap, "For 2 Columbus Circle, a Growing Fan Club," August 18, 2005; Herbert Muschamp, "The Secret History," January 8, 2006.

38. To the astonishment and fury of many, including former chairpersons of the committee, the New York City Landmarks Preservation Committee refused to hold a hearing on 2 Columbus Circle. Herbert Muschamp wrote in the *New York Times*: "The refusal of the New York City Landmarks Commission to hold hearings on the future of 2 Columbus Circle is a shocking dereliction of public duty. Unacceptable in itself, this abdication also raises the scary question of what other buildings the commission might choose to overlook in the future." See Herbert Muschamp, "Architecture: The Lows: Banner Year for Lost Opportunities," *New York Times*, December 28, 2003, 39. It was later revealed that Robert Tierney, the chairman of the Commission, and Laurie Beckelman, who worked for the Museum of Art and Design, the Museum that had purchased Stone's building from the city, conspired to keep the building from being considered by the landmarks panel; Beckelman was herself a former chairwoman of the Landmarks Preservation Committee. See Robin Pogrebin, "Group Seeks Removal of Landmarks Chairman," *New York Times*, May 27, 2005; Tom Wolfe, "The 2 Columbus Circle Game," *New York Magazine*, July 4, 2005; Nicolai Ouroussoff, "Turning Up the Heat on a Landmarks Agency," *New York Times*, November 14, 2005.

39. Robert Stern, "We Should Save Ed Durell Stone's Maligned Marble Masterpiece in New York," *Architectural Record*, no. 11 (November 2000), 63–64. Stern's comments are archived online on the Landmarks West website, along with statements by other advocates: <http://www.landmarkwest.org/advocacy/ad_02/2columbuscircle.html>.

40. Huntington Hartford was an enthusiast who "squandered his fortune" on culturally astute but short-lived and often far-flung projects, like his museum at 2 Columbus Circle, a magazine of the performing arts called *Show*, and on women and drugs. See Lisa Gubernick, *Squandered Fortune: The Life and Times of Huntington Hartford* (New York: Putnam, 1991). As a result of the controversy surrounding the building he originally commissioned, Hartford, in

his late nineties, reemerged in the public eye. See Suzanna Andrews, "Hostage to Fortune: After Squandering His Vast A & P Inheritance, Huntington Hartford Turned to Drugs, Then Vanished from Sight," *Vanity Fair* (December 2004). The building at 2 Columbus Circle existed as Hartford's museum for only five years. In 1969, with lack of funds for either endowment or maintenance, he gave it to Fairleigh Dickinson University. The building was subsequently owned by Gulf and Western, but used by the City of New York as a tourist center. In 1994, Viacom, the company that bought out Gulf and Western, gave the building to the city. A large part of the controversy had to do with the fact that the city owned the building and appeared to be stoking the flames of a bidding war for the highly attractive Columbus Circle site, rather than allowing an official New York City Landmarks Preservation Committee discussion about the building's landmark status to unfold.

41. Herbert Muschamp, "The Secret History: The City May Not Know What to Make of 2 Columbus Circle, but a Generation of Gay New Yorkers Always Did. And Our Verdict Is the One That Matters," *New York Times*, January 8, 2006, 1.

42. Ibid., 1. James McCourt's *Queer Street, Rise and Fall of an American Culture: Excursions in the Mind of the Life* (New York: W. W. Norton, 2004) connects those dots, but does not deal extensively with architecture and design.

43. Ibid., 34; M. Christine Boyer makes a similar argument in *The City of Collective Memory: Its Historical Imagery and Architectural Entertainments* (Cambridge, MA: MIT Press, 1994).

44. Charles Jencks, *Modern Movements in Architecture* (New York: Anchor, 1973), 186.

45. Ibid., 196, 206.

46. Wolfe, *From Bauhaus to Our House*, 80.

47. Ibid., 81.

48. Ibid.

49. Tom Wolfe, "The Building That Wasn't There," *New York Times*, October 12, 2003, 11; Tom Wolfe, "The Building That Wasn't There, Cont'd," *New York Times*, October 13, 2003, 17.

50. Stone, *The Evolution of an Architect*, 146.

51. Charles Jencks, "Philip Johnson and the Smile of Medusa," in Emmanuel Petit, ed., *Philip Johnson: The Constancy of Change* (New Haven: Yale University Press, 2009), 139.

52. Joan Ockman, "The Figurehead: On Monumentality and Nihilism in Philip Johnson's Life and Work," in Petit, *Philip Johnson: The Constancy of Change*, 83.

53. Ibid., 83; see also Vincent Scully, "Philip Johnson: Art and Irony," in Petit, *Philip Johnson: The Constancy of Change*, 209; Jencks, "Philip Johnson and the Smile of Medusa," 136; Emmanuel Petit, introduction to *Philip Johnson: The Constancy of Change*, 2.

54. Ockman, "The Figurehead," 88.

55. Nicolas Adams laments the myopic focus in these studies on what he calls "the organizational impulse within society and its architecture": pointing to Martin's book in particular and the prospects for future historians working on similar material, he asserts, "rather than just follow Martin's lead, they may also look for those subversive zones of fantasy." See Nicolas Adams, *Skidmore, Owings, and Merrill: SOM since 1936* (Milan: Electa, 2006), 14.

56. Oral history of Gordon Bunshaft, interviewed by Betty J. Blum, compiled under the auspices of the Chicago Architects Oral History Project, Department of Architecture, the Art Institute of Chicago, 115–116.

57. Stone, *The Evolution of an Architect*, 150.

58. Manfredo Tafuri, *The Sphere and the Labyrinth: Avant-Gardes and Architecture from Piranesi to the 1970s*, trans. Jessica Levine (Cambridge, MA: MIT Press, 1987), 1.

59. Ibid.

60. Ibid., 2.

61. Ibid., 3.

62. Ibid., 14.

63. Ibid., 13.

64. Ibid., 18.

Chapter 1: The Cult of Immaculate Form

1. Henry Luce, "The Architecture of Democracy," *Journal of the American Institute of Architects* (June 1957), 150.

2. José Luis Sert, Fernand Léger, and Sigfried Giedion, "Nine Points on Monumentality," in Joan Ockman, ed., *Architecture Culture 1943–1968* (New York: Rizzoli, 1993), 29.

3. Ibid., 30.

4. Ibid.

5. On the mural debates, see Romy Golan, *Muralnomad: The Paradox of Wall Painting, Europe 1927–1957* (New Haven: Yale University Press, 2009).

6. Paul Zanker, "Planning in Three Dimensions," in Zanker, ed., *New Architecture and City Planning: A Symposium* (New York: Philosophical Library, 1944).

7. Ibid.

8. Ibid.

9. Sigfried Giedion, "The Need for a New Monumentality," in Zanker, *New Architecture and City Planning*, 550.

10. Louis I. Kahn, "Monumentality," in Zanker, *New Architecture and City Planning*, 577.

11. Ibid., 578.

12. Ibid.

13. Kenneth Frampton, *Modern Architecture: A Critical History* (London: Thames and Hudson, 1992), 224. Frampton thus calls Le Corbusier's work of these years "the monumentalization of the vernacular."

14. These were all what the historian Anson Rabinbach has termed "debris texts." See Anson Rabinbach, *In the Shadow of Catastrophe: German Intellectuals between Apocalypse and Enlightenment* (Berkeley: University of California Press, 1997).

15. Karl Jaspers, *Existentialism and Humanism: Three Essays by Karl Jaspers*, ed. Hanns E. Fischer, trans. E. B. Ashton (New York: Russell Moore, 1952), 74, 85.

16. Ibid., 98.

17. Ibid., 80.

18. Ibid., 85.

19. Ibid., 86, 87.

20. Ibid., 79.

21. Ibid.

22. Alan Brinkley, *The Publisher: Henry Luce and His American Century* (New York: Knopf, 2010), 329.

23. On Luce's early years and travels in Europe, see Brinkley, *The Publisher*, 29.

24. Ibid., 125–126.

25. Quoted in in Terry Smith, *Making the Modern: Industry Art and Design in America* (Chicago: University of Chicago Press, 1993), 162–163.

26. Brinkley, *The Publisher*, 85.

27. Henry Luce, *The Ideas of Henry Luce*, ed. John Knox Jessup (New York: Atheneum, 1969), 231.

28. Luce, "The Architecture of Democracy," 152.

29. William Herberg, *Protestant, Catholic, Jew: An Essay on American Religious Sociology* (Garden City, NY: Doubleday, 1956), 102; Martin E. Marty, *The New Shape of American Religion* (New York: Harper and Brothers, 1959), 31, 77, 78, 79.

30. Luce, "The Architecture of Democracy," 150.

31. Karl Jaspers, *The Fate of Mankind*, trans. E. B. Ashton (Chicago: University of Chicago Press, 1961[first published in German as *Die Atombombe und die Zukunft des Menschen* by R. Piper & Co. Verlag, Munich, in 1958]), 291.

32. Ibid., 295.

33. Michael Augspurger, *An Economy of Abundant Beauty: Fortune Magazine and Depression America* (Ithaca: Cornell University Press, 2004), 238.

34. Luce, *The Ideas of Henry Luce*, 262.

35. "A New Face for the U.S.," *Fortune* (September 1957), 117.

36. Ibid.

37. Ibid., 118.

38. Not incidentally, at the same time the AIA commissioned Smith to produce a portfolio of mural-size photographs of recently completed modern American buildings, including Connecticut General. He traversed the country documenting Minoru Yamasaki's St. Louis Municipal Airport Building (1954), Eero Saarinen's General Motors Research Center in Warren, Michigan (1955), and Frank Lloyd Wright's Prairie Tower in Bartlesville, Oklahoma (1956), along with six other new buildings. Mounted as transparencies on large light boards, these photographs became the centerpiece of an exhibition celebrating the AIA centennial in Washington, D.C., in May 1957, where Luce gave the keynote speech.

39. Domenico Tiepolo's "New World" frescos (1791), for example, similarly sensationalize the sense of collective anticipation of the coming of a new age. In the most famous of these frescos, a band of friezelike figures with their backs to the viewer gaze into a Cosmorama, a mechanical device depicting a fantastic panoply of historical events and exotic landscapes in panoramic, perspectival views. Like the figures in Smith's photograph, they are poised on the threshold of the present, suspended between past and future. In Smith's photograph, the new Connecticut General headquarters serves as a kind of Cosmorama, while the crane finds a parallel in the suspended curtain rod held aloft by the elevated figure in Domenico's fresco.

40. "Insurance Sets a Pattern," *Architectural Forum* (September 1957), 113.

41. Ibid., 113, 114.

42. Ibid., 115.

43. "Oral History of Gordon Bunshaft," interviewed by Betty Blum, © 1990 The Art Institute of Chicago, used with permission (pertains to all citations from the "Oral History"), 304.

44. "A Dramatic New Office Building," *Fortune* (September 1957), 117–118. Similar features appeared simultaneously in the September 16, 1957 issues of both *Time* and *Newsweek*.

45. Ibid.

46. "Insurance Sets a Pattern," 127.

47. Ibid.

48. Joe Alex Morris, "It's Nice to Work in the Country," *Saturday Evening Post* (July 5, 1958), 71.

49. Ibid.

50. Allen Tate and C. Ray Smith, *Interior Design of the 20th Century* (New York: Harper and Row, 1986), 431.

51. Morris, "It's Nice to Work in the Country," 70.

52. "Oral History of Gordon Bunshaft," 115–116.

53. Ibid.

54. Ibid.

55. Ibid., 7–9.

56. Ibid., 2, 4.

57. Ibid., 20, 33–35.

58. Ibid., 69.
59. Ibid., 82.
60. Ibid., 68.
61. Ibid., 85.
62. Ibid., 95.
63. Ibid., 80.
64. Ibid., 21–22.
65. See Rudolf Wittkower, *Architectural Principles in the Age of Humanism* (London: Warburg Institute, 1949; republished, London: A. Tiranti, 1952; New York: Random House, 1965). On the influence of Wittkower's book, see Branko Mitrovic, "A Palladian Palinode: Reassessing Rudolf Wittkower's Architectural Principles in the Age of Humanism," *Architectura* 31, no. 2 (2001), 113–131; Alina Payne, "Rudolf Wittkower and Architectural Principles in the Age of Humanism," *Journal of the Society of Architectural Historians* 53, no. 3 (September 1994), 322–342; Henry Millon, "Rudolf Wittkower, Architectural Principles in the Age of Humanism: Its Influence on the Development and Interpretation of Modern Architecture," *Journal of the Society of Architectural Historians* 31, no. 2 (May 1972), 83–91; James Ackerman, "Architectural Principles in the Age of Humanism by Rudolf Wittkower," *Art Bulletin*, no. 33 (September 1951), 195–200; see also Colin Rowe, "The Mathematics of the Ideal Villa: Palladio and Le Corbusier Compared," *Architectural Review* 101 (March 1947), 101–104.
66. Carol Krinsky, *Gordon Bunshaft of Skidmore, Owings & Merrill* (New York: Architectural History Foundation, 1988), 331.
67. Giedion, "The Need for a New Monumentality," 549.
68. Quoted in John Archer, *Architecture and Suburbia: From English Villa to American Dream House, 1690-2000* (Minneapolis: University of Minnesota Press, 2005), 284.
69. Walter Hixson, *Parting the Curtain: Propaganda, Culture, and the Cold War 1945-1961* (New York: St. Martin's Press, 1957), 22; Blanche Cook Warren, *The Declassified Eisenhower: A Divided Legacy of Peace and Political Warfare* (New York: Penguin, 1981), 13.
70. Hixson, *Parting the Curtain*, 23.
71. See the biographical sketch of Davenport by John Knox Jessup at the beginning of Davenport's book, *The Dignity of Man* (New York: Harper and Brothers, 1955).
72. Russell Davenport, "The Greatest Opportunity on Earth," *Fortune* (October 1949), 296.
73 Ibid., 66.
74. Ibid.
75. Ibid., 294; original emphasis.
76. Ibid., 66.
77. Ibid., 67.

78. Ibid., 68. The call for businessmen to be political, to assert their political rights, was part of the Republican opposition to FDR's New Deal. It gained momentum during Truman's presidency and by 1949 was in full spate. "The Party of Business," an article by Wilfred E. Binkley in the January 1949 issue of *Fortune*, made a similar argument, giving examples of "businessmen turned political strategists." Binkley articulated the fear that Socialism would triumph in America, later addressed by Davenport, by pointing to Truman's so-called "Fair Deal" variation on FDR's New Deal. Binkley's proposed strategy was to adopt the tactic FDR had used to consolidate power and push through the New Deal: to destroy the opposition's will using theories of psychological warfare (propaganda) in the realm of domestic, rather than foreign, policy. This was C. D. Jackson's specialty; he had worked in the Office of Strategic Services on psychological warfare during the war.

79. Ibid., 294.

80. Ibid., 296.

81. Ibid., 69, 200.

82. Ibid., 68.

83. Ibid., 66.

84. Herbert Muschamp, "In Search of Lost Research," in Josef Paul Kleihues and Christina Rathgeber, eds., *Berlin, New York: Like and Unlike: Essays on Architecture and Art from 1870 to the Present* (New York: Rizzoli, 1993).

85. "Oral History of Gordon Bunshaft," 152–153.

86. Ibid. Mayer and Whittlesey would work only a few years later on the master plan for Chandigarh with Le Corbusier.

87. David Riesman, *The Lonely Crowd* (New Haven: Yale University Press, 1961 [first published 1950]), 261.

88. Ibid., 276.

89. Ibid., 264.

90. Ibid., 285.

91. Quoted in Krinsky, *Gordon Bunshaft of Skidmore, Owings & Merrill*, 19.

92. "Oral History of Gordon Bunshaft," 171.

93. Ibid., 167.

94. Philip Johnson, *Writings* (New York: Oxford University Press, 1979), 77.

95. Kathleen James, *Erich Mendelsohn and the Architecture of German Modernism* (New York: Cambridge University Press, 1997), 157.

96. Davenport, "The Greatest Opportunity on Earth," 66.

97. *U.S.A.: The Permanent Revolution* (New York: Prentice-Hall, 1951), 40.

98. Quoted in Richard Immerman, *John Foster Dulles: Piety, Pragmatism, and Power in U.S. Foreign Policy* (Wilmington, DE: Scholarly Resources, 1999), 42; also quoted in C. L. Sulzberger, *A Long Row of Candles: Memories and Diaries, 1934-1954* (New York: Macmillan, 1969), 770; Dwight D. Eisenhower, *Mandate for Change* (New York: Doubleday, 1963), 41; Herbert S. Parmet, *Eisenhower and the American Crusades* (New York: Macmillan, 1972), 101.

99. Roscoe Pound, "The Involuntary Good Samaritan," *Fortune* (November 1949), 171.

100. Henry Luce, "The Reformation of the World's Economics," *Fortune* (February 1950), 59.

101. Ibid.

102. John Knox Jessup, "A Political Role for the Corporation," *Fortune* (August 1952), 154.

103. Ibid., 158.

104. *U.S.A.: The Permanent Revolution*, 37, 34; "The essence of the American proposition can be understood only against the long history of mankind that preceded its formulation. Man first discovered the fatherhood of God, then the brotherhood of all men in Christ; and as he grew in spiritual understanding, he was released in the custody of his own conscience, to seek good and shun evil according to his own lights. ... The human individual thus has a special status with regard to all other things and beings on earth: he must live, and must be entitled to live, by the laws of God, not just by the laws and directives of men."

105. Davenport, *The Dignity of Man*, 107.

106 Ibid.

107. Ibid., 109–110.

108. Ibid., 110.

109. See John Lewis Gaddis, *Strategies of Containment: A Critical Appraisal of Postwar American National Security Policy* (Oxford: Oxford University Press, 1982), 149; Stephen E. Ambrose and Douglas G. Brinkley, *Rise to Globalism: American Foreign Policy since 1938* (New York: Penguin, 1997), 132.

110. John Foster Dulles, "Policy for Security and Peace," *Foreign Affairs* 32, no. 3 (April 1954), 364.

111. "The Military Businessman," *Fortune* (September 1952), 128.

112. C. Wright Mills, *The Causes of World War Three* (New York: Simon and Schuster, 1958), 21.

113. Ibid., 48.

114. Ibid., 54.

115. Ibid., 80.

116. Ibid., 48.

117. Ibid., 77.

118. Ibid.

119. Ibid., 78.

120. Ibid., 96.

121. William Whyte, "The Wives of Management," *Fortune* (October 1951), 86.

122. Lewis Mumford, "Skyline," *New Yorker* (November 17, 1951), 165.

123. Melissa Hyde, *Making Up the Rococo: François Boucher and His Critics* (Los Angeles: Getty Research Institute, 2006), 109.

124. Quoted in Krinsky, *Gordon Bunshaft of Skidmore, Owings & Merrill*, 20.

125. Ian McCallum, "Machine Made America," *Architectural Review* (May 1957), 301.

126. "For Epicureans: Fine Art, Immaculate Forms," *Contract Interiors* (May 1958), 125.

127. Ibid.

128. Ibid.

129. Warren Kimball, *Swords into Ploughshares? The Morgenthau Plan for Defeated Nazi Germany 1943–1946* (Philadelphia: J. B. Lippincott, 1976), 101.

238

130. Ibid., 65.

131. See Wolfgang Schivelbusch, *The Culture of Defeat: On National Trauma, Mourning, and Recovery* (New York: Picador, 2003).

132. William Fitzgerald, "Oppositions, Anxieties, and Ambiguities in the Toga Movie," in Sandra R. Joshel, Margaret Malamud, and Donald T. McGuire, Jr., eds., *Imperial Projections: Ancient Rome in Modern Popular Culture* (Baltimore: Johns Hopkins University Press, 2001), 24.

133. Ibid., 26.

134. Ibid., 25.

135. Jeffrey Richards, *Hollywood's Ancient Worlds* (London: Bloomsbury, 2008), 136–137.

136. Quoted in Ambrose and Brinkley, *Rise to Globalism*, 133.

137. Hannah Arendt, "Introduction *into* Politics," in Arendt, *The Promise of Politics*, ed. Jerome Kohn (New York: Schocken Books, 2005), 163; Simone Weil, "The Iliad, or the Poem of Force," in *War and the Iliad*, trans. Mary McCarthy (New York: New York Review of Books, 2005), 3.

138. Arendt, "Introduction *into* Politics," 163.

139. Ibid., 164.

140. Ibid., 173.

141. Ibid., 183.

142. Mary McCarthy, "The Vita Activa," in McCarthy, *On the Contrary: Articles of Belief, 1946–1961* (New York: Farrar, Straus and Cudahy, 1961), 156.

143. Hannah Arendt, *Between Past and Future* (New York: Penguin, 1993), 208.

144. Ibid.: "The cathedrals were built *ad maiorem gloriam Dei*; while they as buildings certainly served the needs of the community, their elaborate beauty can never be explained by these needs, which could have been served quite as well by any nondescript building. Their beauty transcended all needs and made them last through the centuries; but while beauty, the beauty of a cathedral like the beauty of any secular building, transcends needs and functions, it never transcends the world, even if the content of the work happens to be religious. On the contrary, it is the very beauty of religious art which transforms religious and otherworldly contents and concerns into tangible worldly realities; in this sense all art is secular, and the distinction of religious art is merely that it 'secularizes' – reifies and transforms into an 'objective,' tangible, worldly presence – what had existed before outside the world."

145. Ibid., 109–110: "The ideals of homo faber, the fabricator of the world, which are permanence, stability, and durability, have been sacrificed to abundance, the ideal of the animal laborans. We live in a laborer's society because only laboring, with its inherent fertility, is likely to bring about abundance; and we have changed work into laboring, broken it up into its minute particles until it has lent itself to division where the common denominator of the simplest performance is reached in order to eliminate from the path of human labor power – which is part of nature and perhaps even the most powerful of all natural forces – the obstacle of the 'unnatural' and purely worldly stability of the human artifice."

146. Ibid., 41.

147. Ibid., 73.

148. Ibid., 74, 33: "The 'good life,' as Aristotle called the life of the citizen, therefore was not merely better, more carefree or nobler than ordinary life, but of an altogether different quality. It was 'good' to the extent that by having mastered the necessities of sheer life, by being freed from labor and work, and by overcoming the innate urge of all living creatures for their own survival, it was no longer bound to the biological life process. ... Without mastering the necessities of life in the household, neither life nor the 'good life' is possible, but politics is never for the sake of life. As far as the members of the *polis* are concerned, household life exists for the sake of the 'good life' in the *polis*."

149. Hannah Arendt, *The Human Condition* (New York: Doubleday, 1958), 115–116.

150. Morris Dickstein, *Gates of Eden: American Culture in the Sixties* (New York: Basic Books, 1977), 50; also quoted in Joan Ockman, "Midtown Manhattan at Midcentury: Lever House and the International Style in the City," in Peter Madsen and Richard Plunz, eds., *The Urban Lifeworld: Formation, Perception, Representation* (New York: Routledge, 2002), 178, 199.

Chapter 2: Architecture, Mass Culture, and Camp

1. Norman Jacobs, "Introduction to the Issue 'Mass Culture and Mass Media,'" *Daedalus*, no. 2 (Spring 1960), 273.

2. Thomas Creighton, "The New Sensualism II," *Progressive Architecture* (October 1959), 184.

3. Lawrence Lessing, "The Diversity of Eero Saarinen," *Architectural Forum* (July 1960), 95; William Jordy, "The Mies-less Johnson," *Architectural Forum* (September 1959), 115.

4. Thomas Creighton, "Seagram House Re-assessed," *Progressive Architecture* (June 1959), 145.

5. Allan Temko, *Eero Saarinen* (New York: George Braziller, 1962), 113, 123.

6 Ada Louise Huxtable, "The Park Avenue School of Architecture," *New York Times Magazine* (December 15, 1957).

7. See, for instance, *Anxious Modernisms: Experimentation in Postwar Architectural Culture*, ed. Sarah Williams Goldhagen and Rejean Legault (Cambridge, MA: MIT Press, 2000); Felicity Scott, *Architecture or Techno-Utopia: Politics after Modernism* (Cambridge, MA: MIT Press, 2007); Martino Stierli, *Las Vegas*

in the Rearview Mirror: The City in Theory, Photography, and Film (Los Angeles: Getty Research Institute, 2013).

8. See, for instance, Beatriz Colomina, "Information Obsession: The Eameses' Multi-Screen Architecture," *Journal of Architecture* 6, no. 3 (Autumn 2001); Beatriz Colomina, "Enclosed by Images: The Eameses' Multimedia Architecture," *Grey Room*, no. 2 (Winter 2001); and the essays in *The Work of Charles and Ray Eames: A Legacy of Invention*, ed. Donald Albrecht (New York: Harry N. Abrams, 1997).

9. *Public Papers of the Presidents of the United States, Dwight D. Eisenhower: containing the public messages, speeches, and statements of the President, January 20, 1953 to January 20, 1961*, vol. 6 (Washington, D.C.: U.S. Government Printing Office, 1958), 3.

10. On the transformational nature of this moment for the conduct of the Cold War, see Stephen E. Ambrose and Douglas Brinkley, *Rise to Globalism: American Foreign Policy since 1938* (New York: Penguin, 1997), 161.

11. Herb McLaughlin, a Yale architecture student, cataloged the student generation's reaction to the recent work of Mies and Le Corbusier and ensuing changes to the modernist vocabulary. See Herbert McLaughlin Jr., "The Style of Education," *Progressive Architecture* (July 1958), 55; Saarinen was describing the thinking behind his Tulip Chair and Pedestal Table: "All great furniture of the past from Tutankhamun's Chair to Thomas Chippendale's has always been a structural total." See Eero Saarinen, *Eero Saarinen on His Work*, ed. Aline B. Saarinen (New Haven: Yale University Press, 1962), 5.

12. McLaughlin, "The Style of Education," 56.

13. Vincent Scully, *Modern Architecture: The Architecture of Democracy* (New York: George Braziller, 1974 [originally published 1961]), 32.

14. Gordon Bunshaft's success in the early design stages with Connecticut General (in 1953) led directly to this commission: Harold Talbott, President Eisenhower's Secretary of the Air Force and the man responsible for giving the commission to SOM, was a friend of Frazar Wilde, president of Connecticut General. There was another inside track: architect John B. Rodgers of SOM's San Francisco office knew Colonel Simon Lutz of the Air Force. See Robert Allen Nauman, *On the Wings of Modernism* (Urbana: University of Illinois Press, 2004), 20. Marcel Breuer lobbied hard for this commission, as did all the major architects of the day. On August 16, 1954, Breuer's secretary, Margaret Firmage, sent him the following note about the commission while he was in Paris working on the new UNESCO headquarters: "The information about the Air Academy I got originally from BJ who got it via the architectural grape vine from someone or other. I think if Saarinen and Harrison had been involved, I'm sure the Air Secretary would have mentioned it, so the chances are that dear old Skidmore et al walked off with the whole sugar plum. There's an old Scotch saying that 'the fat sow's hide is always well greased,' which is vulgar, graphic and very applicable in this instance. I'm trying to find out actually whether anyone else than Skidmore is involved, but haven't been able to get any definite – and reliable – information. Everybody 'says' but nobody 'knows.'" She followed this up twelve days later, on August 27, 1954, with the following news: "about the Air

Academy: Skidmore has the job and Saarinen, Harrison and a Western architect will act as advisors to the Air Secretary." Marcel Breuer Papers, Archives of American Art/Smithsonian Institution, Reel 5712.

15. Lawrence C. Landis, *The Story of the U.S. Air Force Academy* (New York: Rinehart, 1959), 18.

16. Quoted in John Lewis Gaddis, *Strategies of Containment: A Critical Appraisal of Postwar American National Security Policy* (Oxford: Oxford University Press, 1982), 154.

17. These were cataloged by Albert Wohlstetter, then a senior policy analyst for the Rand Corporation: "B-52G (a longer range version of the B-52); the March 2B-58A Bomber and a 'growth' version of it; the March 3B-70 Bomber, a nuclear powered bomber possibly carrying long-range air to surface missiles; the Dynasoar, a manned glide-rocket; the Thor and the Jupiter, liquid-fueled intermediate-range ballistic missiles; the Snark intercontinental cruise missile; the Atlas and the Titan intercontinental ballistic missiles; the submarine-launched Polaris and Atlantis rockets; and Minuteman, one potential solid-fueled successor to the Thor and Titan." See Wohlstetter, "The Delicate Balance of Terror," *Foreign Affairs* 37, no. 2 (January 1959), 215.

18. In his book *Populuxe*, the cultural historian Thomas Hine makes connections between the design of bomber jets and cars. He also shows how rocket imagery filtered down into the design of everyday industrial objects, including chairs, clocks, radios, pens, and women's shoes. See Thomas Hine, *Populuxe* (New York: Knopf, 1987), especially the chapters entitled "The New Shape of Motion" and "The Boomerang and Other Enthusiasms."

19. "The Air-Age Acropolis," *Architectural Forum* (June 1959), 159–165.

20. Quoted in Nauman, *On the Wings of Modernism*, 59.

21. Christian Norberg-Schulz, *Meaning in Western Architecture* (New York: Prager, 1975), 14.

22. Ibid.

23. Ibid.

24. Ibid., 30.

25. On the chapel, see Roger Shephard, *Structures of Our Time: 31 Buildings That Changed Modern Life* (New York: McGraw-Hill, 2002), 216–221.

26. John Foster Dulles, "Our New and Vaster Frontier," *Life* (December 23, 1957). The iconography of the cowboy and its relation to the postwar politics and new democratic mythology is discussed by Stanley Corkin, "Cowboys and Free Markets: Post World War II Westerns and U.S. Hegemony," *Cinema Journal*, no. 3 (Spring 2000), 66–91.

27. On Cecil B. DeMille's involvement, see Nauman, *On the Wings of Modernism*, 139.

28. Busch was speaking more generally of architecture in what he called "the Stoller era." Akiko Busch, *The Photography of Architecture: Ten Views* (New York: Van Nostrand Reinhold, 1987), 7. See also Cervin Robinson, *Architecture Transformed* (New York: Architectural League, 1986); William

Saunders, *Modern Architecture: The Photographs of Stoller* (New York: Abrams, 1990).

29. C. Wright Mills, *The Causes of World War Three* (New York: Harcourt Brace, 1958), 51.

30. T. A. Wise, "The Biggest Broker in the World," *Fortune* (August 1960), 96.

31. William S. Paley, *As It Happened: A Memoir* (Garden City, N.Y.: Doubleday, 1979), 344.

32. Ibid.

33. Hannah Arendt, *Between Past and Future* (New York: Penguin, 1961), 202.

34. Ibid., 211.

35. Ibid.

36. Ibid., 207.

37. Ibid., 211.

38. Walter Benjamin, "The Work of Art in the Age of Mechanical Reproduction," in Benjamin, *Illuminations*, ed. Hannah Arendt, trans. Harry Zohn (New York: Schocken Books, 1968), 214.

39. Ibid., 242. Arendt's stress on the "gargantuan appetites" of the masses also recalls Greenberg's repeated emphasis on the "hunger" of "the proletariat and petty bourgeois" in "Avant-Garde and Kitsch." Already by 1939, Greenberg wrote, the avant-garde was "becoming more timid every day that passes … unsure of the audience it depends on – the rich and the cultivated." Below existed the debased culture of an underclass, which in 1939 had not yet won "the leisure and comfort necessary for the enjoyment of the city's traditional culture," but who nonetheless "set up a pressure on society to provide them with a kind of culture fit for their own consumption." Greenberg called it "ersatz culture, kitsch, destined for those who, insensible to the values of genuine culture, are hungry nevertheless for the diversion that only culture of some sort can provide." Kitsch fed on "genuine culture," "a fully matured cultural tradition," drawing out the "life-blood," and discarding the rest as waste: it "converts and waters down a great deal of avant-garde material for its own uses." Arendt describes the same vampire dynamic. See Clement Greenberg, "Avant-Garde and Kitsch," in Greenberg, *Art and Culture* (Boston: Beacon Press, 1961, 1989), 8–11.

40. Arendt, *Between Past and Future*, 206.

41. Susan Sontag, *Against Interpretation* (New York: Dell, 1966), 300, 303.

42. Hannah Arendt, *The Human Condition* (New York: Doubleday, 1958), 2.

43. Sontag, *Against Interpretation*, 290.

44. Ibid., 289.

45. Ibid., 275.

46. Ibid., 276.

47. Ibid., 277–278, 280.

48. Ibid., 277.

49. Walter Benjamin, "Surrealism: The Last Snapshot of the European Intelligentsia," in Benjamin, *Selected Writings*, vol. 2, part 1: *1927–1930*, ed. Howard Eiland and Gary Smith (Cambridge, MA: Harvard University Press, 2005), 207–208.

50. Sontag, *Against Interpretation*, 281.

51. Benjamin, "Surrealism: The Last Snapshot of the European Intelligentsia," 209.

52. Ibid., 210.

53. Ibid.

54. Sontag, *Against Interpretation*, 285.

55. Benjamin, "Surrealism: The Last Snapshot of the European Intelligentsia," 216.

56. Sontag, *Against Interpretation*, 277.

57. Ibid., 289.

58. Ibid.

59. Ibid., 292.

60. Huntington Hartford, "Publisher's Note," *Show*, no. 1 (October 1961), n.p.

61. Arendt, *The Human Condition*, 2.

62. Sontag, *Against Interpretation*, 216.

63. Ibid., 224.

64. Maria Wyke has documented the "extra-cinematic discourses" that "began to accumulate around Mankiewicz's *Cleopatra* long before its release," such as cost overruns and Taylor and Burton's explosive set-side extramarital affair. Taylor's image was exploited by "associated retailing industries as a means of selling fashion and beauty products": Cleopatra wigs and beauty products allowed women to achieve Taylor's look. See Maria Wyke, *Projecting the Past: Ancient Rome, Cinema, and History* (New York: Routledge, 1997), 101. I could not find any building trade advertisements directly related to the film in the realm of design.

65. Sontag, *Against Interpretation*, 296.

66. Ibid., 291.

67. Ibid., 297.

68. Quoted in Paley, *As It Happened*, 343.

69. Quoted in Robert Metz, *CBS: Reflections in a Bloodshot Eye* (New York: Signet, 1975), 242.

70. See Victoria Newhouse, *Wallace K. Harrison, Architect* (New York: Rizzoli, 1989), 154.

71. Thomas Creighton, "Seagram House Re-assessed," 142.

72. Peter Smithson, "Footnote on the Seagram Building," in *Changing the Art of Inhabitation* (London: Artemis, 1994). (Manfredo Tafuri later wrote: "Here the absoluteness of the object is total. The maximum of formal structurality is matched by the maximum absence of image. That language of absence is projected on an ulterior 'void' that mirrors the first void and causes it to

resonate. This is no place for repose or contemplation. Mies said the two basins should be filled to prevent the public [from sitting in the plaza]." Manfredo Tafuri, *Modern Architecture*, vol. 2 (New York: Rizzoli, 1979), 366.

73. Ibid.

74. Louis Kahn, *Essential Texts*, ed. Robert Twombly (New York: W. W. Norton, 2003), 51.

75. "Controversial Building in London," *Architectural Forum* (March 1961), 81.

76. Alden Hatch, *Ambassador Extraordinary: Clare Boothe Luce* (New York: Henry Holt, 1956), 13.

77. These were contentious years in Italy, where the Communist Party was strong, and tensions with Yugoslavia threatened to boil over. Boothe Luce attempted to mediate, and acted covertly to influence Italian politics in a way that would benefit American interests — namely by attempting, unsuccessfully, to discredit and destroy the Italian Communist Party. She was widely criticized for her efforts to get Communist auto workers fired from Fiat, and blamed for losses the Christian Democrats (who were part of the "the center coalition" government) suffered in the summer 1953 elections, because of a shrill speech she gave in Milan in which she threatened Italy with economic sanctions if it voted for the Communist Party rather than the Christian Democrats. See Blanche Cook Warren, *The Declassified Eisenhower: A Divided Legacy of Peace and Political Warfare* (New York: Penguin, 1981), 196.

78. Clare Boothe Luce, "The Ambassadorial Issue: Professionals or Amateurs?," *Foreign Affairs* 36, no. 1 (October 1957), 105.

79. Ibid., 110.

80. Ibid., 114.

81. As an example, during Boothe Luce's time as ambassador to Italy she wrote a thirty-seven-page policy paper entitled "Russian Atomic Power and the Lost American Revolution" (dated August 1954). She predicted Soviet world domination, and made a case for preventive nuclear war. The paper decried the growing consensus in Europe (led by France) for European neutrality with regard to the two superpowers, and Europe's "laggardly tactics" regarding NATO (what she perceived to be its hesitation regarding U.S. military bases). She expressed impatience with Eisenhower's equivocating between the policies of containment and rollback, and advocated the immediate implementation of the latter with nuclear weapons. Her first targeted area was Asia: "the rollback of the Iron Curtain with tactical atomic weapons should begin in Asia"; and she listed the reasons why:

 (a) we still have there two allies eager to fight and able to supply forces — Korea and Formosa [Taiwan]

 (b) Western Civilization (the preservation of which is one of our policy goals) cannot be destroyed there

 (c) Unless Moscow is willing to see China defeated, it must come to her rescue. If it does ... the consequent drain on Russia will ease her military pressure on the European front

The use of the atomic bombs on Japanese cities at the end of the war lent this scenario an air of credibility: from Boothe Luce's perspective, this campaign had already begun – the Japanese example was proof of its success – but it was left unfinished. With the full campaign accomplished, Boothe Luce said, the U.S. would have recaptured "the lost American revolution," and "should soon begin to reaffirm in unequivocal terms the historic American stand in world politics of being for governments of free people." Copies of Boothe Luce's paper were sent to Eisenhower and C. D. Jackson, but elicited no response. Only two original copies are known to exist: Boothe Luce's own, in her papers at the Library of Congress, and the copy she sent to C. D. Jackson, cataloged with his papers at Abilene. According to Warren, Boothe Luce was often in contact with Jackson in his capacity as First Special Assistant for Cold War Planning, especially in her attempt to destroy the Italian Communist Party. See Blanche Cook Warren, *The Declassified Eisenhower*, 195–196.

82. "Controversial Building in London," *Architectural Forum* (March 1961), 81; also quoted in Temko, *Eero Saarinen*, 32.

83. Marcel Breuer, *Sun and Shadow: The Philosophy of an Architect* (New York: Dodd, Mead, 1956), 33, 68.

84. As related by Isabelle Hyman, on the afternoon of May 23, 1941, Breuer scolded Gropius when he arrived late to a department event at the Harvard Graduate School of Design, and Gropius in turn dressed him down publicly. Later that day, Breuer wrote two letters to Gropius, one official, one personal, dissolving their joint architectural practice and their friendship. A few months later, in a rare, impolitic moment, Gropius (who had known Breuer since 1920), when he arrived as part of the second incoming class at the Bauhaus, wrote to Herbert Bayer that Breuer was "too deeply in love with himself, and the 'kleinmeister complex' against the former Bauhaus Director has brought him to commit betrayal towards me. Also he doesn't need me anymore since he has had enough personal success now." Isabelle Hyman, *Marcel Breuer, Architect: The Career and the Buildings* (New York: Harry N. Abrams, 2001), 108–109. This episode is also related by Jill Pearlman, *Inventing American Modernism: Joseph Hudnut, Walter Gropius, and the Bauhaus Legacy at Harvard* (Charlottesville: University of Virginia Press, 2007), 114–115.

85. See Joachim Driller, *Breuer Houses* (New York: Phaidon, 2000); Hyman, *Marcel Breuer, Architect*. On these kinds of magazine-sponsored competitions, see also Mark Jarzombek, "'*Good Life Modernism*' and Beyond: The American House in the 1950s and 1960s," *Cornell Journal of Architecture* 4 (1989), 76–93.

86. Marcel Breuer, *Buildings and Projects 1921–1961* (New York: Praeger, 1961), 258; first published in "On a Binuclear House," *California Arts & Architecture* (December 1943).

87. "Marcel Breuer Builds for Himself," *Architectural Record* (October 1948), 97.

88. Quoted in Driller, *Breuer Houses*, 154.

89. This is the process whereby, as Marx said and as Arendt relates, "nature's material [is] adapted by a change of form to the wants of men," so that "labor has incorporated itself with its subject." See Arendt, *The Human Condition*, 86.

90. Breuer, *Sun and Shadow*, 9.

91. Ibid., 32, 10.

92. Ibid., 35.

93. Marcel Breuer Papers, Archives of American Art/Smithsonian Institution, Reel 5172.

94. Ibid.

95. Ibid.

96. Ibid.

97. Ibid.

98. Ibid., Reel 5713.

99. Ibid.

100. Ibid.

101. Ibid.

102. Giulio Carlo Argan, *Marcel Breuer, disegno industriale e architettura* (Milan: Görlich, 1957), 21.

103. Ibid., 24.

104. Breuer, "Beyond Ages," 13.

105. Hyman, *Marcel Breuer, Architect*, 203.

106. Lewis Mumford, "Out, Damned Cliché!" *New Yorker* (November 12, 1960), 114. See also his follow-up article, "Unesco House, the Hidden Treasure," *New Yorker* (November 19, 1960).

107. Edward Durell Stone, *The Evolution of an Architect* (New York: Horizon Press, 1962), 142.

108. Ibid.

109. Ibid., 15.

110. Ibid., 138.

111. Ibid., 139.

112. Ibid.

113. The embassy opened in 1959. John Kenneth Galbraith, appointed by President Kennedy, was the first ambassador to live and work there. Stone was later commissioned to build a private residence for the ambassador and his family behind the main administrative building. In 1963, Galbraith and his wife were asked about their life there by *Time* magazine's "Modern Living" column. The Galbraiths were unhappy: "You cannot have a quiet chat any-where in the house without being heard everywhere," Mrs. Galbraith said in reference to Stone's grilles. Of a multi-jetted fountain in the reception hall, Galbraith said it sounded like "a toilet permanently out of order." Stone, also interviewed for the article, responded: "Why are they carping about

these little points? These petty features obscure the truth – they are living in a palace." See *Time* (April 12, 1963), 60–61.

114. Ron Robin, *Enclaves of America: The Rhetoric of American Political Architecture Abroad, 1900–1965* (Princeton: Princeton University Press, 1992), 137–138.

115. Philip Johnson, "Retreat from the International Style to the Present Scene," in Johnson, *Writings* (New York: Oxford University Press, 1979), 85.

116. Stone, *The Evolution of an Architect*, 142.

117. On the exhibition program, see Bruce Haddow, *Pavilions of Plenty: Exhibiting American Culture Abroad in the 1950s* (Washington, D.C.: Smithsonian Institution Press, 1997), 71; Michael L. Krenn, *Fallout Shelters of the Human Spirit: American Art and the Cold War* (Chapel Hill: University of North Carolina Press, 2005), 128–129. For Stone's description, see Stone, *The Evolution of an Architect*, 145.

118. Edward Durell Stone, "Break the Rules!," *This Week* (May 8, 1960), 2.

119. Winthrop Sargeant, "From Sassafras to Branches," *New Yorker* (January 3, 1959), 33, 34.

120. Ibid., 36.

121. Ibid.

122. Huntington Hartford, "Publisher's Note," *Show*, no. 1 (October 1961), n.p.

123. Karl E. Meyer, "D.C. Capital Culture," *Show*, no. 1 (January 1962), 93.

124. On the decades-long campaign to realize the center, see Ralph Becker, *Miracle on the Potomac* (Silver Spring, MD: Bartleby Press, 1990).

125. "The New American Style: Aspects and Implications of a Cultural Revolution," *Show*, no. 10 (October 1962), 42.

126. Alistair Cooke, "The Public Face of John F. Kennedy," *Show*, no. 4 (April 1963), 72.

127. Richard Schickel, "Presidents in the Audience," *Show*, no. 1 (October 1961), 106.

128. Ibid., 107.

129. Stone, *The Evolution of an Architect*, 158.

130. Ibid.

131. Vincent Scully, *Frank Lloyd Wright* (New York: George Braziller, 1960); Scully, *The Earth, the Temple, and the Gods: Greek Sacred Architecture* (New Haven: Yale University Press, 1962); Scully, *Louis I. Kahn* (New York: George Braziller, 1962).

132. Vincent Scully, *Modern Architecture: The Architecture of Democracy* (New York: George Braziller, 1961), 28–29.

133. Ibid., 29.

134. Ibid., 31.

135. Ibid., 33, 34.

136. Ibid., 35.

137. Ibid.

138. Ibid., 36.

139. Ibid., 37.

140. Ibid., 40.

141. Ibid., 41.

142. Ibid.

143. Eric Mumford, *The CIAM Discourse on Urbanism, 1928-1960* (Cambridge, MA: MIT Press, 2000), 199; see especially chapters 3 and 4 ("Concerning Architectural Culture: Zevi's Critique of CIAM" and "CIAM '59 in Otterlo and the End of CIAM").

144. Bruno Zevi, *Architecture as Space*, trans. Joseph Barry (New York: Horizon Press, 1957), 17.

145. Ibid., 28.

146. Ibid., 78.

147. Ibid., 82.

148. Scully, *Modern Architecture*, 15.

149. Ibid., 27

150. Ibid., 49.

151. Ibid.

152. Ibid., 50.

153. Charles Jencks, *Modern Movements in Architecture* (New York: Anchor, 1973), 186.

154. Ibid., 187.

155. Ibid.

156. Ibid., 190–191.

157. Ibid., 192.

158. Ibid., 195.

Chapter 3: The Useless Monument

1. Hannah Arendt, *The Human Condition* (New York: Doubleday, 1958), 13, 14.

2. See Beatriz Colomina, "Johnson on TV," in Emmanuel Petit, ed., *Philip Johnson: The Constancy of Change* (New Haven: Yale University Press, 2009), 68–79; Detlef Mertins, "The Delicacy of Modern Tastes," in Petit, *Philip Johnson: The Constancy of Change*, 160–169.

3. Franz Schulz, *Philip Johnson, Life and Work* (New York: Knopf, 1994), 103.

4. Ibid., 126, 144.

5. Vincent Scully, "Philip Johnson: Art and Irony," in Petit, *Philip Johnson: The Constancy of Change*, 19; Joan Ockman, "The Figurehead: On Monumentality and Nihilism in Philip Johnson's Life and Work," in Petit, *Philip Johnson*, 87.

6. Philippa Gates, *Detecting Men: Masculinity and the Hollywood Detective Film* (Albany: State University of New York Press, 2006), 256.

7. Philip Johnson, *Writings* (New York: Oxford University Press, 1979), 110.

8. Schulz, *Philip Johnson*, 146.

9. Ockman, "The Figurehead," 87.

10. Philip Johnson, *Mies van der Rohe* (New York: Museum of Modern Art, 1947), 16, 96; Johnson, *Writings*, 54.

11. Sibyl Moholy-Nagy, letter to the editor, *Journal of the Society of Architectural Historians* 24, no. 3 (1965), 255–256.

12. Johnson, *Writings*, 218.

13. Johnson, *Mies van der Rohe*, 96.

14. Johnson, *Writings*, 218.

15. Ibid., 137, 138, 139.

16. Ibid., 140.

17. "Insurance Sets a Pattern," *Architectural Forum* (September 1957), 127.

18. Johnson, *Writings*, 146; original emphasis.

19. Ibid., 147, 146.

20. Ibid., 144, 147, 148.

21. Ibid., 145; original emphasis.

22. Ibid., 251.

23. Ibid., 237, 238.

24. Ibid., 76.

25. Ibid., 77.

26. Ibid., 79.

27. Ibid., 78.

28. Ibid.

29. Ibid., 79.

30. Ibid., 230.

31. Manfredo Tafuri, *Modern Architecture*, vol. 2 (New York: Rizzoli, 1979), 366.

32. Johnson, *Writings*, 165.

33. Ibid.

34. Schulz, *Philip Johnson*, 193–194.

35. Philip Johnson, *The Sheldon Memorial Art Gallery* (Lincoln: University of Nebraska Board of Regents, 1964), n.p.

36. Charles Jencks, *Modern Movements in Architecture* (New York: Anchor, 1973), 207.

37. Ibid., 212.

38. Hilton Kramer, "Philip Johnson's Brilliant Career," *Commentary* 100, no. 3 (September 1995), 44.

39. Judith Halberstam, *The Queer Art of Failure* (Durham: Duke University Press, 2011); Lee Edelman, *No Future: Queer Theory and the Death Drive* (Durham: Duke University Press, 2004).

40. Jencks, *Modern Movements in Architecture*, 207.

41. Susan Sontag, *Against Interpretation* (New York: Dell, 1966), 14.

42. Johnson, *Writings*, 252.

43. Ibid., 251.

44. Ibid., 252.

45. Ibid., 251.

46. James McCourt, *Mawrdew Czgowchwz* (1975; New York: New York Review of Books, 2002), v.

47. Kevin Kopelson, *Love's Litany: The Writing of Modern Homoerotics* (Stanford: Stanford University Press, 1994), 18.

48. Johnson, *Writings*, 252.

49. Ibid., 220.

50. Ibid., 221.

51. Timothy Rohan, "The Dangers of Eclecticism: Paul Rudolph's Jewett Arts Center at Wellesley," in Sarah Williams Goldhagen and Réjean Legault, eds., *Anxious Modernisms: Experimentation in Postwar Architectural Culture* (Montreal: Canadian Centre for Architecture, 2000), 207–211; see also Timothy Rohan, *The Architecture of Paul Rudolph* (New Haven: Yale University Press, 2014), 40–47.

52. Sibyl Moholy-Nagy, *The Architecture of Paul Rudolph* (New York: Praeger, 1970), 16.

53. Alice Friedman, *American Glamour and the Evolution of Modern Architecture* (New Haven: Yale University Press, 2010), 182.

54. Ibid., 26.

55. Hannah Arendt, *The Origins of Totalitarianism* (New York: Harcourt and Brace, 1951), ix.

56. Hannah Arendt, *Between Past and Future* (1961; New York: Penguin, 1993), 26.

57. Ibid., 15.

58. Hannah Arendt, "Introduction *into* Politics," in Arendt, *The Promise of Politics*, ed. Jerome Kohn (New York: Schocken Books, 2005), 153.

59. Arendt, *The Origins of Totalitarianism*, 443.

60. Ibid.

61. Ibid., 459.

62. Ibid., 460.

63. Arendt, "Introduction *into* Politics," 159.

64. Ibid.

65. Hannah Arendt, *On Revolution* (1963; New York: Penguin, 1990), 216, 217.

66. Edmund Stillman and William Pfaff, *The New Politics: America and the End of the Postwar World* (New York: Harper and Row, 1961), 68.

67. Ibid., 173–174.

68. Ibid., 15, 17, 40, 42.

69. Jonathan Schell, *Selected Works* (New York: Nation Books, 2004), 262.

70. Ibid., 265.

71. Ibid., 263.

72. Stillman and Pfaff, *The New Politics*, 153.

73. Ibid., 154.

74. Arendt, *Between Past and Future*, 252.

75. Ibid., 255; Arendt may have been invoking Vance Packard's *The Hidden Persuaders* (1957).

76. Ibid.

77. Hannah Arendt, "Lying in Politics," in Arendt, *Crises of the Republic* (New York: Harcourt Brace Jovanovich, 1972), 87. In this quote, she was referring specifically to Daniel Ellsberg and the revelation of the Pentagon Papers in 1971.

78. Sontag, *Against Interpretation*, 291.

79. Arendt, *Between Past and Future*, 257.

Epilogue

1. Hannah Arendt, *The Human Condition* (New York: Anchor, 1958), 5.

2. Ibid., 157.

3. Ibid., 296, 297.

4. Ibid.

5. Vincent Scully, *Louis I. Kahn* (New York: George Braziller, 1962), 24. More recent scholarship has shown that it was Anne Tyng who was the guiding force of the bathhouse project, as well as the later City Tower project. See Sarah Williams Goldhagen, *Louis Kahn's Situated Modernism* (New Haven: Yale University Press, 2001), 105–111, 244.

6. Scully, *Louis I. Kahn*, 24.

7. Ibid., 11.

8. Ibid.

9. Ibid.

10. Ibid., 12.

11. Ibid., 37.

12. Ibid., 24.

13. Ibid., 37–38.

14. Louis Kahn, *Essential Texts*, ed. Robert Twombly (New York: W. W. Norton, 2003), 78.

15. Ibid.

16. Ibid., 80.

17. Ron Robin, *Enclaves of America: The Rhetoric of American Political Architecture Abroad, 1900–1965* (Princeton: Princeton University Press, 1992), 137–138.

18. Kahn, *Essential Texts*, 98.

19. Robin, *Enclaves of America*, 137–138.

20. Kahn, *Essential Texts*, 98.

21. Ibid., 99.

22. Ibid.

23. Ibid., 102–103.

24. Arendt, *The Human Condition*, 157.

25. Kahn, *Essential Texts*, 42.

26. Ibid., 37.

27. Ibid., 38.

28. Ibid.

29. Ibid., 39.

30. Ibid.

31. Ibid., 42.

32. Ibid., 41.

33. Ibid., 42.

34. Ibid.

35. Ibid., 51.

36. Ibid.

37. Ibid., 53.

38. Ibid., 56.

39. Vincent Scully, *Modern Architecture: The Architecture of Democracy* (New York: George Braziller, 1961), 27.

40. Hannah Arendt, *The Promise of Politics*, ed. Jerome Kohn (New York: Schocken Books, 2005), 204.

41. Ibid., 201.

42. Ibid., 201, 202.

43. Ibid., 202–203.

44. Scully, *Louis I. Kahn*, 44.

45. Ibid.

46. Sibyl Moholy-Nagy, *The Architecture of Paul Rudolph* (New York: Praeger, 1970), 8.

47. Ibid., 17.

48. Ibid.

49. Ibid., 19.

50. Ibid.

51. Ibid., 10.

52. Ibid., 29.

Select Bibliography

On American Culture and Film

Abrahamson, David. *Magazine-Made America: The Cultural Transformation of the Postwar Periodical*. Cresskill, NJ: Hampton Press, 1996.

Adorno, T. W. "How to Look at Television." In Bernard Rosenberg and David Manning White, eds., *Mass Culture: The Popular Arts in America*, 474–488. New York: Free Press, 1957.

Augspurger, Michael. *An Economy of Abundant Beauty: Fortune Magazine and Depression America*. Ithaca: Cornell University Press, 2004.

Babington, Bruce. *Biblical Epics: Sacred Narrative in the Hollywood Cinema*. Manchester: Manchester University Press, 1993.

Bell, D., and J. Hollows, eds. *Historicizing Lifestyle: Mediating Taste, Consumption and Identity from the 1900s to 1970*. Burlington, VT: Ashgate, 2006.

Bird, William. *Better Living : Advertising, Media and the New Vocabulary of Business Leadership, 1935–1955*. Evanston, IL: Northwestern University Press, 1999.

Bragg, Herbert E. "The Development of Cinemascope." *Film History* 2 (1988): 359–371.

Brown, E., H. C. Gudis, and M. Moskovitz, eds. *Culture of Commerce: Representation and American Business Culture, 1877–1960*. New York: Palgrave, 2006.

Cleto, F., ed. *Camp: Queer Aesthetics and the Performing Subject: A Reader*. Ann Arbor: University of Michigan Press, 1999.

Cohen, Lizabeth. *A Consumer's Republic: The Politics of Mass Consumption in Postwar America*. New York: Knopf, 2003.

Cohn, Jan. *Creating America: George Horace Lorimer and the Saturday Evening Post*. Pittsburgh: University of Pittsburgh Press, 1989.

Corkin, Stanley. "Cowboys and Free Markets: Post WWII Westerns and U.S. Hegemony." *Cinema Journal* 3 (Spring 2000): 66–91.

Dickstein, Morris. *Gates of Eden: American Culture in the Sixties*. New York: Basic Books, 1977.

Doherty, Thomas. *Cold War, Cool Medium: Television, McCarthyism, and American Culture*. New York: Columbia University Press, 2003.

Edelman, Lee. *No Future: Queer Theory and the Death Drive*. Durham: Duke University Press, 2004.

Engelhardt, Tom. *The End of Victory Culture: Cold War America and the Disillusioning of a Generation*. New York: Basic Books, 1995.

Field, D., ed. *American Cold War Culture*. Edinburgh: Edinburgh University Press, 2005.

Friedan, Betty. *The Feminine Mystique*. New York: Norton, 1963.

Glickman, Lawrence. *A Living Wage: American Workers and the Making of Consumer Society*. Ithaca: Cornell University Press, 1997.

Haddow, Robert. *Pavilions of Plenty: Exhibiting American Culture Abroad in the 1950s*. Washington, DC: Smithsonian Institution Press, 1997.

Halberstam, Judith. *The Queer Art of Failure*. Durham: Duke University Press, 2011.

Hine, Thomas. *Populuxe*. New York: Knopf, 1987.

Hixson, Walter L. *Parting the Curtain: Propaganda, Culture, and the Cold War, 1945–1961*. New York: St. Martin's Press, 1997.

Hoberek, Andrew. *The Twilight of the Middle Class: Post-World War II American Fiction and White-Collar Work*. Princeton: Princeton University Press, 2005.

Hodgins, Eric. *Mr. Blandings Builds His Dreamhouse*. New York: Viking, 1946.

Horowitz, R., and A. Mohun, eds. *His and Hers: Gender, Consumption, and Technology*. Charlottesville: University Press of Virginia, 1998.

Huyssen, Andreas. *After the Great Divide: Modernism, Mass Culture, Postmodernism*. Bloomington: Indiana University Press, 1986.

Jezer, Marty. *The Dark Ages: Life in the U.S., 1945–1960*. Boston: South End Press, 1982.

Joshel, Sandra R., Margaret Malamud, and Donald T. McGuire, Jr., eds. *Imperial Projections: Ancient Rome in Modern Popular Culture*. Baltimore: Johns Hopkins University Press, 2001.

Kammen, Michael. *American Culture, American Tastes: Social Change and the 20th Century*. New York: Knopf, 1999.

Keats, John. *The Crack in the Glass Curtain Wall*. Boston: Houghton Mifflin, 1956.

Kopelson, Kevin. *Love's Litany: The Writing of Modern Homoerotics*. Stanford: Stanford University Press, 1994.

Krenn, Michael L. *Fall Shelters for the Human Spirit: American Art and the Cold War*. Chapel Hill: University of North Carolina Press, 2005.

Kuznick, Peter J., and James Gilbert, eds. *Rethinking Cold War Culture*. Washington, DC: Smithsonian Institution Press, 2001.

Lears, Jackson. "A Matter of Taste: Corporate Culture Hegemony in a Mass Consumption Society." In Larry May, ed., *Recasting America: Culture and Politics in the Age of the Cold War*. Chicago: University of Chicago Press, 1989.

Lhamon, W. T., Jr. *Deliberate Speed: The Origins of a Cultural Style in the American 1950s*. Washington, DC: Smithsonian Institution Press, 1990.

Long, Elizabeth. *The American Dream and the Popular Novel*. Boston: Routledge and Kegan Paul, 1985.

Lora, R., and W. H. Longton, eds. *The Conservative Press in Twentieth-Century America*. Westport: Greenwood Press, 1999.

May, Elaine T. *Homeward Bound: American Families in the Cold War Era*. New York: Basic Books, 1988.

May, Larry. *Recasting America: Culture and Politics in the Age of the Cold War.* Chicago: University of Chicago Press, 1989.

McAlister, Melani. *Epic Encounters: Culture, Media, and U.S. Interests in the Middle East since 1945.* Berkeley: University of California Press, 2005.

McBride, J., ed. *Focus on Howard Hawks.* Englewood Cliffs, NJ: Prentice-Hall, 1972.

McCarthy, Mary. *Cast a Cold Eye.* New York: Harcourt Brace, 1950.

McCarthy, Mary. *On the Contrary: Articles of Belief, 1946–1961.* New York: Farrar, Straus and Cudahy, 1961.

McCarthy, Mary. *Stones of Florence.* New York: Harcourt Brace, 1959.

McCarthy, Mary. *Venice Observed.* Paris: G. & R. Bernier, 1956.

McConachie, Bruce. *American Theater in the Culture of the Cold War.* Iowa City: University of Iowa Press, 2003.

Meyerowitz, J., ed. *Not June Cleaver: Women and Gender in Postwar America, 1945–1960.* Philadelphia: Temple University Press, 1994.

Nadal, Alan. *Containment Culture: American Narratives, Postmodernism, and the Atomic Age.* Durham: Duke University Press, 1995.

Newman, Kathy M. *Radio Active: Advertising and Consumer Activism, 1935–1947.* Berkeley: University of California Press, 2004.

Oakley, J. Ronald. *God's Country: America in the '50s.* New York: Barricade Books, 1990.

Paley, William S. *As It Happened: A Memoir.* New York: Doubleday, 1979.

Richards, Jeffrey. *Hollywood's Ancient Worlds.* London: Bloomsbury, 2008.

Robin, Ron. *Making of the Cold War Enemy: Culture and Politics in the Military-Industrial Complex.* Princeton: Princeton University Press, 2001.

Rogers, Ariel. *Cinematic Appeals: The Experience of New Movie Technologies.* New York: Columbia University Press, 2013.

Ross, Andrew. *No Respect: Intellectuals and Popular Culture.* New York: Routledge, 1989.

Rydell, Robert W. *World of Fairs: The Century-of-Progress Expositions.* Chicago: University of Chicago Press, 1993.

Saunders, Frances. *Who Paid the Piper? The CIA and the Cultural Cold War.* London: Granta Books, 1999.

Sherry, Michael S. *In the Shadow of War: The United States since the 1930's.* New Haven: Yale University Press, 1995.

Smith, Jeff. "Are You Now or Have You Ever Been a Christian? The Strange History of *The Robe* as Political Allegory." *Film Studies* 7 (Winter 2005): 1–15.

Strasser, Susan. *Satisfaction Guaranteed: The Making of the American Mass Market.* New York: Pantheon Books, 1989.

Vanderbilt, Tom. *Survival City: Adventures among the Ruins of Atomic America.* Princeton: Princeton Architectural Press, 2002.

Wagnleitner, R., and E. T. May, eds. *Here, There, and Everywhere: The Foreign Politics of American Popular Culture.* Hanover, NH: University Press of New England, 2000.

Walter, Brian. "Love in the Time of Calvary: Romance and Family Values in Crucifixion Films." *CineAction* 88 (2012): 4–11.

Whitfield, Stephen J. *The Culture of the Cold War*. Baltimore: Johns Hopkins University Press, 1996.

Whiting, Cécile. *A Taste for Pop: Pop Art, Gender, and Consumer Culture*. Cambridge: Cambridge University Press, 1997.

Wilson, Edmund. *The Cold War and the Income Tax: A Protest*. New York: Farrar, Strauss, 1963.

Wilson, Edmund. *The Fifties: From Notebooks and Diaries of the Period*. Ed. Leon Edel. New York: Farrar, Strauss, 1986.

Wood, Michael. *America in the Movies*. New York: Columbia University Press, 1975.

Wyke, Maria. *Projecting the Past: Ancient Rome, Cinema, and History*. New York: Routledge, 1997.

On Hannah Arendt and Karl Jaspers

Arendt, Hannah. *Between Past and Future: Six Exercises in Political Thought*. New York: Viking Press, 1961.

Arendt, Hannah. *Crises of the Republic*. New York: Harcourt Brace Jovanovich, 1972.

Arendt, Hannah. *Essays in Understanding, 1930–1954*. Ed. Jerome Kohn. New York: Harcourt Brace Jovanovich, 1994.

Arendt, Hannah. *The Human Condition*. New York: Doubleday, 1958.

Arendt, Hannah. *On Revolution*. New York: Viking Press, 1963.

Arendt, Hannah. *On Violence*. New York: Harcourt Brace Jovanovich, 1970.

Arendt, Hannah. *The Origins of Totalitarianism*. New York: Harcourt Brace Jovanovich, 1973.

Arendt, Hannah. *The Promise of Politics*. Ed. Jerome Kohn. New York: Schocken Books, 2005.

Arendt, Hannah. *Responsibility and Judgment*. Ed. Jerome Kohn. New York: Schocken Books, 2003.

Auden, W. H. *The Dyer's Hand and Other Essays*. New York: Vintage Books, 1968.

Auden, W. H. "Thinking What We Are Doing." *The Griffin* 7 (10) (1958): 4–12.

Benhabib, Seyla. *The Reluctant Modernism of Hannah Arendt*. Thousand Oaks, CA: Sage Publications, 1996.

Benjamin, Walter. *Illuminations*. Ed. Hannah Arendt. Trans. H. Zohn. New York: Schocken Books, 1968.

Benjamin, Walter. *Selected Writings*. Vol. 2, part 1, 1927–1930. Ed. Howard Eiland and Gary Smith. Cambridge, MA: Harvard University Press, 2005.

Calhoun, C., and J. McGowan, eds. *Hannah Arendt and the Meaning of Politics*. Minneapolis: University of Minnesota Press, 1997.

Canovan, Margaret. *Hannah Arendt: A Reinterpretation of Her Political Thought*. New York: Cambridge University Press, 1992.

Canovan, Margaret. *The Political Thought of Hannah Arendt*. New York: Harcourt Brace Jovanovich, 1974.

Curtis, Kimberley. *Our Sense of the Real: Aesthetic Experience and Arendtian Politics*. Ithaca: Cornell University Press, 1999.

Dietz, Mary G. *Turning Operations: Feminism, Arendt, and Politics*. New York: Routledge, 2002.

Euben, J. Peter. *Platonic Noise*. Princeton: Princeton University Press, 2003.

Hill, M. A., ed. *Hannah Arendt: The Recovery of the Public World*. New York: St. Martin's Press, 1979.

Honig, B., ed. *Feminist Interpretations of Hannah Arendt*. University Park: Pennsylvania State University Press, 1995.

Isaac, Jeffrey C. *Arendt, Camus, and Modern Rebellion*. New Haven: Yale University Press, 1992.

Isaac, Jeffrey C. "Oases in the Desert: Hannah Arendt on Democratic Politics." *American Political Science Review* 88 (1) (1994): 156–168.

Jaspers, Karl. *Existentialism and Humanism: Three Essays by Karl Jaspers*. Ed. Hanns E. Fischer. Trans. E. B. Ashton. New York: Russell Moore, 1952.

Jaspers, Karl. *The Future of Mankind*. Trans. E. B. Ashton. Chicago: University of Chicago Press, 1961.

May, L., and J. Kohn, eds. *Hannah Arendt: Twenty Years Later*. Cambridge, MA: MIT Press, 1996.

Pirro, Robert. *Hannah Arendt and the Politics of Tragedy*. DeKalb: Northern Illinois University Press, 2001.

Pitkin, Hanna Fenichel. *The Attack of the Blob: Hannah Arendt's Concept of the Social*. Chicago: University of Chicago Press, 1998.

Reinhardt, Mark. *The Art of Being Free: Taking Liberties with Tocqueville, Marx, and Arendt*. Ithaca: Cornell University Press, 1997.

Young-Bruehl, Elisabeth. *Hannah Arendt: For Love of the World*. New Haven: Yale University Press, 1982.

On History and Politics

Adams, Rachel White. *On the Other Hand*. New York: Harper and Row, 1963.

Adams, Sherman. *First Hand Report: The Story of the Eisenhower Administration*. New York: Harper and Row, 1961.

Alexander, Charles. *Holding the Line: The Eisenhower Era*. Bloomington: Indiana University Press, 1975.

Allen, Craig. *Eisenhower and the Mass Media: Peace, Prosperity, and Prime-Time TV*. Chapel Hill: University of North Carolina Press, 1993.

Ambrose, Stephen E., and Douglas G. Brinkley. *Rise to Globalism: American Foreign Policy since 1938*. New York: Penguin, 1997.

Anthony, P. J. *America: The Hope of the Ages*. Boston: Christopher Publishing, 1959.

Aptheker, Herbert. *The World of C. Wright Mills*. New York: Marzani and Munsell, 1960.

Brinkley, Alan. *The Publisher: Henry Luce and His American Century*. New York: Knopf, 2010.

Brogi, Alessandro. "Ike and Italy: The Eisenhower Administration and Italy's Neo-Atlanticist Agenda." *Journal of Cold War Studies* 4 (3) (2002): 5–35.

Buckley, William F. "The Tranquil World of Dwight D. Eisenhower." *National Review* (January 18, 1958).

Burnham, James. *Containment or Liberation? An Inquiry into the Aims of United States Foreign Policy*. New York: J. Day, 1953.

Cherny, R. W., W. Issel, and K. W. Taylor, eds. *American Labor and the Cold War: Grassroots Politics and Postwar Political Culture*. New Brunswick, NJ: Rutgers University Press, 2004.

Childs, Marquis. *Captive Hero*. New York: Harcourt Brace, 1958.

Clowse, Barbara. *Brain Power for the Cold War: The Sputnik Crisis and the National Defense Education Act of 1958*. Westport, CT: Greenwood Press, 1982.

Cook, Blanche Wisen. *The Declassified Eisenhower: A Divided Legacy*. New York: Doubleday, 1981.

Divine, Robert. *The Sputnik Challenge*. New York: Oxford University Press, 1993.

Domhoff, G. William, and Hoyt B. Ballard, eds. *C. Wright Mills and the Power Elite*. Boston: Beacon Press, 1968.

Drummond, Roscoe, and Gaston Coblentz. *Duel at the Brink: John Foster Dulles' Command of American Power*. New York: Doubleday, 1960.

Dulles, John Foster. "Policy for Security and Peace." *Foreign Affairs* 32 (3) (1954): 353–364.

Eisenhower, Dwight D. *Mandate for Change*. New York: Doubleday, 1963.

Gaddis, John Lewis. *Strategies of Containment: A Critical Appraisal of Postwar American National Security Policy*. Oxford: Oxford University Press, 1982.

Greenstein, Fred I. *The Hidden-Hand Presidency: Eisenhower as Leader*. New York: Basic Books, 1982.

Halsey, Margaret. "America, the Dutiful." *New Republic* (July 7, 1958): 12–14.

Hatch, Alden. *Ambassador Extraordinary Clare Booth Luce*. New York: Holt, 1956.

Herberg, William. *Protestant, Catholic, Jew: An Essay on American Religious Sociology*. New York: Doubleday, 1956.

Herstein, Robert E. *Henry R. Luce: A Political Portrait of the Man Who Created the American Century*. New York: Scribner, 1994.

Herstein, Robert E. *Henry R. Luce, Time, and the American Crusade in Asia*. New York: Cambridge University Press, 2005.

Hughes, John Emmet. *The Ordeal of Power: A Political Memoir of the Eisenhower Years*. New York: Atheneum, 1963.

Huntington, Samuel P. *The Soldier and the State: The Theory and Politics of Civil–Military Relations*. New York: Vintage, 1957.

Immerman, Richard. *John Foster Dulles: Piety, Pragmatism, and Power in U.S. Foreign Policy*. Wilmington, DE: Scholarly Resources, 1999.

Kimball, Warren. *Swords into Ploughshares? The Morgenthau Plan for Defeated Nazi Germany 1943–1946*. Philadelphia: J. B. Lippincott Company, 1976.

Kissinger, Henry. *The Necessity for Choice: Prospects of American Foreign Policy*. New York: Anchor, 1962.

Kissinger, Henry. *Nuclear Weapons and Foreign Policy: Published for the Council on Foreign Relations*. New York: Harper and Row, 1957.

Larson, Deborah Welch. *Origins of Containment: A Psychological Explanation*. Princeton: Princeton University Press, 1985.

Lederer, William. *The Ugly American*. New York: Norton, 1958.

Lerner, Max. *America as a Civilization*. New York: Simon and Schuster, 1957.

Lodge, Henry Cabot. *As It Was: An Insider's View of Politics and Power in the '50s and '60s*. New York: Norton, 1976.

Luce, Clare Boothe. "The Ambassadorial Issue: Professionals or Amateurs?" *Foreign Affairs* 36 (1) (October 1957): 105–121.

Luce, Henry. "The Architecture of Democracy." *Journal of the American Institute of Architects* (June 1957).

Luce, Henry. *The Ideas of Henry Luce*. Ed. John Knox Jessup. New York: Atheneum, 1969.

MacDonald, H. Ian. "The American Economy of Abundance." *Canadian Journal of Economics and Political Science* 25 (3) (1959): 352–357.

Martin, Ralph G. *Henry and Clare: An Intimate Portrait of the Luces*. New York: Putnum, 1991.

Marty, Martin E. *The New Shape of American Religion*. New York: Harper and Brothers, 1959.

Meyer, Karl E. *The New America: Politics and Society in the Age of the Smooth Deal*. New York: Basic Books, 1961.

Miller, William Lee. *Piety along the Potomac: Notes on Politics and Morals in the Fifties*. Boston: Houghton Mifflin, 1964.

Mills, C. Wright. *The Causes of World War Three*. New York: Simon and Schuster, 1958.

Mills, C. Wright. *Listen, Yankee: The Revolution in Cuba*. New York: McGraw-Hill, 1960.

Mills, C. Wright. *The Power Elite*. New York: Oxford University Press, 1956.

Mills, C. Wright. *The Sociological Imagination*. New York: Oxford University Press, 1959.

Morris, Sylvia Jukes. *Rage for Fame: The Ascent of Clare Boothe Luce*. New York: Random House, 1997.

Mumford, Lewis. *The Human Prospect*. Ed. Harry T. Moore and Karl W. Deutsch. Boston: Beacon Press, 1955.

Mumford, Lewis. *The Human Way Out*. Wallingford, PA: Pendle Hill, 1958.

Mumford, Lewis. *In the Name of Sanity*. New York: Harcourt, Brace, 1954.

Mumford, Lewis. "Social Responsibilities of the Business Community: An Address Presented at New Home Office Building, the Baltimore Life Insurance Co., Baltimore, Maryland, April 24, 1961." Baltimore, 1961.

Nash, Philip. *The Other Missiles of October: Eisenhower, Kennedy, and the Jupiters, 1957–1963*. Chapel Hill: University of North Carolina Press, 1997.

Parmet, Herbert S. *Eisenhower and the American Crusades*. New York: Macmillan, 1972.

Rabinbach, Anson. *In the Shadow of Catastrophe: German Intellectuals between Apocalypse and Enlightenment*. Berkeley: University of California Press, 1997.

Riesman, David. *The Lonely Crowd: A Study of the Changing American Character*. New Haven: Yale University Press, 1950.

Rockefeller Brothers Fund. *Prospect for America: The Rockefeller Panel Reports*. Garden City, NY: Doubleday, 1961.

Roman, Peter J. *Eisenhower and the Missile Gap*. Ithaca: Cornell University Press, 1995.

Schell, Jonathan. *The Jonathan Schell Reader: On the United States at War, the Long Crisis of the American Republic, and the Fate of the Earth*. New York: Nation Books, 2004.

Schell, Jonathan. *The Time of Illusion*. New York: Vintage Books, 1976.

Schivelbusch, Wolfgang. *The Culture of Defeat: On National Trauma, Mourning, and Recovery*. New York: Picador, 2003.

Snead, David L., and the Gaither Committee. *Eisenhower and the Cold War*. Columbus: Ohio State University Press, 1999.

Stillman, Edmund, and William Pfaff. *The New Politics: America and the End of the Postwar World*. New York: Harper and Row, 1961.

Stillman, Edmund, and William Pfaff. *The Politics of Hysteria*. New York: Harper and Row, 1966.

Taylor, Maxwell. *The Uncertain Trumpet*. New York: Harper and Row, 1959.

Tilman, Rick. *C. Wright Mills: A Native Radical and His American Intellectual Roots*. University Park: Pennsylvania State University Press, 1984.

U.S. Department of Defense. *Department of Defense: Documents on Establishment and Organization, 1944–1978*. Washington, DC: Historical Office of the Secretary of Defense, 1978.

Watson, Robert D. *Into the Missile Age, 1956–1960*. Washington, DC: Historical Office of the Secretary of Defense, 1997.

Weschler, James. *Reflections of an Angry Middle-Aged Editor*. New York: Random House, 1960.

Whyte, William. *The Organization Man*. New York: Anchor, 1956.

Wohlstetter, Albert. "The Delicate Balance of Terror." *Foreign Affairs* 37 (2) (January 1959): 211.

Wollheim, Richard. "Democracy." *Journal of the History of Ideas* 19 (2) (April 1958): 225–242.

Wrong, Dennis H. "The United States in Comparative Perspective: Max Lerner's America as a Civilization." *American Journal of Sociology* 65 (5) (1960): 499–504.

On Modern Architecture

Adams, Nicolas. *Skidmore, Owings, and Merrill: SOM since 1936*. Milan: Electa, 2006.

Albrecht, Donald. "Design Is a Method of Action." In *The Work of Charles and Ray Eames: A Legacy of Invention*. New York: Harry N. Abrams, 1997.

Archer, John. *Architecture and Suburbia: From English Villa to American Dream House, 1690–2000*. Minneapolis: University of Minnesota Press, 2005.

Argan, Giulio Carlo. *Marcel Breuer, disegno industriale e architettura*. Milan: Görlich, 1957.

Armesto Aira, Antonio. "Quince casas americanas de Marcel Breuer (1938–1965). La refundación del universo doméstico como propósito experimental." [Fifteen American houses by Marcel Breuer (1938–1965). The Refounding of the Domestic Universe on Experimental Grounds.] *2G: revista internacional de arquitectura* 17 (2001): 4–26.

Banham, Reyner. *Age of the Masters: A Personal View of Modern Architecture*. London: Architectural Press, 1975.

Banham, Reyner. *A Critic Writes: Essays by Reyner Banham*. Ed. Mary Banham. Berkeley: University of California Press, 1996.

Banham, Reyner. "Fear of Eero's *Manam*." *Arts* (February 1962): 70–73.

Banham, Reyner. *Megastructure: Urban Futures of the Recent Past*. New York: Harper and Row, 1976.

Banham, Reyner. *The New Brutalism: Ethic or Aesthetic?* New York: Reinhold, 1966.

Becker, Ralph. *Miracle on the Potomac*. Silver Spring, MD: Bartleby Press, 1990.

Blake, Peter. "The Difficult Art of Simplicity." *Architectural Forum* 108 (5) (May 1958): 126–131.

Blake, Peter. *Form Follows Fiasco*. Boston: Little, Brown, 1977.

Blake, Peter. "Form Follows Function – Or Does It." *Architectural Forum* 108 (4) (April 1958): 98–103.

Blake, Peter. *God's Own Junkyard: The Planned Deterioration of America's Landscape*. New York: Holt, Rinehart and Winston, 1964.

Blake, Peter. *The Master Builders*. New York: Knopf, 1960.

Blake, Peter. "Modern Architecture: Its Many Faces." *Architectural Forum* 108 (March 1958): 76–81.

Blake, Peter. "Slaughter on Sixth Avenue." *Architectural Forum* 122 (3) (June 1965): 13–19.

Boyd, Robin. "Has Success Spoiled Modern Architecture?" *Architectural Forum* 111 (1) (July 1959): 98–103.

Breuer, Marcel. *Buildings and Projects 1921–1961*. New York: Praeger, 1961.

Breuer, Marcel. *Marcel Breuer: New Projects*. New York: Praeger, 1971.

Breuer, Marcel. *Sun and Shadow: The Philosophy of an Architect*. New York: Dodd, Mead, 1956.

Bruegmann, Robert, ed. *Modernism at Mid-Century: The Architecture of the U.S. Air Force Academy*. Chicago: University of Chicago Press, 1994.

Busch, Akiko. *The Photography of Architecture: Twelve Views*. New York: Van Nostrand Reinhold, 1987.

Collins, Peter. "Aspects of Ornament." *Architectural Review* (June 1961): 373–378.

Collins, Peter. "Historicism." *Architectural Review* (August 1960): 101–103.

Colomina, Beatriz. "DDU at MoMA." *Any* 17 (1997): 48–53.

Colomina, Beatriz. "Domesticity at War." *Assemblage* 16 (1991): 14–41.

Colomina, Beatriz. *Domesticity at War*. Cambridge, MA: MIT Press, 2007.

Colomina, Beatriz. "Enclosed by Images: The Eameses' Multimedia Architecture." *Grey Room* 2 (2001): 6–29.

Colomina, Beatriz. "Information Obsession: The Eameses' Multi-Screen Architecture." *Journal of Architecture* 6 (3) (2001): 205–223.

Colomina, Beatriz. "The Lawn at War: 1941–1961." In Georges Teyssot, ed., *The American Lawn*. Princeton: Princeton University Press, 1999.

Colomina, Beatriz. "1949." In R. E. Somol, ed., *Autonomy and Ideology: Positioning an Avant-Garde in America*. New York: Monacelli, 1997.

Colomina, Beatriz. "The Private Site of Public Memory." *Journal of Architecture* 4 (4) (1999): 337–360.

Colomina, Beatriz. "Reflections on the Eames House." In Donald Albrecht, ed., *The Work of Charles and Ray Eames: A Legacy of Invention*. New York: Harry N. Abrams, 1997.

Colomina, Beatriz, AnnMarie Brennan, and Jeannie Kim, eds. *Cold War Hothouses: Inventing Postwar Culture from Cockpit to Playboy*. New York: Princeton Architectural Press, 2004.

Colquhoun, Alan. *Modern Architecture*. New York: Oxford University Press, 2002.

De Alba, Roberto. *Paul Rudolph: The Late Work*. New York: Princeton Architectural Press, 2003.

Domin, Christopher, and Joseph King. *Paul Rudolph: The Florida Houses*. New York: Princeton Architectural Press, 2002.

Driller, Joachim. *Breuer Houses*. London: Phaidon, 2000.

Frampton, Kenneth. "America 1960–1970." *Casabella* 35 (1971): 24–38.

Frampton, Kenneth. *Modern Architecture: A Critical History*. New York: Thames and Hudson, 1985.

Frampton, Kenneth. "The Status of Man and the Status of His Objects: A Reading of *The Human Condition*." In Melvyn A. Hill, ed., *Hannah Arendt: The Recovery of the Public World*. New York: St. Martin's Press, 1979.

Friedman, Alice. *American Glamour and the Evolution of Modern Architecture*. New Haven: Yale University Press, 2010.

Friedman, Alice. *Women and the Making of the Modern House*. New Haven: Yale University Press, 1998.

Galofaro, Luca. *Eero Saarinen: La forma della tecnologia*. Turin: Testo & Immagine, 2001.

Gast, Klaus-Peter. *Louis I. Kahn: The Idea of Order*. Trans. M. Robinson. Basel: Birkhäuser, 1998.

Gatje, Robert. *Marcel Breuer: A Memoir*. New York: Monacelli Press, 2000.

Ghirado, Diane. *Architecture after Modernism*. New York: Thames and Hudson, 1996.

Giedion, Sigfried. *The Eternal Present: A Contribution on Constancy and Change*. Vol. 2, *The Beginnings of Architecture*. New York: Bollingen Foundation / Pantheon Books, 1964.

Giedion, Sigfried. *Space, Time and Architecture: The Growth of a New Tradition*. Cambridge, MA: Harvard University Press, 1941.

Golan, Romy. *Muralnomad: The Paradox of Wall Painting, Europe 1927–1957*. New Haven: Yale University Press, 2009.

Goldberger, Paul. Introduction to *Philip Johnson / Alan Ritchie Architects*. New York: Monacelli Press, 2002.

Goldhagen, Sarah Williams. *Louis Kahn's Situated Modernism*. New Haven: Yale University Press, 2001.

Goldhagen, Sarah Williams, and Réjean Legault, eds. *Anxious Modernisms: Experimentation in Postwar Architectural Culture*. Montreal: Canadian Centre for Architecture, 2000.

Handlin, David P. *American Architecture*. London: Thames and Hudson, 1985.

Harris, S., and D. Berke, eds. *Architecture of the Everyday*. New York: Princeton Architectural Press, 1997.

Haskell, Douglas. "Architecture and Popular Taste." *Architectural Forum* 109 (2) (August 1958): 104–109.

Haskell, Douglas. "Jazz in Architecture: It Makes More Fun and Better Sense." *Architectural Forum* 113 (3) (September 1960): 110–115.

Heynen, Hilde. *Architecture and Modernity*. Cambridge, MA: MIT Press, 1999.

Hitchcock, Henry-Russell. "The Architecture of Bureaucracy and the Architecture of Genius." *Architectural Review* 101 (1947): 3–6.

Hitchcock, Henry-Russell. *Introduction to Architecture of SOM, 1950–1962*. New York: Praeger, 1963.

Huxtable, Ada Louise. "The Park Avenue School of Architecture." *New York Times Magazine*, December 15, 1957.

Huxtable, Ada Louise. *Will They Ever Finish Bruckner Boulevard?* New York: Times Books, 1970.

Hyde, Melissa. *Making Up the Rococo: François Boucher and His Critics*. Los Angeles: Getty Research Institute, 2006.

Hyman, Isabelle. *Marcel Breuer, Architect: The Career and the Buildings*. New York: Abrams, 2001.

James, Kathleen. *Erich Mendelsohn and the Architecture of German Modernism*. New York: Cambridge University Press, 1997.

Jarzombek, Mark. "'Good-Life Modernism' and Beyond: The American House in the 1950s and 1960s: A Commentary." *Cornell Journal of Architecture* 4 (1990): 76–93.

Jencks, Charles. *Late-Modern Architecture and Other Essays*. New York: Rizzoli, 1980.

Jencks, Charles. *Modern Movements in Architecture*. New York: Anchor, 1973.

Jenkins, Stover, and David Mohney. *The Houses of Philip Johnson*. New York: Abbeville Press, 2001.

Johnson, Philip. *The Sheldon Memorial Art Gallery*. Lincoln: University of Nebraska Board of Regents, 1964.

Johnson, Philip. *Writings*. New York: Oxford University Press, 1979.

Johnson, Philip, Hilary Lewis, and Stephen Fox. *Architecture of Philip Johnson*. Boston: Bulfinch Press, 2002.

Jordy, William. "The Formal Image USA." *Architectural Review* (March 1960): 157–165.

Kahn, Louis. *Essential Texts*. Ed. Robert Twombly. New York: W. W. Norton, 2003.

Kallmann, G. M. "The 'Action' Architecture of a New Generation." *Architectural Forum* 110 (October 1959): 132–137.

Kaufmann, Edgar Jr. "Architectural Coxcomby or the Desire of Ornament." *Perspecta* 5 (1959): 4–15.

Kieffer, Jeffrey. *Readings from the Architecture of Louis I. Kahn*. Philadelphia: Xlibris, 2001.

Kleiheus, Josef Paul, and Christina Rathgeber, eds. *Berlin, New York: Like and Unlike: Essays on Architecture and Art from 1870 to the Present*. New York: Rizzoli, 1993.

Kramer, Hilton. "Philip Johnson's Brilliant Career." *Commentary* 100 (3) (September 1995): 38.

Krinsky, Carol Herselle. *Gordon Bunshaft of Skidmore, Owings and Merrill*. New York: Architectural History Foundation, 1988.

Laeffler, Jane. *Architecture of Diplomacy: Building America's Embassies*. Princeton: Princeton University Press, 1998.

Landis, Lawrence C. *The Story of the U.S. Air Force Academy*. New York: Rinehart, 1959.

Lange, Alexandra. "Tower, Typewriter and Trademark: Architects, Designers, and the Corporate Utopia, 1956–1964." PhD diss., Institute of Fine Arts, New York University, 2005.

Lavin, Sylvia. "The Temporary Contemporary." *Perspecta* 34 (2003): 128–135.

Leslie, Thomas. *Louis I. Kahn: Building Art, Building Science*. New York: George Braziller, 2005.

Lipstadt, Hélène. "Natural Overlap: Charles and Ray Eames and the Federal Government." In *The Work of Charles and Ray Eames: A Legacy of Invention*. New York: Harry N. Abrams, 1997.

Martin, Reinhold. "Atrocities; or, Curtain Wall as Mass Medium." *Perspecta* 32 (2001): 66–75.

264

Martin, Reinhold. *The Organizational Complex: Architecture, Media, and Corporate Space*. Cambridge, MA: MIT Press, 2003.

Martineau, Pierre. "Sharper Focus for the Corporate Image." *Print* 13 (3) (May/June 1959): 21–23.

Masello, David. *Architecture without Rules: The Houses of Marcel Breuer and Herbert Beckhard*. New York: W. W. Norton, 1993.

Massey, Ann. *The Independent Group: Modernism and Mass Culture in Britain, 1945–1959*. Manchester: Manchester University Press, 1995.

McCallum, Ian. *Architecture USA*. New York: Reinhold, 1959.

McLeod, Mary. "Architecture and Politics in the Reagan Era." *Assemblage* 8 (1989): 23–59.

Merkel, Jayne. *Eero Saarinen*. London: Phaidon, 2005.

Moholy-Nagy, Sibyl. *The Architecture of Paul Rudolph*. New York: Praeger, 1970.

Moholy-Nagy, Sibyl. "Hitler's Revenge: The Grand Central Tower Project Had Dramatized the Horrors Inflicted on Our Cities in the Name of Bauhaus Design." *Art in America* 56 (5) (September-October 1968): 42–43.

Monk, Tony. *The Art and Architecture of Paul Rudolph*. Chichester, UK: Wiley-Academy, 1999.

Mozingo, Louise. "The Corporate Estate in the USA, 1954–1964." *Studies in the History of Garden and Designed Landscapes* 20 (1) (January/March 2000): 25–56.

Mozingo, Louise. *Pastoral Capitalism: A History of Suburban Corporate Landscapes*. Cambridge, MA: MIT Press, 2011.

Mumford, Eric. *The CIAM Discourse on Urbanism: 1928–1960*. Cambridge, MA: MIT Press, 2000.

Mumford, Lewis. *Architecture as a Home for Man: Essays for Architectural Record*. Ed. Jeanne M. Davern. New York: Architectural Record Books, 1975.

Mumford, Lewis. *From the Ground Up: Observations on Contemporary Architecture, Housing, Highway Building, and Civic Design*. New York: Harcourt, Brace, 1956.

Mumford, Lewis. *The Highway and the City*. New York: Harcourt, Brace, 1963.

Nauman, Robert. *On the Wings of Modernism*. Urbana: University of Illinois Press, 2004.

Newhouse, Victoria. *Wallace K. Harrison, Architect*. New York: Rizzoli, 1989.

Norberg-Schulz, Christian. *Meaning in Western Architecture*. New York: Praeger, 1975.

Ockman, Joan. *Architecture Culture 1943-1968: A Documentary Anthology*. New York: Rizzoli, 1993.

Ockman, Joan. "Midtown Manhattan at Midcentury: Lever House and the International Style in the City." In Peter Madsen and Richard Plunz, eds., *The Urban Lifeworld: Formation, Perception, Representation*. New York: Routledge, 2002.

Pearlman, Jill. *Inventing American Modernism: Joseph Hudnut, Walter Gropius, and the Bauhaus Legacy at Harvard*. Charlottesville: University of Virginia Press, 2007.

Petit, Emmanuel, ed. *Philip Johnson: The Constancy of Change*. New Haven: Yale University Press, 2009.

Philip Johnson and the Museum of Modern Art. New York: Museum of Modern Art, 1998.

Reed, Christopher. *Not at Home: The Suppression of Domesticity in Modern Art and Architecture*. London: Thames and Hudson, 1996.

Robin, Ron. *Enclaves of America: The Rhetoric of American Political Architecture Abroad*. Princeton: Princeton University Press, 1992.

Robinson, Cervin. *Architecture Transformed*. New York: Architectural League of New York, 1986.

Rohan, Timothy. *The Architecture of Paul Rudolph*. New Haven: Yale University Press, 2014.

Román, Antonio. *Eero Saarinen: An Architecture of Multiplicity*. New York: Princeton Architectural Press, 2003.

Rowe, Colin. "The Mathematics of the Ideal Villa: Palladio and Le Corbusier Compared." *Architectural Review* 101 (March 1947): 101–104.

Rykwert, Joseph. *Louis Kahn*. New York: Harry N. Abrams, 2001.

The Salk Institute. Photographs by Ezra Stoller. New York: Princeton Architectural Press, 1999.

Salomon, David L. "One Thing or Another: The World Trade Center and the Implosion of Modernism." PhD diss. University of California, Los Angeles, 2003.

Sargeant, Winthrop. "From Sassafras to Branches." *New Yorker* (January 3, 1959).

Saunders, William. *Modern Architecture: The Photographs of Ezra Stoller*. New York: Abrams, 1990.

Schulze, Franz. *Philip Johnson, Life and Work*. New York: Knopf, 1994.

Scully, Vincent. "Archetype and Order in Recent American Architecture." *Art in America* 42 (December 1954): 250–261.

Scully, Vincent. "Doldrums in the Suburbs." *Journal of the Society of Architectural Historians* 24 (1965): 36–47.

Scully, Vincent. *The Earth, the Temple, and the Gods: Greek Sacred Architecture*. New Haven: Yale University Press, 1962.

Scully, Vincent. *Frank Lloyd Wright*. New York: George Braziller, 1960.

Scully, Vincent. *Louis I. Kahn*. New York: George Braziller, 1962.

Scully, Vincent. *Modern Architecture and Other Essays*. Ed. Neil Levine. Princeton: Princeton University Press, 2003.

Scully, Vincent. *Modern Architecture: The Architecture of Democracy*. New York: George Braziller, 1961.

Scully, Vincent. "Modern Architecture: Towards a Redefinition of Style." *Perspecta* 4 (1957): 4–10.

Scully, Vincent. "The Precisionist Strain in American Architecture." *Art in America* 48 (1960): 46–53.

Smith, Terry. *Making the Modern: Industry Art and Design in America*. Chicago: University of Chicago Press, 1993.

Smithson, Alison, and Peter Smithson. *Changing Art of Inhabitation*. London: Artemis, 1994.

Smithson, Alison, and Peter Smithson. *Without Rhetoric: An Architectural Aesthetic*. Cambridge, MA: MIT Press, 1973.

Solomon, Susan G. *Louis I. Kahn's Trenton Jewish Community Center*. New York: Princeton Architectural Press, 2000.

Staniszewski, Mary Anne. *The Power of Display: A History of Exhibition Installations at the Museum of Modern Art*. Cambridge, MA: MIT Press, 1998.

Stern, Robert. *Modern Classicism*. New York: Rizzoli, 1988.

Stern, Robert. *New Directions in American Architecture*. New York: George Braziller, 1969.

Stern, Robert. *New York 1960*. New York: Monacelli Press, 1995.

Stirling, James. "The Functional Traditional and Expression." *Perspecta* 6 (1960): 88–97.

Stone, Edward Durell. *The Evolution of an Architect*. New York: Horizon Press, 1962.

Sykes, Ann. "The Vicissitudes of Realism: Realism in Architecture of the 1970s." PhD diss., Harvard University, Department of Architecture, Landscape Architecture and Urban Planning, 2004.

Tafuri, Manfredo. *The Sphere and the Labyrinth: Avant-Gardes and Architecture from Piranesi to the 1970s*. Trans. Pellegrino d'Acierno and Robert Connolly. Cambridge, MA: MIT Press, 1987.

Tafuri, Manfredo, and Francesco Dal Co. *Modern Architecture*. vol. 2. New York: Rizzoli, 1979.

Tate, Allen, and C. Ray Smith. *Interior Design in the 20th Century*. New York: Harper and Row, 1986.

Temko, Allan. *Eero Saarinen*. New York: George Braziller, 1962.

The TWA Terminal. Photographs by Ezra Stoller. New York: Princeton Architectural Press, 1999.

Welch, Frank D. *Philip Johnson and Texas*. Austin: University of Texas Press, 2000.

Wittkower, Rudolf. *Architectural Principles in the Age of Humanism*. London: Warburg Institute, 1949.

Wright, Gwendolyn. "Permeable Boundaries: Domesticity in Post-War New York." In Peter Madsen and Richard Plunz, eds., *The Urban Lifeworld: Formation, Perception, Representation*. New York: Routledge, 2002.

Zanker, Paul, ed. *New Architecture and City Planning: A Symposium*. New York: Philosophical Library, 1944.

Zevi, Bruno. *Architecture as Space*. Trans. J. Barry. New York: Horizon Press, 1957.

267

Index

Note: Figures are indicated by "f" following page numbers.

271

277

281

283